Praise for *On Freedom*

"Nelson thrives in the intellectually murky spaces that politics wants to simplify. . . . If *On Freedom* can be boiled down to an exhortation (an exercise that Nelson would surely be wary of), it would be to look, to listen—and to get comfortable with the instability you might find upon doing so. . . . [A] sense of optimism sits at the heart of *On Freedom. What else is possible?* it asks. . . . *On Freedom* is an argument for how we engage with objects of analysis—and one another—in a way that is principled but not rigid, that displays care for other people's perceptions, pains and desires, and that has respect for what we cannot know."
—Ismail Muhammad, *The New York Times Magazine*

"If Nelson is advocating for anything, it's that the practice of freedom should be spacious enough for its contradictions, its reversals, its sprawling expressions, its ragged edges; getting comfortable with this complexity is essential to finding our way through it. Many will be soothed, nourished, even thrilled by this proposition, which, for a book about a term as loaded as 'freedom,' is refreshingly flexible. . . . *On Freedom* is ultimately a book that asks us to boldly and generously enter the minefield, to pick up what we find useful, to be pushed and provoked, to polish and discard and reinvent, and then to decide, alone and, ideally, in communion, where to go next."
—Meara Sharma, *The Washington Post*

"In discussion after discussion, Nelson shows the same alertness to context, intellectual modesty, and the conviction that ethical goodness is never all on one side. She doesn't aim to provide a positive account of the meaning of freedom. But if we understand freedom, above all, through our opposition to bondage, we can learn a great deal, as her book shows, from carefully cataloging and challenging the many ways of being unfree."
—Kwame Anthony Appiah, *The New York Times Book Review*

"[An] elastic, imaginative study. . . . By turns taut and discursive, precise and atmospheric, combining fierce intellectual kick with an openness to nuance. . . . [Nelson asks] how to live in a world with crushing oppression, alongside people with cruel and violent beliefs, without giving into despair or violence yourself. . . . After nearly every point, she will complicate it—probe its weak spots and limits, ask what she's not seeing, contradict herself. . . . The result is not fuzziness but precision, a hyper-awareness of moral shading. In *On Freedom*, Nelson is doing what feels like intellectual echolocation: putting out calls and seeing what answers."

—Annalisa Quinn, NPR.org

"Rather than define freedom in exact terms or declare what it is for, Nelson moves through knots of ideology on freedom via 'songs' of art, sex, drugs, and climate, drawing conclusions . . . that obliterate the binary of freedom vs. constraint. . . . If you want to get your hands around something as vast and slippery as freedom, you are going to have to get comfortable moving through an ideological briar patch. *On Freedom* offers navigation tips, but Nelson's call to action is a journey that readers must take on their own." —Alden Jones, *The Boston Globe*

"*On Freedom* is the welcome return of Maggie Nelson, this time tackling the uses, misuses and briars of meaning around an idea that a lot of people easily define but rarely follow through to uncomfortable, contradictory ends. Nelson once again—as she has with cruelty, pregnancy, loneliness—collapses a mountain of thought into a digestible argument that leaves you feeling just a bit *smarter*."

—Christopher Borrelli, *Chicago Tribune*

"[Maggie Nelson is] one of our most radical and forward-looking thinkers. . . . She opens the conversation to her readers as fellow interlocutors—she describes it as 'thinking aloud with others'—in an astonishingly moving way. . . . What makes this book so exciting is precisely the balancing act that enables Nelson to tear everything up at the same time as she retains faith in the values (desire, artistic freedom, difficulty) that shaped her." —Lara Feigel, *The Guardian* (UK)

"The inimitable Maggie Nelson, in her new book, *On Freedom: Four Songs of Care and Constraint*, sees a 'straw man' in such dismissive depictions of sex positivity. She says that sceptics forget its crucial historical backdrop— the feminist and queer AIDS activism of the eighties and nineties."

—Amia Srinivasan, *The New Yorker*

"Nelson bounds across knotty subjects like #MeToo, sex positivity, addiction, queer theory, anxiety and carceral feminism without tiring of the painstaking work of untangling controversies. . . . After reading Nelson, your understanding of the word ['freedom'], and of humanity itself, will expand in surprising directions." —Jessica Ferri, *Los Angeles Times*

"The latest book from poet and writer Maggie Nelson is a meditative and potent examination of freedom. Looking at freedom through the realms of art, sex, drugs and climate, the author of *The Argonauts* explores the contradictions, complexities and rhetoric that surround the term. Combining thoughtful cultural criticism with anecdotes from her personal life, Nelson delivers an intriguing work of nonfiction that seeks to challenge readers' definition of freedom and rethink how the concept operates in our lives." —*Time*

"A sustained, uncompromisingly even-handed meditation on the barbed cultural and political debates around personal freedom and interdependence in the spheres of art, sex, drugs, and climate. . . . Nelson has a vast capacity to embrace and 'hold' the contradictions of difficult art. This critical compassion is one of her great strengths."

—Moyra Davey, *4Columns*

"As ever, Nelson's probing inquiry sits on equal footing with her effortlessly fluid prose, which moves between first-person, anecdotal stories and intense critical examination with the utmost readability. Ultimately Nelson's approach is one that seeks liberation and transcendence, whether sexual, narcotic, or purely biological—something that radiates palpably from her writing, even when she delves into some of the darkest corners of the human psyche." —Liam Hess, Vogue.com

"A refreshing, daring consideration of our most tangled social problems. . . . It is unapologetic in its acknowledgement of what it means to actually think—really, truly *think*—about culture and all the uncertainty that entails. . . . We urgently need more of this 'thinking aloud with others,' just as we urgently need more of Maggie Nelson's measured, empathetic analysis." —Zak Salih, *Washington Independent Review of Books*

"Nelson is, above all, a writer of prose and poetry often startling in its aptness, precision, and unexpectedness. . . . [*On Freedom*] is a subtle and elegant book. . . . What is important about this book is not only its argument but also that it is an excellent example of the practices it commends."
 —Paul J. Griffiths, *Commonweal*

"While her intellect is the driving force of *On Freedom*, Nelson decenters herself to build a canon of radical thought. . . . [Nelson] gets to the marrow of being. It is impossible, she argues, to cure ourselves either of vulnerability or the yearning to be incautious as sexual beings and restless intellects. . . . In defense of what should be obvious—we are beholden to each other and the planet that sustains us—Nelson encourages readers to examine 'how we negotiate, suffer, and dance with that enmeshment,' therein finding meaning, purpose and joy in an age of justifiable anxiety." —Kristen Millares Young, *The Washington Post*

"[Nelson] is more focused on creating a practice of freedom with her style than on any triumphs her style might produce. . . . Nelson's most remarkable achievement, not only in *On Freedom* but across all her books, is that she consistently makes good on this wager to enact a form of care through her style." —Dan Kubis, *Pittsburgh Post-Gazette*

"A supple thinker, [Nelson] challenges us to stretch, asking in so many words, what would it take to hold this truth, and this one too, and that one over there? . . . Nelson is an astute observer of the stories we tell, blind spots and all, and of what mindset and structure of feeling they bring forth. . . . Singing of care and constraint in the same breath as she invokes freedom, Nelson invites us to imagine different desires, new ties of interdependence that we tend to eagerly." —Christina Schmid, *Rain Taxi*

"Nelson has a brain you need to chase, but for readers inclined to hot pursuit there are few thinkers as exhilarating. . . . *On Freedom* is a mighty hymn to context and subtlety, another much-needed celebration of the motley, ungovernable, transgressive and possible. And approached as a symposium—a grand chorus—each of *On Freedom*'s component essays invites (perhaps demands) participation. They welcome dissent. That's the rare and precious pleasure of Nelson's work, her generosity."

—*The Australian*

"A volume of literary philosophy that's no less blazing [than *The Argonauts*]: provocative essays about the 'felt complexities' and 'patient labor' of personal and political liberation." —*Oprah Quarterly*

"The keys for Nelson—acceptance, nuance, context, continued exploration, ongoing work—hint at solutions to reframe freedom in a country obsessed with liberty; to address and expose harmful sex and power but to also push further to reveal new truths and voices; to allow art to be art; and to come to terms with our planet's fate and act in more meaningful ways."

—*Chicago Review of Books*

"Nelson wrestles with the key question of our time: how to cope with the overwhelming reality of climate change without being paralyzed into inaction. It is unanswerable, of course, but her articulation of the predicament is a salve in itself. . . . It is a delight to spend time with Nelson's erudite mind." —Mia Levitin, *The Times Literary Supplement* (UK)

"[*On Freedom*] will leave readers with a lot to ponder, to learn, and to unlearn. It might even prompt one to stay up late blowing up her group chat. Nelson remains respectful of her complex subject matter, never dismissing or oversimplifying what is quite possibly the most important question of our era: Can we ever be truly free?" —Brianne Kane, *Bust*

"Maggie Nelson shows how enlivening new ways of thinking can actually be. . . . [*On Freedom*] is, refreshingly, a true work of criticism, willing to be disagreeable, argumentative and move toward unexpected conclusions."

—Gabriel Chazan, *Triangle House Review*

"Profound. . . . A heady mix of erudite analysis and personal revelation. . . . Nelson brings a critically nuanced appreciation of individual and societal freedom to her mapping of the minefields involved in simultaneously embracing liberty and jettisoning habits of control and paranoia that threaten liberation." —*Booklist*

"Reading Nelson is like watching a prima ballerina deliver the performance of a lifetime: athletic, graceful, and awe-inspiring."
 —Hillary Kelly, *Vulture*

"One of the literary world's foremost cultural critics and essay writers returns with this staggering work. . . . *On Freedom* takes [Nelson's] work to yet another level of approachable complexity. It is, without a doubt, one of the year's best, most timely, and necessary books." —*Shondaland*

"A conversation I've been having in my head (without even knowing it, mostly experienced as anxiety) was suddenly brought out of its cage, lifted up, made dimensional and even weirdly hopeful. *On Freedom* fixes nothing but makes more room for messy contradictions which is all I ask of my art and my friends and my lovers. I feel like I could run and win a million races with this book cheering me on! I sound foolish! But what do we have if not that gasping feeling that comes from other people's good work! Thanks for going through the trouble, Maggie. I do believe it was worth it." —Miranda July

"A top cultural critic plucks the concept of freedom away from right-wing sloganeers and explores its operation in current artistic and political conversations. . . . The subtlety of Nelson's analysis and energy of her prose refresh the mind and spirit." —*Kirkus Reviews*

"Nelson turns each thought until it is finely honed and avoids binaries and bromides. While the literary theorizing is rich, this account soars in its ability to find nuance in considering questions of enormous importance. . . . Once again, Nelson proves herself a masterful thinker and an unparalleled prose stylist." —*Publishers Weekly*, starred review

On Freedom

FOUR SONGS OF CARE AND CONSTRAINT

ALSO BY MAGGIE NELSON

The Argonauts
The Art of Cruelty: A Reckoning
Bluets
Women, the New York School, and Other True Abstractions
The Red Parts: Autobiography of a Trial
Jane: A Murder
Something Bright, Then Holes
The Latest Winter
Shiner

On Freedom

FOUR SONGS OF CARE AND CONSTRAINT

Maggie Nelson

Graywolf Press

This publication is made possible, in part, by the voters of Minnesota through a Minnesota State Arts Board Operating Support grant, thanks to a legislative appropriation from the arts and cultural heritage fund. Significant support has also been provided by the McKnight Foundation, the Lannan Foundation, the Amazon Literary Partnership, and other generous contributions from foundations, corporations, and individuals. To these organizations and individuals we offer our heartfelt thanks.

MINNESOTA
STATE ARTS BOARD

CLEAN
WATER
LAND &
LEGACY
AMENDMENT

Published by Graywolf Press
212 Third Avenue North, Suite 485
Minneapolis, Minnesota 55401

www.graywolfpress.org

Published in the United States of America

ISBN 978-1-64445-062-8 (cloth)
ISBN 978-1-64445-202-8 (paperback)
ISBN 978-1-64445-155-7 (ebook)

2 4 6 8 9 7 5 3 1
First Graywolf Paperback, 2022

Library of Congress Control Number: 2022930741

Cover design: Kapo Ng

Leviathan

Truth also is the pursuit of it:
Like happiness, and it will not stand.

Even the verse begins to eat away
In the acid. Pursuit, pursuit;

A wind moves a little,
Moving in a circle, very cold.

How shall we say?
In ordinary discourse—

We must talk now. I am no longer sure of the words,
The clockwork of the world. What is inexplicable

Is the "preponderance of objects." The sky lights
Daily with that predominance

And we have become the present.

We must talk now. Fear
Is fear. But we abandon one another.

—GEORGE OPPEN, 1965

for Iggy

already & forthcoming

Contents

Introduction 3

1. Art Song 19

2. The Ballad of Sexual Optimism 73

3. Drug Fugue 127

4. Riding the Blinds 171

 Afterword 213

 Acknowledgments 221
 Notes 223
 Works Cited 255
 Index of Names 281

On Freedom

FOUR SONGS OF CARE AND CONSTRAINT

Introduction

STOP HERE IF YOU WANT TO TALK ABOUT FREEDOM — A CRISIS
OF FREEDOM — THE KNOT — ENTANGLEMENT/ESTRANGEMENT —
FREEDOM IS MINE AND I KNOW HOW I FEEL — PATIENT LABOR

STOP HERE IF YOU WANT TO TALK ABOUT FREEDOM

I had wanted to write a book about freedom. I had wanted to write this book at least since the subject emerged as an unexpected subtext in a book of mine about art and cruelty. I had set out to write about cruelty, then found, to my surprise, freedom coming through the cracks, light and air into cruelty's stuffy cell. Once exhausted by cruelty, I turned to freedom directly. I started with "What Is Freedom?," by Hannah Arendt, and began to amass my piles.

But before long I diverted, and wrote a book about care. Some people thought the book about care was also a book about freedom. This was satisfying, as I, too, felt this to be the case. For some time, I thought a book on freedom might no longer be necessary—maybe not by me, maybe not by anyone. Can you think of a more depleted, imprecise, or weaponized word? "I used to care about freedom, but now I mostly care about love," one friend told me.[1] "Freedom feels like a corrupt and emptied code word for war, a commercial export, something a patriarch might 'give' or 'rescind,'" another wrote.[2] "That's a white word," said another.

3

Often I agreed: Why not take up with some less contested, obviously timely and worthy value, such as obligation, mutual aid, coexistence, resiliency, sustainability, or what Manolo Callahan has called "insubordinate conviviality"?[3] Why not acknowledge that freedom's long star turn might finally be coming to a close, that a continued obsession with it may reflect a death drive? "Your freedom is killing me!" read the signs of protesters in the middle of a pandemic; "Your health is not more important than my liberty!" maskless others shout back.[4]

And yet, I still couldn't quit it.

Part of the trouble resides in the word itself, whose meaning is not at all self-evident or shared.[5] In fact, it operates more like "God," in that, when we use it, we can never really be sure what, exactly, we're talking about, or whether we're talking about the same thing. (Are we talking about negative freedom? Positive freedom? Anarchist freedom? Marxist freedom? Abolitionist freedom? Libertarian freedom? White settler freedom? Decolonizing freedom? Neoliberal freedom? Zapatista freedom? Spiritual freedom? and so on.) All of which leads to Ludwig Wittgenstein's famous edict, *the meaning of a word is its use*. I thought of this formulation the other day when, on my university campus, I passed by a table with a banner that read, "Stop Here If You Want To Talk about Freedom." *Boy, do I!* I thought. So I stopped and asked the young white man, probably an undergraduate, what type of freedom he wanted to talk about. He looked me up and down, then said slowly, with a hint of menace, a hint of insecurity, "You know, *regular old freedom*." I noticed then that he was selling buttons divided into three categories: saving the unborn, owning the libs, and gun rights.

As Wittgenstein's work makes clear, that the meaning of a word is its use is no cause for paralysis or lament. It can instead act as an incitement to track *which language-game is being played*. Such is the approach taken in the pages that follow, in which "freedom" acts as a reusable train ticket, marked or perforated by the many stations, hands, and vessels through which it passes. (I borrow this metaphor from Wayne Koestenbaum, who once used it to describe "the way a word, or a set of words, permutates" in

the work of Gertrude Stein. "What the word means is none of your business," Koestenbaum writes, "but it is indubitably your business where the word travels.") For whatever the confusions wrought from talking about freedom, they do not in essence differ from the misunderstandings we risk when we talk to one another about other things. And talk to one another we must, even, or especially, if we are, as George Oppen had it, "no longer sure of the words."

A CRISIS OF FREEDOM

Looking back, my decision to stick with the term appears to have two roots. The first involves my long-standing frustration with its capture by the right wing (as in evidence at the young man's card table). This capture has been underway for centuries: "freedom for us, subjugation for you" has been at work since the nation's founding. But after the 1960s—a time during which, as historian Robin D. G. Kelley recalls in *Freedom Dreams*, "freedom was the goal our people were trying to achieve; *free* was a verb, an act, a wish, a militant demand. 'Free the land,' 'Free your mind,' 'Free South Africa,' 'Free Angola,' 'Free Angela Davis,' 'Free Huey,' were the slogans I remember best"—the right wing doubled down on its claim. In just a few brutal, neoliberal decades, the rallying cry of freedom as epitomized in the Freedom Summer, Freedom Schools, Freedom Riders, Women's Liberation, and Gay Liberation was overtaken by the likes of the American Freedom Party, *Capitalism and Freedom*, Operation Enduring Freedom, the Religious Freedom Act, Alliance Defending Freedom, and so much more. This shift has led some political philosophers (such as Judith Butler) to refer to our times as "postliberatory" (though, as Fred Moten notes, "preliberatory" might be just as accurate).[6] Either way, the debate as to where we stand, temporally, in relation to freedom, could be read as a symptom of what Wendy Brown has called a developing "crisis of freedom," in which "the particular antidemocratic powers of our time" (which can flourish even in so-called democracies) have produced subjects—including those "working under the banner of 'progressive politics'"—who appear "disoriented as to freedom's value," and have allowed "the language of resistance [to

take up the ground] vacated by a more expansive practice of freedom."[7] In the face of such a crisis, sticking with the term seemed one way to refuse this trade, to test the word's remaining or evacuated possibilities, to hold ground.

The second—which complicates the first—is that I've long had reservations about the emancipatory rhetoric of past eras, especially the kind that treats liberation as a one-time event or event horizon. Nostalgia for prior notions of liberation—many of which depend heavily upon mythologies of revelation, violent upheaval, revolutionary machismo, and teleological progress—often strikes me as not useful or worse in the face of certain present challenges, such as global warming. "Freedom dreams" that consistently figure freedom's arrival as a day of reckoning (e.g., Martin Luther King Jr.'s "day when all of God's children . . . will be able to join hands and sing in the words of the old Negro spiritual, 'Free at last, Free at last, Great God a-mighty, We are free at last'") can be crucial to helping us imagine futures that we want. But they can also condition us into thinking of freedom as a future achievement rather than as an unending present practice, something already going on. If ceding freedom to noxious forces is a grievous error, so, too, is holding on to rote, unventilated concepts of it with a white-knuckled grip.

For this reason, Michel Foucault's distinction between liberation (conceived of as a momentary act) and practices of freedom (conceived of as ongoing) has been key for me, as when he writes, "Liberation paves the way for new power relationships, which must be controlled by practices of freedom." I like this proposition very much; I would even say it is a guiding principle of this book. No doubt it will strike some as a giant buzzkill. (*Power relationships? Control? Isn't the whole point to ditch all that?* Maybe—but be careful what you wish for.) This is Brown's point when she says that the freedom to self-govern "requires inventive and careful use of power rather than rebellion against authority; it is sober, exhausting, and without parents." I think she is probably right, even if "sober, exhausting, and without parents" is a tough rallying cry, especially for those who already feel exhausted and uncared for. But I find this approach more inspiring and workable than waiting for the "final

'big night' of liberation," as French economist Frédéric Lordon has put it, "the apocalyptic showdown followed by the sudden and miraculous irruption of a totally different kind of human and social relations."

Lordon argues that letting go of our hopes for this big night may be "the best means of saving the idea of liberation"; I tend to agree. Moments of liberation—such as those of revolutionary rupture, or personal "peak experiences"—matter enormously, insofar as they remind us that conditions that once seemed fixed are not, and create opportunities to alter course, decrease domination, start anew. But the practice of freedom—i.e., the morning after, and the morning after that—is what, if we're lucky, takes up most of our waking lives. This book is about that experiment unending.

THE KNOT

"No matter what cause you advocate, you must sell it in the language of freedom," Representative Dick Armey (R-TX), founder of "FreedomWorks," once said. Whatever my feelings about Dick Armey, I began this project presuming that his dictum was, in the United States, fated to remain pretty solid. By the time I sat down to write, however, it was the fall of 2016, and Armey's dictum seemed to be swiftly unraveling. After years of freedom fries, Freedom's Never Free, and the Freedom Caucus, the rhetoric of freedom appeared momentarily in retreat, with protoauthoritarianism rushing into its place. In the run-up to the election, I spent more hours than I care to admit watching Trump's online supporters come up with new terms of despot endearment, such as "the patriarch," "the King," "Daddy," "the Godfather," the "Allfather," or, my personal favorite, "God-Emperor Trump." And I'm not just talking about the 8chan crowd; after the election, the Republican National Committee sent out a Christmas tweet heralding "the good news of a new King," an indication of all that was to come. Multiple word clouds have since confirmed: "freedom" is scarcely to be found in Trumpspeak, save in the cynical invocation of "free speech" deployed as a troll, or in Trump's ghastly iteration of freedom-as-impunity ("when you're a star, you can

do whatever you want").[8] Even the administration's 2019 effort to brand natural gas "freedom gas" sounded more like deliberate scatological farce than earnest ideological branding.

Over the next few years, the airport kiosks had lit up with titles such as *How Democracies Die*; *Fascism: A Warning*; *On Tyranny*; *Surviving Autocracy*; and *The Road to Unfreedom*. Wendy Brown's warning about "an existential disappearance of freedom from the world" felt newly corroborated, as did her worry that decades of privileging market freedoms over democratic ones may have led some to lose a longing for the freedom of self-governance, and to develop a taste for unfreedom—a desire for subjection, even—in its place. Such concerns many times brought to my mind James Baldwin's observation in *The Fire Next Time*: "I have met only a very few people—and most of these were not Americans—who had any real desire to be free. Freedom is hard to bear."

In such a climate, it was tempting to write a book that aimed to "reorient us as to freedom's very value," or to encourage myself and others to join the ranks of Baldwin's very few people with a real desire to be free. Such entreaties typically begin with a strong argument about what freedom is or ought to be, as in sociologist Avery F. Gordon's *The Hawthorn Archives: Letters from the Utopian Margins*, a collection described on its jacket as a "fugitive space" for the "political consciousness of runaway slaves, war deserters, prison abolitionists, commoners and other radicals," in which Gordon asserts (paraphrasing Toni Cade Bambara): "Freedom . . . is not the end of history or an elusive goal never achievable. It is not a better nation-state however disguised as a cooperative. It is not an ideal set of rules detached from the people who make them or live by them. And it is certainly not the right to own the economic, social, political, or cultural capital in order to dominate others and trade their happiness in a monopolistic market. Freedom is the process by which you develop a practice for being unavailable for servitude."

I have been moved and edified by many such entreaties.[9] But they are not, in the end, my style. The pages that follow do not diagnose a crisis of freedom and propose a means of fixing it (or us), nor do they take

political freedom as their main focus. Instead, they bear down on the felt complexities of the freedom drive in four distinct realms—art, sex, drugs, and climate—wherein the coexistence of freedom, care, and constraint seems to me particularly thorny and acute. In each realm, I pay attention to the ways in which freedom appears knotted up with so-called unfreedom, producing marbled experiences of compulsion, discipline, possibility, and surrender.

Because we tend—often correctly—to associate unfreedom with the presence of oppressive circumstances that we can and should work to change, it makes sense that we might instinctively treat the knot of freedom and unfreedom as a source of perfidy and pain. To expose how domination disguises itself as liberation, we become compelled to pull the strands of the knot apart, aiming to extricate the emancipatory from the oppressive. This is especially so when we are dealing with the link between slavery and freedom in Western history and thought—both the ways in which they developed together and have given each other meaning, and the ways in which white people have, for centuries, cannily deployed the discourse of freedom to delay, diminish, or deny it to others.[10] This approach also makes sense if and when one's goal is to expose the economic ideologies that align freedom with the willingness to become a slave of capital.[11]

But if we allow ourselves to wander away—if only for a spell—from the exclusive task of exposing and condemning domination, we may find that there is more to be found in the knot of freedom and unfreedom than a blueprint for past and present regimes of brutality. For it is here that sovereignty and self-abandon, subjectivity and subjection, autonomy and dependency, recreation and need, obligation and refusal, the supranatural and the sublunary commingle—sometimes ecstatically, sometimes catastrophically. It is here that we become disabused of the fantasy that all selves yearn only, or even mostly, for coherence, legibility, self-governance, agency, power, or even survival. Such a destabilizing may sound hip, but it can also be disquieting, depressing, and destructive. That's all part of the freedom drive, too. If we take time to fathom it, we might find ourselves less trapped by freedom's myths and

slogans, less stunned and dispirited by its paradoxes, and more alive to its challenges.

ENTANGLEMENT/ESTRANGEMENT

In *The Story of American Freedom*, historian Eric Foner describes how Americans' conception of freedom has long been structured by binary opposites; given the foundational role of slavery and its afterlife, a Black/white divide over freedom's meaning has been, for four hundred years now and counting, chief among these.[12] In a 2018 essay on musician Kanye West, Ta-Nehisi Coates lays out this binary in stark terms, describing "white freedom" as

> freedom without consequence, freedom without criticism, freedom to be proud and ignorant; freedom to profit off a people in one moment and abandon them in the next; a Stand Your Ground freedom, freedom without responsibility, without hard memory; a Monticello without slavery, a Confederate freedom, the freedom of John C. Calhoun, not the freedom of Harriet Tubman, which calls you to risk your own; not the freedom of Nat Turner, which calls you to give even more, but a conqueror's freedom, freedom of the strong built on antipathy or indifference to the weak, the freedom of rape buttons, pussy grabbers, and *fuck you anyway, bitch*; freedom of oil and invisible wars, the freedom of suburbs drawn with red lines, the white freedom of Calabasas.

—all of which Coates contrasts to "black freedom," which he describes as that which is built on a "we" instead of an "I," "experiences history, traditions, and struggle not as a burden, but as an anchor in a chaotic world," and has the power to pull people "back into connection . . . back to Home."

This book takes it as a given that our entire existence, including our freedoms and unfreedoms, is built upon a "we" instead of an "I," that we are dependent upon each other, as well as upon nonhuman forces that

exceed our understanding or control. This is so whether one advocates for a "nobody's free until everybody's free" conception of the term (à la Fannie Lou Hamer) or a "don't tread on me" variety, even if the latter attempts a disavowal. But it also recognizes that even the most impassioned insistence on our interdependence or entanglement offers only a description of our situation; it does not indicate how we are to live it. The question is not whether we are enmeshed, but how we negotiate, suffer, and dance with that enmeshment.

Despite Coates's useful and accurate bifurcation of terms, it becomes clear by his essay's end—including to Coates, I think—that a freedom rooted in a "we" rather than an "I" comes riven with its own set of complexities, complexities to which this book is devoted. In contemplating the demise of Michael Jackson, for example, Coates writes, "It is often easier to choose the path of self-destruction when you don't consider who you are taking along for the ride, to die drunk in the street if you experience the deprivation as your own, and not the deprivation of family, friends, and community." Increased awareness of our entanglement can offer sustenance, but it can also confound and hurt; if and when we ascertain that our well-being is linked to the behavior of others, the desire to impugn, control, or change them can be as fruitless as it is intense. Coming into full, acute knowledge as to how one's needs, desires, or compulsions might conflict with those of others, or bring others pain—even those one loves more than anything in the world—does not necessarily spring the trap. The state of addiction makes this excruciatingly clear, as we shall see. But addiction is not the only ring of action in which this predicament shines.

Some people do not find—indeed, cannot find—refuge where others imagine they could or should find it; some forgo anchors for lines of flight; some instinctively spurn moralistic edicts set forth by others; some find—or are forced to find—solace or sustenance in nomadism, cosmic hoboism, unpredictable or uncouth identifications, illegible acts of disobedience, homelessness, or exile than in a place called Home. *On Freedom* pays special attention to such figures and wanderings, as I do not believe they always signify an embrace of toxic ideologies. Seen from

a different angle, they may reveal themselves as further expressions of our elementary entanglement, rather than signs of our unresolvable estrangement (the terms are Denise Ferreira da Silva's, from her essay "On Difference without Separability"). How to forge a fellowship that does not rely on their purge, or that does not reflexively pit freedom against obligation, is this book's deepest call.

To pit freedom against obligation perpetuates at least two major problems. The first is structural: as Brown puts it in *States of Injury*, "A liberty whose conceptual and practical opposite is encumbrance cannot, by necessity, exist without it; liberated beings defined as unencumbered depend for their existence on encumbered beings, whom their liberty in turn encumbers." The second is affective, in that the call to obligation, duty, debt, and care can quickly slip into something oppressively moralistic, more reliant on shame, capitulation, or assuredness of our own ethical goodness in comparison with others, than on understanding or acceptance. (Think of the exasperated slogan, "I don't know how to explain to you that you should care for other people," that started showing up on T-shirts and murals during COVID: while I may think some variation of this sentence ten times a day, I can also see that its conviction of a "you" in need of my explanation is likely obstructing the very change I want to see.) In an interview at the end of *The Undercommons*, Stefano Harney addresses this moralism, and tries to imagine another way: "It's not that you wouldn't owe people in something like an economy, or you wouldn't owe your mother, but that the word 'owe' would disappear and it would become some other word, it would be a more generative word." I don't know yet what this word would be, nor am I sure that, if I found it, I would know how to live it. But I feel certain that such querying leads in the right direction.

FREEDOM IS MINE AND I KNOW HOW I FEEL

As luck would have it, Arendt's "What Is Freedom?" was a wonderfully perverse place to start. For it is here that Arendt offers an extended meditation on her conviction that "inner freedom" is not just irrelevant to po-

litical freedom—that all-crucial (to Arendt) capacity to act in the public sphere—but its opposite. Like Nietzsche before her, Arendt considered inner freedom a pitiful delusion, a booby prize for the powerless. By her account, the idea made murmurs in Greek antiquity, but absolutely bloomed with the advent of Christianity, whose basic tenets regarding the blessedness of the meek Nietzsche famously described as "slave morality." There is, Arendt says, "no preoccupation with freedom in the whole history of great philosophy from the pre-Socratics up to Plotinus, the last ancient philosopher"; freedom makes its first appearance in Paul, then Augustine, vis-à-vis their accounts of religious conversion, an experience notable for producing internal feelings of liberation despite externally oppressive circumstances. Freedom's appearance on the philosophical scene, she says, was the result of persecuted or oppressed people's efforts "to arrive at a formulation through which one may be a slave in the world and still be free." Arendt sneers at this apparent oxymoron, presuming there is nothing worthwhile to be found there. And why would she, believing, as she did, that "without a politically guaranteed public realm, freedom lacks the worldly space to make its appearance. To be sure it may still dwell in men's hearts as desire or will or hope or yearning; but the human heart, as we all know, is a very dark place, and whatever goes on in its obscurity can hardly be called a demonstrable fact."

In her reckoning with neoliberalism, Brown extends this argument, maintaining that "the possibility that one can 'feel empowered' without being so forms an important element of legitimacy for the antidemocratic dimensions of liberalism." I take the point: feeling free or empowered while, say, uploading all our personal information into a corporate surveillance state; driving fast in a gasoline-powered car whose emissions are contributing to the foreclosure of planetary life; partying hard at Pride while leaving mountains of ocean-killing plastic in one's wake; writing a book about feeling free while corrupt, geocidal racists push us toward autocracy and loot our collective trust could all seem the delusions of a tool. The question is how to recognize such imbrication without making a fetish of debunking, decontamination, or bad feeling along the way. (Think, for example, of former Democratic representative Barney Frank's stunning equation, which he used to lay out as a truism

to activists, about good feeling signifying bad work: "If you care deeply about an issue and are engaged in group activity on its behalf that is fun and inspiring and heightens your sense of solidarity with others, you are almost certainly not doing your cause any good." Forget the question of how we're supposed to build and inhabit a world that is fun and inspiring and rich with a heightened sense of solidarity with others if we have no lived experience of how to access or enjoy such things along the way. Feeling bad is a prerequisite for bringing the world we want into being, get it?)[13]

For his part, Baldwin well understood the dangers of focusing on so-called inner freedom at the expense of gaining and wielding political power. But he also sternly warned against ignoring the former in pursuit of the latter. In fact, directly after his comment about freedom being hard to bear, he writes, "It can be objected that I am speaking of political freedom in spiritual terms, but the political institutions of any nation are always menaced and are ultimately controlled by the spiritual state of that nation."

Always menaced and ultimately controlled by. What does it mean? Try as pollsters might, you can't quantify or chart such a relation. You can't take a hard measurement of a spiritual state that would pass Arendt's test for a demonstrable fact. But if there's one thing the Trump era, along with the disinformation campaigns that ushered it into being, has made clear, it's that "politics is always emotional."[14] And somatic: our libidinal upsurges leak from us, get transformed into binary code, are fed back to us as social media warfare, which reaffects our daily emotional and somatic state, in addition to results at the ballot box. People develop hand tremors, high blood pressure, or acid reflux upon witnessing the separation of migrant children from their parents at the border; a Black Lives Matter activist mourning the death of her brother at the hands of the police has an asthma-induced heart attack and dies at age twenty-seven; chronic pain, abuse, and self-harm surge due to the government's failure to manage a pandemic. Given such a swirl, we need not be scared off by the so-called obscurity of the human heart, or buy into a firm partition between it and what Arendt calls "worldly reality."[15]

Instead, we might wonder: Why is the project of *feeling good* "almost always considered an obscenity both from the perspective of the ones who run shit and the ones who resist them," as Moten has put it?[16] What do "feeling good" and "feeling free" have to do with one another? What effects has the insistence—so intensely American—that liberty leads to well-being, or that more liberty leads to more well-being, had on our understanding (or experience) of both terms?[17] How are we to discern—or who gets to discern—which kinds of "feeling free" or "feeling good" stem from or breed bad faith (or sin itself—hence the evocation of obscenity, which literally means "to stand before filth"), and which kinds are nourishing and transformative? How to talk about feeling free or feeling good without forgetting, as Nietzsche reminds us, that the will to power "feels good" to some people?[18] What about the good feelings that derive from experiences of constraint, duty, or the surrender of freedom, and the bad ones that derive from feeling unmoored, unneeded, or hoarding freedom for oneself? What to do with the electric, catastrophic freedom of having "nothing left to lose," wherein death can serve as asymptote or endgame? *Freedom is mine, and I know how I feel*, sang Nina Simone, in a song titled—what else?—"Feeling Good." Who am I, who is anyone, to accuse her of false consciousness, to conclude that her feelings of freedom had no potency, no capacity for transmission, no value in and of themselves? How can anyone pretend to know or judge the full nature and extent of that transmission, when it takes place across time, is ungovernable, is still on the move, even as I write?

In grappling with such questions, I have taken as my guide the words of anthropologist David Graeber, who wrote in *Possibilities*: "Revolutionary action is not a form of self-sacrifice, a grim dedication to doing whatever it takes to achieve a future world of freedom. It is the defiant insistence on acting as if one is already free." The pages that follow highlight figures who act this way, as I believe the border between acting "as if" and actually "being so" to be blurry if not illusory. I go wary of those who pretend to be able to police the difference, as well as of those who aim to diminish or obscure the ways in which feeling free, feeling good, feeling empowered, feeling communion, feeling potency can be literally

contagious, can have the power to break up the illusion not only of the separateness of spheres, but also of our putative selves.[19]

PATIENT LABOR

That the book about freedom you are holding in your hands ended up also being a book about care didn't really surprise me; I've felt out that weave before. What surprised me was that writing about freedom, and, to some extent, writing about care, also meant writing about time.

This book has taken me a long time. Or what feels like a long time, anyway. Of all the genres, criticism always seems to take the most time. Perhaps this is why Foucault once described it as "a patient labor giving form to our impatience for liberty." This sounds about right to me.

Patient labor differs from moments of liberation or itinerant feelings of freedom in that it *goes on*. Because it goes on, it has more space and time for striated, even contradictory sensations, such as boredom and excitement, hope and despair, purpose and purposelessness, emancipation and constraint, feeling good and feeling otherwise. These vacillations can make it difficult to recognize our patient labor as a practice of freedom in and of itself. "Art is like having a nail file and being in prison and trying to get out," says British artist Sarah Lucas; over time, I've come to feel something of the same about writing. This is a change: unless I'm misremembering, when I was younger, "feeling free" through writing felt totally on the menu. Whereas now it feels like a forced, daily encounter with limits, be they of articulation, stamina, time, knowledge, focus, or intelligence. The good news is that such difficulties or aporias do not determine the effect of our work on others. In fact, it increasingly seems to me that the goal of our patient labor is not our own liberation per se, but a deepened capacity to give it away, with an ever-diminishing attachment to outcome.

Shadowing this idea of patient labor, or of freedom as unending political struggle, is the Buddhist discourse on liberation, in which freedom is treated as absolutely and immediately accessible via the most mundane

activities, such as breathing. Listen, for instance, to Vietnamese Buddhist monk Thich Nhat Hanh on how to attain liberation: "When your in-breath is the only object of your mind, you release everything else. You become a free person. Freedom is possible with your in-breath. Freedom can be obtained in two, three, seconds. You release all the sorrow and regret about the past. You release all the uncertainty and fear about the future. You enjoy breathing in; you are a free person. It's impossible to measure the degree of freedom of someone who is breathing in in mindfulness." I'm not asking you to believe it, nor am I saying that I'm able to experience it. But I'm open to the possibility. *If it were not possible, I would not ask you to do it*, said the Buddha.

On Freedom will not argue that mindful breathing will immediately deliver us social equity and justice, or reverse the course of global warming. But it will propose that, if we want to divest from the habits of paranoia, despair, and policing that have come to menace and control even the most well intentioned among us—habits that, when continuously indulged, shape what's possible in both our present and future—we are going to need methods by which we feel and know that other ways of being are possible, not just in some revolutionary future that may never come, or in some idealized past that likely never existed or is irretrievably lost, but right here and now. This is Graeber's point about "acting as if one is already free." And while this sometimes means more protest and puppets (as is Graeber's wont), it can also mean the development of more understated practices by which one develops a greater tolerance for indeterminacy, as well as for the joys and pains of our inescapable relation.

1. Art Song

THE AESTHETICS OF CARE − THE ORTHOPEDIC AESTHETIC −
REPARATIVE, REDUX − WORDS THAT WOUND − COPS IN THE HEAD
− GO WHERE? − I CARE/I CAN'T − AFRAID TO DO WHAT HE MIGHT
CHOOSE − FREEDOM AND FUN − AESTHETIC CARE − COERCED AND
FREELY GIVEN

THE AESTHETICS OF CARE

A few years ago I was asked to be on a panel at a museum discussing "the aesthetics of care." The invitation read, "In a year [2016] marked by divisive political rhetoric and acts of exclusion, the question of care has newly—and forcefully—emerged within cultural discourse. . . . What might an aesthetics of care look like, today, as a deep structure that might drive artistic practice, formally and materially? How do ideas of care—as a form, too, of love—transform the aesthetics of protest? How does art survive—how can we care for it, and how can it care for us?"

The event never got off the ground, but the invitation got me thinking. In a world in which so many do not have enough care, indeed are aggressively, often punishingly *un*cared for, or are regularly coerced into caring for others at the expense of themselves or their loved ones—not to mention a world in which the regular triumph of something we sometimes call "freedom" over and opposed to something we sometimes call "care" may very well end up responsible not just for much past and current

suffering, but also for extinguishing planetary life as we know it—the urge to seek and valorize care in everything, including art, makes sense. The urge correlates to the demand—coalescing in activist circles for some time now—for a "politics of care," defined by Gregg Gonsalves and Amy Kapczynski as "a new kind of politics . . . organized around a commitment to universal provision for human needs; countervailing power for workers, people of color, and the vulnerable; and a rejection of carceral approaches to social problems."[1] It also finds inspiration and echo in the work of scholar Christina Sharpe, who, along with others, has imagined care as "a way to feel and to feel for and with, a way to tend to the living and the dying," and linked it specifically to art making and viewing.[2]

Given my interest in all of the above, why, I wondered, was my first response to "an aesthetics of care" as something that would extend beyond an animating principle for certain artists, *yuck*?

In pondering, I realized that, while I've always taken issue with art that aims to endanger or terrorize its audience or participants, I've never gone to art looking for care, at least not in any direct fashion. In fact, I've often felt that art's *not* caring for me is precisely what gives me the space to care about it. Certainly I have been moved and nourished by some art motivated by care, just as I have, at times, felt myself motivated by it (even if I usually suspect the motivation). But I have also long valued art's *not* caring as a portal to forms of freedom and sustenance that differ in key ways from those engendered by politics, therapeutics, or direct service. As artist Paul Chan has it: "Collective social power needs the language of politics, which means, among other things, that people need to consolidate identities, to provide answers . . . to make things happen. Whereas my art is nothing if not the *dispersion* of power. . . . And so, in a way, the political project and the art project are sometimes in opposition." Acknowledging and allowing for this opposition (when it occurs) is not the same as cordoning aesthetics off from politics. It is about attending to and allowing for differences—between sensibilities, between spheres, and between types of experience—and letting go of the insistence that aesthetic and political practice mirror each other, or even correspond amicably.[3] This is especially crucial when it comes to the call to

care, which is a much trickier rallying cry when it comes to art than it may initially appear.

This trickiness has to do with art's status as a third thing between people whose meaning, as Jacques Rancière has it, "is owned by no one, but which subsists between [artist and spectator], excluding any uniform transmission, any identity of cause and effect." Whereas care can slip quickly into paternalism or control when it isn't experienced as care by its receiver (think of the last time someone did something you didn't want or like "because they cared about you"), art is characterized by the indeterminacy and plurality of the encounters it generates, be they between a work and its maker, a work and its variegated audience, or a work of art and time. Its capacity to mean differently to different viewers—some of whom have not yet been born, or who died long ago—will always complicate any judgment that pretends certainty about any given work's meaning, or that purports that meaning to be self-evident or fixed.

This indeterminacy has never kept critics or curators (or panel organizers) from participating in the age-old sport of imbuing a philosophical, political, or ethical concept with a positive valence (or a negative one, as with Hitler's "Degenerate Art"), then gathering art under its rubric. Progressive and conservative critics alike (for lack of better terms) play this game, insofar as both often embrace the premise that art has a moral function, such as "showing us how to live," or "encouraging connection," or underscoring another value (be it "care," "community," "beauty," "honor," "subversion," "sociality," or "wildness"). In literary circles, philosopher Martha Nussbaum has become well known for the "reading novels can make us better people" argument (they have to be the right novels, of course: master of relations, Henry James, thumbs up; solipsistic Samuel Beckett, thumbs down); many critics have run poetry through a similar sieve, as when Juliana Spahr argues, in *Everybody's Autonomy*, that "when we tackle literary criticism's central question of what sort of selves literary works create, we should value works that encourage connection." But how can one sort out which works "encourage connection" and which don't, when the one thing all art does (even Beckett's!) is transmit a signal, put forth a communication, which is by

no means ontologically invalidated as a transmission if it expresses misanthropic, opaque, or antisocial elements?

Such underlying moralism may be one reason why abstract theorizing about art can take a bit of an embarrassing turn when it runs into actual works of art or artists, who often prefer that the field of play remain less codified or sanitized. Here, for example, is painter Amy Sillman, recounting a talk she attended by Franco Berardi:

> I recently heard Franco "Bifo" Berardi give a talk about not working (something that doesn't make a lot of sense if you actually *like* "working" in your studio). Finally he made a distinction between work and art, saying that to make art is to make something beautiful, meaningful, erotic, empathetic—and as usual, when this is the language used to describe what we're doing, I wanted to barf. We're not making sexy beasts. If anything, call it libido instead of erotics—but we want an art also animated by ugliness, destruction, hatred, struggle. Punk seems as close as one can get to describe it, but what could be *less* punk than staying up late in a studio trying hard to make a "better" oil painting? That's so earnest, so caring—with a smock, and our tongue between our teeth, paintbrush poised, trying so hard—like the artists in a Jerry Lewis movie. So what are we doing? I can still only call it looking for this fragile thing that is awkwardness. This is not alienated labor, nor a commodity precisely, but a need, a way of churning the world, as your digestive system churns food.

Sillman's wanting to barf echoes my "yuck": both are visceral, admittedly juvenile efforts to repel the critics' dogged desire to convert a corporeal, compulsive, potentially pathetic, ethically striated, or agnostic activity into something "beautiful, meaningful, erotic, empathetic." Both cleave to art making as a metabolic activity, a "way of churning the world," rather than as something in need of defending, alchemizing, or otherwise proven socially worthy. Note, too, that Sillman's version of "caring for art" conjures the simple image of the artist in her studio trying to make a better oil

painting: caring for art, so far as most artists are concerned, often means finding the time, space, proficiency, and determination to make the best thing possible, whatever that means to her. For those who remain disproportionately engaged in providing care for others—which still typically means women—this caring may also entail figuring out how to suspend or offload the burden of caring for others long enough to be able to stand around in your studio with your smock on, paintbrush poised.

When I write about art, I try to keep this wanting to barf in mind. I try to imagine approaches that don't moralize or nauseate, knowing we all have our hobbyhorses ("openness," "nuance," "context," and "indeterminacy" might be mine). I try to keep in mind the artist's body—what it feels, what it wants, what it's compelled to try—along with the knowledge that failure—aesthetic and otherwise—is an integral, inevitable part of the process. I try to keep alive Sontag's simple question, posed in *Against Interpretation*: "What would criticism look like that would serve the work of art, not usurp its place?" For this isn't just a matter of how to write good criticism, or how to keep criticism in its allegedly proper place (i.e., subservient to the genius art that gives it rise). It's also an ethical matter, insofar as Sontag's question reminds us that the world doesn't exist to amplify or exemplify our own preexisting tastes, values, or predilections. It simply exists. We don't have to like all of it, or remain mute in the face of our discontent. But there's a difference between going to art with the hope that it will reify a belief or value we already hold, and feeling angry or punitive when it doesn't, and going to art to see what it's doing, what's going on, treating it as a place to get "the real and irregular news of how others around [us] think and feel," as Eileen Myles once put it.

THE ORTHOPEDIC AESTHETIC

So went my thinking in a 2011 book, *The Art of Cruelty*. There I examined the legacy of claims made by the historical avant-garde about the salutary effects of representing (or, more rarely, reenacting) cruelty, violence, and shock. I treated these claims with skepticism, but steered

decisively away from blanket statements about what representations of brutality do or do not accomplish. Instead, I argued for the importance of attending to context, and the indeterminacy wrought by time, which transmutes the initial meaning and audience for works of art, not to mention one's own shifting feelings toward them. I tried to dramatize this argument via narrating my own expeditions into turbulent areas of twentieth-century art, hoping to model a certain openness and curiosity throughout, along with the happy freedom of knowing I could turn away when I saw fit (a condition provided by "art" more than by "life"; as Sontag reminds us about the latter in *Regarding the Pain of Others*, "There isn't going to be an ecology of images. No Committee of Guardians is going to ration horror. . . . And the horrors themselves are not going to abate"). I was critical throughout of what art critic Grant Kester has called "the orthopedic aesthetic"—the avant-garde conviction that there's something wrong with us that requires artistic intervention to fix—even as I recognized that this conviction animates much of the art I care about. But since having strong expectations of what other people should feel, or how certain work should make them feel, is not usually a recipe for their autonomy or liberation, Rancière's formulation that "an art is emancipated and emancipating when . . . it stops *wanting* to emancipate us" served as my enduring guide.

That book was published just a decade ago, but its arguments would seemingly merit an update, now that twentieth-century debates over the merits of *épater la bourgeoisie* have been largely displaced by a discourse about when and how certain transgressions in art should be "called out" and "held accountable," with the twist that now the so-called left is often cast—rightly or wrongly—in the repressive, punitive position, with the right-wing morality police appearing newly (if hypocritically, selectively, even sadistically) enthralled by disinhibition, lawlessness, debauchery, and "freedom and fun" (cf. the ex-lawyer for the neofascist group the Proud Boys—since suspended from practice—who says the group stands for "love of country, small government, freedom, and fun," or self-proclaimed "dangerous faggot" Milo Yiannopoulos, who describes himself as "an artist [who's going to create] provocative, dangerous things" and counter "the oppressive, corporatised, fucking boredom of the mainstream extreme

progressive Left Pride movement" with the "fun, mischievous, dissident magic that made the gay community so fantastic in the first place!").

This reversal may sound strange, but it is not in fact novel. The idea that artistic transgression aligns with what we might now call progressive politics or social justice is belied by the very birth of the avant-garde, marked for many by the 1909 Founding and Manifesto of Italian Futurism, in which its author, Filippo Tommaso Marinetti, introduced the concept of "hygienic violence" that would wreak havoc in the century to come, and famously proclaimed that his movement would "glorify war—the world's only hygiene—militarism, patriotism, the destructive gesture of freedom-bringers, beautiful ideas worth dying for, and scorn for woman." Not but a decade later, Italian Futurism—which pioneered the poetic and typographical innovations known as *parole in libertà* (words in liberty), along with a host of other radical aesthetic activities that presaged performance art and punk rock—officially merged with Mussolini's National Fascist Party.

At a time when bigots and thugs deploy "free speech" as a disingenuous, weaponized rallying cry, it makes sense that some would respond by criticizing, refusing, or vilifying the discourse of freedom, and postulating care in its place. But care demands our scrutiny as well, as do the consequences of placing the two terms in opposition. For beyond today's tinny stereotypes of bully and snowflake, target and troll, defender and supporter, perpetrator and victim, lie dimensions and archives of artistic freedom of critical importance for *all* makers and viewers. Attending to these freedoms while engaging the grave issues that have necessitated their interrogation has become our charge.

The current interest in care has multiple roots and vectors, including socioeconomic analyses of the "crisis of care" wrought by racial capitalism and neoliberalism; long-standing feminist debates over an "ethics of care" (sometimes opposed to an "ethics of justice"); high-profile political battles over access to health care; an intensified focus on self-care and healing as critical components of activism;[4] Foucault's late writing on the "care of the self" (which, notably, grew out of his earlier focus on practices of freedom); a renewed interest in the philosophy of Emmanuel Levinas, wherein care

and responsibility for others precedes and takes precedence over individual freedom; and the "reparative turn" in queer studies, initially forged by theorists Eve Sedgwick and José Muñoz, both of whom emphasized the operations of sustenance, reparation, and utopian world building in the activities of artists, writers, and their audiences.

The reparative turn, as applied to art, is in many ways a continuation of the orthopedic aesthetic, with the difference being that the twentieth-century model imagined the audience as numb, constricted, and in need of being awakened and freed (hence, an aesthetics of shock), whereas the twenty-first-century model presumes the audience to be damaged, in need of healing, aid, and protection (hence, an aesthetics of care). In "The Year in Shock," a roundup published in *Artforum* shortly after the 2016 election, critic and curator Helen Molesworth articulated this shift, and proposed that we might be in the midst of a new avant-garde, this time characterized by "continuous self-reflection and regard for others" rather than an urge to "[counter] shock with shock."[5]

Despite my skepticism of the urge to delineate artistic movements or avant-gardes, I see the value in noting such a shift, especially as it displaces—arguably for the first time in art history—a certain aggression or machismo from the notion of vanguardism (itself a military term), and imagines instead, as Molesworth puts it, "continuity or gentleness" as a potential "hermeneutic of radicality." Not that community care is a new element in certain radical traditions: the Black Arts movement, the Chicano Art movement, certain manifestations of Happenings, and, later, relational aesthetics, have all experimented with community service and care provision, be it via offering food, shelter, murals, education, or alternative venues for living, loving, organizing, and making art. The shift Molesworth is here noting thus has more to do with altered affect than historical rupture, and reflects the rise of therapeutic notions of trauma and healing distinct from (though not unrelated to) previous stresses on confrontation or bellicosity.

These developments interest me, as does some of the art that corresponds to them. What troubles me is the alleged reverse—that is, the trend to-

ward diagnosing some art (or artists) as "caring" and some as not, with the latter treated as capable of wounding, traumatizing, or otherwise inflicting harm—harm for which the artist's (or curator's or publisher's) freedom then becomes subject to blame. One can hear this discourse at work in a recent review (by Jamie Chan and Leah Pires) of German artist Kai Althoff: "Althoff has said in the catalog for his recent mid-career retrospective at the Museum of Modern Art and in an interview with *Mousse* magazine that he does 'not care what others seem to perceive as violent' in his work; that he mustn't 'step into the world like [he's] walking on eggs'; that being an artist means 'being graced with being able to do whatever occurs to [him].' Althoff seems to view acknowledgment of harm as an infringement on his right to do as he pleases." Here we can find a compressed version of a series of presumptions that have been congealing in recent years: depicting violence in art, or certain kinds of violence in art, harms others; there exists some kind of ethical imperative for the artist to acknowledge that harm, even if she doesn't agree with the premise; "not caring" about, not responding to, or not agreeing with one's critics, including not making or doing or saying what those critics would prefer you make or do or say, is ethically negligent; treasuring the freedom to make the art you feel most driven to make correlates to a generalized claim "to do as [one] pleases," analogous to shooting someone on Fifth Avenue, as we now like to say. I mistrust this rhetoric, just as I distrusted that of regenerative violence and "raping a viewer into independence" in *The Art of Cruelty* (the phrase belongs to filmmaker Michael Haneke).

It seems to me crucial—even ethically crucial—to treat with caution any rhetoric that purports to have all ethical goodness on its side, and acts to expel, as Butler has put it (in *The Force of Nonviolence*), "the flawed or destructive dimension of the human psyche to actors on the outside, those living in the region of the 'not-me,' with whom we dis-identify." This is especially so when it comes to art, insofar as artists often make work precisely to give expression to complex, sometimes disturbing dimensions of their psyches kept elswhere under wraps. It also seems to me crucial—even ethically crucial—that whatever reparative intentions or effects a work of art may have be left unscripted, unchaperoned, and

recognized as subject to change over time. The latter always risks appearing ethically insufficient, insofar as caring about art's capacity to unfold in time marshals care toward unknown audiences and unforeseeable futures as much as or more than toward present spectators and demands. We live, after all, in the present: the present is inevitably the context for our reaction and response, and it matters. Yet one of art's most compelling features is how it showcases the disjuncts between the time of composition, the time of dissemination, and the time of consideration—disjuncts that can summon us to humility and wonder. Such temporal amplitude understandably falls out of favor in politically polarized times, in which the pressure to make clear "which side you're on" can be intense. New attentional technologies (aka the internet, social media) that feed on and foster speed, immediacy, reductiveness, reach, and negative affect (such as paranoia, anger, disgust, distress, fear, and humiliation) exacerbate this pressure.

As Sedgwick makes clear in her well-known essay "Paranoid Reading and Reparative Reading, or, You're So Paranoid, You Probably Think This Essay Is about You," a strong theory (the term is psychologist Silvan Tomkins's)—such as paranoia—has a particular relation to time, one Sedgwick describes as "distinctively rigid . . . at once anticipatory and retroactive, averse above all to surprise." That is to say, a paranoid mindset presumes to know—in advance, retroactively, quickly, and totally—what something means now, what it will mean in the future, and what should be done with it. This mindset may be fruitful in politics (though even that's arguable); it is also a sensical, defensive response to an environment in which racism, sexism, homophobia, et cetera, run rampant but are constantly being denied, in which case paranoia is the natural by-product of being continually gaslit. But, as Sedgwick realized, the efficacy of paranoid reading—even when our paranoia is justified—has limits, and the benefits of its application to art are especially shaky. After all, if we already knew what the point or effect of a piece of art was going to be before we made or experienced it, if its message could be delivered by TED talk, PowerPoint presentation, op-ed, protest sign, or tweet, if its interpretation were a preordained, lockstep affair, why would we bother with the slow work of looking, making, reading, or thinking?

Speed, immediacy, reductiveness, reach, and negative affect—all are characteristic of what Tomkins called "strong theory." What follows here, then, proceeds unabashedly under the sign of "weak theory." Weak theory does not set forth a new linguistic or conceptual register (such as that of the rhetoric of harm), attempt to shepherd a wide variety of phenomena under its rubric (aka concept creep), and demand that others assent to its terms. Instead, it emphasizes heterogeneity, and invites a certain epistemological uncertainty. It is undisturbed by inconclusiveness and mess. It takes its time, as well as the risk of appearing "weak" in an environment that privileges muscle and consensus—not to mention one in which concepts such as "nuance," "indeterminacy," "uncertainty," and "empathy" are regularly ridiculed, sometimes with good reason, as both-sides-ist buzzwords of the civility police. My wager is that a rigorous devotion to it—especially one that acknowledges the value of strong theories along the way—enacts its own form of care, both for the issues of our day, and for art as a force that blessedly does not reduce to them.

REPARATIVE, REDUX

The psychoanalytic sense of the reparative that guided Sedgwick and Muñoz has since expanded to include other registers, including that of the harm/repair dyad of restorative justice, reparations for slavery, and the notion of an interpersonal "duty to repair" (a term of real estate law repurposed by Sarah Schulman in her 2016 book *Conflict Is Not Abuse: Overstating Harm, Community Responsibility, and the Duty to Repair*). Each of these spheres has a distinct legacy, and a distinct set of presumptions and imperatives; general invocations of the reparative that don't account for these differences can produce (indeed, have produced) a fair amount of confusion. For my purposes here, I'm going to focus mostly on Sedgwick's and Muñoz's use of the term, as it seems to me that crucial aspects of their sensibilities have faded from the scene even as the reparative has held court.

Sedgwick borrowed the idea of the reparative from the psychological register of Melanie Klein, who posited reparation as something felt and

enacted by a child when she fears she has damaged a love object (usually, a mother), and subsequently feels the need to restore and protect it. Reparation is integral to what Klein called "the depressive position." (Both Sedgwick and Muñoz liked that Klein spoke of "positions" rather than "stages": one does not outgrow reparation per se; it is an activity to which one returns, a motive one experiences, again and again; this repetitiveness helps to explain how it might animate an ongoing creative practice.) From Klein, Sedgwick extrapolated something she called "reparative reading," which she contrasted with "paranoid reading" ("reading" functions here quite broadly, spanning different media): the former is a means of seeking pleasure, nourishment, and amelioration, whereas the latter aims to forestall pain and ward off threats. Her description of reparative practice as a means of "assembl[ing] and confer[ring] plentitude on an object that will then have resources to offer to an inchoate self" makes audible its potential relationship to art: by attending to the "richest reparative practices" of others and ourselves, Sedgwick argued, we can learn more about "the many ways selves and communities succeed in extracting sustenance from the objects of a culture . . . whose avowed desire has often been not to sustain them." What's more, reparative practices are alive with paradox, and decidedly *not* always performed by solicitous people overflowing with a healing "regard for others." As Sedgwick observes about figures such as Ronald Firbank, Djuna Barnes, Joseph Cornell, Kenneth Anger, Charles Ludlam, Jack Smith, John Waters, and Holly Hughes, "It is sometimes the most paranoid-tending people who are able to, and need to, develop and disseminate the richest reparative practices."

Muñoz also conceived of his writing about the art and artists that he loved as a form of reparative practice. But whereas Sedgwick focused on the queer dimensions of such, Muñoz added an exploration of what he called "brown feelings" or a "brown undercommons"; he also added the term "disidentification" (or "disidentificatory practice") to the mix. Disidentification—a complex concept explored in Muñoz's 1999 book by that title—is basically a subset of reparative practice, by which "the minority subject . . . negotiate[s] a phobic majoritarian public sphere that continuously elides or punishes the existence of subjects who do not con-

form to the phantasm of normative citizenship." Faced with the binary choice of aligning with or against so-called exclusionary works of art or culture, disidentification proposes a third way, one that allows people to transform "these works for their own cultural purposes." Some of Muñoz's examples include Jack Smith's play with "'exotic' Third World ethnoscapes"; comedian Marga Gomez's interpellation by mainstream talk shows; Jean-Michel Basquiat's disidentification with Warhol and pop art; Richard Fung's recycling of pornography; and Vaginal Davis's "terrorist drag" about white supremacists in Idaho.

Both reparation and disidentification presume a subject—be it the artist or the spectator—in need of nourishment or healing; like many contemporary thinkers, Sedgwick and Muñoz treated racism, sexism, homophobia, colonialism, capitalism, and so on as principal causes of this depletion or wounding. Of the two, Muñoz's investment in the orthopedic aesthetic was the more overtly political, in that Muñoz passionately believed that works of art can serve as "a utopian blueprint for a possible future." Yet neither critic reflexively opposed freedom and care—Muñoz actually described disidentification as a practice of freedom, drawing on the Foucauldian sense of the phrase. This is in part because both critics kept the focus squarely on the resilience, creativity, agency, and power of minoritarian subjects, for whom the effort spent denouncing work deemed hostile to them, or demanding an "acknowledgment of harm," would requisition an unmerited amount of limited energy and time, and in part because both critics were alive to the fundamental idiosyncrasy and indeterminacy at play in both art making and viewing. The whole point of reparative reading is that people derive sustenance in mysterious, creative, and unforeseeable ways from work not necessarily designed to give it, and that the transmission is nontransferable and ungovernable; the whole point of reparative making is that it is reparative for the *maker*, which guarantees nothing in particular about its effect on the viewer.[6]

Researching and fielding responses to *The Art of Cruelty* made this variegation abundantly clear: art that makes some people feel sick makes others feel sane or enlivened; art that some people find irredeemably toxic,

others find to be a cherished source of inspiration or catharsis. Similarly, artists who create with the explicit goal of providing representation, reparation, or refuge for others (or themselves) may utterly fail to do so (which is how you might get a situation in which an artist who has dedicated his entire career to antiracism and social justice might find himself prominently accused of making an ignorant, white-supremacist work, as was the case with the 2017 installation of Sam Durant's sculpture *Scaffold*, a work to which we will return). Again, the operation of time makes this indeterminacy particularly obvious: works that once may have appeared controversial, useless, or unintelligible often reappear in time as canonical, vital, and lucid; work that once provided us with life-changing sustenance may lose, over time, its value or allure. (One of the virtues of being a teacher is that, in discussing the same texts or works of art over decades, one develops a felt understanding of how certain works read or mean differently to different people at different junctures.)

This all seems to me as it should be, given the heterogeneity of histories, psyches, needs, and tastes we bring to art. It also makes clear that critical attempts to argue for a work's ethical or political utility, on the one hand, or to condemn its wicked hegemonic reinscriptions, on the other, will never, can never, have the last word. Even Langston Hughes, who cast his writing as reparative practice more explicitly (and perhaps more successfully) than almost any writer I can think of, reminded us that pleasing people could never be the goal, and that current reception was but one ring of action: "If white people are pleased [by our art] we are glad. If they are not, it doesn't matter. . . . If colored people are pleased we are glad. If they are not, their displeasure doesn't matter either. We build our temples for tomorrow, strong as we know how, and we stand on top of the mountain, free within ourselves."

Hughes's resilient subject forging creative means of standing "free within [herself]" stands in marked contrast with the more recent focus on the subordinated, vulnerable subject, who feels that (other people's) art poses a nearly (or verily) criminal threat of harm, and wants to see its makers or enablers called to redress. This latter model treats the demand for care and repair—and subsequent calls for castigation if and when the

demand is not met—as forms of reparative labor itself. (It's worth noting here that Sedgwick never suggested that disentangling the paranoid from the reparative was easy or even possible, nor did she argue that the reparative was superior to the paranoid. "Paranoia knows some things well and others poorly" is how she put it; the same could be said of strong vs. weak theory.) This turn became especially pronounced in 2017 in debates over two works of art by white artists: Dana Schutz's quasi-abstract oil painting of Emmett Till in his coffin, titled *Open Casket*, exhibited in the 2017 Whitney Biennial, and Durant's *Scaffold*, a large outdoor sculpture that replicated parts of seven historical gallows, including one on which thirty-eight Dakota men were hanged in 1862, a version of which was installed at the Walker Art Center in Minneapolis, on the homeland of the Dakota people. These works led many to feel as though white artists (and institutions) could use a little (or a lot) more insight and accountability, and less unthinking, uncaring freedom, especially as the latter coincides all too well with the logic of white supremacy, with all its ignorance, impunity, and carelessness.

The turn, in art, from the reparative to a demand for repair, treats art less as "a 'third thing' between people whose meaning 'is owned by no one, but which subsists between [artist and spectator]'" and more as something whose meaning and function can be named and adjudicated—something that can, in fact, be moved out of the category of art, and into other categories, such as hate speech, physical assault, or pure obscenity. Such recategorization takes place across the political spectrum: "It was hate speech, pure and simple," said Bill Donohue of the Catholic League of David Wojnarowicz's video *A Fire in My Belly*, as part of Donohue's (successful) 2010 effort to get the Smithsonian Museum to remove the video from a group exhibition (the offending footage featured ants crawling over a crucifix); "The work of Sam Durant is not art. It is an act of violence. It is a slap in the face of the Dakota people, whose families were hung on a nearly identical gallows in the town square of Mankato," said a protester of Durant's *Scaffold*, whose opponents wanted the sculpture removed and destroyed (a demand to which, after negotiation with the Dakota, Durant assented). It also relies on the merging of the history of noxious constructions of political freedom with those of artistic freedom,

as in artist Hannah Black's open letter to the Whitney Museum, in which Black called for the removal and destruction of Schutz's painting of Till: "The subject matter is not Schutz's; white free speech and white creative freedom have been founded on the constraint of others, and are not natural rights. The painting must go."

That white freedom in the United States was historically founded and has been subsequently maintained upon the enslavement, exploitation, and suppression of nonwhite others is beyond dispute. No matter their critical or empathetic intent, Durant's and Schutz's works summon this history, by re-presenting, albeit in distinct ways, acts of violence perpetrated against Black and Indigenous people that served as violent enforcement—one extralegal, one state sanctioned—of a viciously unequal, indeed homicidal, genocidal, construction of freedom. The fact that this enforcement has shape-shifted rather than dissipated over time is key to understanding a "the painting must go" campaign, as is lynching's long, despicable history as a form of spectacle and entertainment for white audiences, of which the dyad of art and audience can make an ugly echo. The summoning of this legacy of spectatorship inevitably traffics in ghastly business, the ethics and effects of which are impossible to navigate innocuously, especially given the demographics of the artists at hand. Add to this a justified frustration with white artists continuing to receive space, attention, and financial support for work that many consider to be, if not downright offensive, evidencing a paltry or tone-deaf understanding of issues that others have spent their whole lives grappling with, and a boiling over seems both inevitable and warranted.

I think one can say all this (and more) without it following that such work is not art, unequivocally enacts harm, should be removed, or should not exist; I think one can engage seriously with the above issues—perhaps even more seriously—without turning toward the question of whether "curators should have absolute freedom to exhibit what they [want]," as urged by critic Aruna D'Souza in the wake of *l'affaire Schutz*. Whenever someone starts talking about "absolute freedom," you know you're in the presence of a straw man. No one on earth has absolute freedom to

do much of anything; as anyone who has ever tried to install a piece of art with mold on it in a museum or spill blood in a piece of live performance art quickly discovers, such endeavors require planning, permission, negotiation. Art is not a sacrosanct realm, a "state of exception," whereby all one has to do is sprinkle some magic "it's art" dust on an expression or object and all ethical, political, or legal quandaries fly out the window.[7]

And yet, if one is concerned with preserving space for art, it's important to recognize certain arguments that recur in attempts to curtail it. Arguments for its prohibition or destruction usually begin with an attempt to strip it of its ontological status as art. It must become "hate speech, pure and simple," "a slap in the face," or "pure filth," so that new rules might apply.[8] One can hear such arguments in the letter sent to Boston's Institute of Contemporary Art in protest of a post-Biennial Schutz show there—a show that didn't contain the Till painting—in which the authors describe the painting as an act of violence, and demand that Schutz, as part of a tradition of "offending white femmes who perpetrate violence against Black communities," not have her "treacherous painting" go "unchecked," or be "immunize[d] from accountability by institutional sanction." Similar rhetoric pervades academic criticism, which has often served as a ground zero for paranoid reading: see, for example, scholar Arne De Boever's contention that Durant's *Scaffold* didn't just echo or evoke "the violent power of sovereignty," but rather "*reinstate[d] that power] precisely*" (emphasis added). Such arguments push past the imperative to politicize art, and aim toward eliminating the art part entirely, and, in the latter case, treating it as having power analogous to—or "precisely" of—a militarized state.

Suggesting that certain pieces of art should be treated as acts of violence, or on par with the violent power of sovereignty, plays into the same arguments that have long been used to undermine art's legal protections. Under current US law, part of what gives art its "socially redeeming value"—and hence its protected status—is its incapacity to reduce to a singular purpose or interpretation, such as sexual arousal or incitement to violence. Alleging that a work of art has such a singular purpose or

effect, and that that effect poses a threat to individuals or society, is a classic prerequisite not only for censorship but also for the persecution of artists, up to and including their imprisonment. Just ask porn star, sexologist, and artist Annie Sprinkle, who, in an essay titled "My Brushes and Crushes with the Law," explains how she was jailed for making a zine depicting sex with an amputee: "We were charged with over a hundred felony counts combined; 'conspiracy to make and distribute obscene material,' 'sodomy,' and my personal favorite, 'conspiracy to commit sodomy.' In Rhode Island, sodomy is defined as 'an abominable, detestable act against nature,' which is apparently what some folks consider sex with amputees." Spooked by her incarceration, Sprinkle decided to move from the porn world to the art world, where she found more legal protection: "Although I came close many times," she writes, "I was never arrested [again]. Guess I had 'socially redeeming value' on my side."

Taking refuge in this amplitude can create turbulence; no doubt it can and has been abused (Sprinkle's critics in Congress, who saw her subsequent escapades as more filth masquerading as art, no doubt thought she was abusing it). The question is whether the challenges posed by such turbulence lead us to want to whittle away at this amplitude, or to continue to fight for it, knowing that it comes with certain risks for makers and viewers alike. My thinking on this subject likely derives in part from my decade plus of teaching at an art school with an expansive policy about freedom of expression, and a florid history of testing it. The official policy for artwork exhibited at the school reads as follows: "1. CalArts does not censor any work on the basis of content, nor is any work at the Institute subject to prior censorship. 2. If any person objects to any exhibit or presentation, that person should convey the objection in writing to the student's dean. The person will receive a written answer to the objection within 48 hours of its receipt. If the person is dissatisfied with the decision, he/she may appeal [it] to the Institute Exhibit Review Committee. The decision of the Committee is final." This system worked well, not because things didn't get bumpy from time to time, but because they did. (There's a reason why a certain case from CalArts regularly shows up in sexual harassment training at other universities—one

involving a graphite drawing by a student, exhibited briefly in the Main Gallery, which depicted CalArts faculty, staff, and students, including an eighty-two-year-old staff member, engaged in sexual acts. The eighty-two-year-old and her family sued the school for sexual harassment and lost; she never returned to work.)

As the above example suggests, this was not an environment for the faint of heart. In my time there, I contended with student work that involved (or aimed to involve) abduction, cutting, stalking, sexually explicit performance, and more. Sometimes it felt volatile; on occasion it felt frightening. But for the most part, it worked. It worked because being there meant committing to the frame of art as a meaningful, spacious construct deserving of as much respect as we could muster. Because we knew we weren't there to shut each other down, we had to learn how to communicate our pleasures and displeasures differently. Often it reminded me of a job I'd had years earlier, running the open mic night at the Poetry Project at St. Mark's Church, where my duties included making a list of the people who came in off the street to read; giving each person, no matter if it was a woman living in Tompkins Square Park pulling poems out of plastic baggies or a recent Ivy League grad angling for a Lannan, exactly two minutes at the mic; ushering each person along until everyone who wanted to speak had spoken; putting away the chairs; and locking up the church. No matter what I heard those Monday evenings, I always loved the feeling of heading back out into the night, my mind awash with the real and irregular news of how others around me thought and felt.

On more than one occasion when teaching at CalArts, I had cause to sermonize about the distinctions between the ethical and the legal, stressing that transgressions of the former also have consequences. Sometimes provocative student work glistened with punk or even revolutionary spirit; at others, its transgressions sank into the mean-spirited or clichéd. The pedagogical task at hand was not to discipline people for their failures, but to help them make more interesting art, discover how to talk about it together, and allow that shared fortitude and support to become a basis

for motley community. Again, this was not always easy, and it didn't always feel good. The amount of time I've spent politely workshopping hyperviolent work steeped in unexamined misogyny can seem, at least in certain moods, like wasted hours of a life. But I value its lesson that, without suppression, shaming, or ejection as go-to options, we learn to fellowship differently.[9] For this reason, I smiled with recognition when I read the 2017 *New Yorker* profile of artist Catherine Opie, in which Ariel Levy reports the following scene from a class run by Opie at UCLA: after one student criticizes the work of another by saying it "signifies the backbone of colonialism," the artist appears dejected, and mumbles from the corner, "Damned if I do, damned if I don't." Opie then hectors him kindly: "Stand up for your work! . . . Open it up! Don't shut it down, man." Opie is not counseling the student to become a rigid, narcissistic jerk unable to absorb any decolonizing critique. She is just reminding him that, if you truly think your art is worth it, you've got to be willing to stand beside it and up for it, rather than slink into the all-too-familiar postures of woundedness, defensiveness, paralysis, or retaliatory aggression.

WORDS THAT WOUND

When we want to describe how powerful words or images can be, we often make recourse to the language of physical harm ("slap in the face"). We do so in part because words and images can and do have somatic effects on us, and in part because we sometimes hope that if our pain is seen as similar—or even equivalent—to a physical wounding, it will be taken more seriously, and the offending agent might be moved from permissible to disallowed.

Some of the discourse about "words that wound" derives from a 1993 anthology by that name, in which editor Mari Matsuda brought together essays by legal scholars aiming to complicate the orthodoxy of free speech in the United States. Many of the essays argue for expanded regulation of the most virulent forms of hate speech, similar to those that have been operational in other democratic countries for decades.

There seem to me legitimate arguments to be made for and against limiting the rights of, say, armed neo-Nazis to march in the streets chanting anti-Semitic slogans, which is the type of scenario on which *Words That Wound* focuses its attention. But applying such arguments to the realm of art comes with a variety of perils, given that art, even when offensive, presents itself to a diffuse audience with no reducible target; typically contains no singular, fixed message and no expressly malign (or even discernible) intent; and, with the exception of a handful of notorious works, causes no imminent danger to its audience, which generally must seek it out, presumably to be moved by it in unforeseeable and disparate ways.

When asked about recent efforts to conflate speech with bodily harm, Berkeley law professor john a. powell makes the point that the "classic liberal justification for free speech"—that "your right to throw punches ends at the tip of my nose"—may be insufficient now that "we have learned a lot about the brain that John Stuart Mill didn't know. So [contemporary students] are asking, 'Given what we now know about stereotype threat and trauma and P.T.S.D., where is the tip of our nose, exactly?'"[10] This is an intriguing line of thought, and I distrust anyone who presumes to have solved its challenges. At the same time, I have yet to hear any compelling argument as to how this framework could be sanely applied to the world of art in any blanket fashion. Neurologists and psychiatrists may know more now about the workings of trauma or PTSD than in times past (or they may not—the history of psychology does not exactly fill me with faith in its teleological progress). But even with what they, or we, now know, the question of how best to address trauma and PTSD remains open; rarely do treatments for such conditions focus on the attempted banishment or control of the expressions of others.

Expression needs context. Art is one such context, and its specificities matter.[11] It remains our charge to be able to distinguish between the feelings produced by, say, reading a scene in a novel in which someone berates a character by calling her a cunt, from stepping out into the street to get some milk and being called a cunt by a passerby, from a bunch of guys holding Tiki torches surrounding you chanting *cunt*, from being

called a cunt in a sex game with your lover, from being called a cunt by your boss during a meeting, from seeing the word *cunt* spray-painted on a wall as you're walking by, from calling your own cunt a cunt, from reading a paragraph like this one, and so on. It's the homogenizing logic of paranoia that works overtime to flatten or disregard such differences; it's the homogenizing logic of paranoia that demands that all people have the same response to them, and always will.[12] And here one of my favorite works of video art comes to mind, an eight-minute piece from 2008 titled *You Will Never Be a Woman. You Must Live the Rest of Your Days Entirely as a Man and You Will Only Grow More Masculine with Every Passing Year. There Is No Way Out*, made by A. L. Steiner + Zackary Drucker, with Van Barnes and Mariah Garnett, which features Drucker and Barnes, two trans-identified women, exchanging insults in tones ranging from hateful to seductive to tender, all while striking various intimate poses with one another. The filmmakers describe the exchange as a means for the players to "prepare each other for a larger, more dangerous culture of intolerance and violence," with the end result being that both "ultimately regain their agency." But part of the video's genius is that it lets the audience sit with the volatile, multivalent, indeterminate world of derogatory speech, reclaimed or otherwise, allowing us to feel and contemplate its many dimensions as the insults go on and on.

We have the freedom to protest works of art that we think harmful, and to call for their removal or destruction. We also have the freedom to find a piece of art repulsive, wrongheaded, implicated in injustice in naive or nefarious ways, without concluding that it threatens our well-being. We have the freedom to question whether arguments that emphasize our "disempowerment, domination, deprivation, exclusion, marginalization, invisibilization, silencing, etc." offer a full, or uninterrupted description of our lives.[13] (To note: I'm not talking about a straight white guy saying, "Funny, I just don't find that invisibilization or disempowerment really speaks to my experience." I'm talking about allowing for a heterogeneity of stances within groups presumed to have cause to make recourse to such arguments, for whom disidentification, cross-identification, or even counteridentification can be robust, generative, even reparative means of telling and taking it slant, asserting

difference where others would presume sameness.) We also have the freedom *not* to be interpellated by the work of others, to pity people for making what we perceive to be bad art, and walk on by. As writer Zadie Smith wrote about the Schutz painting, "I stood in front of the painting and thought how cathartic it would be if this picture filled me with rage. . . . The truth is I didn't feel very much."

Indeed, one of the strangest things about controversy in art is its reification of the idea that individual works of art make people feel strong feelings, which is, at least in my experience, something of a rarity. I say this as someone who is always going to art hoping, often against hope, to see something, anything, that moves me in any direction. Then again, I would bet that most people who vociferously take sides on controversial works aren't basing their stance on their own personal or somatic experience of them (quite often, they haven't read or seen the work in question), but rather on what others have determined they signify, and a desire to demonstrate solidarity. (Think of Kathleen Folden, the Christian woman who, in 2010, heard about an allegedly blasphemous lithograph by artist Enrique Chagoya on right-wing media, then drove hundreds of miles in her truck to the Loveland Museum in Colorado to find it: she had never seen the work before she yelled, "How can you desecrate my Lord?" and slashed it with a crowbar.)

Historical injustices will always be of vastly greater magnitude than any singular objet d'art, which partly explains why art makes for such a reliable pawn in symbolic warfare. The relative paltriness of the art object can break both ways: focusing on a piece of art can appear to trivialize the stakes (as in the contention that removing Schutz's 39-by-53-inch oil painting from the Whitney would ameliorate in any meaningful way the conditions that endanger Black lives); or it can make the symbolic object seem comparatively easy to surrender ("It's just wood and metal—nothing compared to the lives and histories of the Dakota people," Durant said, in partial explanation of why he agreed to the destruction of his sculpture). I respect Durant's decision, and can imagine making a similar one in his circumstances.[14] Yet I still think placing the fate of a work of art on par with saving or destroying lives is a construction

that there are good reasons—including ethically sound reasons—to question, and at times to refuse.

COPS IN THE HEAD

In their introduction to *The Racial Imaginary*, a 2015 collection of writers' thoughts on "race in the life of the mind," editors Claudia Rankine and Beth Loffreda argue that, rather than a continued insistence on rights and freedom, white artists might instead "embody and examine the interior landscape that wishes to speak of rights, that wishes to move freely and unbounded across time, space, and lines of power, that wishes to inhabit whomever it chooses." About the language of rights that white writers frequently fall back on when their writing is criticized, they write: "This language of rights . . . is a decoy whose lusciousness is evident in the frequency with which it is chased. . . . To say, as a white writer, that I have a right to write about whoever I want, including writing from the point of view of characters of color—that I have a right of access and that my artistry . . . is harmed if I am told I cannot do so—is to make a mistake. It is to begin the conversation in the wrong place. It is the wrong place because, for one, it mistakes critical response for prohibition (we've all heard the inflationary rhetoric of scandalized whiteness). But it is also a mistake because our imaginations are creatures as limited as we ourselves are. They are not some special, uninfiltrated realm that transcends the messy realities of our lives and minds."

I like this passage for several reasons, one of them being its Wittgensteinian suggestion that such conversations set up shop in the wrong spot. The better place to begin, the authors say, is with the notion of whiteness itself. Starting from here, they argue, we can move away from hoary debates over artistic freedom and prohibition, or the more comfortable language of scandal, and set off in the direction of self-examination— "to speak not in terms of prohibition and rights, but desire." I like this shift to desire, even if the call to "embody and examine" an interior landscape constitutes more of an invitation than an imperative (as in "The painting must go").

Rankine and Loffreda are also right to point out that unboundedness, even in art or imagination, is a fantasy. Most artists know well that the imagination tends to reflect, especially at first swipe, the sublunary muck around us, including its most clichéd or hegemonic aspects. I personally know of no artist who has gotten very far into adulthood who still thinks of her imagination as "some special, uninfiltrated realm that transcends the messy realities of our lives and minds." Rather than draw us into unboundedness, our experiments often lead us into some very complex knots (see, for example, poet David Marriott's question—posed by way of Frantz Fanon—"what do you do with an unconscious that appears to hate you?" or French feminist Luce Irigaray's querying "whether the feminine *has* an unconscious or whether it *is* the unconscious"). Getting to the more interesting, unexpected material tends to require extended effort (which is why the Surrealists were always knocking themselves out to invent new ways to ambush the mind, often by means of constraints).

If there is to be any discovery in making art, at some point it must involve the unraveling of our conscious intentions. This unraveling can be a source of happy or unhappy surprise. As scholar Joshua Weiner puts it provocatively in his contribution to *The Racial Imaginary*, "Imaginative writing that polices itself from making 'politically incorrect' statements; or from dramatizing difficult conflicts and disturbing states of consciousness; or from using language disapproved of by today's liberal mores; such writing is useless. . . . One of the social functions of literary art . . . is to expose moral hypocrisy where it hides from view, in our best intentions." Or forget best intentions—at some point, you likely have to give up on intentions altogether. Making art won't feel like reparative labor; it will feel like sanding aluminum for eight hours and breathing in toxic dust, wondering why you're not hanging out with your family or binge-watching Netflix or visiting your sick mother or performing labor guaranteed to pay instead of cost. It will feel, and perhaps it will be, indefensible, despite your developed ability to claim aluminum sanding as a blueprint for a utopian future.[15]

Likewise, rather than feeling themselves moving "freely and unbounded across time, space, and lines of power," most makers I know often feel

depressingly constricted by the paltriness of their vision, abilities, or resources, at which times the very limitedness of the imagination or unconscious turns into a sort of aesthetic creed. ("Poetry has to do with a satisfaction with limited things, a paring down," the Chinese poet Mo Fei once said. "It is the acceptance of a certain form of poverty. It is not endless construction.") There are lines of flight, of course. But one of art's strange miracles is that work capable of imparting to others a sense of permission, vastness, or escape often emerges from physical, emotional, material, or intellectual realities that feel cramped—sometimes insufferably so—to its maker. As Merleau-Ponty wrote about Cézanne, "That is why he never finished working. We never get away from our life. We never see ideas or freedom face to face."

In other words, the patient labor giving form to our impatience for liberty rarely fruits. At least not totally, and perhaps not in one's lifetime. This is disappointing, but also fine. "Abandon any hope of fruition" is a timeworn Buddhist slogan.

Such a paradox may assist us in understanding how and why the aspiration to move freely, to feel unbounded, may be both impossible *and* precious to many artists—especially to those frustrated by the ever-present imperative to speak for or work on behalf of a group they are presumed to represent. (About the pressures on Black artists to dedicate themselves to the cause of collectivity—to "renounce antisocial drives, to be the police to her own criminal *in potentia*"—during the Black Arts era, Darby English writes, "No charge was easier to fling than the one that marked the individual who declined to participate in the consensus-making enterprise. Such an individual was every bit as much an enemy to the community as the most ardent white racist." English argues that such an environment is toxic to art, and that "actual freedom, as it were, becomes possible only when an individual overcomes this instinctual disposition." English's version of artistic freedom relies a bit too heavily on modernism and individualism for my taste, but his analyses are still indispensable for anyone interested in the question of how one might keep a notion of artistic freedom central without collapsing it into "white creative freedom.")

For many artists, art plays a unique and crucial role in working out "what . . . we might want when we're not under surveillance," as Adam Phillips has said of psychoanalysis. By definition, this exploration cannot be about pleasing people, or attempting to satisfy their desires.[16] (As painter Tala Madani has it, "I tell my students sometimes that, if they're making work that their mothers will like, they're in trouble.") Even if one wanted to make work that pleased others (or mothers), one would have to presume to know, in advance, what those others (or mothers) liked or needed, a presumption that comes with its own set of ethical thorns. Also, as Phillips notes, while we can never be entirely free of surveillance of some kind or another (and not always from the usual suspects), that doesn't mean we don't have a real need to create spaces or forms wherein we can temporarily suspend its grip, and practice a certain fugitivity from the "cops in the head," as Augusto Boal, founder of the Theater of the Oppressed, put it. (The cops may be in our heads, Boal wrote, but *the headquarters of these cops are in the external reality. It is necessary to locate both the cops and their headquarters.*")

Art can, after all, be many things at the same time. It can be an outlet for someone's lust for the underage, a force that unforgivably gentrifies neighborhoods, and a place to speak truth to power, all at once. Much of what we find there—perhaps most of it—likely doesn't even correspond to binaries of harmful/reparative, decent/indecent, subversive/hegemonic. Freed from surveillance, we might find that we want forty monochromatic paintings, or a big pile of macramé, or a bunch of clay heads, or a study of tennis or lice or space. The idea that we're all suppressing a cauldron of urges toward taboo behaviors or subjects that are held in check by the repressive forces of superego, law, or Twitter mobs does not seem to me an accurate description of either ourselves or the world.

Learning to follow one's intuitions doggedly without killing them with prejudgment; to hold at bay catastrophizing projections about reception; to have the fortitude to continue on in the face of indifference, discouragement, or intense criticism; to access or sustain the ambition to try things considered unwise, impossible, taboo, or out of step with one's times; to "stand up for your work! Open it up! Don't shut it down,

man!"—all of these things may overlap at times with the aggressive, con-taminated language of freedom and rights. But that doesn't mean they can or should reduce to them. For they are also hard-won habits of ar-tistic devotion that can take years to cultivate, without which a lifelong commitment to art becomes significantly less possible.

Think, for example, of poet Alice Notley's "poetics of disobedience," which she describes as the "rejection of everything I was supposed to be or to affirm, *all* the poetries all the groups the clothes the gangs the gov-ernments the feelings and reasons. . . . I discovered I couldn't go along, with the government or governments, with radicals and certainly not with conservatives or centrists, with radical poetics and certainly not with other poetics, with other women's feminisms, with any fucking thing at all." Notley's epic poem from 2001, *Disobedience*, emanates from this "fuck you" attitude ("my rule for this poem / is honesty, my other rule is Fuck You"), an attitude Notley extends to her readers: "I think . . . of myself as disobeying my readership a lot. I began [*Disobedience*] deny-ing their existence."

Denying the existence of a readership, rejecting everything one is sup-posed to be or affirm, maintaining a "Fuck You" posture in regard to audience, contemporary mores, or reception: none of this speaks to a "regard for others," or is likely to go over very well on a grant appli-cation. But it is precisely what makes Notley's work so visionary and permission giving. I probably don't need to mention here that women—who are still aggressively socialized to please other people, and who fear, often justifiably, the consequences of quitting the mission—may find this disobedience more difficult to access and sustain, which is why Notley's "poetics of disobedience" is a feminist practice (as is Madani's urging her students to make art that won't please their mothers), even if one must disavow all "other women's feminisms," or risk displeasing one's own mother, to get there.

Even when one assumes a posture of not caring (about audience, money, the future, decorum, proficiency, or reception), the work itself typically requires tremendous care, which is why art is no place to take cover. No

matter how punk or defended we may be, it's always vulnerable making to render public what we've worked so hard on—it's "so earnest, so caring—with a smock, and our tongue between our teeth, paintbrush poised, trying so hard." It's in this sense that I tend to think of all art—even offensive or nasty art—as related to care, if "care" means the patient labor—the aesthetic care—that artistic endeavor demands, whether you're the Marquis de Sade or Dennis Cooper or Vladimir Nabokov or Richard Pryor or Vaginal Davis or Kara Walker or Agnes Martin or Adrian Piper or Jack Smith or Jimmie Durham or William Pope.L or Charles Gaines or Wu Tsang or Zadie Smith or Paul Beatty, or whichever other artist someone has, at some point or another, charged with disobedience to a sociality someone believes the artist has an obligation to serve, or to serve differently.

These days, instead of fearing the bogeymen of yesteryear (the humiliation of silence, or a bad review), many fear being trolled, doxed, mobbed, or "called out" almost as soon as they make their efforts public (or beforehand, as in prepublication cancellation campaigns). Given how many women in particular I know who have received multiple online rape or death threats for publishing work that I considered pretty vanilla, it's clear that a whole new level of skill set regarding "if you stop pleasing people, people stop being pleased" is now in order, as the cops in the head have metastasized to include a chorus of disembodied strangers standing at the ready to trash-talk not only your work but also your appearance, your attachments, your demographic markers, your family, and more. The good news is that this behavior has become so commonplace as to follow a somewhat predictable script; exposure to it, something of a rite of passage.

And here we might pause to take note of the great ironies (or tragedies, or paradoxes, or, more generously, productive antagonisms) of the upsurge of interest in care, which is that it has coincided with an onslaught of disinhibited, disparaging behavior, performed largely (though not exclusively) on social media, and deemed by many who partake in it reparative labor, even when it indulges tenuous accusation, ad hominem insult, or threat. This shouldn't come as a surprise; forms of cruelty are

commonly shoveled under the name of care. As always, the prerequisite is the belief that the justice of your cause immunizes you from causing harm, or that the harm you cause is, on measure, worth it.

Such a mise-en-scène heightens the risk of artists being too careful, on the one hand, or of becoming aggressively careless, on the other (the "damned if I do, damned if I don't" grumble). Caring and shame share a tight bond (which is why art openings and book parties are so often fulcrums for self-loathing, or why an author is likely to feel shattered by a prominent bad review, and so on). Given the paralyzing power of shame—and, conversely, the perils of being invulnerable to it—one has to find one's way. If one is so vulnerable to what others say or think in a world drunk on scapegoating, virtue signaling, and public humiliation that one cowers, overcompromises, or petrifies, that's a problem. If one becomes a reactionary asshole whose art (and life) would likely be a lot better were one capable of taking in, even if on occasion, the sage feedback of others, that's a problem. If one cultivates a habit of self-righteously disparaging or ganging up on others in the name of justice or the reparative, that's a problem. One has to find one's way.

As we find our way, we might remember that not all forms of transgression are created equal. In *Fat Art, Thin Art*, Sedgwick writes, "In every language the loveliest question / is, You can say that?" I have always loved this line, have long cleaved to it as an incitement to creative permission and disobedience. But, as the recent testimony of so many self-identified "deplorables" makes clear—those who say they feel newly, gratefully emboldened to say all the bigoted things they had (allegedly) been repressing prior—"breaking silences" or "saying the unsayable" doesn't guarantee anything about the nature of what's being said. "Transgression," "disobedience," even "subversion" have, in the abstract, no particular political valence (remember *parole in libertà*?). As writer John Keene smartly reminds us, racialized risks taken by white artists are not typically as subversive, risky, or courageous as the artists might imagine, given that their backdrop remains a culture rooted in white supremacy. Likewise with misogyny—there's a reason why Charles Bukowski remains an easier sell than Valerie Solanas (though there are

also reasons why most of my feminist and queer friends have books by both on their shelves).

GO WHERE?

The notion of art as the product of "continuous self-reflection and regard for others" seems related at least in part to the program era of art and literature—a period extending from post–World War II to the present in which many, if not most, players on the scene have attended graduate programs in art or writing, and continue to make their living in settings of higher education. Such settings largely consist of more established artists and writers assisting less established ones to develop both their "craft" and the ability to offer rich discursive accounts of it, in part to prepare them for the coming world of panel discussions, press releases, online self-promotion, teaching careers, and so on. In this milieu, the intimate, emotionally charged, institutionally governed setting of the workshop or crit session acts as a kind of primal scene of reception, whose terms often get replicated (if amplified) when students move into the larger world.

I would not have stayed a part of such scenes for over two decades now if I didn't find in them great pleasure, stimulation, and sustenance. At the same time, this perch has granted me insight into the ways in which institutions of higher learning are increasingly shaping the norms and expectations for art and artists. Some of this influence has been positive; other aspects of it have been more troubling. One of the most troubling has been higher education's deepening commitment to "campus security" in the name of student protection, from Title IX tribunals to the development of an ever-ballooning administrative class charged with adjudicating complaints and managing liability. "The campus promises safety, security," Jennifer Doyle writes. "To see that promise through, it must police and expel. It must establish a procedure and manage its risk."

In such a climate, the harm model of expression, and its corresponding demands for increased risk management and protection, have come to

represent a real conundrum. On the one hand, it represents a site of vital protest, a means of addressing long-festering, unjust conditions. On the other, it can serve as an open invitation to institutions to consolidate and wield ever more administrative and disciplinary power over faculty, staff, and students alike. As Doyle and others have made clear, if we do not want the neoliberal university (or the museum or the publisher, many of which are arguably giant corporations in disguise) to turn the demands of social justice into an excuse to consolidate and exert more power, if we want to make structural changes without simply hardening the system in ways that can and will be used against us—including worsening conditions for adjuncts and other precarious labor[17]—we have to be foxier, more creative, and more discerning than calls for expanded protections or quick expulsions typically require. This means wrestling hard with Adam Phillips's question: "If you don't punish people who do unacceptable things, what else can you do with them, or to them?" It's no accident that, in a society with more people locked up per capita than anywhere on earth, we wouldn't have many ready or inventive answers.

When we can't wish others away, often we wish they would just shut up, or at least cede the stage for a while. This is especially so when one sees the world of literature or art as a zero-sum game. This "shut up already" sentiment animates a 2016 document like "The Thanksgiving Paris Manifesto," written by Eileen Myles and Jill Soloway, in which they assert that "to begin a revolution, we are demanding a climate of reparation: Porn made by men is hereby outlawed for one hundred years (one full century). In all other arts and representations, i.e.: film, television, books, poetry, song-writing and architecture, fifty years (one half-century) will be adequate for the ban."

Each time I've read the above passage aloud at a public event, it has earned applause and laughter, indicating that something about it comes as a pleasurable relief. I think people also feel free to laugh because they know such a ban will never be enacted: the hyperbole of the manifesto signals its participation in a performative tradition distinct from that of protest letters seriously endeavoring to get a museum to remove a work

from its walls, or to convince Oprah "to remove the influential impri-
matur" of her book club from a novel charged with not being "imag-
ined well nor responsibly." Nonetheless, even the fantasy of a reparative
ban dependent upon the suppression of male expression brings up a real
question, one related to "the painting must go."

As Jared Sexton wisely observes about Black's letter to the Whitney,
"Three times Black declares, at the crux of the dispute: the painting
must go. Indeed, but even in our most profound agreement we cannot
help but ask: Go where?" The repressed inevitably returns, in part be-
cause our turbulent coexistence—with each other, ourselves, history,
images, noxious ideologies that predate us—comes with no eject button,
no "outside." As both "The Thanksgiving Paris Manifesto" and Black's
letter make clear (if inadvertently), fantasies of addressing our entangled
freedoms and shared need for expression with bans or banishments often
end up relying on distinctions—black/white, men/not-men—that have
difficulty bearing up under pressure (not to mention that their enact-
ment would end up reifying the power of the very institutions the au-
thors mean to challenge).[18]

"Shut up already" can at times be the right response, be it directed at oth-
ers or oneself. At the same time, my experience as a teacher (and a parent)
has taught me that little lasting good usually comes from bearing down
on it, especially without adequate explanation or care. Psychologically
speaking, as Phillips has put it, we tend to hate those who demand that
we inhibit ourselves; this is especially true if we have not been properly
educated about our historically unequal relations to speech. It is mad-
dening and unjust, but nobody is born understanding these historically
unequal relations, or their inheritances in regard to them. We have to
learn them, and we have to teach them. That teaching requires forbear-
ance; its burden should not fall on those who have been made to suffer
most from the inequity.

Any principle, including that of compassion, can be wielded in an un-
skillful, even deleterious, fashion, especially when it's cast as a call or a de-
mand. No doubt feminist writer Laurie Penny speaks for many when she

complains, "I'm so sick and tired of being told to empathise with bigots and misogynists, to understand and excuse the pain that drove them to support that fascist or harass that woman or drive that van. When those people start displaying a shred of empathy for anyone else, call me." But as a matter of both pragmatics and principle, I remain devoted to radical compassion, and not the kind that waits for a call.[19] Figuring out what such compassion looks like in practice—and how to differentiate it from what Chögyam Trungpa has called "idiot compassion" (by which one might let oneself get walked all over, or undertake "doing good" as an act of self-gratification)—is the unceasing, rigorous work of a lifetime. It isn't something one always gets right.

I CARE/I CAN'T

A resistance to the rhetoric of harm on the part of some artists may reflect not ethical inadequacy as much as a tacit acknowledgment that certain forms of care are becoming increasingly implausible even as the demand for them increases. This has something to do with scale, in that art, while it can be felt or taken personally, is not, in essence, personal. The presumption that making a sculpture or writing a novel is somehow on par with entering into an intimate relationship with a viewer or reader, with all the emotional responsibility such a relation typically entails, is a mistake. It is a mistake related to that of thinking we personally know an actor because she stars in our favorite movie, or that we are close to a singer because he has crooned through our headphones at a fraught emotional juncture. The increased accessibility of public figures via social media has made this mistake all the more prevalent: just because it's more possible now to reach people to tell them how their art has made us feel, it does not follow that they are more responsible to or for our feelings.

Refusing to take up the burden of how one's art may make innumerable, heterogeneous, essentially uncontrollable others feel does not to me signify ethical failure. It may in fact signify sane boundaries in a world dedicated—by means of targeted advertising, shared Google calendars,

Paperless Post invitations urgently awaiting your response, 24/7 availability to the approximately 3.4 billion people around the globe using email and social media—to their erosion. Such erosion presumes that one's attention, which is a form of one's care, is something that can be demanded by anyone in the world with strong feelings and access to Wi-Fi. Becoming exhausted by (or addicted to) this attention economy, as so many report feeling, takes time away from the activities and people we purportedly care about the most. And while we may fantasize about our care as limitless—and it may even be so, in a spiritual sense—in our daily lives, most of us run up against the fact that care, too, is an economy, with limits and breaking points.[20]

In "Exhaustion and Exuberance: Ways to Defy the Pressure to Perform," critic Jan Verwoert describes the problem as a matter of scale: "Ethically speaking . . . there is a fundamental problem: when we fully realise the implications of the *I Care*, we are forced to acknowledge that the potentiality of care can never be collectively organised, because the debt to the other implied in the *I Care* is always radically particular. To generalise it means to obliterate its very momentum." Verwoert goes on to note that, to stay engaged in the "disciplines of care" that matter to us most in a media environment and economy dedicated to exhausting time and attention, one has to learn how to set limits. In some situations, Verwoert observes, "to profess the *I Can't*" can sometimes be "the only adequate way to show that you care—for the friends, family, children or lovers who require your presence, or for the continuation of a long-term creative practice that takes its time." How to balance an expansive, spiritual conviction that *we owe each other everything* with this local, particularized economy is an ongoing conundrum, one people will handle differently, according to their appetites and apertures.

It may sting when you get (or give) an *I Can't*, but it likely indicates that care is engaged elsewhere. For many artists, that "elsewhere" is the fierce, sometimes unconscious protection of the conditions that make their ongoing artistic practice possible. This protectiveness can infuriate others. This makes sense, in that aesthetic care is of a different order from other

forms of care. It appears not to care directly for others because it doesn't. Aesthetic care entails caring about other things, such as paper quality, pigment, gravity, oxidization, chance, pattern, the dead, and the unborn. All of this is also the world, also constitutes forces to which one might feel compelled or obliged. That such forces do not always make their claim on us via human bodies or ethics is no reason to doubt the intensity or vitality of their calls. I am married to an artist, and although we presumably understand the importance of each other's work more than many others might, the fact that our work consists mostly of self-directed, time-consuming, solitary labor (accompanied by "breaks" that look a lot to an outsider like wasted time), with few to no hard deadlines or guarantees of financial profit (more often, the work operates at a loss), makes it a quick target if and when one of us thinks the other could or should be doing something else (cleaning the house, playing with the kids, paying attention to one another, making money, and so on). At the same time, we both know—especially as teachers—that one of the most vital things we have to impart, both to ourselves and our students, is the importance of making time and space for one's art in a world that will always threaten to disregard or diminish it.

Certainly there come moments in an artist's life when an "I can't care" stance becomes unviable (my own marriage probably hits one a week). But while we can always ask others for something more or different, the demand that others react to or engage with us on our terms reflects first and foremost our desire. And desire is always at risk of being disappointed. The response to "you must listen to me" or "you must care for me" or "you must respond to me"—whether you're addressing an artist, an institution, your lover, your child, or your representative in Congress—can always be "no" (or "not in the ways you're asking me to").[21] In which case, you're going to need a plan B. Usually we need robust plan Cs and Ds as well. For once we truly acknowledge that there are other people in the world—which is harder to do than it sounds—we must reckon with the fact that we cannot control them, even as we depend upon them (Phillips). Such lack of control is frightening—enraging, even. It is also, as Phillips has said, the beginning of political life, not to mention the birthplace of reparative experiment.

AFRAID TO DO WHAT HE MIGHT CHOOSE

When Hughes asserted that "an artist must be free to choose what he does, certainly, but he must also never be afraid to do what he might choose," he was most concerned with the "urge within the [Black] race toward whiteness." In particular, he was thinking of a Black poet (widely believed to be Countee Cullen) whom Hughes quotes as saying, "I want to be a poet, not a Negro poet." Being afraid in this context, then, mostly meant being afraid—indeed, being ashamed—of being Black and writing Black, whatever that meant to Hughes at the time.

I don't want to warp Hughes's words by removing them from their context. But letting their complex wisdom travel also seems one means of giving them their due. For there is no doubt that his mantra has proved itself impressively elastic and germane to situations and speakers beyond that which gave it rise. Each generation has its own forces that might make an artist "afraid to do what he might choose"; certainly the question was of grave importance to Hughes, who, in addition to partaking in fierce intracommunity debates about audience, patronage, and accessibility, was hounded by the FBI during the Red Scare of the 1940s and '50s.

Rankine and Loffreda are absolutely correct when they argue that it's crucial, especially in racialized controversies in art, to avoid mistaking "critical response for prohibition," a mistake they see as "the inflationary rhetoric of scandalized whiteness." Suffice to say, I'm not too worried about the likes of novelist Lionel Shriver, who complained, while sporting a sombrero: "I confess that this climate of scrutiny has got under my skin. When I was first starting out as a novelist, I didn't hesitate to write black characters, for example, avail myself of black dialects, for which, having grown up in the American South, [I had] a pretty good ear. I am now much more anxious about depicting characters of different races, and accents make me nervous." God forbid a little hesitation, a little nervousness, a little introspection, before letting one's "good ear" rip into Black dialects! The complete absence of the notion that there might be anything challenging, constructive, aesthetically or ethically illuminating—even if momentarily discomfiting—to be found in

introspection or education on the subject tells one everything one needs to know about the fragility of Shriver's sense of artistic freedom, which apparently shrivels upon contact with the vexed, often deeply racist history of the white depiction of Black speech, or the prospect of being criticized for her engagement with it.

It seems to me, however, that if and when we really are calling for the destruction and/or prohibition of a piece of art, and/or punitive consequences for its maker or exhibitor based on the art alone (such as disciplinary action at the artist's workplace, the cancellation of a museum show, the destruction of the work, the blacklisting of that artist from other institutions, stripping the work of honors, obstructing the artist from presenting the work in public, threatening an artist's personal safety, and so on), it is disingenuous to argue, as has often been argued to me, that we aren't *really* calling for any of that, based on the premise that, since we lack the power to carry out such demands, they are best understood as inert performance designed to garner attention that a critique without such demands wouldn't receive. Likewise, if by "consequences" we really mean "requesting that the powers-that-be step in to discipline and punish," we should face that urge squarely. Critic Andrea Long Chu has a point when she asserts, in a piece about #MeToo, that "the *desire to punish*, for better or worse, isn't the same thing as *punishment*." Yet once this desire finds robust public expression, I'm not sure this distinction has the ethical solidity she supposes. Just because we might not single-handedly have the means to bring about a lawsuit or ensure someone's social or professional death doesn't mean that our allegations or pressure campaigns are without effect, including punitive effect. (If they were, why would anyone bother?) Further, if one accepts the ACLU's working definition of censorship—"Censorship, the suppression of words, images, or ideas that are 'offensive,' happens whenever some people succeed in imposing their personal[,] political[,] or moral values on others. [It] can be carried out by the government as well as private pressure groups"—one recognizes that organizing for the suppression of certain works, or the blacklisting or firing of artists on account of their work, can indeed be censorious; one doesn't need a badge or governmental affiliation to make it so.

I get the adage that protest is something done by people "without power," whereas censorship is something done by people "with power," by which logic something like Black's call for the removal and destruction of Schutz's painting cannot be properly called "censorious" save in senti- ment. (At one point Durant used this distinction to explain why he did not feel that the destruction of *Scaffold* was acquiescing to censorship, though he has since revisited the issue with more nuance.)[22] But we prob- ably don't need to agree as to whether something technically qualifies as "censorship" to think critically about our tactics, habits, and presump- tions about power. Power shape-shifts and travels—as nearly every effec- tive activist knows, asserting it goes a long way toward its actualization. Letting go of a calcified conviction of what and where power is and how it moves can be a crucial part of instigating its redistribution; acknowl- edging and feeling what power we *do* have—not to mention analyzing our own will to it—invites us to investigate what we want to do, or are al- ready doing, with it. Claiming that all's well that ends well if and when institutions refuse to cave in to our demands (e.g., the university doesn't fire the professor, the museum doesn't take down the painting, the pub- lisher doesn't pull the book) does not strike me as planning to win.

As far as self-censorship goes, it is notoriously difficult to measure: one can collect anecdotes and absorb the atmosphere, but individual artistic decisions remain, for the most part, affairs of the hard-to-know human heart, to which not even we ourselves have full access. Further, we self- censor all the time, often to profoundly beneficial social, personal, even aesthetic effect (in writing, one might even call it "editing"). Some see in certain forms of self-censorship proof of salutary changes in norms (as in changed standards of acceptability vis-à-vis bigoted speech); some even feel consoled by its presence, in that they read it as a sign that a cer- tain measure of freedom is still operational (it tends to cheer people up, for example, when they hear that a YA author or a Sam Durant made the decision to withdraw a book from publication or have a sculpture de- stroyed themselves, rather than seeing the institution charged with rep- resenting the work succumb to external pressure). Bill Donohue of the Catholic League, whose aim is to cause artists so much grief that they eventually opt to self-censor any potentially blasphemous work before

making it, goes so far as to call self-censorship "a friend of freedom." Conversely, some see a rise in self-censorship as signaling the triumph of a more insidious type of unfreedom ("But it was all right, everything was all right, the struggle was finished. He had won the victory over himself. He loved Big Brother").

The National Coalition Against Censorship (NCAC) has been contending with these issues for decades, arguing that "while regulating one's own speech so as not to offend others may be a good thing, the rhetoric of offense has also been used as justification to threaten institutions with physical violence or with loss of funding, thus triggering a kind of self-censorship that endangers the cultural life of the country." In the wake of the *Scaffold* controversy, the NCAC criticized the Walker's actions as follows:

> Cultural institutions and artists urgently need to develop creative ways to respond to such critique and controversy and productively engage diverse communities while taking seriously their responsibility for the artworks that are in their care. Without active institutional support for their work, artists— who can face extreme pressure on social media, ad hominem attacks and even physical threats—may feel they have little choice but to consent to their work's destruction, to commit to avoiding certain subjects in their art (self-censorship), and or even to sign away their intellectual property rights.

Durant has rejected the idea that he had "little choice" but to acquiesce to the protesters' demands; casting doubt on his account of his agency would be to level charges of false consciousness, which isn't my wont. In fact, I read the story of Durant's engagement with the Dakota as a painful but ultimately rousing tale of the possibilities of protest, dialogue, and resolution. But it also seems foolish not to acknowledge, as the NCAC here does, that the current environment is capable of putting novel forms of intense, sometimes menacing pressure on individual artists—pressure we haven't yet fully fathomed or reckoned with, but which undoubtedly affects us all.

To say that such pressure pales in comparison to certain current and past practices of discrimination, exclusion, and governmental suppression is correct; it's for this reason that you won't find me throwing words like "totalitarian" around to describe it. As Masha Gessen has it, "Totalitarian ideology had the power of the state behind it. The enforcers of totalitarian ideology—be they Central Committee members, Writers' Union leaders, or the distributors of store-window signs—had the power of state institutions behind them. Protesters in the streets of American cities and the journalists who support them are not backed by state or institutional power, but just the opposite: in every instance, they are in confrontation with it." At the same time, focusing exclusively on the perils of state power risks sidestepping or minimizing the particular challenges of our times, which include a metastasizing privatization of the so-called public sphere, wherein more and more elements of our lives are shaped by nongovernmental forces, including corporate forces; it also underestimates the importance that spheres other than the political—such as the social, private, affective, and spiritual—have in affecting our felt experience of our communities and lives.

If the current reckoning underway in the art world about structural racism, inequitable opportunity, toxic philanthropy, art washing, community relations, restitution, and divestment is as thorough and transformative as it should be, a lot of people are going to feel—and be—disturbed and displaced. This seems right. My hope is that we can undertake such a reckoning while also remembering that we go to art—or, at least, many of us went to it at some point—precisely to get *away* from the dead-end binaries of like/don't like, denunciation/coronation—what Sedgwick called the "good dog/bad dog rhetoric of puppy obedience school"—all too available elsewhere. Many of the artists who matter to me deeply have had problems with the law, and not always for ethically sound reasons (for every Thoreau there's a Marquis de Sade, for every Hughes there's a Cleaver, for every Goldman there's a Solanas). Many of the artists and thinkers I've drawn on in these pages have experienced some sort of "takedown" or another; in fact, this book has taken so long that some have moved through their takedown phase into the category of "problematic fave," a term I despise. I despise it because it presumes there are

human beings who are or could ever be "nonproblematic," which I guess means that nothing they ever said, believed, experimented with, or did would unsettle any other, which defies most of what I know about what it takes to think hard, make good art, or be a complicated human being. Such an approach reflects the "idealize, degrade, discard" logic that characterizes a narcissistic apprehension of other human beings, which is to say, a nonapprehension of them. The notion that if we could just make fixes to people—snip off a little alcoholism here, a little pedophilia there (or machismo or transphobia or personality disorder or whatever)—we could then resume our hero worship of them, strikes me as ludicrous—cruel, even. Certainly it has little to do with the ideology of restorative justice, an ideology from which it liberally borrows without a corresponding commitment to its foundational principles.[23]

The mythos of the outlaw artist (or the megalomaniacal director, or the incorrigibly horny novelist, or whatever) should not continue to serve, as it has served for so long, as an excuse for unacceptable behavior. At the same time, it's naive and unfair to expect artists and writers to have special access to the most intense, extreme, or painful aspects of life, then to act surprised and appalled when they turn out to have a relationship to those things that exceeds that of abstract contemplation or simple critique. Thankfully, acting as if the world neatly divides (or that our task is to divide it) into problematic, ethically turbulent, essentially dangerous people who should stay "over there," and nonproblematic, ethically good, essentially safe people who should be allowed to stay "over here," is not our only option. After all, what I've just described is a prison.

FREEDOM AND FUN

The stakes of pitting disinhibition and freedom against inhibition and duty extend way beyond the world of art. As I write, the alt-right is waging what Wendy Brown has described as "a brilliant . . . campaign" to associate "anti-egalitarian, anti-immigrant, and anti-responsibility sentiments with freedom and fun," while casting "left and liberal commit-

ments as repressive, regulatory, grim, and policing." This campaign seduces its would-be converts with the promise of release from responsibilities of all kinds, be it "for the self, for others, for the world, for a social compact with others, for a social compact with the future, in the name of a certain kind of political and social disinhibition." Brown's warning—which has deepened in urgency over the time I've spent writing this book—is that the fusion of this libidinal "freedom and fun" with a "new authoritarian statism" has formidable velocity and power, with a particular capacity to appeal to "the young, the immature, the reckless, and the wounded." This fusion, Brown says, lands us in "deeper trouble than we knew," and requires that we "think really hard about what strategies would most successfully counter" it.[24]

One such strategy has been to bring the libidinal charge of unleashed aggression to the resistance, which indemnifies itself from ethical misstep by the conviction that insult, trolling, and even unprovoked physical assault are justifiable sources of "freedom and fun" so long as they issue from the vulnerable toward the powerful.[25] To note that this approach can lead to behaviors that mirror the disinhibited cruelty that's come to be known as Trumpism is not necessarily to engage in "both-sides-ism," as some would doubtlessly argue. It is to note that the problem of taking delight in the unleashing of vitriol or bellicosity upon those whom we have deemed the appropriate bad object for our (often legitimate) grievances is something to which each of us is susceptible, and for which each of us must answer.

Another strategy has been to embrace the role of the "killjoy," as in Sara Ahmed's "being a killjoy can be . . . a world-making project." For Ahmed and others, being a killjoy means acknowledging that there is a lot in this world to feel justifiably unhappy about, and that drawing certain others' attention to those unjust, unhappy things will risk making them feel unhappy too (which, in turn, tends to make the messenger into the bad object, if she wasn't already, simply by virtue of her presence). Ahmed's killjoy defiantly resists the demand to be happy, especially if and when that happiness relies on the suppression of the unhappiness of others, up to and including their subjugation.[26]

Killing joy can be an important station en route to figuring out how to foster more just and shared forms of well-being; performed with humor and creativity, it can even be fun (as in the immersive art project *KillJoy's Kastle*, a lesbian feminist haunted house created by artists Allyson Mitchell and Deirdre Logue that brings "'dead' theories, ideas, movements, and stereotypes back to life with queer flair" in the form of "Polyamorous Vampiric Grannies," "Zombie Folk Singers," "Riot Ghouls," and "demented women's studies professors").[27] But there is simply too much I don't yet know (and desperately want to know) about unforeclosed pleasure, insubordinate conviviality, and radical compassion for me to spend time venerating the rhetoric of the killjoy or complainant, as all too often such veneration slips into a "kind of warped communal alienation in which people are tied together not by blood or a common language but by the bad feeling they compete over," as Moten has put it. This situation tends to produce, as Moten says, a whole lot of people spending "a whole lot of time thinking about stuff that they don't want to do, thinking about stuff that they don't want to be, rather than beginning with, and acting out, what they want."

Art has long served as a place for people to act out what they want and think about stuff they want to be thinking about. It has long been a place to engage in open-ended experiments with extremity, wildness, satire, defiance, taboo, beauty, and absurdity, to make space for anarchic gestures and urges that might otherwise rip apart (for better or worse) social norms or fabric. It has long been a site of freedom and fun that does not make—or rarely makes—recourse to intimidation, threats, or bullying.[28] As Dawn Lundy Martin has said about Kara Walker's work, it can also be "an exorcism . . . a purging of cultural demons"—a frame to contemplate or bevel that which is simply uncontemplatable elsewhere. To some of us, it offers magic—magic hard to come by elsewhere, and which can make life feel more worth living. To those who would scoff at such a characterization as sentimental enchantment, or who have come to see art as just as another bankrupt concept or damaging tributary of capital, I offer no rebuttal, save a reminder that it can be other things, too—things that to some of us matter as much as or more than the fruits of demystification.

AESTHETIC CARE

The shift to a language of duty and care in the realm of art mirrors the conviction that all forms of human relations, including art, can and should be judged against the utilitarian standard of whether they help to make life "more humane and livable for us all," as Susan Sontag put it in "On Style." Sontag did not share this conviction. Here is the relevant passage: "Morality, unlike art, is ultimately justified by its utility: that it makes, or is supposed to make, life more humane and livable for us all. But consciousness—what used to be called, rather tendentiously, the faculty of contemplation—can be, and is, wider and more various than action."

I've returned to this essay many times, always finding something new in it; the phrase that jumps out at me today is "wider and more various than action." Caretaking, the reparative, making life more livable and humane for us all—all of these things matter enormously (they also mattered enormously to Sontag). But, for better or worse, they are not everything. For many—perhaps even most—life feels more ample, more livable, "wider and more various," when it *doesn't* reduce to one long episode of caretaking or repair. It feels good when it has more texture, more space for different kinds of pursuits, compulsions, and delights, even those with no apparent use value. Despite frequent and fervent assertions to the contrary, such expansiveness is not the exclusive province or aspiration of the privileged.[29] In fact, many artists from so-called marginalized groups eventually find that one of their hardest battles isn't for the right to make work that reparatively addresses "the barbaric realities of racial and gendered violence on which our lives are founded," which Hannah Black names as art's worthiest goal, but for the ability to be heard, seen, or taken seriously when they choose to address almost anything else (I live with an artist who fights this battle daily, and finds it supremely dehumanizing).

One irony of holding art to a utilitarian standard is that it echoes capitalism's own fixation on quantifiable results—in which case, celebrating art for its nonutilitarian aspects, for the "nothing" it makes happen,

can be a means of calling attention to the presence of a different schema of values, a different mode of being. "Given how many bad things happen," writes Wayne Koestenbaum, channeling Oscar Wilde, "wouldn't it be better if things didn't happen? Poetry making nothing happen is the thing it makes happen. It prevents the violence of much of what constitutes 'happening,' which is destruction." Sontag makes a similar argument in *Regarding the Pain of Others*, when she writes, "There's nothing wrong with standing back and thinking. To paraphrase several sages: 'Nobody can think and hit someone at the same time.'" Such notions may frustrate critics looking to art to enact new counterpublics or forms of community care; they may also displease artists who consider their art a form of activism. But they shouldn't. That art *can* be reparative is not the same as saying it *must be* in order to have value. Further, the so-called reparative works in mysterious ways: it wouldn't be too much of a stretch, for example, to call Sontag's "nourishment of consciousness" a reparative effect;[30] at a certain point, what's reparative and what's not becomes a matter of semantics, a game we engage in only when we presume art (or certain art) needs justification.

Aesthetic care—in which one focuses one's attention on, say, one thousand graphite squares, and not, at least for the moment, on directly caring for others, or on the question of whether caring for a thousand graphite squares has or could ever have any relation to caring for others—is one source of texture and amplitude. The devaluation of aesthetic care has long gone hand in hand with the diagnosis and disapproval of something variously called "art for art's sake" or "formalism" (a history Black summons in her letter when she invokes "empty formalism," a derogatory term activated by philosophers from Hegel to the Frankfurt School). But formalism is not made full when artists share the same motivations or concerns, and made empty when they differ. Nor need artists work from the same foundational questions in order for their work to have value. (See Mike Kelley: "I make art in order to give other people my problems.")

The irony of this resurgent, politicized moralism in which formalism once again plays a negative role is that the past few decades have seen an

explosion of art and criticism that finally seems to be pushing away from the tired binaries of form/content, abstraction/figuration, art as autonomous apolitical object/art as political weapon, art as subversion/art as hegemonic reinscription, which have dominated the discourse for nearly a century now.[31] I'm thinking, for example, of recent revisitations of formalism, abstraction, and conceptualism through the lenses of queerness and blackness, be it via "queer formalism," or open-ended curatorial engagements with blackness and abstraction, such as those undertaken by Glenn Ligon and Adrienne Edwards.[32] Artist Mark Bradford's theory and practice of "social abstraction" (which he describes as abstract art "with a social or political context clinging to the edges") is germane here, as is the theorization of a queer formalism that doesn't set itself up as purged of, or in opposition to, the bogeyman of identity politics.[33]

Sillman—a queer feminist who has dedicated the bulk of her career to abstract painting—articulates this notion as follows: "What would be much more interesting than the strong opposition to identity politics would be a more interesting identity politics, the formation of more questions about other people's actual experience and perceptions, conducting more nuanced examinations of subjectivities, *local culture*." Her comment brings to mind Aimé Césaire's famous remark, made in a 1956 letter: "I'm not going to confine myself to some narrow particularism. But I don't intend either to become lost in a disembodied universalism. . . . I have a different idea of a universal. It is a universal rich with all that is particular, rich with all the particulars there are, the deepening of each particular, the coexistence of them all."

In that same piece, Sillman describes her employment in Bard College's MFA program, explaining that she was initially hired in an affirmative action effort to get more women on faculty, and that years of such hiring practices made a seismic shift in the gendered culture at Bard: "We have moved off from square one, from mere quotas and tokens, the groundwork has been laid for moving on to more interesting, more complicated conversations. Identity politics hasn't kept us all bracketed away from each other in separate self-serving units, but has allowed for the luxury of folding gender questions together with all of the other things that

interest us, like form, color, history, memory, affect, meaning, visuality, etc." It has been difficult for many people—including many so-called formalists—to understand that one way to ensure that things like "form, color, history, memory, affect, meaning, visuality, etc." *aren't* discussed in an interesting fashion is to keep rigidly opposing them to "content" (i.e., "politics" or "identity politics" or what have you) and maintain a reactionary resistance to the latter, which keeps us forever unable to contend with difference, forever stuck on the square one Sillman describes. Often it's fruitful to tackle the mess head-on (as in works such as choreographer Miguel Gutierrez's 2019 piece *This Bridge Called My Ass*, in which Gutierrez grapples with "the perception that artists of color are always doing content work [i.e., dealing with identity politics] and white artists are only doing form and line," or Sillman's own practice of leaving comedic, politicized zines in galleries showing her abstract paintings).

Forcing all abstract work (or any kind of work, really) under the lens of so-called identity politics can be throttling. But, as the riddle of English's book title *How to See a Work of Art in Total Darkness* suggests, it remains a challenge to shed the habit of predictable, reductive, identity-based responses (such as those that would treat, as English has it, all abstract art by Black artists as "the cryptic articulation of fierce racial pride awaiting disencryption") without simultaneously reifying the idea that if we could just *get past* all these annoying differences of lot and station, the *real* subjects of art would reveal themselves to us, especially as this latter mindset risks reaffirming, yet again, the stale hierarchy in which the universal lords over the particular, the abstract over the figurative, resplendent white over variegated color. The trick is to find unforeseen ways to refuse the terms, to upend the game, to stay alive to Césaire's "universal rich with all that is particular, rich with all the particulars there are, the deepening of each particular, the coexistence of them all."

COERCED AND FREELY GIVEN

A few years before the "aesthetics of care" invitation, I was asked to be on a different panel, this one about women writers, which did come to pass.

Participants were given two questions to address. The first was: "Can women writers effect the social imaginary in ways that positively change our psycho-sexual organization?" Sure, I thought (even if I sighed inside at the endless desire for utility or positivity; don't even get me started on the idea that one's psychosexual life could be organized). The second was: "Are they obliged to, or is this another version of mothering that restricts women?" Absolutely not, I thought.

At the time, I batted away the "or is this another version of mothering?" part of the question, as it seemed to me an unnecessary, stereotypical winnowing of the concept of obligation. Years later, however, it's still, or newly, on my mind. This is in part because I've since become a mother; it also has to do with the tidal wave of recent theory and philosophy foregrounding questions of debt, interdependence, and obligation, some of which can be traced to Levinas, who, as Simon Critchley has it, "makes the extreme claim that my relation to the other is not some benign benevolence, compassionate care or respect for the other's autonomy, but is the obsessive experience of a responsibility that persecutes me with its sheer weight. . . . In short, the Levinasian ethical subject is a traumatic neurotic."

It never ceases to astonish me, in reading account after account of this neurotic, explicitly compound figure whose responsibility for the care of another displaces the primacy of the self, to find that most of these accounts either ignore the maternal, which has literally been the repository for such for millennia, or alchemize it into metaphor. Levinas's own description of ethical responsibility figures it as "*like* a maternal body," one "that bears the Other without integrating him or her into the same" (italics mine).[34] Verwoert's essay "Exhaustion and Exuberance" makes the same move, as when Verwoert describes a politics based in "an indebtedness to the other" by using, as an example, a quotation from artist Annika Eriksson, who observes that "as a mother, (when your child is in need of you), 'there is no no.'"

I'm writing all this with my cell phone positioned right next to the keyboard, so that if my son's fever from yesterday returns I can drop everything and go pick him up. If and when the call comes, of course there

is no no, which leads one to wonder—for whom is there, has there, historically been a no, and for whom is the introduction of the concept so radical? (I wrote that sentence years before the pandemic; now I've spent months with him by my side, sometimes on my lap, as I try to write.) In a nation dedicated to indebting and overworking its populace and eviscerating social services and bonds, I challenge anyone to find me a mother—especially a poor, overworked, nonwhite mother—who feels freshly arrived to the notion of "infinite debt," or the displacement of the primacy of her self by an "obsessive experience of a responsibility that persecutes [her] with its sheer weight."

Given the general repression, uncritical valorization, or undertheorizing of the maternal, I credit Moten for his comments, in an interview at the end of *The Undercommons*, that "you can't count how much we owe one another. It's not countable. It doesn't even work that way. Matter of fact, it's so radical that it probably destabilizes the very social form or idea of 'one another.' But, that's what Édouard Glissant is leading us towards when he talks about what it is 'to consent not to be a single being.' And if you think about it, it is a sort of filial and essentially a maternal relation. When I say 'maternal,' what I'm implying there is the possibility of a general socialisation of the maternal." I see this possibility too, and in many ways hope for it (if by "socialisation" Moten means a redistribution of the burdens and entanglements that have heretofore lodged in the maternal). This redistribution is, in fact, the point of all the analogizing, which means to emphasize that care and responsibility can and should circulate apart from the maternal body, as well as apart from biological ties (hence, "Other").

The problem with this analogizing is that it continues a long tradition of relying on the maternal as an idealized model for selfless care provision without contending with the experience of actual mothers themselves, who complicate the picture by having their own needs, not to mention an understanding of caregiving as historically and psychically interwoven with disintegration, failure, inequity, and coercion. To question the use of the mother as a model of selfless care provision and a priori obligation means facing the psychological and political repercussions of

having feminized this labor for thousands of years, as well as the vexations that such a model has produced for those presumed felicitously to embody it.

If "consenting not to be a single being" is essentially, or analogically, a maternal relation, it's worth placing this observation beside Jacqueline Rose's warning, in *Mothers: An Essay on Love and Cruelty*, that "we should never underestimate the sadism that mothers can provoke." This dynamic stems in part from larding up the maternal function with the charge of providing limitless, unconditional, self-sacrificial love and care to others, without reserve or resentment, within systems that make such a thing difficult or impossible, be they sociopolitical, economic, psychic, or all of these. This is obviously a setup, which is why Rose writes, "Mothers always fail. . . . Such failure should not be viewed as catastrophic but as normal." Each day as a mother brings large and small reminders of the omnipresent specter of inadequacy. For example, today I open my email and find a message from a French journalist who interviewed me a week ago; she says she has but one follow-up question, which turns out to be: "Did you say you pick your son up from school every day, or just some days?" One can only speculate as to her motivation, but the gist seems clear enough: a mother's aesthetic or intellectual care must always be haunted by the specter of not good enough care for her child—an intimation that, I scarcely need to point out, does not regularly get put to artist- or writer-fathers, for whom a single pickup from school a week typically incites an orgy of encomium.[35]

I think I have a pretty good idea of what the journalist wanted me to say. Still, I chose not to answer. My reassuring anyone that mothers can "do it all" would allow my staggering privilege to obscure the excruciating burdens so many face in their attempts to construct livable lives; it would also disrespect the inevitability of maternal conflict and failure. One of the lessons of this conflict and failure is that while providing (or seeking) care may feel better—more enjoyable, more rewarding, maybe even more moral—when it feels (or truly is) uncoerced, when it comes to caretaking, the distinction between the mandated and the voluntary is often far murkier than we sometimes hope or desire.

The eruption of these issues into the realm of art via the uncritical valorization of care no doubt contributed to my "yuck," insofar as it risks suggesting that art—a realm to which women have been allowed entrance basically one second ago in human history—should become yet another place where women must grapple with an already-feminized, maternalized duty to care and repair, else be charged with aping toxic, masculinist forms of freedom if and when they insist on "wider and more various" avenues of expression and devotion. My "yuck" was childlike because I am a mother who is also someone's daughter, which means that I am familiar with the pleasures and difficulties of wanting and needing to devote myself entirely to someone else's needs, while also wanting and needing to differentiate and contend with my own. It means that I am familiar with the anger, fear, and anguish a child feels when she realizes that no one—not even a perfect mother—can protect her from suffering, and with the anger, fear, and anguish a mother feels when she confronts that same fact from the other side. (This is why Madani's *Shit Moms* paintings are so novel and great, as, for the first time in painting history, "shit moms"—moms made of shit, albeit shit rendered in paint, and also "shitty moms," *bad moms*—get plenty of space to play.)

Bearing the above situation is not optional. Bringing an unworked-out version of it to the realm of art is. Perseverating on the fantasy that, had the care been good enough (from the artist, the curator, the museum, the university, the teacher, etc.), we would not have been exposed to the bad thing and would not now be suffering (or would at least be suffering less) is not an accurate, fruitful, or fair model. At its worst, it risks activating the punitive sadism that, when it comes to the maternal, is always waiting in the wings.[36] It also risks reducing care to giving, protecting, and fixing, rather than treating it as a negotiation of needs that involves assuming strength in the other, resisting the temptation to provide all the answers, inevitable failure and disappointment, allowing for the fact that our desires for others may chafe against what those others want for themselves, and making space for pain, individuation, and conflict without falling apart, or without losing an underlying conviction of fellowship and love.

At the end of her pivotal essay "The Belly of the World: A Note on Black Women's Labor," Saidiya Hartman describes the care provided by Black women from slavery to the faux emancipation of wage labor as "coerced and freely given." This poetic paradox means to acknowledge how much care has been extracted from Black women at their expense, and how much they have continued to give, regardless: "The forms of care, intimacy, and sustenance exploited by racial capitalism, most importantly, are not reducible to or exhausted by it." Hartman makes clear that this paradox is specific to the sexual and domestic labor of Black women, and cannot be assimilated into the lexicon of the political, including that of the Black worker. Yet "coerced and freely given" gestures toward a broader dynamic about care that deserves our attention.

Caring and coercion often exist in a knot, with their extrication never simple, nor sometimes even possible. That doesn't mean we shouldn't work to reduce elements of coercion from it; that is the ongoing work of abolition, as well as of the socialization of the maternal. But since aspects of this paradox will always be with us, doubling down on the familiar—often leftist—insistence that our salvation lies in liberating ourselves from the dark clutches of need and ascending to freedom's bright expanse is not good enough, nor is simply exalting need, care, and obligation in freedom's place.[37] The former conjures an all-too-familiar schema in which self-sufficiency and independence are valued over reliance, service, and infirmity; the latter throws the door open to all kinds of unrealistic and dysfunctional demands made of ourselves and others, bringing us into mirthless territory ranging from codependency to shaming to servitude.

The internal compulsion that drives some people to make art obviously differs from the external demand that we work for bread; that was Marx's whole point, in distinguishing "the realm of freedom" from "the realm of necessity," and aligning unalienated labor with the former, and exploitative work with the latter. No doubt this was the distinction Berardi was drawing on when he so annoyed Sillman with his veneration of "not working" (though I'm willing to bet that Sillman would agree that "staying up late . . . trying hard to make a 'better' oil painting" is distinct

from, and preferable to, putting in a double shift at Target; she indicates as much when she calls painting "not alienated labor, nor a commodity precisely").[38] And yet, Sillman's wanting to barf in the face of such distinctions doesn't seem to me solely a misunderstanding. I also hear in it a resistance to the certainty of classification, an insistence on the fact that, when we make art (as when we mother), we often don't know what we are doing. We can never really be sure if it's need, leisure, compulsion, transaction, freedom, or submission—likely because it can be all these things at once, or in turns. Sillman's own difficulty in describing it ("what are we doing? I can still only call it looking for this fragile thing that is awkwardness") serves as a happy reminder that, more often than not, we stay in the shit, as in Sillman's description of making art as "a way of churning the world, as your digestive system churns food." This churning need not be disciplined into emancipation, reparation, or obligation. It can be a sign that we are, or once were, alive.

2. The Ballad of Sexual Optimism

A STORY WE ARE TOLD — FREEDOM FROM + FREEDOM TO —
BRILLIANT AND BRAVE — DARK ROOMS — QUEER LESSONS —
ALWAYS AROUND POWER — MY BODY HAS NOTHING TO DO WITH
YOUR BODY — NO SUCH THING AS A TRUE STORY — THE MYTH OF
FREEDOM — ANOTHER NOW

A STORY WE ARE TOLD

I start with the opening of an essay titled "Undoing Sex: Against Sexual Optimism," published under the initials C. E. in 2012, five years before what will become known as the #MeToo movement began. I start here because although much of this essay's stance is nonnative to me, it expresses something of the current mood:

A story we are told:

You are on the brink of sexual freedom; it is here and at your disposal. It is asked only that you find it or make it. If before we were ugly, we may be beautiful now. . . . You were traumatized but you may recover, simply possess yourself. This is work to be done but it is good work. Work on your shame, perhaps even fight those that shame you, and it follows that you will be free. At the end of it you will be whole and you will have reclaimed your natural pleasure. The right of man

is to fuck and to orgasm. Feel free with your body to do these things because they are good. The feminists and the sexual liberationists knew this and this is why their movement is over. *Cosmo* and Oprah know this now and therefore everyone knows it. Sex is good and pleasure is powerful, and it is this proposition that will save us from our pain. . . .

If it was once radical and marginal to assert an essential, or simply available, goodness to sex, it is now central, institutional. Far from the domain of some radical set, it is at once an ideology of patriarchy and of the majority of its opponents, a disparate, heterogeneous collection of discourses united in common aim. It is the optimism that insistently, cruelly returns us to the work of fucking.

This optimism is what I position myself against.

If sexual freedom has become nothing more than the cruel insistence that we "return to the work of fucking"—and if this mandate appears to emanate from everyone from incels to Beyoncé to radical queers to "burgundy lipstick, bad highlights, second wave feminist has-beens" (to use a recent phrase of intergenerational feminist warfare)—I understand why it might feel vital to reject it. But C. E. is not just rejecting the pressure to be sexual. A stand against sexual optimism here means rejecting any link between sex and liberation, healing, goodness, empowerment, or politics. This stance does not care whether this optimism derives from feminist, queer, or straight/mainstream quarters. The imperative *It is necessary to learn how to desire sexual freedom* could spring from the pages of *Cosmo* or queer philosopher Paul Preciado (in this case, it's Preciado), and it would still be met with resistance or refusal.[1]

C. E.'s essay appeared in a small queer feminist journal, but the story it tells proliferates far and wide. Most versions offer pithy rewrites of decades of variegated feminist and queer history to conclude, as does Moira Donegan in a 2019 reconsideration of Andrea Dworkin, that "the end of the sex wars did not bring with it the more liberated world that feminists like [Ellen] Willis envisioned. Instead, the nuanced pro-sex position championed by Willis gave way to a more individualistic and

conciliatory approach to women's rights—one that focused not on the second wave's project of 'liberation' but on a simpler, less ambitious, and more market-friendly idea of 'empowerment.' In time, third-wave sex positivity became as strident and incurious in its promotion of all aspects of sexual culture as the anti-porn feminists were in their condemnation of sexual practices under patriarchy." In the *Nation*, journalist Joann Wypijewski echoes this argument, adding the cannibalizing force of capitalism to the mix: "What besides backlash happened to the sexual revolution? Capitalism bit down, absorbed the liberationist impulse, mass-produced the sex but everywhere devalued education, manifold reality; and liberationist forces were too besieged or internally at odds to withstand it. What remains is a simulacrum of freedom: at one end, the ultimate symbols of marketable feminine sexuality protesting objectification; at the other, legions of ordinary joes opening e-mails urging, 'Get bigger, last longer, become the beast she always wanted.'"[2]

There are many valid points to be made about backlash, assimilation, the limits of individual empowerment, and the commodification of liberatory impulse. Add to this the outpouring of stories from the #MeToo movement testifying to widespread, ongoing sexual harassment and violence, and it's clear why some might feel compelled to turn away from liberatory rhetoric, bear down on detailing the gruesomeness and pervasiveness of (hetero)sexual power relations, and rue the idiocy, however good-hearted, of those sex positives who thought they had changed things but, for a variety of reasons, failed to deliver.

But this, too, is a story, and one there are serious costs to investing in too thoroughly. Its most telling feature may not be its truth-value per se, but the disappointment it reveals, the sense of betrayal or frustration it expresses, the primal scream it sets loose about the injustices that still plague us, the paranoia it exhibits in not wanting to be caught holding on to the naive dream of "sexual freedom" peddled by those once foolish enough to have believed in it, be it for themselves or others. One could also read this disappointment as innate to the logic of liberation itself, insofar as undue faith in moments of liberation (especially when experienced by somebody else, or at some time prior) over ongoing practices

of freedom (which must be performed, however imperfectly, in the present and by us) inevitably produces the dashed hope that someone, somewhere, could have or should have enacted or ensured our liberation, but they fell short. Perhaps, the story goes, we are even worse off for their efforts, since now we must inhabit the ruins of their dreams, the dystopian letdown. This narrative can be almost religious in its mourning for a lost Eden, and its search for subjects to blame. (It can be especially painful when it emanates from feminist quarters, providing yet another opportunity to blame one's foremothers for not having been good enough, or to pity them for having been streamrolled by forces that proved too powerful to vanquish.)

If sexual optimism means the totalizing conviction that sex, desire, or pleasure is essentially good, essentially healing, essentially empowering, essentially political, essentially any one thing at all, I, too, reject it. There are major drawbacks to making an attachment to sex central to any politics, in part because of sex's arguably amoral nature, in part because anything posed as an imperative inevitably invites its rejection, and in part because sex varies in its meaning and importance to people, with that importance fluctuating over the course of a life. The claim for sex as an unequivocal good that we must have more of in our lives eventually crashes up, in one way or another, against queer theorist Leo Bersani's famous quip: "There is a big secret about sex: most people don't like it." Further, those who thought Reichian orgasmatrons or queer orgies were going to bring about the death of capitalism or fascism always misjudged the possible relationships between pleasure, desire, capital, and power. (Gilles Deleuze and Félix Guattari did not: "Sexuality is everywhere," they wrote. "The way a bureaucrat fondles his records, a judge administers justice, a businessman causes money to circulate; the way the bourgeoisie fucks the proletariat; and so on. . . . Flags, nations, armies, banks get a lot of people aroused.") And God knows capitalism has an astonishing power to "absorb the liberationist impulse," to affix an "Inc." as soon as the first leopards come to drink at the temple.

But that's just the thing—we know that already, and a hundred times over. Nothing stays avant-garde forever; you have to keep moving. If one were

to judge the possibility of emancipatory (or simply worthwhile) experience based on whether or not certain elements of it were ever co-opted, contaminated, backlashed, stripped of their radical import, marketed, bought and sold, one's entire life would pass by without any felt sense of discovery, invention, expansion, or escape. Mainstream, corporate-sponsored, mass-produced culture will always feel like a "simulacrum of freedom" or a "market-friendly view of 'empowerment'" because *it's a product*, and not, I would hazard, where most of our actual erotic lives are lived.

I believe that those who came prior did the work, and that their victories were real. (As Sylvia Rivera told the Latino Gay Men of New York Club in a speech about Stonewall, one year before her death from cirrhosis, at fifty, "We were determined that evening that we were going to be a liberated, free community, which we did acquire that. Actually, I'll change the 'we': *You* have acquired your liberation, your freedom, from that night. Myself, I've got shit, just like I had back then. But I still struggle, I still continue the struggle.") What they didn't do—because no one can—is bring about a world in which the burdens and blessings of practicing freedom have been lifted from the living. Contrary to the breezy proclamations made in op-eds and Twitter feeds across the land, our options are not a once-and-for-all happy and liberated sexuality vs. *The Handmaid's Tale.* One can and should always aspire to make conditions more conducive to practicing freedom, which is, as Foucault (and Arendt) says, a matter of *making space*, of increasing degrees of possibility and decreasing degrees of domination. This does not mean pitching toward a promised land in which all power relations and possibilities of suffering have vacated the field. This is especially true when it comes to sex, in that our sexual motivations are not always rooted in a quest for pleasure or well-being. Sex can also entail moving toward difficulty and wrestling with pain, as writer Katherine Angel has put it. Accepting that, rather than insisting that the most successful or ethical sex moves us incontrovertibly *away* from difficulty, pain, or even revulsion, can give us more space to accept our motley selves, sexual and otherwise.

Even under the best of circumstances, sexual experience does not—indeed cannot—transfer in any simple fashion from one generation or one body

to another. Each of us has our own particular body, mind, history, and soul to get to know, with all our particular kinks, confusions, traumas, aporias, legacies, orientations, sensitivities, abilities, and drives. We do not get to know these features in a single night, a year, or even a decade. Nor is whatever knowledge we gain likely to hold throughout the course of a life (or even a relationship, or a single encounter). None of us is born knowing how to manage our sexual drives and disappointments; none of us is born knowing how to contend with the various limitations, persecutions, and allowances of sexual freedom society has prepared for us prior to our arrival. We can work against noxious norms and laws that curtail sexual and reproductive freedom; we can create generations of people less likely to be injured, persecuted, or driven to self-harm on account of gender or sexuality; we can educate each other about mutuality and communication, the location of the clitoris, and difference beyond a gender binary; we can challenge ourselves to accept "benign sexual variation" (theorist Gayle Rubin's contention that no sexual behavior, so long as it is consensual, is intrinsically any better or worse than any other): these are a few good starts. But each sexual exchange—particularly ones performed with partners you haven't repeatedly had sex with, but even then—is going to resemble a certain wandering into the woods, because of the fundamental unknowability of ourselves and each other, and the open question of what any new interaction might summon.

This inchoateness is not just a by-product of sexual experience. It is part of what makes it worthwhile. Without it, we're in the ballpark of the Marxist joke Eve Sedgwick retells in "Paranoid Reading and Reparative Reading": "'Comes the revolution, Comrade, everyone gets to eat roast beef every day.' 'But Comrade, I don't like roast beef.' 'Comes the revolution, Comrade, you'll like roast beef.'" As Ahmed argues about happiness, a sexual liberation that aims to homogenize desire or pleasure, much less demand it, is no liberation at all. And here we might recall that Foucault's remark that "liberation paves the way for new power relationships, which must be controlled by practices of freedom," was made in relation to sex and sexuality, and against the idea that sexual liberation "give[s] rise to the happy human being imbued with a sexuality to which the subject could achieve a complete and satisfying relationship."

Back when Foucault was all the rage, there was an ongoing academic debate about whether his thinking about decentralized, omnipresent power relations—and of the way resistance cannot help but be intimately entwined with that which it resists—meant that we are less free than we might imagine and always will be. This question has been on a slow burn in my psyche for the past thirty years; likely it burns behind this entire project. It's only lately, however, that I've really been able to hear Foucault, or, rather, hear him anew, as when he explains:

> Power relations are possible only insofar as the subjects are free. If one of them were completely at the other's disposal and became his thing, an object on which he could wreak boundless and limitless violence, there wouldn't be any relations of power. Thus, in order for power relations to come into play, there must be at least a certain degree of freedom on both sides. . . . This means that in power relations there is necessarily the possibility of resistance because if there were no possibility of resistance (of violent resistance, flight, deception, strategies capable of reversing the situation), there would be no power relations at all. This being the general form, I refuse to reply to the question I am sometimes asked: "But if power is everywhere, there is no freedom." I answer that if there are relations of power in every social field, this is because there is freedom everywhere. Of course, states of domination do indeed exist. In a great many cases, power relations are fixed in such a way that they are perpetually asymmetrical and allow an extremely limited margin of freedom. . . . In such a situation of domination, all of these questions demand specific answers that take account of the kind and precise form of domination in question. But the claim that "you see power everywhere, thus there is no room for freedom" seems to me absolutely inadequate. The idea that power is a system of domination that controls everything and leaves no room for freedom cannot be attributed to me.

Just so: when it comes to sex, power may be circulating everywhere, but that does not mean that there is no freedom. Again, it's a matter of

degree—perpetually asymmetrical arrangements diminish the margin of freedom, which is why their rearrangement is so crucial. As we undertake this work, attempting to be precise about the nature, extent, and singularity of the power at hand really matters, as does recognizing the role that we ourselves play in acceding to or refusing its terms. In which case, attending to nuance in the so-called gray areas of sexual relations is not a sideshow primarily indulged in by astralized academics with their own degenerate asses to cover, or by "free thinking" reactionaries stumbling toward *Quillette*. It is critical to seeing, feeling, and acting on whatever freedom is also everywhere, and growing it.

FREEDOM FROM + FREEDOM TO

Critics of "sexual optimism" or "sex positivity" tend to argue that certain "freedoms to" (such as the freedom to seek and engage in a wide variety of sexual relations without undue regulation or punishment) have taken priority over certain "freedoms from" (such as freedom from harassment, discrimination, intimidation, coercion, violence, trafficking), and that it's time to right the balance. In a 2014 essay titled "'Freedom To' and 'Freedom From': A New Vision for Sex-Positive Politics," feminist scholar Breanne Fahs lays out this case, arguing that, while so-called positive and negative liberty need to occupy equal ground, or at least stay in balance, it's "positive liberty" (aka "sex positivity") that needs to be cut down to size, a task accomplished by bringing more "critical consciousness" to bear on "any vision of sexual liberation," and paying more attention "to the insidious aspects of disempowerment."

In her quest to reveal "the tenuous nature of sexual empowerment," Fahs gives several examples of the kinds of false consciousness that allegedly afflict uncritical, sex-positive women. Fahs asserts that women imagine "they have far more personal freedom when 'choosing' how to groom and present their bodies" than they actually do (because certain grooming choices incite shaming and ostracization). Experimenting with same-sex desire? It's been "appropriated by the patriarchal lens and converted into actions that women undertake to gain acceptance in certain set-

tings." Not even sex toys escape the tar of false consciousness: "When couples 'spice things up' with accessories, they often avoid the harder questions about their goals, desires, and relationship needs. . . . When women masturbate with sex toys, they learn *not* to touch their vaginas in the same way." Even the toys themselves are hopelessly complicit, as they "exist within a capitalistic framework [and] equate liberated sexuality with *purchasing power*, buying things, and (perhaps) distancing women from their bodies (not to mention that the labor politics around making such toys, where women's labor in developing countries is often exploited in the name of First World pleasure)."

Why sex toys made in developing countries are politically fouler than, say, the clothes you and I are wearing, the bottled water we're drinking, or the technologies we're each deploying to write or read these words is unclear to me, save by the logic that affixes more shame or blame to the contaminations of sex than to any other activity. Such a critique ends up a reboot of the age-old feminist sport of judging other people's sexual desires or behaviors as riven with faux liberation or political toxicity, as if the very fact that we exist in webs of relation (including those spun by a "capitalist framework," patriarchy, racist histories, or just plain old intimate, turbulent entanglement with one another), rather than as unencumbered, uncontaminated, "free" individuals, spoils our sexuality and sex lives. This approach can have the ghoulish effect of inflating the power of that which it opposes so thoroughly that no expression or experience, no matter how compelling, experimental, challenging, or enlivening, ever seems more than a flower delusionally placed into the barrel of a gun.

Such arguments also tend to rely on bringing critical consciousness to bear on *other people's* sexual behavior, desires, beliefs, or experience, while leaving the author's own an unexamined aporia. A 2019 essay by activist-journalist Natasha Lennard titled (unironically) "Policing Desire" provides a classic example of the genre: though Lennard begins by invoking the confessional mode, she quickly makes clear that her essay will focus on "a threesome I didn't have" and "certain porn that I don't watch," before going on to lambast the sexual proclivities of an ex-boyfriend as politically rotten. (As for the porn she did watch, she reports, "We'd watch

together, but more often to discuss it than to get off with each other."
Phew!) After reflecting on content that "would sometimes pop up (stolen)
as a tube site click in the ex's searches," she lobs a righteous imperative
directed at both him and her readers: "Don't speak to me about radical
sexual preferences if you claim to care about intersectional struggle but
search 'BDSM gang bang' on a tube site of stolen content, which directly
hurts workers, and which runs on a taxonomy of violently reductive tags."

I don't have a problem with thinking critically about sexual liberation,
or with discussing how free porn affects the income of sex workers. I
do have a problem with bringing critical consciousness to bear solely
or primarily on the sexual behavior or desires of others, which contin-
ues a long-standing tradition of focusing on how others are doing sex
(or sexual liberation) wrong, judging their behavior or desires as flawed,
delusional, or dangerous, while neglecting the far more crucial and chal-
lenging question of what we ourselves do or want to do, and how our
desires and behaviors square (or don't) with the political stances we as-
pire to elsewhere.

Not very many people want to discuss their sex lives in public, and who
could blame them? But training one's sights on those of others without
reciprocal vulnerability repeats a toxic dynamic that has long haunted
feminism. As proud pervert Patrick Califia said in the 1980s, address-
ing the women of WAP (Women Against Pornography) who were en-
gaged in a fierce campaign to blacklist "sex positives" like Califia (then
called Pat): "I would like all of you to explain, in print, how the way you
get off exemplifies the ideals of the women's movement. This may seem
like a very rude and personal question, but I'm very tired of being singled
out. . . . If equality is so important to feminists, surely we can become
equally vulnerable when we talk about sex. Let's all take our clothes off,
starting right now. . . . I am no more brainwashed or poisoned by the pa-
triarchy than you are."

For those of us who remain avidly on the lookout for candor and com-
plexity in women's stories about sex, the outpouring of #MeToo tales—
and here I'm talking about those of the "gray area" variety, not those

exposing rank assault, abuse, or harassment—has presented something of a conundrum. On the one hand, such tales have added to the archive of courageous women breaking silences about not-good-enough encounters or treatment. On the other, since these stories are, by mandate of the genre, focused on exposing and judging the sexual misbehavior of others, they contribute to the very large archive of sex writing in which female waywardness, transgression, desire, and agency must be scrubbed from the scene in order to ensure that the other party comes off as maximally gross. Since complainants know their accounts will be scrutinized down to every last comma and clause, there is strong motivation for this elision. The result has been a collection of tales of resistance that unwittingly continues our culture's silence concerning—indeed, its profound, punishing distaste for—expressions of female complexity and desire.

Breaking one silence without continually breaking the other leaves significant problems intact. Journalist Peggy Orenstein discovered this while writing her book *Girls and Sex: Navigating the New Complicated Landscape*; she says all her research "kept coming back to this idea that we are completely silent around girls' sexual entitlement and girls' pleasure. And one of the things that I really took away from this research is the absolute importance of not just talking about them as victims or not just talking about them as these new aggressors but really surfacing these ideas of talking clearly and honestly to girls about their own desires and their own pleasures. And we still just really don't do that." Part of why we don't do that is that, as columnist Michelle Goldberg has put it, "one socially acceptable way in which women can talk about sexual discomfort . . . is to use the language of violence and trauma. Thus both terms are expanding." (In her scathing feminist manifesto *King Kong Theory*, French writer and filmmaker Virginie Despentes addresses the issue in starker terms: "In Judeo-Christian morality, it is much better to be taken by force than considered a bitch in heat.")

I hear C. E. and others—including many of my students—when they say that the pressure they've felt to be "a bitch in heat" (or what novelist Gillian Flynn calls a "Cool Girl": "a hot, brilliant, funny woman who adores football, poker, dirty jokes, and burping, who plays video games,

drinks cheap beer, loves threesomes and anal sex, and jams hot dogs and hamburgers into her mouth like she's hosting the world's biggest culinary gang bang while somehow maintaining a size 2, because Cool Girls are above all hot")[3] rivals or complements the pressure they have felt not to speak up about sexual discomfort or displeasure. Given how much victim blaming still goes on in the courts of law and public opinion, not to mention the intense opprobrium that greets women whether they acknowledge their complex desires or disavow them, I understand the disinclination to undertake more open-ended exploration, especially in public forums. But since it's the *doxa* of rape discourse that holds that "one cannot be a sexual subject and also innocent," as Jennifer Doyle has put it, *somewhere* we have to be able to violate this doxa's terms. *Somewhere* we have to be willing to be sexual subjects, which means learning how to inhabit and articulate sexual experience outside the dyad of wrongdoer and wronged.

For such reasons, I couldn't care less about Lennard's ex's searches. I'm far more interested in what she was thinking and feeling while watching all the porn she now strains to distance herself from. I would like to know more about the head that Grace says comedian Aziz Ansari gave her on the kitchen counter, rather than be invited to scoff at Ansari's penchant for oral-digital play (a penchant I happen to share, though it's hard to say if his Claw would be mine). For if we truly aspire to live by Rubin's concept of benign sexual variation (and, let's be honest, a lot of people, including a lot of feminists, don't), we must reckon with the fact that our sexual liberation or self-knowledge does not magically arrive via the kink shaming of others, even when their behavior apes things they've seen in porn, evidences flawed labor politics, stands afield from that which turns us on, or reaffirms heteronormative clichés. Lodging complaints about serious misbehavior or unprofessional conduct is often necessary and, under certain circumstances, heroic. (Sadly, it can also become routine: over the course of writing this book alone, I've voiced complaints to three "professionals": a dentist who, while working on my mouth, described poking holes in his wife's diaphragm; a physical therapist who, ostensibly to get me to activate a certain muscle, instructed me to imagine getting

into an elevator with a really hot guy I didn't want to fart in front of; and an accountant who, when I asked if I could go behind his desk to point out a number, said, "Sure, but only if you rub your boobs in my face"). Yet even when our complaints are justified, it's worth staying alert to the ways in which complaint can become a default posture, a negative feedback loop, wherein we cultivate the habit of shoring up our own virtue or worth by distancing ourselves from the sorry, sordid desires and defects we diagnose in others. We need to be able to lodge our complaints without overvaluing complaint as a habit of mind, especially as such a habit can make it harder for us to forgive our own mistakes, or deepen our self-understanding.[4]

Beyond assertions of innocence and impotence, beyond passive-aggressive perseveration on what you didn't like ("I didn't get to choose and I prefer red, but it was white wine," says Grace, in her account of her night with Ansari) lies an ocean, the ocean of what you *do* like, what you *do* want, what you are able to ask for, what you need help in asking for, what you don't know you want until you try it, what you thought you wanted but it turns out you don't (or at least not tonight), and so on. We must learn to swim in this ocean if we don't want to simmer endlessly in resentment, frustration, and complaint. (I say this as someone who has done plenty of such simmering.) If and when someone's desires reveal themselves to be incompatible with ours, of course they can seem repulsive or wrongheaded. But repeatedly placing ourselves in the position of rejecting or passing judgment on them can become its own form of exercising shame and power, not to mention of insulating ourselves from the risks that come with naming our own desires, or even admitting *that* we desire. And there really are risks, insofar as owning our lust, kinks, vulnerabilities, and choices means opening them up to being judged by others—as laden with false consciousness, politically imperfect, unshared or unwelcome, asking for it, self-destructive, weird, vanilla, "TMI," perhaps even as prosecutable.

To get there, we need to allow ourselves to be unafraid of the contaminations of ambivalence, and unafraid of experimenting with describing—indeed, experiencing—sexual encounters in frames beyond that of sin,

abuse, violation, or trauma. As porn performer and host of the podcast *Against Everything* Conner Habib has put it, "Sex holds meaning for people. Talking about it as merely a site of danger, or an urge some people can't keep under control, or power, or an afterthought, or an accoutrement to life, robs us of so much." One such frame would cast sex as a *scene of learning*. "Sexual promiscuity brings its own forms of intelligence; too few people get to know the truth of this," writes Doyle. We don't need to advocate for promiscuity per se to note that recasting the scene of sex as a potential site of learning, of *intelligence gathering*, could be a worthwhile addition to—and perhaps worthwhile displacement of—the more socially palatable ways of describing sex and one's role in it. Without scenes of learning, we have no chance of figuring out what we want (or what we might want to get away from).

I agree with Fahs that "true liberation and freedom must include *both* the freedom *to* do what we want to do *AND* the freedom *from* oppressive structures and demands." But I will never share in' the desire to cut "freedom to" down to size, for the following reason: experimenting with a robust *freedom to* has the power to diminish the deprivations and degradations that fall under the rubric *freedom from*. The "defiant insistence on acting as if one is already free" produces a different reality than does perseverating on the "insidious aspects of our disempowerment"; concentrating solely on the latter does not deliver us unto the former. Staying alive to "freedom to" will not and cannot annihilate one's exposure to misbehavior, shaming, or danger; no measure of empowerment will extinguish the awfulness of the world, nor should it delimit our protest of it. But it does have the power to fundamentally rearrange our reactions, apertures, capacities, and aspirations, not to mention our repertoire of responses to both wanted and unwanted sexual activity, as well as activity that falls somewhere in between (as, let's face it, much sex, even with a regular partner, does). It can also change what one attracts—not, again, in the sense that one could ever completely repel the unwanted, but in the sense that, without it, one has little to no chance of creating the conditions of possibility to attract (or bear) what one wants, or at least what one is open to trying.

BRILLIANT AND BRAVE

Faced with the ebullient pessimism of C. E.'s essay, it can be tempting for those of us over, say, forty, to judge the current moment against the idealized circumstances of our own coming of age, and find it less fun, less free. Listen, for example, to provocateur Laura Kipnis, in *Unwanted Advances: Sexual Paranoia Comes to Campus*:

> For my generation, coming of age in the all-too-brief inter-regnum after the sexual revolution and before AIDS turned sex into a crime scene replete with perpetrators and victims—back when sex, even when not so great or when people got their feelings hurt, fell under the category of life experience—words like *pleasure* and *liberation* got tossed around a lot. But campus culture has moved on and now the metaphors veer to-ward the extractive rather than the additive—sex takes some-thing *away* from you, at least if you're a woman: your safety, your choices, your future. It's contaminating: you can catch trauma, which, like a virus, never goes away. You don't hear much talk about liberation anymore; the slogans are all about sexual assault and other encroachments: "Stop Rape Culture," "No Means No," "Control Yourselves, Not Women."

Insofar as my own personal and political proclivities have always drawn me away from what's sometimes called carceral or governance femi-nism, and toward concepts (and experiences) of *pleasure, liberation, life experience*, and *contamination*, I'm with Kipnis. (I'm definitely not im-mune to the "lock 'em up" mentality, but when it rears up in me, I con-sider it a symptom, not a solution.) Even so, it's not hard to see that Kipnis, too, is telling a story, one that gleefully embraces a totalizing script of intergenerational warfare, in which WE were brave, impres-sive adults seeking (and finding) pleasure and liberation, whereas YOU are pitiable, cowardly children obsessed with safety and trauma. I have a hard time seeing how this script serves anyone beyond the person speaking it. Belittling a generation of impassioned activists and their concerns because they conflict with one's own history or sensibility

does not seem to me particularly wise; trying to shame people into sexual pleasure or liberation is probably even less effective than trying to shame them out of it.

My own coming of age, which took place roughly twenty years after Kipnis's, may appear in my memory as one long, pangendered bacchanalia, but it was widely derided at the time as stricken with the same moralism, negativity, and policing that Kipnis here rues. We heard the critique of our PC-ness loud and clear, and certainly there was dissent within the ranks (Michelle Tea's observation that she has "never seen a quadrant of people so ready to tear each other's faces off as queers," from her essay "How Not to be a Queer Douchebag," held as true then as it does now). But we didn't experience our moment as the phantasm of political correctness as concocted by the right; few people on the inside of their lives and skin do. (No doubt the same is true today.) There were definitely more fisting seminars, professor/student affairs, and BDSM clubs than there were Title IX complaints, mattresses carried for a semester, or ace communities. But I myself ran consent workshops as a sexual assault educator and attended my share of Take Back the Night rallies before deciding that my contributions would be of greater value elsewhere.

More formative for me, especially in retrospect, was the fact that this time was completely tied up with the AIDS crisis. It was through AIDS that I absorbed—through the work of ACT UP, Queer Nation, Lesbian Avengers, Sex Panic!, and so on, as well as through the work of artists such as Marlon Riggs, Karen Finley, David Wojnarowicz, Vaginal Davis, and Cookie Mueller—how one might maintain a voracious, unapologetic, open attitude toward sex and desire while contending with the contaminations of life-threatening disease, sexual violence, governmental malice, feminist and queer infighting, one's own unconscious and conscious desires, and the perils of making choices that don't always feel like choices, but remain choices nonetheless.[5]

Sexual assault and unwanted sexual interaction were omnipresent issues, of course. But for me and many of my peers, the overriding fear was HIV

infection, and had been as long as we'd been sexual beings. (As Brian Blanchfield puts it in "On Frottage," an exquisite essay about coming of age during this time, "I never had a sex life without having a status.") Visitors to my high school in San Francisco in the 1980s didn't come to our assemblies to talk about consent; they came covered in Kaposi sarcoma to tell us the facts known and unknown about HIV. Later on, slipups meant waiting *six months* to get a test at the clinic, then making a follow-up appointment that you may or may not have had the wherewithal to show up for, given that a positive test was a death sentence. And these are just the milquetoast memories of someone never considered "high risk," and who did essentially no real time in the trenches, compared to so many of my peers, mentors, and deceased elders.

Teaching college for the past twenty years has taught me that the AIDS crisis—at least as it was before antiretrovirals—has disappeared almost completely for those born after its peak. This is in many ways a natural, arguably welcome effect of the passage of time and medical treatment. But it has also had a disorienting effect on much of the intergenerational conversation going on about sex positivity, pleasure, and danger, a conversation that makes far less sense when the influence AIDS had—indeed, the formative crater it made—in so many of our lives has fallen out of the picture.

For many who came up in the 1980s and '90s, forging a commitment to sex positivity was not about downgrading the feminist or queer liberatory missions of the '60s and '70s to a tinny, neoliberal version of empowerment. It was about insisting, in the face of viciously bigoted moralists who didn't care if you lived or died (many preferred that you died), that you had every right to your life force and sexual expression, even when the culture was telling you that your desire was a death warrant, and that if it killed you, you deserved it. Rather than sunshine and rainbows (or cheap beer, threesomes, and hot dogs), the word "positive" evoked positive HIV status (as in *POZ* magazine); to be sex positive in this climate meant talking condoms instead of quarantine. As Amber Hollibaugh, a self-described lesbian sex radical who founded the Lesbian AIDS Project (LAP) of the Gay Men's Health Crisis (GMHC) in the

1990s, described this time: "While being made into sexual pariahs, gay men and drag queens and dykes and queer men of color and their sisters and brothers, and other communities of sex and racial justice warriors, spoke up and spoke out *for sex*, struggling to claim the right to desire even in the face of an epidemic and a virus transmitted through sex. We refused to be shamed or disowned because of our desires or our antibody status. This was a truly terrifying time. But through it all—although we were frequently wrong—we were also brilliant, and we were brave."

Such a stance conflicted mightily with the intense sexual moralism of certain feminist groups active in the sex wars (such as WAP), and led many feminists (such as Hollibaugh) to replace a reflexive commitment to gender solidarity with queer fellowship, which here meant fellowship with "sexual pariahs, gay men and drag queens and dykes and queer men of color and their sisters and brothers, and other communities of sex and racial justice warriors." (Speaking about what she learned from the sexual openness of gay men during this time—an openness she found depressingly lacking in certain feminist circles—Hollibaugh says, "They didn't decide something was bad before they tasted it.")[6] The resulting exchange allowed many women—me included—to stake claims on horniness and perviness in terms that feminism had enabled, but that queer culture made differently possible. One could argue that, given the brutal legacies of heterosexuality, sex positivity was (or is) easier for queers to access than straight folks. But one thing I've learned from floating between realms is that most sexual lessons are eminently transferable; the concept of benign sexual variation does not apply to queers only (even "queerness" may not apply to queers only).

In the face of this history, Donegan's charge that "third wave sex positivity" became "strident and incurious in its promotion of all aspects of sexual culture" strikes me as something of a straw man. Who are or were all these uncritical, incurious, happy-go-lucky sex positives anyway, all these women and/or queers who didn't adequately understand the danger or damage that sex can entail? Every "sex positive" figure from that time

on my bookshelf—not to mention in my life—has had deep exposure to sexual gnarliness: Annie Sprinkle. Virginie Despentes. Joan Nestle. Amber Hollibaugh. Dorothy Allison. David Wojnarowicz. Samuel R. Delany. Essex Hemphill. Marlon Riggs. Patrick Califia. Leslie Feinberg. Nayland Blake. Gayle Rubin. Michel Foucault. Bruce Benderson. Hervé Guibert. Sylvia Rivera. Eileen Myles. Gregg Bordowitz. Michelle Tea. The list could go on and on. Most of these people are (or were) intimately familiar with sexual violence, sex work, or sexual persecution; several died of AIDS, lost legions of friends to AIDS, or worked their asses off to help the dying. To presume their legacy dissolved into a fizzled-out, market-friendly version of empowerment is a startling impoverishment of what it still has to offer.

We may all be inclined to privilege our own salad days over those of the poor souls struggling to figure things out after us. But the thing is, I don't really privilege my salad days. Due to AIDS, much of that time was fearful and awful. I do, however, have a tremendous respect for the lessons it imparted. One of those lessons was summarized for me by Dorothy Allison, who once said in characteristically tough terms, "All my life I have known that everything I wanted had a cost and that I could not always get away without harm." Allison came by this knowledge by means of an upbringing that was in many ways the polar opposite of mine, in terms of privilege and hardship. Yet her fortitude spoke to me then, and speaks to me still. No one wants the price of desire to be a fatal disease or a life-shattering assault. Expanding the space for the practice of freedom means working to diminish the likelihood of such things for ourselves and for others. But we can do this work without fantasizing a world in which our safety is guaranteed, or one in which the success of an encounter is judged by whether we got away unmarked.

In a moving essay about seroconverting after years of working as an HIV activist, art historian Douglas Crimp underscores this point:

> The mainstream media and conservative gay journalists alike treat sex as a simple behavior, obedient to will and reason, as

if it were no different from, say, driving a car. When driving, there are rules and regulations and courtesies that any responsible person will follow in order to remain safe and help ensure the safety of others on the road. Although there are many uncivilized drivers, to be a civilized driver does not require overcoming insurmountable psychic conflict. Sex, however, represents nothing but conflict in relation to civilizing impulses.

Why, then, do gay men have unsafe sex, and how do we talk to the media about it? . . .

I have a simple answer: We are human. . . .

I seroconverted because I, too, am human. And no, no one is safe, not you, your boyfriend, or any of your negative friends. Because you and they are human too. . . . To accept my humanity is to accept my frailty. Or to put it differently, it is to accept that I have an unconscious. It is to accept that everything I experienced, everything I knew, everything I understood could not guarantee my safety.

This passage underscores one of the difficulties in blithely telling women that they need to get clearer about knowing and expressing what they want. They, too (newsflash), are human; they, too, have an unconscious. But, thankfully, just because you can't know everything doesn't mean you can't know anything. Sometimes the psychic conflict sex produces feels insurmountable; other times, not so much. Doubtless there are legions out there having regular or intermittent monogamous sex (I am among them) who long ago ceased to experience it as inherently in conflict with "our civilizing impulses" (even if the conflict is more at bay than evaporated). Yet any activity that by its very nature engages unpredictability, interpenetration, physical or emotional nakedness will always pose some sort of risk; a goal of obliterating that risk can unwittingly (or intentionally) grow a "pervasive sense of vulnerability [that] yields a constant state of crisis—the building of one set of walls, and then another," as Doyle puts it. Given that our vulnerability isn't going anywhere, we benefit from cultivating a relationship to it that doesn't demand the building of walls or living in a constant state of crisis.

DARK ROOMS

In looking back on my own youthful experience of (straight, for the moment) desire, I recognize in it a certain dynamic I've since seen echoed in the behavior of countless other girls and women: many girls are *deeply* compelled by their desires, but since they don't have much practice in articulating them, often not even to themselves, they instead become expert at putting themselves in situations in which "trouble" (aka sexual activity) might occur, while agilely blurring out the question of what they might be looking for (alcohol often abets this project).

Keeping one's desires amorphous to both oneself and others is not without its efficacy, or even its pleasures. It allows for a certain fissured sovereignty, one that lessens the burden of always having to keep one's guard up, of always having to be utterly explicit about what one desires, or even having to know if, not to mention what, one desires. It allows for the pleasure of *not knowing*, a noninstrumentalized openness to experience and to others. "Emergent desire" some might call it: the exact opposite of heading out on the town with a scorecard. This openness can even have a kind of magic to it—the magic of attracting rather than aiming. As I describe it, I recognize it as one of my favorite feelings.

And yet, desire consistently purchased at the price of plausible deniability comes at a cost, both to oneself, and to the nature of the relationships or encounters it generates. Unlike cruising, wherein one acknowledges that one is looking for sex in some form, insisting that one is asking for or seeking *nothing* reifies the tiresome sexist construct that sex is something boys seek and girls must either fend off or submit to, and continues the culture's dirty work of rendering female desire imperceptible, irrelevant, or impugning. Unexamined, it can turn into a kind of default erotic posture or identity, with elements of quicksand. There is also the problem that, as Carol Gilligan's work with adolescent girls suggests, girls learn to say "I don't know" about their desires when they fear that what they have to say isn't what boys or men want to hear, sensing that, in certain encounters, their outspokenness might be precisely what puts them in danger;[7] distinguishing between an erotics of passivity and a

fear of assertion can be a difficult charge. Keeping one's desires amorphous can also create the conditions for perpetual letdown, if and when the nitty-gritty nastiness of sex conflicts with the pleasures of floating in a cloud of open-ended possibility (leading to the old "whatever I wanted, it wasn't *that*" feeling). Further, intentionally putting oneself in unpredictable situations in a world full of gnarly people comes with certain risks, as writer Chelsea Hodson explores in an autobiographical essay titled "Pity the Animal": "The truth is I stayed at the party waiting for something to happen. Everyone at the party left, and still, nothing had happened. He wasn't a stranger—I knew he was a bad man, I'd known that for a long time. That's why I stayed. I spent so much of my youth waiting for something to happen. Unsupervised, I had my choice of dark rooms. I knew which rooms were bad and I entered them anyway. It was a sort of power." The "bad man" then forces himself on Hodson (her words), an act she neither blames herself for nor uses as a mandate to erase her own decision to enter the "bad room."

Back in 1992, Joan Nestle wrote in "The Femme Question": "One of the most deeply held opinions in feminism is that women should be autonomous and self-directed in defining their sexual desire, yet when a woman says, 'This is my desire,' feminists rush in to say, 'No, no, it is the prick in your head; women should not desire that act.' But we do not yet know enough at all about what women—any women—desire." I love this remark, not because it rehashes the (always rhetorical, exasperated, and homogenizing to the point of nonsensical) question "What do women want?" but because it reminds us that even we ourselves don't always know what we want, or if there even exists something called "desire" that can be analyzed as separable from the situations and sensations that give it rise.[8] At the same time, Nestle's "we don't yet know enough" suggests that there's still more to be revealed, that we benefit from ongoing wondering and telling.

Figuring out how to talk about straight erotic desire without worrying that something politically wicked is afoot has long been a vexing problem for feminism. Legal scholar Janet Halley zeroes in on this problem in her scathing critique of cultural feminism, which, as she says, has

long demonstrated a "pervasive lack of interest in women's erotic yearning for men and a foreclosure of theoretical space for an affirmation of men's erotic yearning for *them*. . . . There seems to be no urgent need [in cultural feminism] to understand *women's* version of what Leo Bersani, writing on behalf of *gay men*, has called '[gay male] love of the cock.' . . . It's just missing." I, too, have noted this omission. On the level of literature, it's not that writing of this nature doesn't exist. It's more that it rarely finds an easy home in a feminist canon, especially a white feminist canon, wherein it tends to get treated as "brainwash[ing] or poison[ing] by the patriarchy." Listen, for example, to legal scholar Mary Anne Franks's outraged response to Halley's comments: "What Halley seems to be after is not mere reinstatement of patriarchy, but patriarchy with a smile—with a stamp of (erotic) approval from women." Frank's collapse of "love of cock" into "reinstatement of patriarchy" is a classic deprivation, one that elides the fact that millions of women presumably negotiate every day a world in which they desire and enjoy cock and masculinity—both in cis men and untethered from them—while working against patriarchy's grip.

The terms of the #MeToo era at times seem to suggest that the principal way out of heterosexual sexual malaise is role reversal—that women should feel emboldened to make first moves, rather than waiting for men to be the active party (this doesn't solve the problem of the erotics of passivity, or that an "unwanted advance" cannot, as Kipnis points out, be known to be unwanted until it's made, but it does have the virtue of redistributing responsibility, potential humiliation, and agency). This same logic encourages women to be more active, vocal partners in bed, rather than thinking that stoically tolerating something uncomfortable, unpleasurable, or unwanted is the price of the game. I support such changes. But it might be paradoxically empowering for women to remember that, as Lauren Berlant and Lee Edelman put it, in sex we often "*desire* to be nonsovereign, and sometimes not-autonomous," and that such desires aren't always or only a sign of gender oppression. They can also indicate the presence of a different kind of freedom drive—one that longs to be self-forgetful, incautious, overwhelmed. (When coagulated into an identity, some might call it "bottoming.") How to honor and allow for this drive and its erotics in a world full of crappy gendered

dynamics and inconsiderate people is turbulent business. One starts by recognizing it.

Nestle's *The Persistent Desire: A Femme-Butch Reader* is again instructive here, insofar as it showcases how femmes often take certain aspects of the default sexuality and gender with which most women get saddled, and reclaim them as self-conscious, performative identities, reminding us that (a) such behaviors or proclivities need not (indeed, they do not) suit all women, though they may provide powerful erotic charge for some, and (b) if embraced with self-awareness, they need not be experienced as capitulation to a gender/sex regulatory system. For example, "butchy femme" Mykel Johnson describes her femme-ness as meaning that "my desire gets sparked . . . by feeling someone desiring me, yielding to her pleasure in making love to me." Every time I read a critique of straight women getting off on being desired, or yielding to someone else's pleasure, I think about all the bold, articulate femmes who have been putting words to such pleasures for decades, and I think: is it really that these desires are inherently rotten, or is it just that we don't want women to feel obliged to put them at the center of their sexuality in a compulsory fashion?

When Nestle says "we do not yet know enough at all about what women—any women—desire," it might seem that, if and when we finally hear it, the earth will crack open at the sound of the heretofore unexpressed roar. But there also exists the real possibility that carnal desire of all kinds has more in common with itself than not—that, despite our revolutionary hopes, the lust languages of women and queers don't stand a world apart from all others. One of the side effects of evacuating female lust from cultural discourse is that its language gets continually ceded to men, attributing everything from "objectification" to horniness to promiscuity to them, as if they alone owned what it meant to look upon or approach other bodies with appetite and appreciation. This isn't to say, "There's nothing to see here, folks, go back to *Portnoy's Complaint* and *Hustler,* and you'll know everything you need to know." I wouldn't have spent much of my life seeking out sexually explicit work by women and queers were that the case. In fact, it may be just the opposite: that a lot

of what we treat as heterosexuality is actually just desire; straight people and culture don't own it.

If and when, for example, we attribute all coarse language, all perseveration on individual body parts (yes, even "unattached" from the whole), all desires to consume, top, penetrate, or fetishize to cis men, we stay deaf to or stand in judgment on real aspects of female, lesbian, and queer expressions of desire, which do not always find expression in a gender-abolished, power-free, tentacular stew. (This isn't news to gay men, but can remain somewhat verboten in "not-men" circles.) As Cherríe Moraga once said in conversation with Hollibaugh, Moraga didn't come out as gay because "men were really fuckers" but because "I wanted women so bad, I was gonna die if I didn't get me one soon!" Hollibaugh responds by wondering how dykes "who wanted tits" were supposed to fit into a sexual paradigm that treated ravenous desire for women's body parts as inherently foul. This might not be what some people want to hear, but so it goes, when unapologetic women speak candidly to one another.

Even as I write the words "pleasure" and "desire," and even as I argue for their resurgence in women's narration (and experience) of their sexual lives, I have to admit the terms can get on my nerves, if only because they connote a cheerfulness that doesn't feel entirely commensurate with sexual reality. As Berardi has written, "Those who glorify desire as if it was a good force did not get the point. Desire is not a force, but a field. Moreover it is not positive at all, it can actually be cruel, evil, convoluted, self-harming, elusive, destructive and deadly."

As Hodson's account makes clear, getting to know our desires (or acting on them) doesn't necessarily mean that we will discover their essential goodness (or that of others'). It may, in fact, entail contending with the fact that we sometimes desire (or partially desire, or desire in fantasy) that which is dangerous, if not outright destructive. Since acting on such desires can bring shame or pain (*why did I do that to myself, or why did that happen to me, again?*), it can be easier to disavow or displace the desire altogether, rather than to say (as many queers have helped people say), *Sometimes I desire sex that feels self-shattering, self-obliterating.*

Sometimes I desire unsafe sex, up to and including courting HIV infection. Sometimes I desire sex that replicates my worst traumas. Sometimes I desire sex with someone who repulses, even frightens, me. Sometimes I desire sex with someone who is clearly, for a million reasons, the wrong person to have sex with. Sometimes I desire to cause another pain. Sometimes I desire pain. Sometimes I desire sex until I have it, then feel disgusted by it. Sometimes I want to relinquish the burden of my agency, come what may. One might then contend with such feelings by recalling Rubin's mantra: "Fantasies are hungrier than bodies." If your body is still hungry, you can stack up the pros and cons of acting on your fantasies, and take it from there. If acting on them—however unconsciously—brings you repeatedly to pain or regret, you can then investigate their roots, and see if understanding their etiology opens them, or you, to change.

Faced with such challenges, C. E. writes, *"Trying to heal from trauma managed to fuck me up worse because I started to ask 'what do I want? What do I really want out of sex?' and diving down in search of my damaged sex drive I couldn't find anything, really. . . . How boring to expect that at the bottom of everything, if we only push harder, there will be something good. All Sade got was a lot of corpses who never had what he wanted."* What if we don't presume, however, that there is any bottom to our desire, that it doesn't lie in a black box at the bottom of the sea? What if there isn't any single, foreseeable thing we want from sex, no Truth to be found? What if learning to notice our shifting drives, identities, curiosities, disinterests, or aversions, be it over the course of an encounter or a lifetime, is our truer calling? What if there is no one truth about our sexual selves (such as it's submissive, stone, sadistic, straight, broken, healed)? Doesn't most sex fall somewhere between manna from heaven and piles of corpses? Doesn't desire itself quicken, dissipate, die, shift course, and reawaken, often in inscrutable ways?

It may also help to remember that "pleasure" does not just mean "orgasm," or the kind of sex that brings, like, a smile to your face. Given the fact that straight girls are, statistically speaking, still not receiving anywhere near their fair share of orgasms, I hesitate to defend sexual life without them. ("I am so sorry for sounding like *Cosmopolitan* right

now," writes Michelle Tea after foraying into straight sex, "but I was shocked to learn all the complaints straight women have had about men forever are *true*. They really *do* want to fuck without condoms! It really *is* all about their penises! They really *do* come way too fast and then guess what—you're done! *Boring!*") But it's worth remembering that pleasure is a very broad category, and that there exist whole realms of desirable and satisfying sexual experience that don't have a simple or predictably achieved aim. I'm thinking in part of stone butches, many of whom derive pleasure from giving pleasure to their femme partners, rather than allowing themselves to be touched or pleasured directly; of deeply active erotic lives lived primarily through voyeurism or other forms of distance; of a beautiful male lover I once had who never really came and never really cared; of folks with disabilities who have had cause to redefine what sexual gratification means to them and their partners; and so much more. I'm also thinking of Catherine Millet's sexual autobiography, *The Sexual Life of Catherine M.*, in which Millet writes—after 186 pages of meticulously recounted, sought-after sexual exploits: "I wouldn't be exaggerating if I said that, until I was about 35, I had not imagined that my own pleasure could be the aim of a sexual encounter."

Surely some will jump (indeed, many have jumped) to pity Millet for her antifeminist false consciousness (allegedly confirmed by her signing of the notorious French anti–#MeToo letter, the one signed by actor Catherine Deneuve).[9] Nonetheless, Millet's elegant, remarkably frank sexual autobiography makes an enormous amount of space for heretofore underarticulated aspects of sex, including desires that don't reduce to "getting off." I particularly appreciate her modeling of a nonnegative, nonsubmissive female relationship to radical openness, as in: "I am not docile because I like submission . . . but out of indifference to the uses to which we put our bodies." In a world that so often presumes that everyone cares so much, or cares in the same ways, about the use, meaning, and big-dealness of our bodies and their various parts, Millet's fundamental sexual agnosticism has always struck me as a huge, vitalizing relief.

One of my favorite moments in *The Sexual Life of Catherine M.* is when Millet and her lover Eric become furious at a "narrow-minded idiot"

they meet in a bar who attempts to shame Millet for her promiscuity (she is a group sex aficionado) by saying the bar was "beginning to 'smell of burned rubber.'" There really aren't enough moments, in literature or in life, in which women—with the support of a male ally, no less—align against those who would shame them for their alleged sluttiness. For those out there who would complain that the deck is still punitively stacked against girls, women, and queers who affirm their right to pleasure or desire, I feel you. Nearly every female or queer friend of mine who gave themselves room to explore their desires while growing up was slut-shamed or bullied; I've got a kid in high school and one en route, so I know the scene (which at times seems miraculously improved; at others, depressingly unchanged). The transgressions of sluttiness also signify altogether differently for white women, whose contrived chasteness underwrites an entire racial order, than for those who have been made to suffer inequitable sexualization, violation, and punishment.[10]

And yet, if you want a reality in which it's the "narrow-minded idiots" who seem like the outliers and intruders, you can find it and live it. Obviously this is harder—by which I mean *much harder*—in some circumstances rather than others. But nearly every queer I know who was born into bigotry and bullying and eventually found their people has done it. One needs role models and friends and partners, which takes time, sometimes a lot of time. I would be nowhere today without the hilarious, bawdy, shit-talking, shameless cast of characters who have buoyed me along for many years, some of them since high school. Their example of how to make swift hash of other people's narrow-mindedness and moralism, how to locate, build, and inhabit worlds that do more than resist or protest the mythical One World, as David Wojnarowicz used to call the doxa, has sustained and changed me, forever altering what I have been able to feel and know.

Wojnarowicz was one of these people for me, though I never met him; so was Eileen Myles, whom I first saw read when I was around eighteen, and whom I basically followed from that night onward. I can still see the little green Semiotext(e) paperback of Myles's 1991 collection, *Not Me*, lying on a table at St. Mark's Books, can still see myself picking it

up for the first time, not knowing how much "freedom to" was about to rush into my world. I delighted in lines such as: "I remember / you handing me the most beautiful / red plate of pasta. It was like your cunt / on a plate," or "I need / whiskey sex / and I get / it." Big cunty plates of pasta! Whiskey sex you could want and get! Then, in 1994 came "Robin," in Myles's *Chelsea Girls*: "I must fuck Robin. That was my job. She had the largest . . . cunt, vagina I have ever stuck my finger in. It was big red and needy. . . . I've always received complaints that I was rough but I felt like I could have been shoving a stick up this woman, a branch. . . . Such a woman, I have never met such a horny animal nor have I ever so distinctly serviced a woman before. Do you want my fist inside you. Anything[,] she shrieked, anything." Just as Millet wears her burned rubber as a badge, Myles here turns the big, red, needy vagina into an icon of sexiness and desirability. Whether or not one shared Myles's exact desires wasn't the point. The point was their frank testimony to sources of hotness and aliveness elsewhere inaudible. There were others, of course. But for me, it was "Robin" that let me know there would be— there could be—no going back.[11]

For much of my early adulthood, I wanted whiskey sex and got it, and was (mostly) glad that I did. I am equally glad that I eventually got sober. One of the gifts of sobriety is that it demands we take responsibility for all the drinks we've taken, no matter our gender or sexuality, no matter our life situation. This doesn't mean one is responsible for the bad actions others might take while one is intoxicated. It just means that it is of no ultimate benefit to us to off-load our decisions about substances onto others (as in, "he got me drunk"). And here I agree with Kipnis, who thinks we should talk more openly and less fearfully about alcohol and sex—that we should acknowledge that heavy drinking, especially when performed with the aim of lessening if not obliterating self-coherence, may be a symptom of "uneven progress toward emancipation for women (including ambivalences about responsibility for our own freedom)."

Ambivalence about responsibility for our own freedom does not mean we are stupid, self-destructive, incapable, or desirous of harm. It means

we are human. And part of being human is not always wanting every moment of our lives to be a step on a long march toward emancipation and enlightenment. It also means contending with desires to circle or enter dark rooms.

Alcoholic or no, most who drink do so in part to ease the terrible burden of our volition; we drink in part because it can be delightful and exciting as much as scary and awful to "let things happen," to find yourself in places and with people your sober self might not have sought, or might have outright rejected. This can be especially so for those of us socialized to be fearful. I was a pretty fearful kid, raised in the shadow of the sexualized murder of my aunt, and the teenage troubles of my wayward older sister. I thus found no small measure of euphoria and relief in tossing my drunken, twentysomething body upon the whims of late-night New York City, stumbling home regularly at 3:00 a.m. with a wad of waitressing cash stuffed in my bra or shoe. The problem, of course, is that the very substance that allows you to feel this freedom is the self-same substance that inhibits your capacity to remove or protect yourself if a situation becomes unwanted or dangerous. There is no magic cure for this dilemma; it is a knot with which each of us must grapple. Only we can know when we've had enough of the kind of wonky judgment that comes with combining sex and substance; it took me until I was thirty-three to have had enough. Some of my times were good and some were bad (none, thankfully, was catastrophically bad). But they were my times—I chose them, until I chose another way. I know—if and when you're under the sway of a substance, it might not feel like you're choosing anything. But one revelation of sobriety is that you actually can choose another way, even if this choice depends, paradoxically, on surrendering your illusion of control, and tiring of the particular brand of freedom that the substance has to offer.

QUEER LESSONS

In the years since #MeToo got started, I have often found myself talking with queer friends who feel shut out by the mainstream focus on the

heterosexual dyad of male predator/female victim, insofar as the conversation seems to elide, once again, the experience and perspective that queers have to offer. The folks I've been in conversation with are not typically yearning for more attention drawn to their own often extensive experiences of harassment, discrimination, bullying, or even violence. Rather, they tend to express more vigilance about the slippage between a watershed and a sex panic, as Masha Gessen has put it, in part due to the fact that many have themselves been suspected or accused of inappropriate sexual desires or behavior at some point, often just by virtue of their very existence. Such experience tends to make queers more alive to the paranoid logic that holds that expressing any concerns about #MeToo's logic or methods is an attempt to preserve the status quo, or, more nefariously, an indication that anyone who expresses such concerns may themselves pose a danger.

Despite (or because of) their knowledge of this history, many queers have felt the need to tiptoe, for reasons Jane Ward lays out in an essay titled "Bad Girls: On Being the Accused":

> All these mother fucking men. These men who grope and threaten and assault girls, boys, and women. They are finally *going down*. We are celebrating, so the commentators say. We are enraged, they say. Every pundit has something to say about what has happened to us—the "survivors" of rape culture.
>
> We, it seems, are also being careful, strategic. We are whispering to one another, *please don't muddy the waters by talking about false equivalences right now*. We are admonishing each other out of fear, *please, I beg you not to distract from this powerful wellspring of feminist truths, this unstoppable testimony of violation and survival, by attending to gray areas and complexities. Not now. The stakes are too high. This is finally working!* In trusted company we acknowledge these complexities, but we ask that they not be spoken outside our carefully guarded feminist chambers, where we trust they will be handled with great care.

But these complexities are not theoretical. And they are not private. Nor are they evidenced only by the starkest historical examples, such as Carolyn Bryant's lies about Emmett Till, or the day-care satanic sexual abuse panic of the 1980s and 90s, or the lesbians now known as the San Antonio Four, falsely accused of sexual abuse in the mid 1990s. . . . The complexity—by which I mean the fact that seemingly feminist, zero-tolerance responses to sexual assault are often animated by racism, sexism, and heteronormativity rather than any kind of substantive feminist intervention—is *the* key fact for many of us, absolutely impossible to compartmentalize or put off for discussion until a more convenient time.

Ward goes on to tell the story of her (female) partner, a high school teacher, who was disciplined by her school for "failing to ensure a safe sexual environment" after it was discovered that two of her students had been sneaking into the classroom at recess to have consensual oral sex. Ward connects this story to the long history of dykes "being the first suspect when sexual misbehavior is (or is imagined to be) afoot; being told to stay away from the children in one's extended family; keeping your distance in locker rooms and bathrooms and other places where straight women presume the absence of same-sex desire and panic when they realize it could present," and so on. She reminds us that "many queers, including queer women, are aware that queer life means risking accusations of having made other people uncomfortable, perhaps even making them feel violated, with our sexual excess or illegibility or unpredictability or boldness. It is for this reason that some of us cannot so immediately vilify the accused and 'believe all women,' because we have been the accused, we have loved the accused, and we have watched institutions manufacture and take down the accused to protect their own interests."

Some would mock such concerns as "a moral panic about a moral panic," or cast those voicing them as apologists for bad actors, or potential bad actors themselves. Some would argue that, due to advances in LGBTQ+ rights, such concerns are essentially relics, and that legacies of homophobia and transphobia should not be used as excuses to ignore misconduct

by people of any sexuality or gender. Some would argue that "nuance," "complexity," "context," and "gray areas" are code words employed to undermine or distract us from simpler truths, simpler charges, and simpler punishments; some would flick off the problem of "roadkill" by pointing out that the side of the road is littered with women and queers who have been treated as such, so it's regrettable but only fair to return the favor on an infinitesimally smaller scale.

Such attitudes make sense when we are overcome with anger at people who have done unacceptable things, and at the entrenched systems that have worked overtime to enable or encourage them. But unprocessed anger makes particularly poor soil from which to grow political commitments. Prison abolitionist Mariame Kaba explains:

> So one of the things I always talk about is the importance of your individual traumas being transformed into political commitments. So you have an individual trauma that you experience and then you have a political commitment that may be separate from that trauma.
>
> Here's an example of what I mean. So I'm a survivor of rape. And I was a reactionary survivor. . . . I wanted revenge. That was important. I had to process that. I had to go through that. . . . If you had put me right on a panel after that and said what should we do to rapists I would have said we should kill them. That would have been the response. . . .
>
> [But you] have to think about the political commitment you develop from the experience you've had that's a personal and harmful experience and then you have to think about how to apply that across the board to multiple people and major different contexts. . . .
>
> We have to be in community with each other enough to be able to say to our friends[,] you're being reactionary as hell. . . . We're not going to extrapolate your personal harmed feelings of fear and anger and turn that into a policy that then is going to govern a whole bunch of other people who did nothing to you.

As we do the work of developing our political commitments, it can seem like a no-brainer to say that standing in solidarity with nonnormative sexual practices never entails defending coercion, abuse, or harassment. Except, of course, that it isn't always so clear-cut. Given the elastic—and sometimes idiosyncratic—deployment of such terms, anyone dedicated to resisting the psychiatric-carceral state's avidity for defining and persecuting sexual deviance, anyone who goes wary of sexual moralism in all its forms—including its feminist forms—will inevitably need to examine closely any ideology that purports to know what ethical sex is, what falls outside its limits, and how its outliers should be punished. Even—or especially—when we are in pain, it's worth taking the time to make sure our pain is not partnering with our puritanism or punitiveness, as such partnering reinforces the flawed dichotomies of innocent/guilty, dangerous/not-dangerous, disposable/worthy, upon which the carceral state depends.[12]

Even if we can generally agree on the goals of more mutuality and less domination, thorny issues remain, including (but not limited to) age of consent, disclosure of STD status, barebacking, sex work, polygamy, statutory issues, consent by people with mental disabilities, as well as "consensual sex between employees or students, unwanted kisses or touches that ended as soon as the uninterested party said no, sexual propositions deemed inappropriate or unprofessional by institutions but not by the people actually involved, the presence of sex or desire in places that some people would rather it was not present or between people disciplined into believing they are not supposed to desire one another (cross-racial desire, queer desire, cross-generational desire, etc.), and messy conflicts between people that may have a sexual element," as Ward summarizes. The desire to make one-size-fits-all ethical (not to mention legal) prescriptions about when sexual relations are inappropriate or abhorrent deserves a tough reckoning with the principle of benign sexual variation (and by tough, I mean tough—see, for example, Joseph Fischel's *Screw Consent: A Better Politics of Sexual Justice*, in which Fischel considers what sex on the social margins, including bestial, necrophilic, cannibalistic practices, might have to tell us about creating new models for sexual justice).

The media's abundant deployment of the imprecise but nasty-sounding phrase "sexual misconduct" to cover all manner of public complaint has provided ample occasion for those of us alert to sexual smearing to wince and worry, especially as one watches "misconduct" bleed into "harassment" or even "assault" across headlines and conversations, as if in a dangerous game of telephone. I understand where they're coming from, but it still pains me to hear people salivating at the idea of men quaking in their boots at the possibility of a questionable sexual incident from their past coming back to haunt them, especially when so many women, queer and straight, have expressed to me some variation of "Wow, it's a good thing no one gives a shit about my past." They don't typically mean that they've engaged in assault or quid pro quo abuses of power, but they may mean flirting or having sex with someone much younger than themselves; hitting on someone aggressively; going in for a kiss or touch without knowing for sure if it's wanted; sleeping with someone in a fraught category, such as an employee, boss, fan, teacher, or student; good old-fashioned lyin' and cheatin'; exerting emotional pressure on someone or behaving recklessly in moments of distress; and more.

For these reasons, I find it truly stunning when people making blanket calls for increased institutional intervention and/or sexual policing appear utterly sanguine about or ignorant of its history, freely insinuate that those who disagree with them are would-be or covert abusers, don't ever seem to imagine themselves on the wrong end of the stick, and appear saturated with a conviction of their own primordial impeccability. They don't seem to have ever had cause to worry about how, say, social workers sent by the state to ratify an adoption might judge all the funky sexual material on their bookshelves or walls; what to do if and when their "obscene" art lands them in potentially serious legal trouble; the plausibility of becoming a sacrificial lamb at one's place of employment if and when the institution needs a way out of a liability panic; how they might feel if unsettling material, conversation, or critique in their seminar (or an accusation about them made by tweet) led to a serious investigation of them at their workplace; whether every moment of their own sexual or emotional life has truly been, and will always be, without reproach, especially when held against changing standards of acceptability; or whether

it furthers feminist and queer aims to make common cause with bureaucrats mindlessly promoting traditional sexual morality (as in the many faculty meetings I've sat in during which we debated, straight-faced, whether student/teacher affairs that lead to matrimony should be treated differently from those that don't).

Fear of "slippery slope" logic is not an excuse for letting misconduct go unaddressed. But proximity to the above situations has led me to believe that, as we address them, we owe ourselves and each other as much specificity and attention to context as we can muster, as well as a dedication not to treat anyone as roadkill. Otherwise, our efforts are likely to backfire on the very people they're meant to serve.[13] This includes clarity about whether and when we're protesting gendered hierarchy under the name of sexual misbehavior, as this confusion, when unacknowledged or unaccounted for, can become quite perilous. The message, restated by #MeToo founder Tarana Burke in the wake of accusations against academic Avital Ronell and #MeToo activist Asia Argento, that the gender or sexuality of a perpetrator is irrelevant, as the movement is really about "power and privilege," intended to clarify, but ultimately led further into the murk. Certainly there are times when the power and privilege at play correspond to institutional or legal prohibitions (such was the case with both Ronell and Argento). But outside of such circumstances, determining what constitutes power or privilege in any given encounter between two consenting adults is by no means settled or easy business. Nor is the question of what role power or privilege plays, or should play, in sex between consenting adults in the first place, and who should be its arbiter.

ALWAYS AROUND POWER

At the 1981 Barnard Conference on Sexuality, where antiporn feminists protested Hollibaugh's presence, as well as that of Nestle, Rubin, and Allison, Hollibaugh had this to say about the role of power in sex:

> The truth is that our current state of feminist affairs has demanded that women live outside power in sex. We seem to have

decided that power in sex is male because it leads to dominance and submission, which are in turn defined as exclusively masculine. Most of our theorizing has suggested that any arousal from power felt by women is simply false consciousness. In real life this forces many feminists to give up sex as they enjoy it and forces an even larger group to go underground with their dreams. For the many women who have no idea what they might eventually want, it means silencing and fearing the unknown aspects of their passions as they begin surfacing. Silence, hiding, fear, shame—these have always been imposed on women so that we would have no knowledge, let alone control, of what we want. Will we now impose these on ourselves?

Decades later, #MeToo has rekindled similar questions. Much of this renewed analysis of power has been exceedingly important, and has been clearest when focused on the workplace, where questions of quid pro quo, harassment, and retribution loom large. When the analysis moves out of that sphere, however, it's worth proceeding cautiously, and pausing over the default premise that "correct" sex—the sex that is the most ethical and just and that we all should be moving toward having—is sex stripped of as many power relations as possible.

Power is integral to some people's sexuality. Some could take or leave it; for others, it's a complete turn-off. For her part, Hollibaugh attests: "My own sexuality is fundamentally grounded in danger. A lot of women I know felt their sexuality that way: always around power and always around danger." (One could offer a two-cent take on this propensity, but bear in mind, there is a two-cent take on yours as well.) There is also the difficult fact that, as Fischel has put it, "sexual partners are rarely if ever equal; in fact, it is hard to make sense out of what equality might mean." As Fischel sees it, "A stipulation to regulate sex in relations of dependence leads two ways: either all sex everywhere is impermissible since all power differentials functionally manufacture consent, or the stipulation is to be junked precisely because it holds all sex everywhere suspect, and this cannot be right, as sex is good or fun or mutually desired despite and sometimes because of power asymmetry."

Analyzing the power dynamics of any particular scenario can be crucial to our understanding what happened and why. It does not follow, however, that if elements of power exist—as they always do—our agency is extinguished, or that an abuse of power has occurred. The exercise of agency is always a negotiation of available possibilities and pressures; there is no world in which "agency" or "free will" exists apart from webs of relationality, which includes relations of power. Nor will it do to map our own constellations of power onto the psychology of others, for we do not all attribute power to the same people or forces, or feel affected by that power in the same ways. Not all women take kindly to being told that certain people inevitably have power over them; charges of false consciousness or impaired decision-making always risk patronizing the very people for whom they're intended to care.

Some may have cheered, for example, when the singer of the indie band Pinegrove—no doubt inspired by #MeToo's analysis of "the insidious aspects of disempowerment"—posted the following message on social media: "i have been flirtatious with fans and on a few occasions been intimate with people that i've met on tour. i've reached the conclusion now that that's not ever appropriate—even if they initiate it. there will always be an unfair power dynamic at play in these situations and it's not ok for me to ignore that." But I found it maddening. The singer can do whatever he wants, and more power to him if he's decided not to have sex with fans for whatever reason (one big reason, no doubt, is that he'd been accused of "non-physical sexual coercion" by an ex; one suspects that he was here echoing her claims about his behavior). But there's a point at which an assertion of an "unfair power dynamic at play" is simply a reification of (male) power, which (once again) disappears or distrusts female autonomy (i.e., his fans' desire for sex can't be trusted, "even if they initiate it"). If I hit on a guy after being super turned on by his charismatic performance and he responded, "Sorry, I know you think you want this, but due to the implicit power I hold over you because of my celebrity and gender privilege, it's simply not possible for you to know what you want," I would be livid. People in positions of relative power—be it by age, by station, by sobriety, etc.—no doubt benefit from considering the potential consequences of entering into sexual rela-

tions shaped by these dynamics. (These consequences can cut both ways: time and time again, I've seen relationships begun in adulation crash and burn when the object of adulation reveals themselves to be an ordinary, needy human being, and is subsequently rejected by the party who put them on a pedestal.) Engaging in such reflection differs from nurturing a reflexive surety about where power immovably lies, presuming all forms of power mean "power over," or demanding a consensus view as to which forms of power differentials are acceptable among consensual adults, and which are not.[14]

The problem of demonizing power extends well beyond the sphere of sex. As J. K. Gibson-Graham explains:

> When power is identified with what is ruthless and dominating, it becomes something the left must distance itself from, lest it be co-opted or compromised (Newman 2000). . . .
>
> Successful political innovation seems perpetually blocked or postponed because it requires an entirely new relation to power. It will need to escape power, go beyond it, obliterate it, transform it, making the radical shift from a controlling, dominating power to an enabling, liberating one (Newman 2000). But since distance from power is the marker of authentic radicalism and desire is bound up in the purity of powerlessness, the move to reinhabit power is deferred. If we are to make the shift from victimhood to potency, from judgment to enactment, from protest to positive projects, we also need to work on the moralistic stance that clings to a singular conception of power and blocks experimentation with power in its many forms.

No doubt there is much to feel powerless about these days, and no doubt certain bodies bear the brunt of this fact to a much greater extent than others. But locating authentic radicalism in the purity of powerlessness does not necessarily lead to our empowerment, or to more just, responsible exercises of it. A deepening conviction of our powerlessness can at times make us insensitive to the power we do have, even as we demand

such an accounting from others. As writer and prison abolitionist Jackie Wang has put it in a different context, "When people identify with their victimization, we need to critically consider whether it is being used as a tactical maneuver to construct themselves as innocent and exert power without being questioned."

We also benefit from examining our own role in bestowing power, and any libidinal investment we may have in the game. Whenever I hear, for example, that the fame, charisma, talent, or success of a writer (or artist or band member, etc.) has imbued him with a certain power (à la the Pinegrove singer), I feel extremely wary, insofar as this equation seems to me a gendered phenomenon that typically runs but one way. That is to say, at no point in my literary life has anyone ever said to me anything like, "You must be getting all the pussy now," as Ta-Nehisi Coates reports an "elder statesman" of literature said to him after the success of *Between the World and Me*. (See, too, rock musician Carrie Brownstein's memoir, *Hunger Makes Me a Modern Girl*, in which she summarizes a truism known to female rockers far and wide: "People often ask me about groupies on tour, about whether I had random and meaningless and super-hot sex. The answer is no. To all of it. We never had groupies. With that sad little sentence, I wish we *had*, just so instead I could have written 'Yes, of course we had groupies! Endless, countless numbers of groupies. A cornucopia of groupies, groupies coming out of my ears, groupies for days.' . . . Persona for a man is equated with power; persona for a woman makes her less of a woman, more distant and unknowable, and thus threatening.") There are exceptions—lesbian and queer groupies do exist, and some brave straight guys crush out on powerful, charismatic women. But wherever the doxa holds that sex exalts men and degrades women, a version of this dynamic will remain in play. (See Chrissie Hynde: "A male groupie is a fan. It's not the same. A male groupie is not someone who's going to offer you a blow job.")

Doxa is not a force separate from us that acts only upon us. We play a part in its creation and sustenance. The idea that a (male) singer on a stage or a (male) writer with a Pulitzer holds power over us, or the keys to our creative or professional kingdom, is not an objective fact experienced

similarly or accepted by all. There are other ways to perceive our situation and proceed in it, many of which were forged by those who made a way out of no way.[15]

MY BODY HAS NOTHING TO DO WITH YOUR BODY

Some years ago I found myself emerging from the Astor Place subway into a Slut Walk in the East Village of Manhattan. Generally speaking, the spectacle was a delight. Nonetheless, in the years since, I have found myself musing on the first thing I saw up on the street, which was a group of young women wearing pasties and low-slung jeans carrying a banner that read MY BODY HAS NOTHING TO DO WITH YOUR BODY. While not unfamiliar, the slogan seemed so patently untrue in this context that it struck me as almost comedic. For starters, the banner needed about five women to hold it up, so five bodies were united in service of an announcement that the bodies at hand had nothing to do with each other. Also, the announcement was being set forth at a march very much intended to show how bodies have to do with other bodies, via a public amassing of scantily clad flesh capable of drawing attention and stopping traffic. I knew the "your body" on the sign was supposed to refer to some imagined enemy or intruder, but given that anyone reading it was likely to feel interpellated by its call, the banner had the weird effect of pulling you into an exchange only to insist on your irrelevance to it. It reminded me, perhaps a bit sadly, of sex itself, wherein an activity ostensibly about two or more bodies "connecting" can shimmer in and out of a drama of those bodies asserting their independence or alienation from one another.

The sign also led into a paradox at the heart of sexual freedom. On the one hand, it makes sense to think of sexual freedom, as Janet Jakobsen and Ann Pellegrini do in *Love the Sin: Sexual Regulation and the Limits of Religious Tolerance*, as "the freedom to form human relationships"—in other words, as the freedom to do something, make something, be something, together. On the other hand stands the fact that, in the United States, many of our most basic and hard-earned sexual freedoms (such

as the right to use contraception, procure an abortion, or engage in sodomy) are legally dependent on principles of individual liberty derived from a "right to privacy," cobbled together from constitutional amendments and backed up by court cases in which the protected relationships remain quite narrow (e.g., a married couple, a "woman and her doctor," a "same-sex couple"). This conundrum has led many to wonder how our conception of sexual freedom might differ were the etiology of *Griswold v. Connecticut*, *Roe v. Wade*, and *Lawrence v. Texas* derived from different legal bases (if they are overturned, we might someday find out).[16]

The conflict between understanding sexual freedom as something we possess or aim to possess, as individuals, and something we make and experience together, brings us into the heart of "consent culture" and its discontents. Many have noted the irony of the fact that consent culture in the university—with all its talk of individual autonomy, rights, permissions, and contracts—has blossomed alongside the academic evisceration of the rights-bearing, autonomous liberal subject, and a celebration of concepts such as porousness, interdependence, interpenetration, "transcorporeality," vulnerability, and intersubjectivity. Australian feminist Astrida Neimanis zeroes in on this phenomenon when she writes, "I have recently been thinking about the paradox I face as a feminist: arguing both for an autonomy of embodiment ('our bodies, ourselves'; 'get your laws off my body,' etc.) as well as an inescapable vulnerability and shared embodiment that transcorporeality underscores. Navigating these paradoxes is a pressing challenge for thinking what embodiment might be and do." Her point is a good one: insofar as contemporary consent culture depends upon liberal contract theory and the liberal individuals who animate it, it will always be in tension with an urge to emphasize our intermingled nature, and the innumerable, ungovernable, often invisible agencies operative at any given moment, even down to the cellular level.

If Foucault taught us anything about sex, it's that the discourse we use to talk about it plays a big part in shaping what we take it to be. (He also demonstrated, in his analysis of the "repressive hypothesis" of the Victorian period, the tremendous libidinal pleasure that can be taken in the repres-

sion or demonization of sex, especially by the demonizers.) It's worthwhile, then, to consider what kind of sex, for example, an "affirmative consent" model produces or aims to produce. As scholar Tanya Serisier puts it in "Is Consent Sexy?": "The enthusiastic consent model . . . proposes that a verbal contract model of sex is the best—or even only—way to have good sex, implicitly devaluing other forms of sexual practice or sexual communication. . . . The assertion that this kind of consent is the model of both ethical and sexy sex presumes there is something wrong with people who do not behave in this way." This doesn't necessarily mean we have to trash the model. It just means we benefit from staying as alert as possible to what it's doing, and to any unintended consequences.

In thinking about consent, many have pointed to BDSM as a subculture with a lot to teach those less accustomed to owning their desires and kinks. The way I see it, the lessons of BDSM have less to do with contracts or safe words per se (many practitioners will tell you that such boundaries don't always work as advertised), and more to do with its treatment of consent as a portal that enables getting into the real work of desire. (Typically you don't just "consent" to being hog-tied and flogged, or to having your erogenous tissue needled; you want it, you ask for it, you arrange it. Your desire is the driving force, not an afterthought or an acquiescence; quite often, it is the bottom who must know what he wants.) Brown digs into the issue as follows:

> Since "consent" is such a critical term in debates about sexuality and pornography among feminists, I want to clarify that while I am suggesting that where consent really matters, it matters because it marks relations of subordination. It is nevertheless often used—infelicitously, in my view—to legitimate activities in relatively egalitarian settings. Thus, for example, feminist justifications of sadomasochism that rely on the "consensual" nature of the activity defensively address the anxiety that the manifest appearance of sexual domination or inequality might obscure the mutual desire for the activity. But this defense, rather than quelling the anxiety, probably activates it precisely by raising a subterranean specter of inequality in the

language of consent. Why not say "this is her desire" rather than "she consented to what may appear as her violation"? Why is consent the only language we have for mutual agreement that is not contract, and what is revealed by the failure of language here?

As Brown suggests, beyond consent and legitimated subordination lie higher level practices of freedom, as indicated by the still-radical assertion "This is her desire." (Think, too, of the "Four Magic Words" sex columnist Dan Savage encourages straight folks to learn from gay folks: "What are you into?") Grace complains that Ansari kept asking her over and over again, "Where do you want me to fuck you?"—a question Grace says she found tough to answer because "she didn't want to fuck him at all." I get that he may have skipped a crucial step (or several); I get that it may have been hard for her to point that out; I get that he may have seemed uninclined to listen. But if and when someone is asking us a question about our desire over and over again and we can't answer it, it seems to me that we have a lot of work to do. Others can learn to help more than hinder. But at its core, this is work no one else can do for us. This is partly because saying no is hard, but so is saying yes, especially if it involves something more or different than acquiescence.

NO SUCH THING AS A TRUE STORY

I want to talk a bit about time and memory and sex and freedom; if I could (which I know I can't, at least not entirely), I'd like to talk about it at a remove from the misogynist imago of the harpy-accuser who allegedly consents (or at least acquiesces) to sex by night, then files charges in the morning (or ten years later), as well as from the charged question of how, when, and whose memories of sexual encounters can be trusted. I want to talk about time and sex and memory and freedom because I find it interesting that, likely because sex can have the virtue of nailing us to the present moment, offering us a momentary escape from the relentless talons of meaning making, it's often only in retrospect that we can apprehend the various forces that brought any particular situation into being.

Sometimes these forces appear infused with magic, as in *How did we find each other? How did you know how I felt? How did I get so lucky?* At other times, they have a grimmer cast, à la *How did this happen to me (again)?* It's possible to look back at events and choices and determine ourselves to have been freer than we supposed ourselves to be at the time, but more often, I'd wager we feel the opposite—we see, in hindsight, how our lives and choices were determined, perhaps overdetermined, by the forces and patterns that shaped us heretofore, as well as those that shaped the others with whom we collide. While we sometimes think of this enmeshment as making us "less free," we could also see our capacity to assess it and reassess it over time as a practice of freedom in its own right.

Assembling the various encounters and tribulations of a life into a narrative that attempts to recast chance as karma has always struck me as dubious business. This is especially so when it comes to sexual stories, since, for girls especially, an "asking for it" narrative stands ever ready to disguise the raw fact that most of us have been subjected to a tsunami of unwanted sexual attention before we've even hit puberty. (My own preadolescence was exceedingly tame on this account, yet I can still see with cinematic clarity the uncircumcised dick hanging outside a man's suit pants as he/it followed me, age ten, around our local stationery store; I can still hear the menacing voice of the guy who came up to me, age twelve, at a beach snack bar, and whispered, "You still look young enough to bleed.") I had quite a bit of sex in high school, most of which I considered neither fantastic nor terrible. Later, as feminist college students often do, I subjected my history to a thorough reevaluation, and was predictably disoriented to recognize that experiences I had considered consensual at the time seemed to be laced, in retrospect, with at least some degree of coercion, mainly of the head-shoved-into-the-crotch, "just suck it" variety.

And yet, as I thought back on my primary erotic attachment in high school, a guy with a penchant for the head shove and light but potent humiliation, I also had to reckon with the fact that I repeatedly drove sixty miles each way to see him, lied to my mother about my whereabouts to do so, and obsessively replayed the details of our every encounter after the fact as masturbatory fodder. Put simply, there was no one

true story about our relationship. He acted gross sometimes, but I was in large part the relationship's engine, and brought to it a shocking amount of desire, often embarrassingly unrequited. In retrospect, I can see that I was experimenting with erotic masochism while trying to avoid any truly destabilizing self-harm or humiliation. I was only moderately successful, but I was also only sixteen. Such complications are partly what led me to quit my job educating first-year college students about consent, as I felt the program did not leave enough space to discuss the ravenous, turbulent fact of female desire, which I had experienced as the most powerful force ripping through my life, but literally had no place in the program's script, which mostly focused on role-plays about how to eject a guy from your dorm room if a massage turned sexual.

Interpretation is never a static activity; very rarely does one story "stick" throughout a life. As we go along, we often find the stories we have been telling ourselves don't work any longer; we find we need to change them, so that they can do different work for us, accommodate new sets of knowledge and insight. It is in this sense that there is no such thing as a true story. This does not mean that all facts are fungible, nor does it mean that we don't each have a right to our own stories. It just means that the events of our lives will appear differently to us at different times, and that our attraction, aversion, or indifference to objects, people, or events is always conditioned by our state of mind.

One famous example of such ongoing reassessment is that of Monica Lewinsky, who has revisited the tale of her affair with Bill Clinton multiple times in print over the years, most notably immediately in the wake of the #MeToo movement. I find her latest account remarkable for a number of reasons, so I will quote from it liberally:

> I've lived for such a long time in the House of Gaslight, clinging to my experiences as they unfolded in my 20s and railing against the untruths that painted me as an unstable stalker and Servicer in Chief. An inability to deviate from the internal script of what I actually experienced left little room for re-evaluation; I cleaved to what I "knew." So often have

I struggled with my own sense of agency versus victimhood. (In 1998, we were living in times in which women's sexuality was a marker of their agency—"owning desire." And yet, I felt that if I saw myself as in any way a victim, it would open the door to choruses of: "See, you did merely service him.")

What it means to confront a long-held belief (one clung to like a life raft in the middle of the ocean) is to challenge your own perceptions and allow the *pentimento* painting that is hidden beneath the surface to emerge and be seen in the light of a new day.

Given my PTSD and my understanding of trauma, it's very likely that my thinking would not necessarily be changing at this time had it not been for the #MeToo movement—not only because of the new lens it has provided but also because of how it has offered new avenues toward the safety that comes from solidarity. Just four years ago, in an essay for this magazine, I wrote the following: "Sure, my boss took advantage of me, but I will always remain firm on this point: it was a consensual relationship. Any 'abuse' came in the aftermath, when I was made a scapegoat in order to protect his powerful position." I now see how problematic it was that the two of us even got to a place where there was a question of consent. Instead, the road that led there was littered with inappropriate abuse of authority, station, and privilege. (Full stop.)

Now, at 44, I'm beginning (*just beginning*) to consider the implications of the power differentials that were so vast between a president and a White House intern. I'm beginning to entertain the notion that in such a circumstance the idea of consent might well be rendered moot. (Although power imbalances—and the ability to abuse them—do exist even when the sex has been consensual.)

But it's also complicated. Very, very complicated. The dictionary definition of "consent"? "To give permission for something to happen." And yet what did the "something" mean in this instance, given the power dynamics, his position, and my age? Was the "something" just about crossing a line of sexual

(and later emotional) intimacy? (An intimacy I wanted—with a 22-year-old's limited understanding of the consequences.) He was my boss. He was the most powerful man on the planet. He was 27 years my senior, with enough life experience to know better. He was, at the time, at the pinnacle of his career, while I was in my first job out of college. (Note to the trolls, both Democratic and Republican: none of the above excuses me for my responsibility for what happened. I meet Regret every day.)

"This" (sigh) is as far as I've gotten in my re-evaluation; I want to be thoughtful. But I know one thing for certain: part of what has allowed me to shift is knowing I'm not alone anymore. And for that I am grateful.

I can easily imagine someone cheering Lewinsky on—Hey, sister, you're almost there! You've almost entirely let go of the ruse of your agency and pleasure! Just swim a little farther across the choppy waters, and you'll arrive at the shore wherein the only thing that remains is Clinton's abuse of power (this may, of course, contaminate to the point of erasure the hotness of your affair and lived experience of it, but that's the price you have to pay to see "abuse of power" with clear eyes). But what I love about her account is her equivocating—her "(*just beginning*)," her interjection "But it's complicated," her "(sigh)," her acknowledgment that "this is as far as I've gotten in my re-evaluation," when it would clearly be so easy for her to gain applause by putting all her chips on one party line. Instead, her "sigh" marks a certain resistance on her part, an unwillingness to submit to the dogma that holds that "complex and ambivalent erotic aims are less good than simple, stable ones" (Janet Halley). This seems to me a deeply worthwhile, if uncomfortable, place to stand. Equally important: Lewinsky here demonstrates how such resistance can coexist with gratitude for feminist solidarity, insight, and protest, because it can.

After all, who is to say that, after a few years of living with the "I was actually a victim of Bill Clinton's disgusting abuse of power, and I realize now that whatever desire or agency I felt or thought was 'my own' was

actually manufactured, contaminated, and illusory" narrative, Lewinsky might feel differently once again? We tend to grow tired of our stories over time; we tend to learn from them what they have to teach, then bore of their singular lens. I see Lewinsky's shifting take on her story as a practice of freedom in its own right, a claim on an indeterminacy unopposed to clarity. I also suspect she is somewhere preserving the part of her experience that refuses to be embalmed or explicated—the part that's privately held, as so many of our intimate memories are, as an inscrutable engram we retain the right never to fully diagnose, justify, or understand.

THE MYTH OF FREEDOM

For some time now, I have attributed the notion that "there is no such thing as a true story" to Buddhist thought, specifically to Shambhala Buddhism, a tradition that has generated some of the texts that have most inspired me as a writer and human being. *The Myth of Freedom*, by Chögyam Trungpa, has sat on my desk throughout this writing, just as that book's second half, "Styles of Imprisonment," laid the mental and formal groundwork for a previous book of mine, *The Art of Cruelty*. Trungpa's most famous student is Buddhist nun and author Pema Chödrön, whose book *When Things Fall Apart: Heart Advice for Difficult Times* has been a best seller since 1996. (The phrase "No Such Thing As a True Story" is the name of a chapter in Chödrön's *The Wisdom of No Escape*, a book whose title alone underscores a certain attitude toward the knot of choicelessness and freedom that shapes these pages.)

In 1993, Pema Chödrön gave an interview to the Buddhist magazine *Tricycle* called "No Right, No Wrong," which focuses in part on Chödrön's devotion to Trungpa, who was known for, among other things, sleeping with his female students, heavy drinking, and unruly behavior filed under the rubric "crazy wisdom." The 1993 interview predates our era of trigger warnings, safe spaces, and call-out culture, but its subject matter remains uncannily relevant. The interviewer opens by asking Chödrön, "Since [Trungpa's] death in 1986, there has been

increasing concern about the inappropriate use of spiritual authority, particularly with regard to sex and power. Today even some students who were once devoted to Trungpa Rinpoche have had a change of heart. Behavior that they may have formerly considered enlightened they now consider wrong. Has there been a shift in your outlook?" To which Chödrön responds, "My undying devotion to Trungpa Rinpoche comes from his teaching me in every way he could that you can never make things right or wrong." The interviewer pushes on: "[But if] you knew ten years ago what you know today . . . would you have wanted some of the women you've been working with to study with him, given their histories of sexual abuse?" Chödrön still doesn't budge, and says she would have encouraged potential students "to decide for yourself who you think this guy is." Near the end of the interview, Chödrön offers the interviewer a final assessment: "My personal teacher did not keep ethical norms and my devotion to him is unshakable. So I'm left with a big koan."

In the same interview, Chödrön fields a number of questions about safe spaces. The interviewer asks, "There's a lot of talk in Buddhist circles of 'safe' places to practice, 'safe' teachers, even 'safe' environments in which to hold conferences for Buddhist teachers. And the idea of safety seems to imply guarantees and predictability, that things are going to unfold according to plan. This seems so different from your own training. How do you handle students' desire to be in a 'safe place' at the abbey?" To which Chödrön replies:

> We just did this program where people were falling apart
> right and left. Frequently, students would say, Well, this place
> feels safe to let it all hang out. So the environment was safe,
> but the teachings were threatening. . . . A situation where
> no one rocks the boat and the whole thing is smooth creates
> a very weak understanding and feeds into the avoidance of
> pain, which is the major cause of suffering, the major cause of
> samsara. . . . You're never going to erase the groundlessness.
> You're never going to have a neat, sweet little picture with no
> messiness, no matter how many rules you make.

I'm riveted by this formulation, "the environment was safe, but the teachings were threatening," as it names a paradox at the heart of much intellectual and artistic creation and pedagogy, one especially relevant for those of us who have devoted much of our lives to the contemplation and creation of transgressive work, as well as to supporting and respecting students. You can work to make a safe environment, but if the teachings at hand are meant to rattle, people are going to feel rattled. From a Buddhist point of view, this isn't a bad thing, insofar as Buddhists treat our habitual attempt to avoid pain and difficulty as precisely that which swells their force, and diminishes our capacity to deal with them skillfully.

Of course there are occasions upon which giving warnings is ethically warranted (if not legally required), in which case it doesn't matter whether they're likely to be heeded: we give them anyway, out of care and caution. I spend about 95 percent of each day warning my kids about everything from UV rays to creepy Lyft drivers to fentanyl, praying at least some of my monologue is seeping in. But for better or worse, you can't really warn anyone off anybody or anything. Not heroin, not cheaters, not cults, not even bungee jumping. As anyone who's ever planned or enacted an intervention knows, laying out what you consider to be right and wrong (and what your ultimatum will be when the alleged wrongdoer doesn't conform to your preeminent wisdom) is widely considered a counterproductive, unwise means of attempting assistance, in that it can diminish a person's sense of agency rather than giving it space to grow. Most teachers and parents (not to mention counselors, social workers, AA sponsors, and so on) know that making space for this growth is paramount, even if it doesn't read as "care" as quickly and superficially as does "protection." This type of care respects the heterogeneity and autonomy of others, and allows for indeterminate, uncontrollable outcomes, excruciating as that may sometimes be. (Parenting poses a special challenge here, in that the job begins as raw protection, then must transform along the way into a more spacious and complex form of care, without clear markers as to when and how such a transition might be made, or instructions as to how to bear it.)

People are different from each other, which means that we seek and learn from different styles of care, thought, pedagogy, and experience. Due to these differences, not all styles work for all people. As Chödrön explains to her interviewer: "My heroes are Gurdjieff and Chögyam Trungpa Rinpoche and Machig Labrum, the mad yogi of Bhutan. I like the wild ones. Probably because I've invested so much in being a good child and have always gotten great feedback from it. But my friends and teachers have always been the wild ones and I love them. I'm bored by the good ones. Not exactly bored, but they don't stop my mind. I'm the kind of person who only learns when I get thrown overboard and the sharks are coming after me." I feel a deep kinship with her self-characterization here, which is likely why her own methods (and those of Trungpa) have been so inspiring to me. Of course, not being as spiritually enlightened as Chödrön, I'm more likely to call out certain behavior in moralistic terms when I see it, nor can I imagine pledging undying devotion to someone who goes by the name of King (as did Trungpa's son, Mipham Rinpoche—also known as the Sakyong—who went down in a #MeToo scandal as I was writing this chapter, and who was attempting a comeback as I finished it).[17] Nor do I seek out as much wildness as I used to— as one grows older, one finds that the sharks come, alas, unbidden.

Chödrön's stance is unlikely to please everyone, and she herself has undertaken her own journey over the years (in 2020, she resigned from her duties at Shambhala, in part because of the Sakyong's return to his). But I remain happily haunted by her formulation: "My personal teacher did not keep ethical norms and my devotion to him is unshakable. So I'm left with a big koan." Who isn't? Our desire to treat everyone with compassion, kindness, and forgiveness and to throw harmful assholes off a cliff is a big koan. Practicing freedom in a world of constrained, often shitty circumstances is a big koan. Our desire to retain control over what happens to our bodies and psyches while also seeking experiences of surrender and abandon is a big koan. Our desire for increased protection from institutions while insisting that they get the fuck out of our lives is a big koan. Our desire to take the risk of finding things out for ourselves while staying essentially protected is a big koan. Maintaining a steadfast spiritual commitment to "no right, no wrong" while also giving

people "confidence that when harm is done there will be consequences" (as Chödrön wrote the Shambhala community in a 2018 letter regarding the Sakyong) is a big koan. As one Buddhist teacher posted online in the wake of Shambhala's reckoning, "To hear that the Guru may be deeply flawed gives us the chance to give up such expectations once and for all. Stop looking for someone to rescue you. Focus on what *is* rather than what you hoped would be. Stop wishing there was another now."

ANOTHER NOW

It's awfully hard, of course, to stop wishing there was another now. C. E. gives voice to this frustration when they write: *"Where did the old feminists think difference would emerge from? What in this world could make up the next? I ask this not to mock them but because I keep returning to it, expecting the answer to be different, expecting that I'll find it by accident some day and then everything will be okay. But it's not coming, so what now?"*

What now, indeed? As I write, multiple states are passing draconian laws outlawing all abortion, each hoping theirs will be the golden ticket to overturn *Roe v. Wade*, thus ushering in a new era of enforced child-bearing, this time turbocharged by the apparatus of mass incarceration. Michelle Goldberg paints a grim picture of what's potentially to come: "It's important to understand that we're not necessarily facing a return to the past. The new wave of anti-abortion laws suggests that a post-Roe America won't look like the country did before 1973, when the court case was decided. It will probably be worse." C. E. amplifies this pessimism, adding nostalgia to the mix: "If thousands of years ago there was a pre-gendered mode of pleasure, embodiment, and usage of genitalia, it is irretrievably lost to us. . . . [Now there is] only an endless field of touch, affect, craving, survival, and power relations, produced and mediated by our material conditions."

Call me crazy, but an "endless field of touch, affect, craving, survival, and power relations, produced and mediated by our material conditions" doesn't sound so bad to me (especially with "material conditions" imagined

more expansively, even wondrously, than in the Marxist sense). It sounds like a world in which "liberation paves the way for new power relationships, which must be controlled by practices of freedom," one in which we cease measuring the status of our liberation against the ideal of an unfettered, static, happy sexuality, and commit instead to the ride, knowing that certain unfreedoms and suffering will always be part of it, even as we work to diminish their prevalence and force. (That we can accept the inevitability of suffering while working to diminish it is another big koan, perhaps one of the biggest.)

Such an approach invites us to leave behind the poles of pre- vs. post-liberatory, negativity vs. positivity, optimism vs. pessimism, utopia vs. dystopia, and to reckon instead with the fact that everything is *not* going to be OK, that no one or nothing is coming to save us, and that this is both searingly difficult and also fine. We don't need to make things worse by yearning for an irretrievable, phantasmagorical past, or spook ourselves with images of a future invariably imagined as worse. We can look back in gratitude rather than disappointment; we can look ahead with curiosity and determination, filling ourselves up with what the late, great feminist artist and sexual liberationist Carolee Schneemann called "the firm expectation of great times to be won together." As Schneemann's lifelong exploration of these great times—which she never severed from the terrible ones—demonstrates, such a conviction can enrich so much more than our future.

3. Drug Fugue

THE INTERSECTING CUT — TO ENJOY A DRUG ONE MUST ENJOY BEING
A SUBJECT — I LIKE TO HORRIFY PEOPLE — THE REHABILITATION OF
ADDICTION — THE BLONDES — WORKING THE TRAP — NONHUMAN
PEOPLE — BY ABANDONMENT

THE INTERSECTING CUT

There are a lot of stories about why people take drugs. Some of these stories
have to do with freedom. As in: people take drugs because they feel un-
free, and drugs make them feel freer. Or, people take drugs because they
want to escape their heavy and painful conditions, but sadly find them-
selves reburdened and enslaved by addiction (*addictus* = "to give over, to
surrender; also, to be made a slave"). Or, people take drugs because free-
dom is hard to bear, and addiction offers a counterweight to the unbear-
able lightness of being. Or, people take drugs to free their minds, not just
from suffering, but also from conventional perception, from doxa. Or,
people take drugs because, by using a substance that has been prohibited,
they feel they are freeing themselves from the confines of the law. Or, as
Marcus Boon puts it in *The Road of Excess: A History of Writers on Drugs*,
people take drugs because they (by which I mean we) have a legitimate
desire to feel high. And part of the desire to feel high is the desire to feel
free, however briefly, from the burdens of agency, subjectivity, sovereignty,
autonomy, relationality, even humanity for which we generally presume
people yearn to be people. The drug drive tells us otherwise.

The relationship between drugs, addiction, and freedom has been of keen interest to me at least since the early 1990s, when I came upon Avital Ronell's *Crack Wars: Literature Addiction Mania*, one of the first books to show me that theorizing could be a literary act. In it, Ronell writes, "The intersecting cut between freedom, drugs, and the addicted condition (what we are symptomatologizing as 'Being-on-drugs') deserves an interminable analysis whose heavily barred doors can be no more than cracked open by a solitary research."

I read these words around 1994, no doubt sitting on my fire escape with a fifth of Jim Beam and a Camel cigarette, looking out over my desolate, druggy corner of the Lower East Side. I was newly twenty-one, and entering a scene awash in drugs, mostly booze and heroin (the latter I avoided, primarily by relying on the former). The "crack wars" of Ronell's title had been waged for almost a decade; Bill Clinton's Violence Crime Control and Law Enforcement Act had just been passed; AIDS was the leading cause of death for those aged twenty-five to forty-four. In such a context, Ronell's title performed a weird bait and switch, summoning, primarily for punk effect, the vicious, intentional persecution of Black and brown bodies taking place through "the war on drugs," then turning sharply away from the subject, into literature and philosophy. What felt critical to me then was the book's conjoined proposition that "drugs"—a fuzzy, culturally induced category to which no cluster of molecules inherently belongs without juridical-political classification—named a deep structure at the basis of our culture, and was intimately bound to the question of freedom. Compelled by this proposition as I was, I didn't fully understand it (the legendary opacity of Ronell's writing didn't help); almost three decades later, from the perch of sobriety in a very different time and place, I'm still trying to figure it out.

"To gain access to the question of 'Being-on-drugs' we have had to go the way of literature," Ronell writes at the start of *Crack Wars*. I, too, here go mostly this way, with a handful of detours into personal experience. This is partly a matter of taste: with a few exceptions (such as Peggy Ahwesh's great crack-era film, *Strange Weather*), I don't enjoy movies about drugs, with all their straining to convey disorientation using kaleidoscopic lenses,

nor do I typically find references to drugs in song adequate portals by which to ponder their "fractal interiorities," as Ronell has it (though, were I a deeper listener, the music itself could likely provide such access). Mostly I go the way of first-person literary accounts because I like first-person literary accounts. But I also think Ronell is onto something when she says that literary works "have always worked as informants but they were nobody's fools—they talked to the philosophers because they had inside knowledge." I have spent decades listening to this inside knowledge, and feel eager to contribute to the interminable analysis it deserves.

As befits the realm, we might begin with a few warnings. Whatever inside knowledge literature provides, it is not sociology. Since only a handful of users are or ever become writers of note, using their testimony as a sample from which to derive empirical data about the nature of drugs or addiction seems ill advised (though perhaps no more ill advised than using literature as an informant about any other realm). Despite the legend of immediacy that so often attends drug writing (as in the tale of a speed-addled Jack Kerouac typing *On the Road* at 100 words per minute on a 120-foot-long scroll), drug experience is notoriously difficult to represent, either in the moment or in retrospect ("I solved the secret of the universe last night, but this morning I forgot what it was," Arthur Koestler once quipped about a mushroom trip). As Michael Clune, literary scholar and author of one of the best dope memoirs I've read, *White Out: The Secret Life of Heroin*, explains (in *Writing Against Time*), "The literary interest in the description of the striking effects of addictive substances is familiar. Less often noted is the curious divergence of these descriptions from empirical studies of the experiences of addicts, for whom a dulling and deadening of perception is a characteristic of narcotic and alcohol addiction on the sensorium." In other words, to be "good literature," drug writing needs to be enlivening, surprising, and gripping, whereas the experiences being narrated are often characterized by monotony, inattentiveness, and vacancy. This alone should remind us of the transformation that must take place in order for experience to become art.

Another warning: literature is not moralism. Those who would present themselves as being "against drugs" (whatever such a thing might mean)

often mix up content and quality, and interpret the appearance of what William Burroughs called "Tired Old Junk Talk and Junk Con"—that is, "the same things said a million times and more and there is no point in saying anything because NOTHING *Ever Happens* in the junk world"—as evidence that there is nothing meaningful to be found in an LSD trip, an ayahuasca retreat, a tequila bender, or a heroin nod, rather than as a clue one might be reading a not-so-great book. They might also charge the writer, or the writer's fans, with the sin of aestheticizing or glamorizing that which should be roundly condemned.

Given that representation or aestheticization inevitably glamorizes to some extent, those inclined to worry this way have ample cause. See, for example, the *New Yorker* review of *White Out*, which contends: "Any critic with a sense of social responsibility . . . has got to have some qualms about conceding that [Clune's *White Out*] is as good as it is." I don't consider myself dead to social responsibility, but nor can I conjure such qualms. "It is as preposterous to be 'for' drugs as it is to take up a position 'against' drugs," Ronell writes; I tend to agree. This does not mean I am insensible to the cataclysmic, often lethal suffering that drugs and addiction can cause—far from it. The question is how not to repress this suffering while also conducting an open-minded inquiry into "the intersecting cut between freedom, drugs, and the addicted condition."

Much drug writing is brutal and depressing, especially when imbibed in large quantities (something I rerealize whenever I teach a class on the subject). The unredeemed, icy portrait of addiction painted in Burroughs's *Naked Lunch*—as when Burroughs describes how, during a long dope binge, if a friend came to visit, he would "[sit] there not caring that he had entered my field of vision—a grey screen always blanker and fainter—and not caring when he walked out of it. If he had died on the spot I would have sat there looking at my shoe waiting to go through his pockets. Wouldn't you?"—is characteristic of the genre, as is Burroughs's challenge to the reader to cop to her own moral failings. The behavior described in portraits of addiction is often repugnant, as in jazz musician Art Pepper's description of raping a woman in his shattering, epic junkie memoir, *Straight Life*—a scene that remains the only extended

first-person account of raping someone I've ever read (most people don't admit to certain acts in print unless they feel, as did Pepper, that they have nothing left to lose).[1] The assuredness about the immoral nature of intoxication offered by, say, Emmanuel Levinas—"The relaxation in intoxication . . . is a suppression of fraternity, or a murder of the brother"—is often muted or absent in drug literature, even when the tale ends in recovery. I find this suspension of morality discomfiting, uncommon, and at times worthwhile.

Last warning: in teaching drug writing over the years, I've noticed that people's reactions to it are inevitably colored, at least to some extent, by their own experiences with substances or addiction. By extension, the same must be true of myself. I may write now as someone who prefers "loving without alcohol, drugs and madness—becoming-sober for a life which is richer and richer," as Deleuze had it, but my attitude toward drug writing has probably become *less* moralistic over time (likely because it has become less defensive), and more alive to humor and surprise. If I celebrate the genre, it is not for any blueprint of emancipation it provides, or for any confirmation of inevitable entrapment. It is for the flickering showcase it offers of our conjoined urges toward freedom and unfreedom, self-consolidation and dissolution, interiority and sociality, control and abandon—urges that move through us all the time, but that drug writing has the contestable virtue of presenting in extremis.

TO ENJOY A DRUG ONE MUST ENJOY BEING A SUBJECT

Crack Wars is not, as mentioned, really about crack. It is about the condition of Being-on-drugs as filtered through the lens of Emma Bovary, the decidedly unheroic heroine of Flaubert's infamous 1856 novel, which was itself put on trial for obscenity in 1857, charged with injecting poison into the social body. Despite the fact that the only drug proper in the novel is the arsenic of Emma's suicide (provided by the obnoxious, anticlerical, entrepreneurial town pharmacist, Monsieur Homais), Ronell reads the story as being fundamentally "about bad drugs," along with suicidal anguish and interiorized violence. By placing Emma Bovary and

her behavioral addictions at the center of the overlap between "freedom, drugs, and the addicted condition," Ronell implicitly suggests that, of all the available informants, "EB"—with her toxic maternity, food issues, trashy reading habits, overspending, failed religiosity, bourgeois romanticism, hystericized adultery, and death drive—is a rich source for an inquiry into pressing questions about freedom, care, nourishment, craving, and anxiety that have compelled philosophers from Kant to Nietzsche to Heidegger. I support this sly feminist gesture, in which a female human animal is treated, without fanfare, as a fulcrum for the human condition.

This gesture has not been a common one. If one "goes the way of literature," the most oft-cited cast of characters in the literature of intoxication includes Antonin Artaud, Charles Baudelaire, Walter Benjamin, John Berryman, Charles Bukowski, William Burroughs, Jim Carroll, Carlos Castaneda, Samuel Taylor Coleridge, Aleister Crowley, Thomas De Quincey, F. Scott Fitzgerald, Sigmund Freud, Allen Ginsberg, Aldous Huxley, Denis Johnson, Jack Kerouac, Ken Kesey, Malcolm Lowry, Henri Michaux, Arthur Rimbaud, Jean-Paul Sartre, Hunter S. Thompson, Alexander Trocchi, and Irvine Welsh. (Adding Emma Bovary to the mix may not be as disruptive as it might initially seem, as she is a creation of Flaubert's.) For readers of a certain generation, the preceding list likely provokes a host of heroic keywords, such as rebellion, quest, wildness, experimentation, bravery, defiance, transcendence. Why else are their books among the most shoplifted in the world, often propped up behind the bookshop counter, as if the transgressions they documented were somehow contagious?

I love many of these authors, some of them quite dearly. But it has never ceased to amaze me that their works are treated as vessels of macho liberation, even if, when read for their actual words and sentiments, many describe abject, even explicitly feminized experiences of dependency, fragmentation, abasement, compulsion, and penetration. Listen to Michaux, for example, writing about mescaline in terms reminiscent of being date-raped: "I had come prepared to admire. I was confident. But that day my cells were brayed, buffeted, sabotaged, sent into convul-

sions. I felt them being caressed, being subjected to constant wrenchings. Mescaline wanted my full consent. To enjoy a drug one must enjoy being a subject." That such testimonies of subjection can be so easily alchemized into examples of virile emancipation merits our attention.

As writer Kate Braverman, a self-identified drug addict for seventeen years, put it, "When men engage in bad behavior, they're enacting the mythic artist's life. When a woman writes about outlaw activities, she's considered a mentally ill whore." Such a double standard is obviously maddening; in its face, it can be tempting to flip the script, and to underscore, on the one hand, the penetrated, neutered, often pathetic quality of what Burroughs memorably called "The Algebra of Need" ("A dope fiend is a man in total need of dope . . . in a state of total sickness, total possession, and not in a position to act in any other way"), and, on the other, to lionize a fresh species of female outlaw whose drug use suffuses her with agency, coolness, and power ("Wow, man! I was a junkie. Jay-you-en-kay-eye-ee junkie. Junkie was something special, something big and important and heroic. Real wild. A name that meant something powerful and gutsy like Annie Oakley or Wild Bill Hickok," writes Barbara Quinn in her 1971 dope memoir, *Cookie*).

Such a reversal offers some immediate gratification. But eventually it leads to a cul-de-sac, in part because it ignores the dynamic—articulated by the late great critic Barbara Johnson—that male authors' "playing femininity" has never posed an impediment to the consolidation of privilege or prestige. To the contrary: in her 2000 essay "Gender and Poetry," Johnson points out how male bards have long testified to the "fragmentation, wounding, or loss of psychic intactness and control" brought about by romantic love, and how this testimony has long been presumed to convey profound insights into the nature of desire. But when women describe something analogous, it gets treated as proof of an intrinsic, specifically female instability or masochism. Add drugs to the mix, and you get closer to the "mentally ill whore" (cf. Emma Bovary). Add race, and you get the stereotypes of the crack mom or strawberry—two figures that feature incessantly in male representations of trauma or bottoming out.

Drug literature is often deeply pathetic at its core, which but magnifies the dynamics Johnson describes. Weirdly, the more pathetic the masculinity at stake, the more heroic it can seem (think of the reception of Karl Ove Knausgaard, for example, whose *My Struggle* plumbs new depths of pathetic masculinity, often in relation to the humiliations—and, in one indelible instance, a literal defacement—wrought by alcohol). As Eileen Myles writes in an essay about pathetic art and gender, "The concept [of the pathetic] is clear when a man does it because a man has to DO SOMETHING in order to be pathetic. He is not intrinsically pathetic like a woman is." A similar dynamic led Johnson, back in the heyday of deconstruction, to wonder whether the popularity of the concept of "self-resistance" (as elaborated by Paul de Man, Johnson's former teacher, and others) was "one of the few viable postures remaining for the white male establishment."[2]

I don't think that, when exploring self-resistance, male artists or writers are necessarily aiming to take up one of the few remaining postures left to them; I'm totally into pathetic masculinity. My curiosity lies in how we might spring ourselves from the trap Johnson describes: "It would seem that one has to be positioned in the place of power in order for one's self-resistance to be valued." Escaping, or refusing, this trap makes two things possible: it enables us to register self-resistance from those presumably disinclined to it, and it allows us to register differently the self-resistance of those whose subjecthood is presumed to be a priori compromised or shambolic.

Johnson's use of the passive voice—"one has to be positioned in the place of power in order for one's self-resistance to be valued"—implies that we might have to wait for the broader culture to change before undertaking such a rearrangement. But why wait? About Baudelaire, Johnson asks, *Why is male masochism the secret that it is lyric poetry's job to keep?* What if we noticed something similar about drug literature, and let the secret out? After all, it seems clear enough that when Michaux writes, "To enjoy a drug one must enjoy being a subject," by "subject" he means an entity that has submitted to a superior power, either by force or consent (or some combination thereof), not the "other kind" of subject, aka

a sovereign individual, imbued with free will, fully in control. One could argue that Michaux's comment is specific to the drug at hand (mescaline); certainly there are some substances—namely, amphetamines—that famously make one feel "on top of the world" rather than overpowered or adrift. (To avoid the generalizing about drugs in which I am here indulging, Boon smartly divides *The Road to Excess* into chapters on narcotics, anesthetics, cannabis, stimulants, and psychedelics, arguing that each drug has produced its own canon.) But, as speed addicts come to know, this "take charge" feeling has an underside, a comedown, that sabotages whatever inflated sense of sovereignty and control the drug provided, leading right back into the thorny knot of subjecthood and subjection.

We often treat these opposite meanings of the word "subject" as an accident to be ignored or denied. But, as philosopher Étienne Balibar has explained, this two-thousand-year-old "historical play on words" may actually "provide us with the clue to unraveling the following enigma: why is it that the very *name* which allows modern philosophy to think and designate the *originary freedom* of the human being—the name of 'subject'—is precisely the name which *historically* meant suppression of freedom, at least an intrinsic limitation of freedom, i.e. *subjection*?"[3] I have no quick answer to this question, save noticing that freedom gains meaning in relation to its limits, and that drug writing provides a rich place to contemplate the at times manic inhabitation of this enigma.

I LIKE TO HORRIFY PEOPLE

At the end of *Crack Wars*, Ronell invents her own "EB" to joust verbally, alongside a handful of other unmanageable women (Marguerite Duras, Marguerite Faust, Saint Teresa de Ávila, Irma of Freud's "Dream of Irma's Injection"), with several European male thinkers famous for their pontifications about addiction, including Ernst Jünger, Derrida, Heidegger, Freud, Nietzsche, Baudelaire, and Benjamin. At one point in this dialogue, Ronell's EB says, "I smoke in order to metabolize my anguish. In the public sphere, it is a provocation. I like to horrify people. They abhor signs of woman's narcissism. One smokes for oneself, even against the other."

This comment draws us into one of the most common stigmas attending women and addiction: that addiction derails the natural desires of the female animal, which should properly circulate around the needs and desires of others. Such caring, the story goes, preserves the bonds that glue together family, community, humanity, and biosphere, even—or especially—if men go around trashing them. The particular pathos of female addiction is that, as sociologist Elizabeth Ettore has written, it replaces the culturally acceptable norm of female dependency (dependency as subordination) with a reviled one (dependency as addiction).

Seen in this light, one of the reasons that male drug use and/or addiction can so easily mesh with the "hero's journey"—that ancient narrative structure characterized by quest, trial, transformation, and triumphant homecoming—is that the hero's journey is, by definition, a sojourn *away* from domestic sociality (even if the eventual goal is to rejoin it), fueled by a fabled, nearly irresistible need to "ramble on," or "get experienced," rather than stay behind and care for those back at the ranch. In this way, the desocializing quality of addiction—its tendency to supplant caring for others with care for one's next high—corresponds to certain common expectations of masculinity, be they heroic, pathetic, or even queer. (See, for example, Alfred Leslie and Robert Frank's 1959 film *Pull My Daisy*, in which painter Larry Rivers plays Milo, a man prodded away from his ball-and-chain, hetero-domestic environment by the giggling, stoned, homoerotic crew of Allen Ginsberg, Gregory Corso, and Peter Orlovsky; the film ends with Milo escaping for a night out with the boys while his wife, caretaker of their young son, weeps in protest. "Don't cry. There's nothing to cry about," Milo tells her. "What do you know about what to cry about?" she says. "I certainly do know what there is to cry about and it ain't nothing that has to do anything with this that's happening right now," Milo says, angrily kicking a chair on his way out. With whom, I wondered as a young poet, was I here supposed to identify?)[4]

Such shirking chafes against stereotypes of the male provider—hence the charge against the (male) addict that he "produces nothing, nothing true or real" (Derrida), or that he is on the side of the "takers, not the makers" (à la Mitt Romney, circa 2008). But in truth, the provider and

rambler mythos are linked via a certain well-worn loop (think: "Lord, I was born a ramblin' man, / Tryin' to make a livin' and doin' the best I can. / And when it's time for leavin', / I hope you'll understand, / That I was born a ramblin' man"). Such a loop produces strife, but has nowhere near the monstrous valence of the spectacle of a "woman's narcissism"— EB's smoking "for oneself, even against the other." This is especially so if the woman in question is a mother or potential mother (which is to say, most women, in the eyes of many).[5] Imagine if Delphine Seyrig, the actor who plays the suffering wife in *Pull My Daisy*, decided to join the boys in smoking some hash, guzzling a bottle of cheap wine, and setting out for a night on the Bowery, leaving her son asleep upstairs; the film would quickly shift from lighthearted Beat classic to appalling portrait of maternal negligence. Seyrig's virtuoso performance sixteen years later in Chantal Akerman's feminist masterpiece, *Jeanne Dielman, 23, quai du Commerce, 1080 Bruxelles*, makes for an interesting bookend here, insofar as that film depicts Seyrig's character dutifully performing three days of domestic duties before suddenly stabbing a man to death with a pair of scissors.

Think, too, of the well-trod narrative of the Black male addict waking up from a drug haze into a renewed and sustaining political consciousness (cf. Malcolm X, Iceberg Slim, D. Watkins, etc.), compared to the lack of a well-worn narrative arc of political redemption or enlightenment for the addicted Black mother, despite her endless depiction in popular films, from *Boyz n the Hood* to *Jungle Fever* to *Losing Isaiah* to *House of Payne* to *Moonlight*. I'm all for supplanting drug dependency with political agency, but it's important to note that, if and when this journey is synonymous with "becoming a man," the female addict's "freedom struggle" will remain forever "opaque, untranslatable into the lexicon of the political," as Hartman has said of the plight of the Black female domestic laborer.

Such untranslatability derives from radical injustice and inequity. But it may also signal possibility, in spite of its noxious root. At the very least, it forces us to slow down and examine our drive to convert struggles of all kinds into heroic narratives of personal or political reconstitution.

It makes us stay a little longer with breakdown, which in turn leads us to ask more questions about what, exactly, when something has broken down, we want to build up in its place.[6]

Rather than a bottoming out followed by a bounce back to a (re)con-solidated subjectivity, drug writing by women often features a hurtling past bottom, and emerging somewhere else entirely. This doubling down can be quite harrowing, especially when sex is part of the equation, as it often is. Male film directors often illustrate this combination by way of a repulsive, gaunt female figure staggering into the frame to sell sex for drugs, or a semiconscious female form being fucked mercilessly in a cor-ner; in films made by white men—such as in 2000's double whammy of *Traffic* and *Requiem for a Dream*—a wasted white girl having sex with a nonwhite man serves with gross regularity as some kind of ultimate deg-radation. When we peel ourselves away from such spectacles and stick with the women, however, we hear different sounds. These are not nec-essarily pleasing sounds, but they have the virtue of expanding our pre-vious sense of the palatable or possible.

One such sound is the express rejection of empathy, sociality, and dependency-as-subordination. As one of Anna Kavan's characters, in a story from Kavan's deeply strange, classic collection, *Julia and the Bazooka* (the bazooka being a syringe), puts it, "I've never enjoyed my life, I've never liked people. I love the mountains because they are the negation of life, indestructible, inhuman, untouchable, indifferent as I want to be." I may personally hope to be a warm, life-affirming per-son with strong social bonds, but given the rage that customarily greets women who don't feel put on the planet to be earth mothers, giving trees, community glue, or moral consciences, their icy or insurgent rejec-tion of such roles can be a bracing, doxa-rearranging pleasure.

At the far end of this "negation of life" lies Ellen Miller's 1999 novel *Like Being Killed*, in which our narrator—a fat, erudite, "suicidal, strung-out, psychotic Jew under thirty," Ilyana Meyerovich—actively couples drugs and BDSM sex in pursuit of her "auto-exterminationist" campaign con-ducted on the Lower East Side:

I was doing exactly what Primo Levi warned against: bringing into my own home what was inflicted upon people who looked like me in a catastrophe that might have been mine. The world I chose to inhabit now had appropriated a history of suffering and slaughter that I despised strenuously but of which I had been made an instrument. . . . Methyl-amphetamine, known here as copilots, synthesized in Germany, fed to the Luftwaffe before blitzkrieg operations. Göring addicted to heroin—a trade name derived from the German *heroisch*, for heroic, a conceptual link that persisted in brands available on these streets: Balls, Courage. Heroin marketed by Adolf von Baeyer, discoverer of barbiturates, such as Luminal, known here as Purple Hearts.

There was no final solution. Heroin was just one weapon, and addiction just one strategy, in a struggle that no one won or lost, while forces were deployed. . . . I needed something totalizing—an auto-exterminationist campaign—but instead I circled the drain, flickered on and off, faded and lingered, dwindled, dwindled.

As Ilyana dwindles via drugs, her personal pain striated with an urge to replicate her Jewish family's experience of historical violence, her "circling the drain" becomes nearly literalized in an affair she begins with a hairy, sadistic plumber she finds in the *Village Voice*. "I was falling, and I wanted the plumber—who arrived two hours after I'd beeped him—to join the descent." And join her he does—by his second visit to her filthy apartment (she's been shitting in her cat's litterbox), he's hog-tied her, fed her innumerable drugs, stuffed her mouth full of a pack of cigarettes, and told her, "I just want you to get so fucked up you won't even know what I'm doing to you." And that is precisely what happens, over many subsequent visits and hard-to-read pages.

No matter the excruciating pornography of these scenes, which involve knives, a neurowheel ("He left my face alone"), asphyxiation ("I blacked out once, but each time, I woke up eventually, with gashes and rope burns encircling my neck"); and nearly fatal amounts of force-fed drugs,

Ilyana is not satisfied. Eventually, she wants gunplay. And it's not enough for her to have the plumber clip open her labia with clothespins and fuck her with his Colt, nor for him to fuck her in the ass with it, then make her fellate it ("The gun tasted brackish," she reports). She doesn't want it to feel "like being killed"; she wants the plumber to kill her. When he won't do it, she is angry at him for letting her down, and takes matters into her own hands. "I would give the gun a blow job the plumber would never forget," she says, before dizzily placing the gun in her mouth and pulling the trigger. She pees herself, but remains alive; the plumber, it turns out, had been playing with blanks.

Miller was onto the double standard that meets this kind of writing. In a 1998 interview, the interviewer tells her, "I can honestly say I have never read sex scenes as upsetting as these. I was reading some of it while lying in bed with my boyfriend, and I was tsking and gasping and saying 'Oh my God, oh my God!' and when he asked what I was reading, I found I couldn't even tell him. I couldn't even say the words." Miller says, "Well, the reaction to this kind of writing is highly gendered. People are more willing to swallow this type of thing when men do it, and even think they're cool. They're adventurers. When you're a man, it's courage; when you're a woman, it's disgusting." But Miller's not content with the simple reversal that would refigure the abject as cool or courageous. She's interested in how the quest for obliteration—to be "crusty and bloody and caked with shit and puke and snot and dirt," to be wrecked, fucked, but *not dead yet*—links to the spiritual quest to feel "part of something that is bigger than the sum of its parts." "Convoluted as it is, as misdirected and re-routed as it is, being with the plumber is [Ilyana's] own very distorted quest for joy," Miller tells her interviewer (to which the interviewer responds, "*Good God almighty*"). Undeterred, Miller goes on: "Or power, or a sense of existing in relationship, not in a completely isolated monad of the self. One thing we can't deny about her and the plumber is that they know what each other wants. Not that many people in her life have been willing to pay that kind of attention to her. . . . I believe, and I hope the reader believes, that for Ilyana, everything she does, including the most terrible things, have some kind of wish for redemption behind them."

I believe it, because *Like Being Killed* makes me believe it. Whatever liberation is to be found in its pages doesn't lie in the success or failure of Ilyana's quest (she does end up alive—which, tragically, is more than can be said of Miller, who died of a heart attack at age forty-one, with *Like Being Killed* left behind as her only work). It lies in Miller's jocular audacity as she explores the awful and awesome kinship between this search for redemption, company, and recognition; the pain of intergenerational trauma; and the desire for self-obliteration. It lies, too, in Miller's insistence on pursuing this kinship through the most gruesome waters, daring to write things down about which others might say, *I couldn't even say the words* (I felt similarly, in retyping some of the above passages).

Again, not all transgressions are created equal: God knows, just because something is hard to read or watch, that doesn't mean it's intrinsically worthwhile. But in this instance, the sounds feel to me vital and novel. And also, not novel: as Ilyana says in punctuation of her final soliloquy about "like being killed," a state in which, in your darkest hour, "there's still a violence in you that's inspired and struggling": "And the voices of eternally, exquisitely suffering women soared in the air, resounding above and through my words." Whether Ilyana/Miller is being sarcastic about this chorus of women scarcely matters: they sing on, regardless.

THE REHABILITATION OF ADDICTION

Miller's approach is wry but operatic; for a more straight-up satire focused on the Venn diagram of sex, drugs, abjection, and liberation, I know of none better than Iris Owens's classic novel *After Claude*, published in 1973, six years after the Summer of Love. The first two-thirds of *After Claude* consist of our caustic narrator, Harriet, slugging wine and tranquilizers, engaging in sociopathic stunts, and hurling witticisms and abuse at her French lover, Claude, who is struggling to uproot her from his Greenwich Village apartment. The last third takes place at the Chelsea Hotel, where Claude has finally dumped Harriet. "Had anyone ever been more irrelevant, more excluded from the human celebration?" a strung-out Harriet

wonders upon waking up on a "thin, tufted mattress [that] had crippled [her] for life." Eventually Harriet staggers to the room next door, where an aspiring cult leader named Roger is running a Manson-like harem of stoned women who vie for his attention, play the bongos, and watch the static on TV.

Owens could have used her serrated wit simply to eviscerate a figure like Roger, a "prematurely balding, soft-skinned, pale-eyed fetus type" wearing nothing but "Levi's held to his hips by a wide, silver, buckled belt," who alternates between giving sermons about letting go and engaging in rank sadism and manipulation (you know the type). But rather than exposing his scam in order to let Harriet come out the wiser, Owens paints Harriet as both onto his trip *and* needy to the point of pitiful in its face. The combination underscores a principle upon which Owens's ex-friend Emily Prager, in her introduction to a reprint of *After Claude*, says she and Iris were in full agreement: "There is nothing that warms a smart girl's heart like the smile on the face of a sadist."

In the novel's final scene, Roger talks Harriet through taking off her clothes and bringing herself to orgasm in front of the group: "Now, Harriet, I want you to observe how your body becomes one undifferentiated mass of feelings. . . . It's beginning to free itself of its murderous fragmentation. It's becoming a unity, a simple, palpitating diffusion of sensations. Go ahead, play with it, confuse it, show it some love. My beautiful free brave girl, it makes me so happy to watch you make yourself happy. . . . Open your eyes, look at me, baby; let me see how happy you're making yourself, please." Looking into his bloodshot eyes, "the rims speckled with white flakes, his face drawn with a profound fatigue," she comes, raucously: "I was afraid the spasms would possess me forever, and when they began to subside and weaken, I shut my eyes and tried for at least one more." Afterward, one of the girls asks Roger, "Did you get it on tape?" Which, of course, he did. Harriet is angry and humiliated, but still, she begs Roger to take her with him to his "Institute" in Vermont. "Please, Roger," she pleads. "I want to be a bird. I want to fly with you." He refuses, leaving Harriet on her own once again. The novel ends with Harriet back in her room: "I opened a fresh pack of Marlboros and stared

at the brown and white circles. I had no thoughts, only a dim awareness of myself listening and waiting."

In an interview about how *After Claude* came to be, writer Stephen Koch says that he typed up whatever Owens managed to scribble down each week, as Owens had a "capacity for procrastination, indolence, and inaction beyond anything [he'd] ever seen in someone so gifted." But Owens never let Koch see or type up the final scene at the Chelsea. "I'm not quite sure why," he says. "I can't even speculate. Except it was for her, everything. The final scene was essential. It couldn't not be there. Its role was overwhelmingly significant." I can't know why Owens didn't let Koch type it up either, but her prepublication privacy concerning this conflagration of release and humiliation makes sense to me. The scene fiendishly skewers the idea of liberation to be found at the hands of skeezy guys who encourage you to finger yourself on tape while feeding you wine and weed, at the same time refusing to offer a simple model of feminist liberation in its place.

As with *Like Being Killed*, whatever feeling of freedom *After Claude* imparts stems not from the narrator's journey but from Owens's writing— from her uncompromising, insubordinate wit and her willingness to let Harriet be both nobody's fool and so pitiable she inhabits a place beyond pity. That we leave Harriet staring at her cigarettes seems right, insofar as they have become a talisman of both rebellion and servitude: on his way out the door, Roger instructs Harriet not to smoke, grabbing her last cigarette and tearing it into pieces (one of his girls tells Harriet he considers commercial cigarettes a "nasty habit"). If she leaves her cigarettes behind, she is doing Roger's paternalistic bidding; if she picks them up, she will continue to make herself sick, as she has been convinced she is having a heart attack for many pages. (According to Koch, Owens—a heavy smoker—was long terrified of developing lung cancer, which eventually she did; she died within a week of her diagnosis.)

There is precious little in *After Claude* that feels "sincere," but its final line—"I had no thoughts, only a dim awareness of myself listening and waiting"—moves me. It echoes the last line of *Like Being Killed*, in which

Ilyana sits next to her friend who is dying of AIDS, "each holding the other's hand in the air between our chairs, loosely, like a rickety footbridge of flesh suspended over a ravine—for a very long time." Rather than achieving redemption or falling into unredeemable wretchedness, there is pause, suspension. We sit with our narrators in an uncomfortable, loaded silence, then take their leave. There is no telling what is going to happen next.

As much as I may admire Owens's searing wit, Miller's portrait of radical self-degradation, or Ronell's assertion, via EB, that she likes "to horrify people" (an amplification, perhaps, of Ronell's comment elsewhere that one of her motivating slogans is that a woman should be "a pain in the ass"), it has always struck me as deeply suspect to try to reclaim the suffering or monstrosity of the female addict as some kind of role model. Even if and when one turns away from relations of care or connection that feel compelled or constricting, replacing them with compulsive drug use is not usually a recipe for liberation. Some critics have attempted to argue otherwise—see, for example, Karen Kopelson's advocacy for something she has called the "rehabilitation of addiction," wherein we could see "(women's) drug use and/or addiction as a kind of embodied practice of freedom": "To argue for the emancipatory properties of addiction and drug use may indeed seem unreasonable, even impossible. . . . 'Reason,' however, is a hegemonic, masculinist logic par excellence, and the circumscription of possibility is what feminist deployments of excess have always aimed to transgress."

I appreciate this argument's disobedient spirit. Unfortunately, in addition to ceding to men the domain of "Reason," it depends upon the opposition of freedom to a sobriety conceived of as a "compelled indentured servitude to the supreme values of moderation and restraint," an internalization of "the regulative ideal of freedom itself." It's well and good to stay alive to how, when, and why certain forms of freedom might become regulatory in their own right. But the failure to see sobriety as anything but a "compelled submission to total self-denial/abstinence" strikes me as limited to the point of absurd, as does Kopelson's faith that any defiance of "hegemonic, masculinist logic" automatically delivers a salutary opposite.

Attempts to revisit and revalue the pathologized, criminalized behavior of women in revolt (as in Saidiya Hartman's 2019 book *Wayward Lives, Beautiful Experiments*) can offer inspired models of recuperative practice (even if, as Hartman makes clear, she does not consider *Wayward Lives* a text of sexual liberation—Graeber's "defiant insistence on acting as if one is already free" does not, for Hartman, constitute liberation). Alas, when it comes to drugs, recuperative practice runs into serious potholes. Foremost among these is that those in the grip of addiction are not known for distinguishing between the defiance of norms and values we might think deserve defiance, and the violation of ethical principles we might hold dear. As Owens once said to Prager (on a night when they were both blasted), "Whenever you feel yourself wanting to do good, run in the opposite direction." I believe she meant it.

Famous addicts who double as feminist icons—such as Courtney Love or Billie Holiday—may embody for spectators essential forms of disobedience, fugitivity, and excess; I have felt that way about both singers. But we don't need to put big contradictory messes into a machine and extrude either liberation or failure; we don't need to redeem their struggles into "embodied practices of freedom," especially if doing so entails refuting their own testimony. (Think, for example, of the plaintive "I want the cure" speech that Holiday gave to the judge about to sentence her to hard labor in a West Virginia penitentiary for heroin possession, or her comments in her autobiography: "People on drugs are sick people. . . . Imagine if the government chased sick people with diabetes, put a tax on insulin and drove it into the black market, told doctors they couldn't treat them . . . then sent them to jail. If we did that, everyone would know we were crazy. Yet we do practically the same thing every day in the week to sick people hooked on drugs." We can hail Holiday's excess, wiliness, and power, along with her valiant attempts to outrun the racist cops who worked for so many years to destroy her—"They are going to arrest me in this damn bed," she said of the narcs hounding her, and she was right—she was indicted by a grand jury and handcuffed to her hospital bed as she lay dying, age forty-four—without exalting her addiction into a practice of freedom she herself would not recognize.)[7]

As Owens's legendary difficulty suggests (Koch calls her "a sort of monster" with a "very wide sadistic streak"), the pleasures of socially disruptive or ethically transgressive behaviors can be far easier to bear and celebrate on the page or stage than in "real life"—a phenomenon underscored by the highly publicized Title IX case filed against Ronell in 2018, in which one of Ronell's male graduate students charged her with toxic pedagogical care and sexual harassment. As the case cycled through the news, even making the front page of the *New York Times*, many eagerly vilified Ronell as a narcissistic, pathologically fragile, sexually incoherent, even vampiric woman whose idea of being *a pain in the ass* had led her to abuse power rather than challenge it (*" 'EB,' c'est moi"*?). Ronell's professional misdeeds seemed to me real. But the voracious appetite for her public humiliation was instructive, insofar as it demonstrated how quickly the celebration of female thinkers and artists who explore extremity and transgression can turn into sanctimonious repulsion if and when their relationship to such things turns out to be contaminated, not to mention how quickly we rain down censure on the living while sanguinely worshipping the transgressive imaginary or dead.[8]

The tendency to celebrate certain forms of transgression only from afar or in the abstract makes a kind of sense: acts of rebellion inevitably read to us differently depending on our point of view, and on our distance from those acts in space and time. Many people's aperture or appetite for chaos—including my own—is much larger when it involves "art" rather than "life," or strangers rather than intimates. This all strikes me as fine. Less fine, I think, is to celebrate certain behaviors as "embodied practices of freedom," then to express disgust and censure when confronted with living examples at close range. At a minimum, such a reaction ought to remind us of the difficulty of difficult things, drugs not least among them.

THE BLONDES

The literary genre of the "addiction memoir" has tended to be very white, and, even when it's not, very male.[9] The reasons behind such a situation are numerous and complex, and likely have something to do with white writers'

propensity to frame their experience as detachable from socioeconomic-political forces that tend to be glaringly obvious to others; such a propensity leads to the creation of works more easily classifiable as "addiction memoirs."[10] But while white addiction narratives may at first glance appear to be devoid of racial consciousness, upon closer inspection, most appear saturated with anxieties about whiteness, as well as with strategic (if unconscious) deployment of racialized tropes that "surface endlessly when one begins to look carefully," as Toni Morrison has it in *Playing in the Dark*.

In the case of *Crack Wars*, one doesn't even have to look past its title, whose aforementioned bait and switch highlights its own chaotic symptomology. For whatever horrors the transgressions of Emma Bovary/EB/Ronell may provoke, they fade in comparison with the brutal state-sponsored persecution and punishment of Black people, including Black mothers, that characterize the War on Drugs.[11] Yet whatever unease, revulsion, and anger I've felt on this account has, over time, deepened my interest in *Crack Wars*. For by throwing EB into the combustible cauldron of the "war on drugs," Ronell invites certain questions about the relationship between white girls and the racialized construction of drugs and transgression—questions that go mostly unanswered in *Crack Wars*, but which crack open the door to further inquiry.

Given their lack of access to public space and independent funds prior to the 1960s, many white women used drugs as patients—either as in-patients in residential settings (as was the case with Kavan), or by scamming drugs from medical settings (cf. the infamous pill-popping milieu memorialized in Jacqueline Susann's *Valley of the Dolls*).[12] But as white women hit the street market, their literary accounts began to reflect the racialized dynamics that have long shaped the criminalized world of "drugs." Some evidence a fetishizing enthusiasm, as in Ann Marlowe's chiseled, chilly memoir *How to Stop Time: Heroin from A to Z*: "Copping feeds the middle-class fascination with the street. Finally you're out there with the scary people, not cowering from them, but joining them." (The combination of Marlowe's enthusiasm for being "out there with the scary people" and her unabashed elitism—she was a Wall Street exec by day,

Alphabet City crawler by night—is often perfectly revolting, with the debatable virtue of advertising that which others tend to euphemize.) For white girls with more social conscience and savvy, such as Michelle Tea's first-person narrator in the autofictive *Black Wave*, there is more self-awareness and political discomfort, both of which are ultimately mowed over, for better or worse, by the power of the drug: "Michelle wondered for a second if there were diseases to be caught from the burned glass pipe of a career crackhead, but she had learned that fearful questions in such situations could lead to racism, to classism, to all sorts of unevolved and judgmental states of mind, and so one did not think too hard. One just accepted the chipped pipe with its charred bowl and one inhaled."

Whether embraced or disavowed, the most common trope is that of whiteness as a spiritually or culturally deficient identity that white folks long to leave behind, either through the destabilizing effects of the drugs themselves, or by means of the relatively "mixed company" that buying and using can occasion (think not only of Marlowe's "joining the scary people," but also of Norman Mailer's "White Negro" [1957]—the white hipster who opts to slum it in nonwhite realms associated in the white cultural imagination with liberation, pleasure, and drugs, be it a kif den in Tangier, a jazz club in lower Manhattan, or a shamanistic ceremony in Mexico). This urge is a staple of white "outlaw" drug writing, from Rimbaud to Kerouac to Burroughs to Paul Bowles. (While a certain envy, erotics, or infatuation with the fantasized Other is most common here, there also exists some more directly antagonistic, stone-cold racism in this tradition—see De Quincey's horror of the so-called Orient from which his opium comes, or the erratic, searing racism in Pepper's *Straight Life*; one could fairly see this envy and antagonism as flip sides of the same unseeing coin.)

Rimbaud's *A Season in Hell* (1873) provides a kind of Ur-text for white avant-garde primitivism and the "White Negro" current of the century to follow. Rimbaud starts out with a description of his own whiteness and ancestry—"From my ancestors the Gauls I have pale blue eyes, a narrow brain, and awkwardness in competition. I think my clothes are as barbaric as theirs. But I don't butter my hair"—before moving into

spasms of hatred for the white race, Europe, and Christianity. He then announces: "My daytime is done; I am leaving Europe. The air of the sea will burn my lungs; lost climates will turn my skin to leather. To swim, to pulverize grass, to hunt, above all to smoke; to drink strong drinks, as strong as molten ore, — as did those dear ancestors around their fires. I will come back with limbs of iron, with dark skin, and angry eyes." Rimbaud even goes so far as to tell his interlocutors that his whiteness is something of a case of mistaken identity: "I have never been one of you; I have never been a Christian; I belong to the race that sang on the scaffold; I do not understand your laws; I have no moral sense; I am a brute; you are making a mistake . . . I am an animal, a *nègre*." He vows to "quit this continent" and "enter the true kingdom of the sons of Cham." It seems no accident that this desire correlates to a desire "above all to smoke; to drink strong drinks, as strong as molten ore," and to undertake a "long, boundless, and systematized disorganization of all the senses" (a phrase taken up a century later by Jim Morrison, a Rimbaud devotee).

In what sense Rimbaud ever did enter "the true kingdom of the sons of Cham," no one knows for sure. But he did leave Europe—first for Java, then Cyprus, then finally Abyssinia, where he traded guns and coffee for a decade until his death at thirty-seven. In 1936, Artaud took a related tack, leaving Europe in search of peyote rituals among the Tarahumaras in Mexico. Derrida characterizes Artaud's mission in Mexico as follows: "There was the project of uncovering a system of norms and prohibitions which themselves constitute European culture and especially European religion. He hoped that Mexican drugs would allow the emancipation of the subject; provide an end to that subjection which from birth had somehow expropriated the subject; and most of all, provide an end to the concept of the subject."

Seeking "an end to the concept of the subject" sounds more highbrow than, say, the purple prose, white-boy lament of Kerouac in *On the Road*: "At lilac evening I walked with every muscle aching among the lights of 27th and Welton in the Denver colored section, wishing I were a Negro, feeling that the best the white world had offered was not enough ecstasy for

me, not enough life, joy, kicks, darkness, music, not enough night. . . . I wished I were a Denver Mexican, or even a poor overworked Jap, anything but what I was so drearily, a 'white man' disillusioned." In the end, however, I doubt the visions are all that different. Despite Artaud's frantic (and, it must be said, mad) attempts "to be done with the judgment of God" (and Rimbaud's insistence—allegedly recanted on his deathbed—that he had "never been a Christian"), both appear firmly in the grips of a particularly white rendition of a "loss of the garden of Eden"—"a weird nostalgia," as Baldwin put it in an essay on Mailer (in which Baldwin also discusses this passage in Kerouac), for a better time against which the present comes up unbearably short, whether via "not enough life, joy, kicks, darkness, music, not enough night," or the desire to Make America Great Again.

What to say? One could simply respond to this passage in Kerouac as Baldwin did: "This is absolute nonsense, of course: objectively considered, and offensive nonsense at that; I would hate to be in Kerouac's shoes if he should ever be mad enough to read this aloud from the stage of Harlem's Apollo Theater." And so it is. I mean, how great to realize how screwed up whiteness is, albeit in a *Dances with Wolves*, let's-leave-white-settler-colonialism-behind-and-go-Native kind of a way; how quintessentially fucked up to then presume that your emancipation, your "freedom and fun," are to be found in the cultures (or fantasized cultures) of non-white peoples whom you and/or your ancestors have spent the past several centuries colonizing, plundering, demonizing, incarcerating, murdering, and appropriating; how galling to perform this search for spiritual emancipation while the criminal justice system works overtime to make sure that nonwhite others disproportionately pay the price. Adherents of the MAGA mindset imagine their lost Eden as a land unequivocally governed by white supremacy, and promulgate the fiction that Black and brown others are the cause of their fall and suffering; adherents of the "disillusioned white man wishing he were a Negro" mindset seem to be suffering a different but related hangover, like: *It was all supposed to be so great—the Enlightenment, the colonies, the Constitution, the Wild West, the Confederacy, postwar superpowerdom—so why do I feel so rotten? Why can't I access the ecstasy, the "joy and kicks," that I feel should be my due? Maybe*

there IS a kind of freedom specific to those who have suffered bondage, and maybe it's a better, deeper one, than the kind I've got! Maybe I should go get that, too! This is the mise-en-scène of Mailer's "White Negro," in which Mailer makes the case that, due to the threat of atomic annihilation, white hipsters finally know something of the danger and dread that has characterized "Negro life" for centuries ("Any Negro who wishes to live must live with danger from his first day, and no experience can ever be casual to him, no Negro can saunter down the street with any real certainty that violence will not visit him on his walk," Mailer wrote, over sixty years ago).

Those in the grips of such fetishism have not misdiagnosed the profundity of their malady (which is what makes Mailer's essay both so offensive and so hard to bury). But they often fail to recognize that the problem was seeded long ago, with the invention of whiteness, which entails the projection onto Black and brown bodies of all the irrationality, disobedience, heathenism, and open rebellion that constitute the underside, or the "outside," of so-called civil society and reason. Given such a projection, the racialized War on Drugs (and its twin, mass incarceration) was only a matter of time, the latest manifestation of a centuries-old habit. As Derrida wrote, "The luminaries of the Enlightenment (*Aufklärung*) . . . are in themselves a declaration of war on drugs."

The urge to transgress, to stray from normative boundaries of self, law, and society—to "allow the emancipation of the subject," up to and including self-resistance and the annihilation of ego—are enduring and legitimate human desires, shared by people of all kinds, in all places, throughout time. The way through this predicament cannot lie in hoping for their extinguishment. But we must squarely face the ways in which running them through a racialized schema has been catastrophic—for Black and brown people, most crucially and cruelly, and for white people as well. So, before joining in a rousing chorus of Patti Smith's "Rock N Roll [N-gger]," in which Smith (leaning heavily on Rimbaud) unites and celebrates all kinds of outsiders, from Jesus Christ to Jimi Hendrix to Jackson Pollock to "grandma, too" under the rubric of "n-gger," we might instead pause, and attend to this history. This task is not about deciding

whether or not to cancel a particular artist or song; the songs are powerful for a reason. (Part of this reason has to do with the anarchic, oft-repressed possibilities of interracial and cross-racial identification, as made explicit in, say, Baldwin's writing on Joan Crawford and Bette Davis in *The Devil Finds Work* [1976], or Hilton Als's 2014 essay collection *White Girls*, which takes as its premise Als's identification, as a Black man, with white women, and sets out to explore the complex cross-racial identifications of figures such as Eminem and Richard Pryor.) It's about reckoning with the historical construction of transgression, the challenges of uneasy alliances in the quest for liberation and defiance, and the question of what white folks can or should do (or shouldn't) when they recognize that the systems they've constructed or inherited damage, degrade, and kill them also.[13]

I can't speak to the effect Rimbaud or Artaud had on the people and places they visited, but such encounters tend to follow a certain script, one that played out lucidly in the story of Mazatec shaman María Sabina, who became famous in the 1960s after R. Gordon Wasson, a J. P. Morgan banker turned ethnomycologist, published a 1957 article in *Life* magazine about Sabina's knowledge of psilocybin mushrooms, which sent scads of foreigners rushing to find her.

At first, Sabina welcomed the visitors who came to her home in Mexico searching for transformative hallucinatory experiences. (She called her visitors—who included Mick Jagger, Bob Dylan, Keith Richards, and John Lennon—"the blondes.") But, as Sabina recalls in her remarkable oral autobiography, *The Life*, the blondes eventually had a ruinous effect, not only on Sabina's community, but on the mushrooms themselves. "From the moment the foreigners arrived to search for God," she says, "the *saint children* lost their purity. They lost their force; the foreigners spoiled them. From now on they won't be any good. There's no remedy for it." Sabina's dealings with the blondes brought her other forms of suffering as well: she was persecuted by the Mexican police for drug trafficking, her house burned down, presumably by her Mazatac neighbors, as punishment, she believed, for her decision to give "the ancestral secret of our native medicine to foreigners."

As a healer, Sabina was mostly appalled that the foreigners came looking for God rather than attempting to heal sickness. "'We come in search of God,' they said. It was difficult for me to explain to them that the vigils weren't done from the simple desire to find God, but were done with the sole purpose of curing the sicknesses that our people suffer from." Derrida may contend that what we hold against the drug user is his pursuit of "experience without truth," but Sabina adds an important twist: whether a drug experience brings "real truth" or "false truth" may be beside the point if the pursuit of truth itself, either conceived of as "God," "the secret of the universe," "cosmic excess," or something else, is simply *the wrong quest*. Sabina's clarity on this account, along with her wit as a storyteller, makes *The Life* especially generous and mordant, as in the following passage: "A young foreigner who wore multicolored clothes and sandals wanted to give me a big, pretty dog. I told him I didn't want a dog, that I didn't have the money to maintain it. What was the animal going to eat? Shit? The young foreigner understood my situation and took his dog with him."

If she could do it all over again, however, Sabina says she would still have shared her wisdom with the blondes, "because there is nothing bad in that." No one in her autobiography comes off as a saint—not her Indigenous community, not the Mexican government, not her intimate family, not Sabina herself; nor does she treat the foreigners—including R. Gordon Wasson—as sinners. Most often she just calls the blondes "stupid" and "disrespectful." The layers of suffering, violence, and exploitation in Sabina's story describe a centuries-old colonial history and a legacy of rural poverty, replete with other causes of suffering, such as husbands who cheat and abuse and men who kill out of jealousy, vengeance, and drunkenness (at one point a drunk man shoots her three times, after which she is cured for the first time by "a Wise-One-in-Medicine," aka a Western doctor—Salvador Guerra—whom she at first distrusts, but later feels so grateful to that she insists he take some mushrooms, as a trade-in-healing-wisdoms). A devout Christian, Sabina repeatedly links the mushrooms to Christ and the church, to which she swears absolute obedience: "The *children* are the blood of Christ. . . . I've always had respect for everything that has to do with God. I obey

the priests. I am also obedient to the words of the municipal authorities. They are the heads. They govern us."

For these reasons, despite the deep suffering in her story, and despite the fact that it follows a destructive script endemic to such encounters, *The Life* is less of a cautionary tale with a clear moral lesson (i.e., this particular encounter with the blondes, this particular sharing of wisdom, should never have happened and should be prohibited from happening again), and more of a rumination on the tragedy and the comedy, and, to a certain extent, the inevitability, of high-stakes cross-cultural contamination and entanglement. The moral complexity of her story remains critical, as the saga remains ongoing, albeit with different characters, locales, and drugs.[14]

The sound of white folks making audible their apprehension that the systems that have given them dominance have also drained something vital from them, fucked them up in ways they feel strongly but have difficulty understanding or articulating, is not usually pleasing. (Or, at least, it isn't pleasing anymore—Rimbaud, Artaud, Mailer, Kerouac, etc., became literary giants in part for giving voice to it.) My claim is solely that continue to sort it out they (or we) must, and that drug writing offers a rich if often repulsive site to hear out the symptomology. As I listen, I like to keep Sabina in mind, with her severe critique of the stupid motherfuckers who came and ruined everything, and her staunch, nearly unfathomable conviction that certain forms of wisdom belong to everyone.

WORKING THE TRAP

In 2008, Spanish writer Paul Preciado published a book of wild theory in the tradition of *Crack Wars* titled *Testo Junkie: Sex, Drugs, and Biopolitics in the Pharmacopornographic Era*. Rather than pick a single drug (such as crack or opioids) as the signature drug of our times, Preciado argues that we are all wittingly or unwittingly subjects of a new, post-Fordist economic order called "pharmacopornism"—a fusion of pharmacy and

sexuality encompassing everything from Viagra to synthetic hormones to SSRIs to antipsychotics to benzos to fentanyl to Ritalin to techno-sperm to techno-blood to antibiotics to IVF to sex work to the Pill to Grindr to mail-order brides to internet porn. Preciado is intentionally unconcerned with the nuances of individual substances, or even with whether all of the above qualify as "substances" per se, and more inter-ested in how our desires, subjectivities, and bodies feed the pharmaco-pornographic machine, and are in turn fed and shaped by it. *Testo Junkie* vacillates between dense theoretical chapters and autobiographical sec-tions that follow three main threads: a hot-and-heavy love affair between Preciado and writer and filmmaker Virginie Despentes (aka "VD"), the death-by-overdose of Preciado's friend, writer Guillaume Dustan (aka "GD"), and Preciado's initial immersion in testosterone, described in the book's introduction as "a political experiment that lasted 236 days and nights and that continues today under other forms."

Counter to the likes of Wilhelm Reich, who imagined our "orgastic potency" as a force of liberation, Preciado sees "the (real or virtual) strength of a body's (total) excitation"—a force Preciado calls "*potentia gaudendi*"—as the very fuel of pharmacopornism, capitalism's latest itera-tion. Preciado's stance is essentially a Foucauldian one: there is no way out of the pharmacopornographic trap—you are in it, by virtue of being a desiring, biopolitical subject. But you can hack it from within: "Your memory, your desire, your sensibility, your skin, your cock, your dildo, your blood, your sperm, your vulva, your ova . . . are all the tools of a potential gendercopyleft revolution." Lest this stance sound too "kinda hegemonic, kinda subversive," as Sedgwick might have had it, it's worth noting that it echoes the trap of being alive in general; "working the trap we inevitably find ourselves in," as Judith Butler once said of gender per-formativity, is a fair description of our mortal coil. (In the full quotation, Butler draws a distinction between this state and freedom: "[This] per-formativity . . . is not freedom, but a question of how to work the trap that one is inevitably in." Other philosophers might see it differently—see, for instance, Brian Massumi: "Freedom is not about breaking or es-caping constraints. It's about flipping them over into degrees of freedom. You can't really escape the constraints. No body can escape gravity. . . .

Freedom always arises from constraint—it's a creative conversion of it, not some utopian escape from it.")

As its title suggests, *Testo Junkie* proffers a maximalizing theory of addiction, by which one can become a "junkie" (*yonqui*, in the original Spanish) for anything, from food to sex to shopping to social media to politics to video games to smartphones to relationships to prescription drugs to exercise to hormones to 12-step groups themselves. This overarching theory of addiction has become a nearly uncontested truism of our times, overtaking nearly all its dissenters. One such dissenter was Sedgwick, who, in her 1991 essay "Epidemics of the Will," laid out her reservations about maximalizing theories of addiction (before either *Crack Wars* or *Testo Junkie* was published). Sedgwick here argues that, if one can bring "not only every form of substance ingestion, but more simply every form of human behavior into the orbit of potential addiction attribution," one risks furthering—even if unwittingly—a certain "propaganda of free will," in which the constant specter of unhealthy compulsion summons its counterstructure: a heroic, ethical, healthy free will in constant need of awakening, salvation, purification, or liberation. Sedgwick locates this "propaganda of free will" in the late writing of Nietzsche; she also finds it in the work of libertarian psychiatrist Thomas Szasz, a fierce critic of coercive psychiatry and "the therapeutic state," and a diehard advocate for something Szasz called "our right to drugs."

As Szasz saw it, there exist two models of the drug addict: the first imagines the addict as a "stupid, sick, and helpless child, who, tempted by pushers, peers, and the pleasures of drugs, succumbs to the lure and loses control of himself" (à la Burroughs or Holiday); the second as "a person in control of himself, who, like Adam, chooses the forbidden fruit as the elemental and elementary way of pitting himself against authority" (à la Ann Marlowe). These two models, Szasz wrote, "frame two different moral perspectives," each offering a distinct moral strategy: "If we side with authority and wish to repress the individual, we shall treat him as if he were helpless, the innocent victim of overwhelming temptation. . . . If we side with the individual and wish to refute the legitimacy and reject the power of authority to infantilize him, we shall treat

him as if he were in command of himself, the executor of responsible de-
cisions." Both these positions make sense, Szasz says. What makes *less*
sense—what he calls "confusing in principle and chaotic practice"—is
the attempt to "treat people as adults and children, as free and unfree,
as sane and insane" at the same time. (A libertarian, Szasz preferred the
second model, and vehemently opposed attempts to control the behav-
ior of drug users or the mentally ill, even if and when their behavior is
self-harming.)

Treating people as both "free and unfree" may complicate policy making
or legal arguments (feminists will be familiar with such debates through
the Battered Woman Syndrome theory, and its controversial application to
prostitutes and victims of sex trafficking). But as everyday philosophy,
the notion that we are both free and unfree seems to me so fundamen-
tally incontestable as to be banal. (Althusser: "*There are no subjects except
by and for their subjection.*") Ironically, while polemicists get caught up in
presuming it has to be all one way or another, recovering addicts nego-
tiate every day the paradox of being free and unfree in the face of a sub-
stance, as reflected in 12-step programs' dual emphasis on powerlessness
and the ongoing, daily decision not to use (as reflected in slogans such
as "One day at a time" and "Don't pick it up, and it won't get in you").

The power and pleasure of *Testo Junkie* derives from its embrace of that
which is "confusing in principle and chaotic practice," its spirited ca-
reening between sane and insane, free and unfree, compulsiveness and
will, along with its wanton undercutting of its own strong theories, in-
cluding the maximalizing theory of addiction itself. As with *Like Being
Killed* and *After Claude*, the liberation it offers lies not in any blueprint
for escape or reclamation of unfettered agency but in its rendering of
wrestling with paradox and contamination as a rollicking good time,
ablaze with energy and experiment. This is primarily an affective feat:
due to *Testo Junkie*'s headlong pitch, its willingness to contradict itself,
and its raw, often comic autobiographical excursions, it doesn't proceed
by way of argument alone, which is what lands it outside the realm of
academia proper (a field known for articulating liberatory possibilities in
language that often excites little to no felt sense of them).

Despite the book's title, as Preciado's "voluntary intoxication protocol" with T goes on (with the adjective "voluntary" already chafing against the titular "junkie"), Preciado's express desire to become addicted to testosterone remains maddeningly unfulfilled. "I would have liked to have fallen into a dependence, have the security of permanently and chemically clinging to something," Preciado writes. "Deep down, I was hoping that testosterone would be that substance. To be attached, not to a subjectivity, but to the change produced by the ingestion into my organism of a substance without will. Depending on no one for that ingestion. Confronting my wish for an object that has no wish."[15] T's failure to "be that substance" may have to do with the fact that, as a synthetic hormone/anabolic steroid, T doesn't have the same addictive properties as, say, narcotics. But then again, neither does shopping, or Cardio Barre. Eventually, the question of "addicted" or "not addicted," "trapped" or "free," reveals itself as something of a mirage; once we see past or through it, more compelling subjects come into view.

One of these has to do with unclassifiable gender. At one point, Preciado muses, "If I don't accept myself as a transsexual, as someone with 'gender dysphoria,' I must admit that I'm addicted to testosterone. . . . My biopolitical options are as follows: either I declare myself to be a transsexual, or I declare myself to be drugged and psychotic." But this is absurd—a ventriloquized binary Preciado rejects even as he rehearses its terms. He knows it's possible to be neither addicted to T nor a transsexual as defined by state; his book is about occupying that space, about refusing to conform to prescribed gender protocols while also refusing to be cast off as "drugged and psychotic." Another has to do with a certain gendered binary about freedom and care that has long haunted queer circles—that which would align lesbians with "care" (for each other, for the well-being of the world, for their dogs, etc.), and gay men with "freedom" of a careless, even reckless, variety (partying, promiscuity, drugs, etc.). This binary rears its head in Preciado's writing about GD, an inveterate drug taker and HIV-positive advocate of radical sexual freedom (including controversial practices such as barebacking) whom Preciado admiringly describes as "the ultimate French representative of a form of written sexual insurrection."

Testo Junkie begins with the news of GD's death—"October 5: Tim tells me you've died"; later that night, stunned with grief, Preciado performs a "videopenetration" for him, in which Preciado films himself shaving his head and pubic area, making "a fag's moustache" by gluing his hair to his upper lip, and penetrating himself in his lower orifices. He then doses with T and says to the newly departed GD, "This testosterone is for you, this pleasure is for you." The desire to "cross-dress into [GD]," to connect with him through T and sex, is clear; what remain to be explored are the schisms in the twinning. These schisms become apparent in the contrast between Preciado's heavy-hitting, even logorrheic scholarship, and GD's standing by as hedonistic jester, ready to mock Preciado's efforts and convictions (cf. Sillman: "so earnest, so caring . . . paintbrush poised, trying so hard"). At one point, Preciado flashes back on a conversation he once had with GD, in which Preciado is telling GD about a trans history project Preciado is hoping GD will financially support and publish:

> You [GD] say, "I mean, shit, what could you have to say about this queer stuff?"
>
> You say you thought I wasn't like all the other chicks, and that for me it was all about fucking, but now you realize I'm like the other lesbians, ready to become the political nurse for anyone I meet. I answer, I'm not a lesbian, I'm trans, a boy, that the fact that I don't have a shitty biocock like yours doesn't mean I'm not a guy. I tell you, Stop treating me like cow shit just because you take me for a girl. You tell me I bother you, that you're ashamed for me, that I shouldn't count on you publishing that fag stuff, that it would be a better idea for me to call *Têtu* and write an article. You burst out laughing. I don't want to contradict you. I don't want to get mad at you, because if you don't publish my books, who will? But I hate you for speaking to me that way.

The heavily researched, politically committed work by which "not man" intellectuals must typically prove their seriousness and stature is here voided of phallic currency: politics is now embarrassing, and lesbians

are "political nurses" unable to speak to the true "queer stuff" of fucking, freedom, and pleasure (see GD's *Dans ma chambre*: "Sex is the main thing. Everything revolves around it: clothes, short hair, being good-looking, the right equipment, the stuff you take, the liquor you drink, the stuff you read, the stuff you eat, can't be too heavy when you go out, otherwise you won't be able to fuck"). Rather than defend his trans history project or reject the sexist terms at play, Preciado is here mostly angry that GD has misjudged his gender: shitty biocock or not, Preciado is a GUY, and should therefore be treated with respect (not like cow shit, as presumably befits the ladies). Because Preciado fears he cannot get the funds and publishing venue he wants elsewhere, in the face of GD's disparagement, he tries to avoid conflict: "I don't want to contradict you." Some things change, some things stay the same.

Listening to two masculine-identified writers duke it out over whether one of them should be treated like cow shit because he's been mistaken for a girl isn't exactly revolutionary fare. But such scenes take on a different valence when placed against Preciado's affair with VD, an outspoken feminist whose artistic prolixity, sexual fervor, and general ferocity make GD's binary of druggy fucking/conscientious nursing feel dull and retro. Here, for example, is Preciado's account of one of their first sexual encounters:

> That day, in the same room as Karen and Raff's, we screw naked for the first time. Her pelvis is glued to mine, her vulva connected to mine, our organs gnawing each other like the muzzles of two dogs that recognize each other. As we screw, I feel as if my entire political history, all my years of feminism, are moving directly toward the center of her body and flowing into it, as if her skin provided their only real niche. When I come, Wittig and Davis, Woolf and Solanas, La Pasionaria, Kate Bornstein, and Annie Sprinkle bubble up with me. She is covered with my feminism as if with a diaphanous ejaculation, a sea of political sparkles.

The elation—and recognition—I feel in reading such passages has to do with their depiction of sex neither as a reinforcement of a politics (as

in Ti-Grace Atkinson's "feminism is the theory; lesbianism is the practice"), nor as a force antithetical to or annihilating of politics (as in the Leo Bersani–Lee Edelman–Guillaume Dustan model), but as sex alit, even festooned, by politics, imagined here through the uncommon and capacious figures of *flowing, bubble, diaphanous,* and *sparkles.* Such a description constitutes a perhaps unprecedented attempt to represent the material presence of one's political life during the act of fucking as a kind of ironic ecstasy.

Preciado tries to cast his relationship with VD as a form of addiction: "It becomes obvious that my relationship with V belongs to the type of codependency categorized under the sign of addiction. *Dependence.* I've found my drug, and it is, like all drugs, available and elusive at the same time." But while the affair may have had elements of addiction and codependency in it (most hot-and-heavy affairs do), the addictive frame again feels almost intentionally inadequate. Preciado testifies to a desire for an "object that has no wish," but in choosing VD, he gets the antithesis: VD is a wrecking ball to the idea of the mute muse, and in fact appears throughout *Testo Junkie* writing her own book, *King Kong Theory,* an electric manifesto about VD's "rape, about the period when she was a prostitute, on why the twenty-first century will or won't be feminist": "Her back very straight. Tangled, blond rocker hair, a ring on each finger. . . . I read the chapters as she finishes them, and I get them as if they were babies still drowsy, opening their eyes for the first time before me. A turn-on. I recognize the voice that excites me, fucks me: the voice of a teenage punk who has learned to speak using a cis-male program for the production of gender, the aristocratic brain of a futurist she-wolf lodged in the body of a hooker, the intelligence of a Nobel Prize winner incarnated in a street dog."

The excitement in watching Preciado's formidable intellect dance alongside VD's as they come together at "a fractal moment, on the edge of a techno-Greek tragedy: she has just started to go out with girls, and I've started to take testosterone," is precisely the "queer stuff" I want to read. The sexual and intellectual communion they find together is neither circumscribed by the mandates of "political nursing" nor aligned with a

freedom that resembles a death drive. It has a new sound, one that, as queer sounds tend to do, grieves and pays homage to its forerunners as it shape-shifts and moves ahead. Hence Preciado's closing graveside address to GD, in which Preciado bids farewell to a certain form of insurrection and heralds the birth of another: "If you were still alive, you'd hate us, VD and me, with a hot hate that was as silky as the skin of a cock that doesn't get hard, because you'd know what she and I are together, like the revolution on the move."

NONHUMAN PEOPLE

Preciado's frustrated desire to become attached to a "substance without will" may have to do with the specific properties of T, the willful force of VD, and/or the ambivalence of Preciado's own urges toward dependency and dominance. But it also likely has to do with the instability of the subject/object dichotomy itself—an instability that drug writing (and experience) famously discloses. Time and time again, users testify to a sense that, far from being "an object that has no wish," substances have their own inclinations, make their own demands, even appear imbued with things we might call agency, liberty, or desire ("Mescaline wanted my full consent"). To convey this sense, writers frequently make recourse to personification, as in Sabina's chanting about the "*saint children*," or Holiday's lamenting the loss of her "lover man."[16] Indeed, part of what makes drug literature so weirdly compelling is that books themselves are also "mute objects" we experience as capable of bewitching or making demands on us: the ambiguity, in drug experience, of who or what is doing what to whom, finds a mirror in the experience of reading itself (hence the ancient distrust of the intoxicating powers of the written word, from Plato's *Republic* to the obscenity trial for *Madame Bovary*, as threatening forms of *pharmakon*).

It's tempting to shrug off such anthropomorphism as a literary trope by which writers endeavor, often feebly, to make drugs come alive as characters. Yet the frequency with which drugs come alive in drug writing also invites us to consider whether drugs come alive because drugs *are* alive.

All that anthropomorphism may be one way of honoring our sense that drugs are something other than inert matter—what political theorist Jane Bennett calls "vibrant matter," or what ecological theorist Timothy Morton calls "nonhuman people." Whether it makes sense to talk about vibrant matter or nonhuman people as having agency or liberty of their own is a subject of long-standing scientific, philosophical, and spiritual debate. But if, as feminist physicist Karen Barad puts it, all matter "feels, converses, suffers, desires, yearns and remembers," there may truly be no such thing as "an object that has no wish"—which is another reason that Preciado's desire for such fails.[17]

For those accustomed to humankind asserting its will and power over nature, with the latter conceived of as a collection of inert, mute objects, the experience of grappling with "demands" made by those objects can be disorienting and chaotic ("I had come prepared to admire. I was confident. But that day my cells were brayed, buffeted, sabotaged, sent into convulsions"). For those accustomed to thinking of—and treating— nonhuman forces otherwise, our vulnerability to being dispossessed or interpenetrated by them—and the consequent need to negotiate with and respect them—will come as less of a surprise. A passage in Anthony McCann's 2019 book *Shadowlands*, in which McCann traces conflicts between right-wing militia members and the Burns Paiute tribe in the Pacific Northwest, makes this difference clear: a tribal archaeologist named Diane Teeman tells McCann: "If we take a plant, or part of a plant, we always make an offering or ask permission. We need to respect the plant's liberty"; McCann then contrasts this notion of liberty with that of the militia members' (and many Americans') understanding of the term, whereby "liberty is for people and their property—and for corporations and money." Needless to say, these two notions of liberty stand in stark contradiction to each other.

Drug memoirs often serve as a repository for this elsewhere-repressed sense of awe at the force of nonhuman people. In *White Out*, Clune is veritably obsessed with the talismanic properties of heroin and its signifiers (ditto Art Pepper in *Straight Life*, albeit in less philosophical or scientized terms). For Clune, it's the "white tops" on certain heroin vials that

act as the source of fixation: "You might think the whiteness of the white tops isn't that important. . . . But the first stuff I ever did was in a vial with a white top, and its whiteness showed me dope's magic secret." (Again, one doesn't have to look very hard to find a discourse about whiteness here, even if its exact schema in *White Out* remains opaque.) Elsewhere, Clune has expressed interest in recent neurological research demonstrating how cues alone (e.g., the sight of a white top) can occasion dopamine surges in the brain, creating, for the addict, a troubling assemblage of vibrant matter.[18]

Knowing that we respond physically to things we've neither ingested nor touched need not reify or magnify feelings of powerlessness or unfreedom. Like the discipline of phenomenology, which asks us to consider phenomena such as intention, orientation, and proprioception as structuring our experience of the world, such knowledge can help us fathom the mysterious nature of our enmeshment, which does not stop at our skin or the human. From here, we might see that the pathos of drug addiction isn't necessarily that it displaces a natural love for other human beings with an unnatural love for a cold, mute object, but that it reveals our porousness to nonhuman people—our appetite for them, and our vulnerability to them. If one is attempting sobriety, figuring out how to manage this porousness while also keeping faith that "if you don't pick it up, it won't get in you" is crucial.

Perhaps ironically, Clune explores this permeability less in *White Out* than in *Gamelife*, a subsequent memoir about growing up immersed in video games. Save for one indelible flash forward, *Gamelife* meticulously avoids invoking the heroin use of Clune's adulthood, and meditates instead on the link between the world of computers, gaming, and "the alien thing we call nature or God." In a painful passage near the book's end in which Clune's mother is trying to get him to join the world of human sociality from which he has excluded himself (and from which he has been excruciatingly excluded), she tells him: "The meaning of your life is the quality of your human relationships, Michael. My therapist says it, it says it in the Bible, everyone knows it, Michael! When we *die*, the *only* thing that matters is the *quality* of our *human relationships*. . . . Now turn off this *goddamn* game and start thinking about how you can *make* those kids *like* you again."

Clune's mother doesn't explicitly call gaming an addiction (an idea Clune has elsewhere troubled).[19] But her advice does correspond to an idea prevalent in some recovery circles (and articulated in a popular 2015 TED talk by journalist Johann Hari), that the opposite of addiction is not sobriety but human connection. But Clune isn't buying that "the only thing that matters is *the quality* of our *human relationships*," or at least not totally. On *Gamelife*'s last page, after yet another devastating social humiliation, Clune spends some time describing the amazing color of the sky, "the magic sky," in May 1989, his thirteenth year. He then revisits his mother's advice, this time adding: "There's a warm red heart for people, true. But there's also another heart. A heart that moves through time. A heart made of the enduring stuff of mountains or stars. Or pixels. Or sky. . . . When I die, I will remember the color of the sky." Of course we want Clune to have friends and a red beating heart and a deathbed rich in memories of loving and being loved. But he is also here acting as an emissary from the world of numbers, stars, pixels, and sky, to remind us that our heart is human and alien, both. (Sabina reminds us of something of the same: "I take *Little-One-Who-Springs-Forth* and I see God. I see him sprout from the earth. He grows and grows, big as a tree, as a mountain. His face is placid, beautiful, serene as in the temples. At other times, God is not like a man: he is the Book. . . . a white book, so white it [is] resplendent.") We may root for Clune to "turn off [the] *goddamn* game"—and, later in life, to leave behind the white tops and all the damage they've caused—but we aren't exactly rooting for him to exchange altogether his uncommon aliveness to the nonhuman for *meaningful relationships with other people*. We're rooting for him to find some way to respect the power of the former without pretending at its mastery, or exposing himself to further suffering. Sometimes, this means learning to let certain nonhuman people be.

BY ABANDONMENT

Near the end of *Testo Junkie*, Preciado writes, "My gender does not belong to my family or to the state or to the pharmaceutical industry. My gender does not belong to feminism or the lesbian community or to

queer theory. . . . I don't recognize myself. Not when I'm on T, or when I'm not on T. I'm neither more nor less myself. . . . It is fundamental not to recognize oneself." This disrecognition may be, as Preciado asserts, a "condition for the emergence of the political as the possibility for transforming reality." (It is also an effect of some drugs, especially those that provoke disassociation.) But no one is saying it always feels good, or that such disorientation leads in any direct or assured way to change for the better. As Butler makes clear in her writing on grief, disrecognition and breakdown often go hand in hand with a profound, destabilizing sense of bewilderment and loss. For Butler, this is as it should be. "Let's face it," she writes. "We're undone by each other. And if we're not, we're missing something."[20]

This feeling of the "I" gone missing ("I think I have lost 'you' only to discover that 'I' have gone missing as well," Butler writes) is undoubtedly a form of the "emancipation of the subject" sought by Artaud and others. But it is not necessarily found, or it is not only found, in transcendental high. It can also arrive in the state colloquially known as "bottoming out." People sometimes think of bottoming out as a place of freedom, if only the freedom of having "nothing left to lose." But the addict's problem is actually that, no matter the radical losses she's racked up, there *is* something left to lose: the possibility of getting high. Things may have completely fallen apart, but the voice of addiction counsels that things actually *can* be put back together—after *just this one more time*. Or, it promises that *this* time will be different—*this* time, rather than furthering the ruin, will be what sets things right.

One has to become totally fed up with this way of thinking. The Tibetan phrase *ye tang che*, meaning "totally tired out" or "totally fed up," is relevant here; as Chödrön describes it, "[*Ye tang che*] describes an experience of complete hopelessness, of completely giving up hope. This is an important point. This is the beginning of the beginning." Such hopelessness has little to do with the deployment of a regime of self-denial or abstinence—the "regulatory form of freedom" some imagine sobriety to be (12-step folks call such a mode "white knuckling"). Nor is it a shoring up of oneself as a free individual "in command of himself, the

executor of responsible decisions," as Szasz and other free-will devotees would have it. It's a kind of freedom one can't go at or for directly, by an act of will, but must be accessed indirectly, through renunciation, undoneness, abandonment. This is not a consolidation of personhood, or a reinforcement of one's sense of self or self-worth. It isn't a revelation that your life "matters." It's more of a subtraction, by which one touches a certain bareness, the bareness of one's own bare life. "Who I am has little to do with addiction and recovery," Clune writes near the end of *White Out*. "Who I am isn't the first thing I need to know to get better, it's maybe the last thing."

This undoneness is related to what some Buddhists call "the trick of choicelessness." Most religions have something of this trick embedded within them—a sense that, once you've glimpsed or opened to grace, or radical honesty or the noble path or God's will or basic sanity, or what have you, the choice has already been made. You can turn away, but you can no longer fool yourself; even in relapse or misdeed, you will be haunted by the call you once heard. The trick, as Chödrön explains, is that "we think we have a choice about whether or not to make this commitment to sanity, but the fact is, it's been choiceless all along. It's a compassionate trick, a trick to help us realize that there really is no exit." This trick of choicelessness is, in turn, related to what Trungpa called "the myth of freedom." This phrase doesn't mean that freedom is mythological, that it doesn't exist. Rather, the myth is that it's accessed by means of will or escape, rather than by radical acceptance, which includes a species of hopelessness.

For whatever reason—I don't pretend to understand it—sobriety, especially the moment of "deciding" to become sober, granted me more intimacy with this particular form of freedom than nearly any other experience I've had—and certainly more than any drink or drug I've ever taken, no matter how liberating it might have felt at the time (and it did often feel, and in fact often was, liberating). After all, the painful paradox of some substances, or of some substances for some people, is that they *do* provide access to feelings of freedom, relief, sociality, or insight, but that access can flip—sometimes without warning—into acute

experiences of hindrance, despair, or alienation. (When sober people tell you that drugs or alcohol quit them and not the other way around, this is usually what they mean.) In other words, drugs can grant nearly matchless access to feeling free while simultaneously working, over time, to diminish the space in a life for practices of freedom. This dynamic becomes palpable in the addict's deepening negotiation between the desire for relief and abandon, on the one hand, and obsessive efforts at self-regulation and measurement, on the other (counting drinks, doses, available funds, hours, days, or months spent clean, and so on). As these latter efforts reveal themselves to be more and more in vain, eventually existing primarily for their inevitable transgression and the self-rebuke that follows, a repetitive cycle takes hold, in which the desire to quiet the ego or will instead summons an inflated version of it, whose imperative is to justify the mission of using.

Like many drinkers, I spent a lot of time trying to self-regulate (marking bottles with tape, taking restorative reprieves, positively comparing myself to more saliently out-of-control others, some of whom I served as a bartender, some of whom were my chosen intimates). But the simple idea of *not ever drinking again* seemed utterly impossible, a grim and untenable negation of all convivial life. I spent so much time warding off the idea that, when it finally breached, it seemed to have come from somewhere else. It floated down to me in the form of a single sentence that I wrote down on the back flap of the book I was holding in my hand when it landed: *I won't drink anymore.* The relief in writing it down—and meaning it—was so total, I'd never felt anything like it. I was terrified of what it might mean. But wherever it came from, I knew, as I wrote it, that it was true. It was a vow to which I felt, almost despite myself, now sutured.

Lest I'm making this moment sound like a pleasant feather that wafted down from a benevolent god, I might add that, the day prior, I had awoken at a rural writing residency so hungover from cheap wine, so dejected and heartbroken, so full of self-loathing about recent sexual encounters that had disgusted me, that, while walking to the grocery store (to buy more wine, surely), I experienced the nearly overwhelming urge

to throw my body into the oncoming traffic. In that moment, which also seemingly came out of nowhere, a different sentence had floated into my head, one with nearly equal force: *I won't live anymore.* Somehow I managed to cross the roadway and call a friend (there were, incredibly, still pay phones) who listened as I wept. It seems clear to me now that the following day's sentence arrived as a corrective to and displacement of the first.

In an interview about sobriety, Clune explains its relation to freedom as follows: "When you're an addict, if you can imagine life without drugs, it just seems to you like this boring[,] endless, pleasureless expanse. This desert. But freedom from that grind, freedom from that depression, that despair is like a high every day for me, to be honest. And then it just opens the door to all the ordinary pleasures of life." I wouldn't have believed him if I hadn't come to know it for myself. For at a certain point, it's using that guarantees monotony, and sobriety that signifies the indeterminate or the unknown. As Butler says about mourning—and I consider early sobriety a form of mourning, insofar as it involves letting go of a self or a past or forms of hoping or coping that one previously felt unable to go on without—it involves "agreeing to undergo a transformation (perhaps one should say *submitting* to a transformation) the full result of which one cannot know in advance." This can be very painful. But its refusal can be even more so.

It's remarkably difficult to talk about such revelations without making recourse to moral, even religious, framing, as in: the user went seeking God, but looked in the wrong places, got duped by simulacra, and ended up hooked on a false idol, perhaps even a demon. In a 1961 letter to Bill Wilson widely credited with helping Wilson decide to make AA a spiritual program, Carl Jung offered just such a narrative, likening the craving for alcohol to the desire for "union with God," and concluding, "You see, 'alcohol' in Latin is 'spiritus' and you use the same word for the highest religious experience as well as for the most depraving poison. The helpful formula therefore is: spiritus contra spiritum." A hundred years earlier, lapsed preacher Emerson addressed the matter in more secular terms: "The one thing which we seek with insatiable desire is to

forget ourselves, to be surprised out of our propriety, to lose our sempiternal memory and to do something without knowing how or why. . . . The way of life is wonderful. It is by abandonment. . . . Dreams and drunkenness, the use of opium and alcohol are the semblance and counterfeit of this oracular genius, and hence their dangerous attraction for men." I have long loved this passage for its acknowledgment that the desire "to forget ourselves, to be surprised out of our propriety," to do new things without knowing how or why, to live by way of abandonment, is not the problem. The problem is one of method and side effect. Which brings us back to Burroughs, who, despite his legendary junkie status, always took pains to remind us that "anything that can be done chemically can be done in other ways."

The difference between forms of abandonment that vitalize and those that thwart—not to mention the desire to choose the former over the latter—is something one must come to know for oneself (which is why AA considers alcoholism a self-diagnosed disease). In considering the complex relationship between drug use and drug writing, Boon makes a similar point: "The fact that people still become addicted to narcotics, after generation upon generation upon generation of writings of addicts, suggests that for many people, only personal testimony wrought through experience leads to knowledge." It's easy to rue this situation (especially as a parent, a subject position that often feels defined by the hope that one's knowledge is transmissible, or that one's love will have the power to conquer all). But the fact remains that no one can ferret out for us which pleasures are taken in an "*experience without truth*" (Derrida), and which have truth-value (or something otherwise worthwhile); no one can figure out for us which modes of abandonment are wonderful, and which do damage (or more damage than they're worth); no one can determine for us when a strategy of liberation has flipped into a form of entrapment. As the slogan *May you be blessed with a slow recovery* suggests, such proximities constitute a knot that benefits from patient, perhaps even lifelong, untangling.

4. Riding the Blinds

TRAVEL TOWN — GAME OVER — THE MANSION OF MODERN FREEDOMS — OUR CHILDREN AND THE CHILDREN OF OUR CHILDREN — WHAT HAS THE FUTURE EVER DONE FOR ME? — UGLY FEELINGS, REVISITED — POLITICS AND THERAPY — RIDING THE BLINDS

TRAVEL TOWN

As he is my son, he may as well be the first boy ever to love a train. For the past two years, in addition to spending hours watching on YouTube what I can describe only as conceptual endurance videos of steam trains passing through towns in rural America in real time (first you see the smoke, then you wait and wait and wait for the train to hurtle past), he and I have spent a lot of time together at Travel Town, a cul-de-sac in Griffith Park where unthinkably large locomotives have gone to rest. First stop is always the biggest, blackest train, Engine 3025, the first parked in the yard. We ascend the steep stairs—the driving wheels among the largest ever built—so that he can sit in the cab and become Jim, the heroic engineer in Virginia Lee Burton's classic *Choo Choo*, one of innumerable children's books, mostly written by white women in the first half of the twentieth century, in which a runaway train who goes by a female name or pronoun must be caught, dragged back to the round-house by a heavy chain, and disabused of the notion that there is any better job for her on earth than to serve her Jim.

Once inside the cab, my son places his left hand on the throttle, his right hand out the window, and, save for the occasional pause to feed the tender with imaginary coal and water, he drives that train with an enthusiasm I've rarely beheld in close quarters. *WOO-HOO, WOO-HOO! DINGA DINGA DINGA!* he yells, imaginary countryside flying by, imaginary wind streaming through his hair. God help the toddler who wants a turn while he's driving. "The engineer needs his space," he says, showing them the palm of his hand, not yet three.

Nearly every time we go to Travel Town together, I think, *I've never been happier in all my life.* Sometimes I say this aloud, be it to him or myself or the uncaring air. This is one of the things I've learned about happiness: when you feel it, it's good to say so. That way, if and when you say later in depression or despair, "I've just never been happy," there will be a trail of audible testimony in your wake indicating otherwise.

"The end of the world has already occurred," writes Timothy Morton. Not only that, Morton says, but "we can be uncannily precise about the date on which the world ended. . . . It was April 1784, when James Watt patented the steam engine, an act that commenced the depositing of carbon in Earth's crust—namely, the inception of humanity as a geophysical force on a planetary scale." This era—our era—which is defined by human impact on the earth—is widely referred to as *the Anthropocene.*[1]

It's not as if I didn't already have reservations about steam trains: in addition to the antifeminist narrative noted above (which contains within it a potent reminder of the female engine's desire to run free), nearly every train book in our house exalts the role of the railroad in what remains euphemistically called "the settling of the American West," cheerily omitting the carnage. It's not as if I don't, didn't, know the role played by slave and indentured labor in building the railroads, or the role that they have played in making possible the extraction, transport, consumption, and sale of fossil fuels over the past two centuries, all of which will surely be remembered—should there be anyone left to do so—as an object lesson of human shortsightedness, exploitation, and greed.

And yet, here I am, watching my son faux-conduct the quiescent train, admiring his beautiful face, his mouth agape at the machines he so adores, about which he knows nothing save what a human creature alive for barely three years can know: they're sensationally large and powerful; they make loud noises; they belch amazing clouds of black smoke; and when they get going, they impart a feeling of freedom—of speed, transformation, leave-taking, escape, anonymity, rush—whether you're riding or watching them speed by. (You can feel this weird reciprocity via the ministeamer ride that encircles the park, wherein waving to others is somehow irresistible, whether you're a passenger or pedestrian.) Here I am, still feeling the unprecedented (in my life, anyway) sensation of simple, total happiness in witnessing another's simple, total happiness, of beholding a new beginning in this world, while the words *The end of the world has already occurred* tick by under the scene.

Is what my son and I are doing part of that ending, even if it feels like a beginning to both of us? Is there any new beginning that doesn't already contain the seeds of its end? "When you give birth to a child, if you really want to cling to life, you should not cut the umbilical cord as he is born," writes Trungpa. "Either you are going to witness your child's death or the child is going to witness your death. Perhaps this is a very grim way of looking at life, but still it is true." Utterly unbearable, utterly ordinary.

One of the intellectual and emotional vexations of the climate crisis is that it strands us in a state of bewilderment as to whether our moment is mundane or exceptional. Sages throughout time have warned us against the delusion that our particular moment on Earth is extraordinary, reminding us that all forms of life, including the life of the planet itself, have always been accompanied by the specter (and reality) of impermanence and extinction. "Are we not especially significant because our century is?—our century and its unique Holocaust, its refugee populations, its serial totalitarian exterminations; our century and its antibiotics, silicon chips, men on the moon, and spliced genes?" writes Annie Dillard. "No, we are not and it is not. These times of ours are ordinary times, a slice of life like any other. Who can bear

to hear this, or who will consider it?" On the other hand, there's the truly startling news, delivered by climate scientists and environmentalists to anyone who will listen, that our actions over the past 250 years have brought about a sixth mass extinction, with one million species on track for extinction within the next few decades alone, our fate linked to theirs, whether or not we feel that link or believe in it.[2] Yes, there have been mass extinctions before, including a handful of occasions on which carbon dioxide has flooded the atmosphere. But in Earth's half-billion-year history of animal life, there have been only a few, and none was preventable in the way this one is (or was); none was caused by a single species (not to mention a species with the ability to address the threat to itself). The last sixty years have been particularly brutal: while the steam engine and founding of the modern petroleum industry may have marked the beginning of large-scale burning of fossil fuels, over half of all CO_2 emissions have been released since 1988, well after climate scientists—and oil executives—knew these emissions would end up trapped by the atmosphere ("the greenhouse effect"), causing irreversible warming.[3]

So, while no one wants to be one of Dillard's dupes, drunk on an ahistorical, spiritually unwise conviction of our era's special significance, it seems just as idiotic (not to mention genocidal, geocidal) to ignore the extraordinary facts of our moment, which, when allowed in, elicit awe (as well as fear, grief, anger, and other hard-to-bear feelings). Even if one took Dillard's sage counsel, it does not follow that everything is going to be all right. We can console ourselves that Earth or the greater universe will abide in some form without us—as theorist Andrew Culp has put it, "the combined detonation of all the world's nuclear weapons would be like a warm summer breeze to Gaia"—but such perspective doesn't necessarily help us to figure out how to contend with the "dismal picture of the future of life, including human life" the National Academy of Science confirms we face, or how to alter course. If the patenting of the steam engine marked the sealing of our fate, perhaps it's only fitting that one of the most common metaphors for our current predicament is that of being strapped to a runaway train.

Is it any wonder so many would prefer to ride the blinds? Avoid looking squarely at where we're headed, just to get through the day? Is it any wonder that the version of freedom so many seem enthralled by these days is nihilistic in nature, powered by impotence, denial, escapism, or indifference, rather than one that imagines—indeed, actually believes in—the possibility of ongoing coexistence, mutual aid, and survival? Take almost any other problem—the ravages of capitalism, racism, a more contained environmental disaster—and you might be able to argue that things getting worse is part of their getting better, in a "darkest just before the dawn" kind of way. I don't tend to buy such arguments, but even if I did, they don't apply to global warming. We might hope to burn down certain systems or ideologies and build up a better world from the ashes, but we can't burn down our atmosphere, then build it back. All the platitudes in the world about the patient labor that democracy or social justice requires crumble in the face of our current ecological dilemma, which is, as longtime climate activist Bill McKibben has it, "the first timed test that humans have ever had." Even if we stopped emitting CO_2 today, we have already locked in a certain amount of warming, the effects of which will continue for decades, if not centuries.[4] The task before us is therefore no longer to stop climate change from happening, but "mitigation and adaptation": mitigation of the harm we've already set into motion, by means of averting, through rapid decarbonization, a further rise in temperature, and adaptation to the changes the warming we've already locked in will bring. If we don't undertake more serious mitigation soon—within a decade, most experts say—the task of adaptation becomes exponentially harder. Eventually, it may not be possible for us.

These are difficult facts. It's tempting, when confronted with them, to make recourse to apocalyptic fantasy, by which the whole human experiment (or planet) goes out in one painless flash and bang. Such fantasies relieve us from imagining, not to mention committing to, the hard work that mitigation and adaptation require. The fantasy of an equally distributed apocalypse also relieves us from grappling with the fact that the same people who always suffer worst and first will continue to do so, are already doing so, which makes any "might as well enjoy the

ride" nihilism one more choice instance of off-loading risk and suffering onto more vulnerable others.[5] As Belgian philosopher Isabelle Stengers has put it, rather than bringing about "the mythical sudden end of the world," global warming will more likely be "a long process" in which "our children and the children of our children will have to go along and live in the technologically sophisticated ruins of our dreams." What else, one might ask, is Travel Town?

GAME OVER

I wrote the preceding paragraphs several years ago. We had five years on the clock to curb CO_2 emissions that we no longer have; five more years of emissions have been deposited into the atmosphere, with the rate ever climbing. I don't know what's going to be happening by the time these words move into print, but if I had to bet, it wouldn't be on radical change. Never before has the time that writing takes, its *patient labor giving form to our impatience for liberty*, felt so painful, so patently *not good enough*. My son doesn't care about trains anymore—we gave away his meticulously collected heap of Thomas trains long ago; last week, when we took our bikes to the parking lot of the L.A. Zoo, which is right around the corner from Travel Town, he told me he didn't even remember the place, which I had presumed would be indelible. (We had gone to the zoo parking lot because we had heard it was completely empty, due to the pandemic; there I watched him, now eight, do donuts in the gargantuan concrete expanse, practicing how to stand up on his pedals, to pump up his speed. As there was no one else around, I let him take off his mask, so he could really feel the breeze.)

Not a day goes by that I don't wonder how I could have birthed a being so bright-spirited, so resilient, so sanguine. *Don't worry so much, Mama, or else life isn't any fun!* he tells me. Or, *Don't worry, Mama, I got this!*, this last typically delivered with all the confidence and perspective of someone who has taken a turn (or several) here before. Even when pregnant, I had the distinct impression that his was something of a repeat appearance: he had a condition the doctors were worried about; after each ap-

pointment at which the outside people would worry, I would ask him, *Hey, you OK in there? BAM! BAM!* he would kick. He still kicks.

Once I asked a shrink if she thought these reassurances on his part indicated that I had passed too much of my anxiety onto him, forcing him to take care of me rather than the other way around (something I had long and probably unfairly accused my mother of doing, and sworn not to repeat if I ever became a parent). The shrink offered the totally surprising thought that he might be talking to himself, as a way of teaching himself courage, self-soothing, and survival. *Imagine that, Mom—he isn't always talking to you!* He has a relation to himself. *He has a self.* He talks to it. Your anxious care, however crushing or crucial you may feel it to be, is not and will not be his everything. *What a relief.*

It is not a relief to know that he will have to find a way to live in the "technologically sophisticated ruins of our dreams" (though that sounds better than fire, fire, and more fire, as is the style in California, from where I write). But there is some comfort in knowing that this predicament is not necessarily extraordinary, insofar as investing in dreams has always courted their ruin. *Cruel optimism*, theorist Lauren Berlant calls it. As my son grows up, his native capacity for courage, self-soothing, and survival will no doubt be tested: just the other night at bedtime, he asked me with uncharacteristic trepidation, *Mama, is it true that if we don't stop using gasoline, the earth will become as hot as Venus and kill me?* Although global warming was basically all I'd been thinking about for months, I had not yet mentioned it to him. As I struggled to come up with the right response, I flashed on the galley I'd recently received of Roy Scranton's latest, *We're Doomed. Now What?*, whose table of contents listed a final essay titled "Raising a Daughter in a Doomed World"—page 305. I had skipped right away to page 305, thinking there might be news there that I could use. But page 305 was blank, save the words: "Essay to come in final version of *We're Doomed. Now What?*" Just then my son interrupted my reverie to up the ante, asking: *Or will I just get shot?* Finally I rushed in to reassure him on both accounts without mobilizing cruel optimism, but he quickly tired of my middle way. He patted me on the arm and said, *It's OK, Mama. If that*

happens, we'll go together. We will have had a good life. This time, however, he had tears in his eyes.

For better or worse, the question of *what we tell each other*—and what we tell ourselves—has become a staple in the discourse on global warming. The field is teeming with narrative concerns, be they about genre (Are we living an apocalypse? a horror story? a tragedy? a fable? a farce? a typology?), origin stories ("It was April 1784, when James Watt patented the steam engine"), the problem of not knowing how the story ends or develops (climate scientists do not disagree on warming, but they do debate questions of "tempo and mode"), even the value of storytelling itself (Are stories still worth telling or recording if the likelihood of a future human audience for them is diminishing? What can the stories of much earlier humans tell us about our current crisis? What is the relationship between storytelling and adaptation, or storytelling and evolution?), and so on.

This makes sense, insofar as global warming, like narrative, is a temporal problem. It is the result of the accumulation, over time, of carbon dioxide in the earth's atmosphere, put there by the actions of millions of human beings acting individually and collectively over hundreds of years, to burn material that itself took millions of years, millions of lives and deaths, to accrue. If one were in a compassionate mood, one might say that the tragedy of global warming is in part a tragedy of greed, and in part a tragedy of the human mind's—or some human minds'—failure to apprehend or care about deep time.[6] (The two are, of course, related: caring solely for one's self-betterment does not typically correspond to caring for the future or honoring the past, though some peoples have had an easier time merging these goals than others.)

I haven't read the final version of Scranton's book, but I presume he is not likely to project, either to his readers or to his daughter, the "possibility of a new turn in the future," but to encourage us to "come to terms nobly with the irreversibility of human extinction along with numerous other species with whom it is entangled." These are not Scranton's words, but those of political theorist William Connolly, describing the

"game over" attitude shared by some—perhaps an ever-increasing num-
ber of—climate scientists, such as Guy McPherson, who predicts that
human extinction will arrive sooner—much sooner—than some expect;
McPherson's conservative estimate is 2030, the year my son turns eigh-
teen, nine years after this book's publication.

Connolly is critical of McPherson—not for the implausibility of
McPherson's claims, but rather for the fact that "McPherson has not yet
told one old guy how to inform his children, partner, students, grand-
children, and Facebook friends about such an implacable future." Theorist
Donna Haraway echoes this critique when she says that the "game over"
attitude "makes a great deal of sense in the midst of the world's sixth great
extinction event," but she has concerns about its discouraging effects on
others, including on young people, such as her students. "There is a fine
line," Haraway writes, "between acknowledging the extent and serious-
ness of the troubles and succumbing to abstract futurism and its affects
of sublime despair and its politics of sublime indifference."

When I'm feeling fearful or suspicious, I read these writers and think,
A fine line, indeed. Is all that's left to us deliberating about the right
or wrong way of delivering the news to ourselves and others, includ-
ing those whose care or futurity we feel most responsible for? Are these
thinkers practicing their own form of denial by worrying more about the
"discouraging effects" of the bad news on our children, grandchildren,
students, and others, than on the bad news itself? At which point I am
forced to realize that my desire for the bad news—"give it to me straight,
Doc"—reflects my own craving for an end to indeterminacy, an end to
negotiating the interregnum between being born and dying—an end,
that is to say, to the problem of living.

For however much we may want the straight news, no one necessarily
has it to give. No one, not even McPherson, knows exactly what the fu-
ture holds (which is decidedly *not* the same as saying we know nothing
and should therefore do nothing; we act all the time based on best ex-
planations, best options, best intentions). Part of the pain of our present
moment, as Haraway has it, is that we "know both too much and too

little"—an epistemological quandary that can encourage us to "succumb to despair or to hope." "Succumbing to hope" may sound odd to those conditioned to believe that hope is the sole pathway to right action. But increasingly it seems that relentless hope and despair may be but "2 sides of the same emotionally immature, over-privileged coin," as climate justice writer Mary Annaïse Heglar has put it. Now that we are virtually certain to raise the earth's temperature by at least two degrees Celsius, Heglar's call for the climate movement to "occupy the space in the middle" makes a lot of sense. It pushes us away from the binary of "fucked" or "not fucked," and toward thinking of global warming as "a problem that gets worse over time the longer we produce greenhouse gas, and can be made better if we choose to stop," as David Wallace-Wells has put it. This means that, as Wallace-Wells says, "no matter how hot it gets, no matter how fully climate change transforms the planet and the way we live on it, it will always be the case that the next decade could contain more warming, and more suffering, or less warming and less suffering. Just how much is up to us, and always will be." Again, these are difficult facts. But knowing that *something* is still "up to us, and always will be" can inject a measure of freedom into a situation that makes most of us feel throttled.

For what it's worth—and believe me, I know gender essentialism isn't always worth very much—it interests me that many women writing on climate, especially women of color, rarely engage in the "game over" style of thinking or feeling common to "doomer dudes" (Heglar calls them "de-nihilists"), even when their apprehension of the problem—and sometimes their experience of it—is equally grave or more so.[7] This makes sense, insofar as fears of an apocalypse come to transform or destroy one's secure, comfortable, hopefully inheritable lifestyle are nothing if not indicative of a certain class, racial, or national status, one for which civilizational collapse has been but a novel or notional threat rather than something that has already occurred. "If the Anthropocene proclaims a sudden concern with the exposures of environmental harm to white liberal communities, it does so in the wake of histories in which these harms have been knowingly exported to black and brown communities under the rubric of civilization, progress, modernization, and

capitalism," writes Kathryn Yusoff in *A Billion Black Anthropocenes or None*. "The Anthropocene might seem to offer a dystopic future that laments the end of the world, but imperialism and ongoing (settler) colonialisms have been ending worlds for as long as they have been in existence." After centuries of such exportation, it might seem grotesque to turn around and seek guidance on mourning and survival from those whose pasts and presents have been ravaged by imperialism, colonialism, environmental degradation, and slavery.[8] All the more reason, then, not to seek guidance per se, but to let those with more wisdom as to how to live past "game over" lead the way.

THE MANSION OF MODERN FREEDOMS

One of the terrible ironies of our having refused to act on the warnings issued by climate scientists for so long is that, as McKibben tells it, there once was a time—and not all that long ago—when changing course would have been relatively painless, would have required far less sacrifice, disruption, and "unfreedom" than it will now. By wantonly whipping past that point, and by squeezing the amount of time we have left to deal with the problem into a matter of years, we have managed to ensure that the necessary interventions will both bring far more disruption *and* make less of a dent in the problem, thus failing to obviate suffering and loss that could have been avoided had we acted sooner. (Our national response to COVID-19, McKibben has pointed out, has followed a similar course.)[9]

As a problem gets harder to solve, ignoring it becomes all the more tempting. Ignore it long enough, and eventually it becomes unsolvable. Giving up can then seem to deliver a measure of relief, in that it appears, at least for a moment, to liberate us from the agonies of our failing efforts. But such relief cannot last, as the unsolved problem will continue to create problems and cause suffering. This suffering rarely feels like freedom.

In 2011, Naomi Klein attended the Heartland Institute's Sixth International Conference on Climate Change, "the premier gathering for those dedicated

to denying the overwhelming scientific consensus that human activity is warming the planet," and reported on the discourse of freedom she found there. As Klein tells it, the Heartlanders deeply believe—or at least purport to believe—that climate change is "a plot to steal American freedom." As a senior fellow told the crowd, "You can believe this is about the climate, and many people do, but it's not a reasonable belief. [The issue is that] no free society would do to itself what [the global warming] agenda requires." According to this logic, even if global warming were not a nefarious "collectivist" or Chinese hoax (as many Heartlanders believe it to be), it would *still* have to go unaddressed, as a truly "free society" would opt for a suicidal course rather than acquiesce to the "freedom-killing" modifications in fossil fuel extraction or consumption that addressing the problem requires. (Unsurprisingly, Klein reports that *Give me liberty or give me death* rhetoric abounds at Heartland, often cast through the lens of attachment to household appliances. "You can pry my thermostat out of my dead cold hands," one participant declaimed. COVID has brought out a similar sentiment, and not just from the fringes: as Representative Trey Hollingsworth (R-IN) told a radio reporter in April 2020, "It is always the American government's position to say, in the choice between the loss of our way of life as Americans and the loss of life of American lives, we have to always choose the latter." If only such loss—of lives, of species, of habitable regions—could be restricted to those who have agreed to it—but, alas, our interdependence stops nowhere.)

One could argue that the philosophical discourse about freedom at such gatherings—like that of the "Free Speech Week" planned and then abandoned by right-wing activists at UC Berkeley in 2017—is deliberately unserious, a means of giving intellectual and pseudoscientific cover to oil and gas executives while they pile fortune onto fortune (unsurprisingly, the petroleum industry finances the work of many of the "climate realists" featured at Heartland). One could even argue that Heartland acts as a troll within a troll, in that right-wing climate denialism is itself a sort of hoax: Exxon and other oil giants have known for decades about the science of global warming—*and have believed it*—with the difference being that they made the strategic decision to inculcate climate denialism in

others in order to buy more time to drill and sell—a decision McKibben calls "the most consequential deception in mankind's history."[10]

Klein, however, is willing to take seriously the debate about freedom on offer at Heartland, in part because she thinks that the Heartlanders apprehend the nature of the problem better than the "green capitalists" do. The Heartlanders are right, Klein says, when they say that climate change isn't really an "issue." Rather, she says, "climate change is a message, one that is telling us that many of our culture's most cherished ideals are no longer viable." These ideals—shared by people on both the right and left, Klein explains—involve a paradigm of a civilization based on progress and expansion rather than one based on an apprehension of and respect for natural limits, including the limits of human intelligence, and the material, planetary parameters that make human life possible. The hard lesson climate change has for freedom, Klein argues, is that the only way humans can stick around to practice it is by ceasing to conceptualize it as the defying of limits, and reimagining it as the practice of negotiating with the various material constraints that give our lives shape and possibility.

This seems right to me. The fact is that our bodies can survive only within a narrow range of conditions—as McKibben has it, "When temperatures [pass] thirty-five degrees Celsius (ninety-five degrees Fahrenheit) and the humidity [is] higher than ninety per cent, even in 'well-ventilated shaded conditions,' sweating slows down, and humans can survive only 'for a few hours, the exact length of time being determined by individual physiology.'"[11] No matter our truly impressive reserves of ingenuity and resiliency, no matter the bubblesuits a costume designer imagines we might someday wear in that fabulous Mars terrarium, no matter the celebrities taking field trips to experience weightlessness at Zero G facilities, no matter the Google executives trying to upload their consciousnesses to the cloud, we cannot and will not escape the constraints that constitute the parameters of our mortal existence, such as our need for water, food, air, shelter, and love, nor do I see why we would want to. Accepting and working with such constraints, rather than hoping to be liberated from them by some unforeseeable technofix, divine intervention, or bloody boogaloo,

demands a more sensible, some might say a more grown-up, conception of freedom. (Massumi: "You can't really escape the constraints. No body can escape gravity. Laws are part of what we are, they're intrinsic to our identities. . . . Freedom always arises from constraint—it's a creative conversion of it, not some utopian escape from it.")

The divide between those who want to drill, baby, drill, and those who want urgent action on the climate, often gets posed as a struggle between those who value freedom (imagined as the freedom to excavate whatever one wants, make whatever profit one wants, consume whatever one wants, do whatever one feels like doing in the moment) and those who value obligation (imagined as the duty to be good stewards of the earth, cohabit it responsibly with the millions of life-forms whose fate is linked to ours, take into account the well-being of future generations). The problem with this binary is that it risks reducing "obligation" to moral hectoring, and "freedom" to a cheap, self-serving hedonism. Neither helps us seize the moment to shed some of freedom's more exhausted—and toxic—tropes and myths, or to experiment with its next iterations. We could imagine, for example, *restraint* as a choice, as in the restraint needed *not* to extract the 80 percent of the fossil fuel that remains underground, in order to maintain the conditions of possibility for ongoing human life. (Obviously a veneration of restraint means and applies differently depending on the circumstances: for example, the poor cannot and should not be expected to "restrain" themselves from making a living in the sole ways available to them.) As the state of addiction makes clear, repetitive, compulsive sating of our immediate desires rarely leads to emancipation. And yet, before we mock those who find freedom in air-conditioning, solitary driving, disposable wrapping, plastic straws, hamburgers, or frequent airline travel, we might note that many of us have similar feelings and attachments: the goal is to invent new norms that feel palatable—desirable, even—to people, not to shame them for their cathexis to comforts and ways of living in which we share.

Rethinking freedom in the context of climate change also invites us to consider how the concept itself—like all concepts that have itinerantly preoccupied the human mind—has been shaped not just by human-made

phenomena (slavery, technology, distinct forms of government, and so on) but also by the nonhuman materials and forces with which we've been partnering, consciously or not. Historian Dipesh Chakrabarty's 2009 essay "The Climate of History: Four Theses" is instructive here, in that in it Chakrabarty asks us to see the entire modern history of freedom in its geological context:

> In no discussion of freedom in the period since the Enlightenment was there ever any awareness of the geological agency that human beings were acquiring at the same time as and through processes closely linked to their acquisition of freedom. Philosophers of freedom were mainly, and understandably, concerned with how humans would escape the injustice, oppression, inequality, or even uniformity foisted on them by other humans or human-made systems. Geological time and the chronology of human histories remained unrelated. This distance between the two calendars, as we have seen, is what climate scientists now claim has collapsed. The period I have mentioned, from 1750 to now, is also the time when human beings switched from wood and other renewable fuels to large-scale use of fossil fuel—first coal and then oil and gas. The mansion of modern freedoms stands on an ever-expanding base of fossil-fuel use.

Chakrabarty's thinking here is tantalizingly porous, insofar as he notes a temporal and structural relation between fossil fuel use and the "mansion of modern freedoms" without hammering out its exact nature. (His phrase "mansion of modern freedoms" may jar, as he's talking about the same 250 years that contained peak transatlantic slave trade, colonization, industrial pollution, and more. But Chakrabarty knows all this, so I'm guessing the mansion he has in mind is the sum total of discourse generated by human beings about freedom during this period, not the equitable distribution of it.)

Thankfully, other historians and scholars have filled in many of the gaps—Timothy Mitchell's *Carbon Democracy: Political Power in the Age of Oil*,

for example, offers a historical account of the linked development of modern democracy and oil to demonstrate how "fossil fuels helped create both the possibility of modern democracy and its limits." "Rather than a study of democracy and oil," Mitchell writes, "[this] became a book about democracy *as* oil."[12] As Mitchell tells it, fossil fuels created the conditions of possibility for people to gather, organize, and mount challenges to oligarchical forms of rule, thus enabling modern democratic politics, including revolutionary politics. But insofar as these movements have tended to treat ecological limits as extrinsic to their cause, and imagined the future as a "limitless horizon of growth," they, too, have not been able to keep us from the maddening situation we are now in, wherein democratic governments appear incapable of doing what it takes to ward off catastrophic warming.

The entanglement of modern democracy with fossil fuels does not necessarily mean we have to quit the former in order to wean ourselves off the latter (I remind myself of this whenever I find myself drifting toward ecofascist fantasy—like, *What if we just allowed an environmentalist dictator to take power for a teensy bit of time, just long enough to force us all to stop emitting CO_2, so that we have a chance of continuing any experiment in human governance*). As Mitchell makes clear, just because forms of energy *shape* our politics does not mean they *determine* our politics. The more alert we are to this dynamic, the more we can engage thoughtfully and inventively with it, and wrestle with the proposition that "the building of solutions to future energy needs is also the building of new forms of collective life." (This is what Haraway is getting at when she says, "It matters what matters we use to think other matters with; it matters what stories we tell to tell other stories with; it matters what knots knot knots; what thoughts think thoughts. . . . Think we must, we must think.")

To date, we have all thought modern freedom with oil, whether we aimed to or not. Carbon powers the very equipment by which our thoughts and voices and bodies reach one another; it powers our public conversations about the nature of freedom, autonomy, justice, and self-governance, from street protests to conference panels to Twitter wars. It even powers the ways in which we love our children: "Someday I must tell my son

what I have done," NASA climate scientist Kate Marvel writes. "My comfortable, safe life is in large part a product of the internal combustion engine. Fossil fuels power the trains that take us to the beach, the factories that make his plastic bucket and spade, the lights I switch off when I kiss him good night. . . . In the end, I am responsible for the gases that are changing the climate and, in raising my son in comfort and convenience, am passing on that responsibility and guilt to him." Even if our apprehension of deep time is minimal (as I believe mine to be), I believe that *something* inside us perceives the fundamental chasm between the millions of years it took for fossil fuels to accrue, and the mind-boggling speed at which we have extracted, consumed, and excreted them. The awe my son felt at Travel Town was justified: we *should* feel awe in the face of the energy we've generated by burning deep time in no time. Our own bodies have been shaped by this power, through the speed of planes, trains, automobiles, and cybercurrents, all of which have become integral to our conception of freedom. We often take freedom to mean freedom of movement—be it the freedom to leave behind a bad scene for a (hopefully) better one; the freedom to leave behind cramped origins and forge new kinships in a bigger, more anonymous, place; the freedom to choose the unknown over the known. Capitalist, abolitionist, queer, and revolutionary consciousnesses alike have depended on such dreams and desires, some of which are dear to my own heart.

I grew up, after all, in California, where my adolescent freedom was synonymous with driving my 1976 VW bug on the open road; after a long, carless sojourn in New York City, I have since returned to the gospel of solitary driving (or so I had before the pandemic—now my car collects dust in the driveway, which turns out to be its own form of freedom—the freedom of not having to go anywhere, which vibrates uncomfortably beside the feeling of there being nowhere to go). For the many years I lived in New York City—and even now, in my melancholic exile from it—poet Frank O'Hara's words from "Meditations in an Emergency" always spoke my heart: "One need never leave the confines of New York to get all the greenery one wishes—I can't even enjoy a blade of grass unless I know there's a subway handy, or a record store or some other sign that people do not totally *regret* life." The paid labor

I perform in the world is exclusively cultural, and I like it that way; the only two jobs I've ever really had have been that of waitress/bartender and professor/writer. I cherish the anonymity and plethora of metropolises, have no special love of "the local," and harbor no anticiv fantasy of going "back to the land." I don't even garden. As British theorist Mark Fisher once wrote in a spasm of cosmopolitan honesty, "Hands up who wants to give up their anonymous suburbs and pubs and return to the organic mud of the peasantry. Hands up, that is to say, all those who really want to return to pre-capitalist territorialities, families and villages. Hands up, furthermore, those who really believe that these desires for a restored organic wholeness are *extrinsic* to late capitalist culture, rather than fully incorporated components of the capitalist libidinal infrastructure." It is intimidating, then, as well as rousing, to wonder what can and will happen to our conception of freedom when we begin thinking it, feeling it, living it, apart from so many of our current fetishes and habits. But this experiment is a necessary and worthwhile one, as only a fundamentally nostalgic, claustrophobic view of freedom would insist it stay allied to one technology of energy production, especially if and when continued reliance on that technology ensures painful new constrictions and claustrophobic new forms of suffering. (These are not abstract: I'm writing today with all the windows in my office taped shut and towels stuffed under the doors to block out the hazardous wildfire smoke seeping in from all sides. *Think we must, we must think.*)

The good news for those of us whose hands stayed down is that "post-civ" will not and need not resemble "pre-civ" or "anti-civ." As Bruno Latour has made clear, the opposition of the local and the global is pretty much spent: "The planet is *much too narrow and limited* for the globe of globalization; at the same time, it is *too big*, infinitely too large, too active, too complex, to remain within the narrow and limited borders of any locality." Climate change has revealed how local actions have global effects, and that those global effects are invariably experienced locally. Rather than continuing to think in terms of local/global—or right/left—Latour argues (persuasively, I think) that it would be more fruitful to think in terms of the Terrestrial/Out-of-This-World, with the Out-of-This-World signifying the abandonment of even the pretense of a

shared earth and common future and the subsequent mission of *"get[ing]
rid of all the burdens of solidarity as fast as possible,"* and the Terrestrial
signifying a willingness to "come down to Earth," accept our entangled
state, work with it and each other. Latour's approach encourages us to
move beyond increasingly antiquated debates about freedom as big vs.
small government, totalitarianism vs. democracy, and start thinking
about freedom ecologically, which involves reckoning with the limita-
tions and possibilities of our shared environment, rather than hoping for
walls, moats, ethnostates, apocalypse retreats, treasure troves, or space-
crafts to sever us from it.

None of this will sound novel to anyone who has but dabbled in femi-
nist, environmentalist, postcolonial, or Indigenous thought, all of
which has long pointed out, albeit from distinct angles, the various
intellectual, ecological, and ethical errors—aka catastrophes—that
have ensued from the presumption of a bounded individualism sepa-
rate from and superior to a supposedly inert Nature.[13] "Many humans,
particularly those under the seductive spell of Western Enlightenment
thought, had for centuries insisted that they existed on a plane far above
the base material world around them because their ontology was one of
creation and self-creation. Humans were subjects, never objects," writes
historian Timothy LeCain. "Yet what happens when humans' think-
ing and creating results not in their transcendence of nature, but their
abrupt descent back into it? This is precisely the phenomenon occur-
ring with anthropogenic global warming." Throughout these very same
centuries, however, many humans *have* been treated as objects. What's
more, those objects did and do fight back (cf. the opening of Moten's
In the Break: "The history of blackness is testament to the fact that ob-
jects can and do resist"). They resist not only their masters, but also
notions of freedom or humanity that depend upon the domination or
transcendence of a base material world with which they are repeatedly
aligned. (Hence, Hartman's argument in *Scenes of Subjection* that the
abstract, universal subject of liberalism has always depended upon the
"fleshy substance" of castigated subjects in order to achieve and main-
tain its "ethereal splendor," a construction that ensures injustice even as
it promises liberation.)

Acting upon entanglement—like acting on care—is more difficult than simply professing fidelity to the principle: the master-slave relation is a form of entanglement, too. Think, for example, of how feminist physicist Karen Barad's notion of "living ethically," defined as constantly "taking account of the entangled phenomena that are intrinsic to the world's vitality and being responsive to the possibilities that might help us and it flourish," mixes up with Morton's observation that "because of interconnectedness, it always feels as if there is a piece missing. Something just doesn't add up. We can't get compassion exactly right. Being nice to bunny rabbits means not being nice to bunny rabbit parasites." This not-getting-it-exactly-right means that there will always be occasions for disagreement, be it about the "we" who is to flourish (bunny rabbit or bunny rabbit parasite?), the meaning of "flourish," and so on. Even if the type of freedom we value most is that of the "nobody's free until everybody's free" variety, such interdependence cannot spare us difficult trade-offs, ethical dilemmas with imperfect and sometimes even brutal outcomes. Our entanglement is above all complex, and complexity leads to difficulty. That difficulty is easier to bear once we recognize that our desire to solve it once and for all may also signify our desire to no longer be a part of it.

OUR CHILDREN AND THE CHILDREN OF OUR CHILDREN

Given the weird temporal situation we currently find ourselves in, wherein our past actions have locked in a certain amount of warming whose effects we have begun to experience, as we barrel toward significantly more intense effects in the not-so-distant future (with the terrifying possibility of runaway acceleration), it's unsurprising that so many people writing and thinking on the climate have found themselves grappling with the dizzying notion of futurity itself. More often than not, this grappling relies upon the figure of the child. I myself performed such an invocation in the opening pages of this chapter, in part because it felt "natural," and in part to set the stage for further questions.

Many movements aiming to "make the world a better place," from Black Lives Matter to Fridays for Future to Standing Rock to Never Again to

Families Belong Together, frame their actions as service to children and the unborn. ("This moment requires *you* to ensure your own freedom," said BLM activist Tamika Mallory in a 2020 speech in the wake of the murder of George Floyd. "And the freedom of your children—born and unborn.") In other words, they make recourse to reproductive futurism, defined by queer theorist Lee Edelman in his polemic *No Future* as the twofold idea that there is a future we can and should make better, and that the Child is its emblem. *No Future* provocatively posits itself against this ideology, proposing that *"queerness* names the side of those *not* 'fighting for the children,' the side outside the consensus by which all politics confirms the absolute value of reproductive futurism." Many have taken Edelman up on this provocation—some, to disagree with it (see, for example, the late José Muñoz, who argued passionately that "queers have nothing but a future," and called Edelman's antifuture stance "the gay white man's last stand"); others, to extend its lens to any number of novels, movies, environmental campaigns, political speeches, or personal decisions in which reproductive futurism can be sniffed out and rebuked.[14]

Given that queers have long been punished, often violently, for being perceived as threats or outsiders to reproductive futurism—and given how much kinship and culture they have been able to construct outside of it—it makes sense that a strand of queer theory would spend time uncovering and valorizing the "queer temporalities" repressed or occluded by straight norms. Jack Halberstam's *In a Queer Time and Place* (2005), for example, takes on something Halberstam calls "repo time," in all its micro and macro manifestations: "Family time refers to the normative scheduling of daily life (early to bed, early to rise) that accompanies the practice of child rearing. This timetable is governed by an imagined set of children's needs, and it relates to beliefs about children's health and healthful environments for child rearing. The time of inheritance refers to an overview of generational time within which values, wealth, goods, and morals are passed through family ties from one generation to the next." In "Paranoid Reading and Reparative Reading," Sedgwick addresses the perils of "paranoid temporality"—the "dogged, defensive narrative stiffness . . . in which yesterday can't be allowed to

have differed from today and tomorrow must be even more so"—that Sedgwick sees as intrinsic to the "generational narrative that's characterized by a distinctly Oedipal regularity and repetitiveness: it happened to my father's father, it happened to my father, it is happening to me, it will happen to my son, and it will happen to my son's son." In *Staying with the Trouble*, Haraway sets forth the anti-reproductive-futurism slogan "Make Kin Not Babies!," by which she attempts to fuse the queer capacity for nonbiological kinship with ecological concerns about overpopulation and anthropocentrism.

Such theorizing has been crucial to recognizing, and sometimes enacting, forms of kinship and temporality not based in the heterosexual, privatized, white, nuclear, or even human family. Unfortunately, however, as often happens in academia, such critiques have at times slid into a knee-jerk dismissal of anything perceived to be contaminated with reproductive futurism, which includes, at this point, most major forces in the climate fight, which is partly being led by children themselves. (Think of teenage activist Greta Thunberg, who, along with fifteen other children, lodged an official complaint to the United Nations' Committee on the Rights of the Child against nations failing to meet the emission reduction targets they agreed to in the Paris Agreement; the Sunrise Movement, "an army of . . . ordinary young people who are scared about what the climate crisis means for the people and places we love"; the twenty-one youth plaintiffs in *Juliana v. the United States*, a 2015 lawsuit alleging that the US government's inaction on climate science "deliberately discriminat[es] against children and future generations in exerting their sovereign authority over our nation's air space and federal fossil fuel resources for the economic benefit of present generations of adults"; the thousands of kids who have taken to the streets as part of the Youth Climate Strike; and more.) As so often happens when adults must listen to actual children rather than hide behind the pabulum of reproductive futurism (or the punk bravado of its no-future antithesis), the real difficulties of intergenerational conversation come to the fore.[15]

In such a context, Edelman's refusal to "[abjure] fidelity to a future that's always purchased at our expense," or Lauren Berlant's 1997 lament that

"a nation made for adult citizens has been replaced by one imagined for fetuses and children," or Andrea Long Chu's quip that "having a child, like heterosexuality, is a very stupid idea. . . . Children are a cancer," begin to sound more passé than avant-garde, insofar as they reify the division between children and adults, with adults the privileged category. In other words, it's hard to get excited about queerness as a force come to "ruptur[e] our foundational faith in the reproduction of futurity" (Edelman) when climate change is accomplishing the same goal, to catastrophic effect. Ask the kids of *Juliana v. United States* what they think about the foreclosure of generational regularity and repetition; ask the child complainants to the UN whether the real problem is that we've imagined a world made solely for "fetuses and children"; ask anyone whose homeland or livelihood has been obliterated by climate change how they feel about the fact that their yesterday will not resemble their tomorrow.

The point isn't that reproductive futurism was right all along, and now that queers have become more welcomed into its fold, we should all just pile in and swallow it whole. It's more that all replication is not created equal: environmental activists making recourse to reproductive futurism do not want to reproduce the same world that brought us radical inequity and ecological devastation. They want a world that reproduces the same or similar conditions of habitability that other human animals have been able to enjoy for the past 11,500 years. Likewise, while it's well and good to say (as does Rebekah Sheldon in *The Child to Come*) that we need to learn how to live "without the demand for safety and the pleading face of the child that is its warrant," all safety is not created equal either. The climate fight—like the fight for racial justice, with which it is inextricably linked—absolutely has to do with a demand for increased safety, insofar as it is about reducing the threat of premature death or extinction for those disproportionately exposed to it, be it at the hands of police, the torching of the Amazon, or a rising tide. No wonder, then, that certain queer groups have begun to shift course: see, for example, the collective Parliament of Bodies, whose most recent summit in Bergen, Norway, named its goal as figuring out "how to redefine our alliances with those who are not presently living . . . [and take] responsibility for those who are no longer, or not yet, here," or the Institute

of Queer Ecology (IQECO), "a collaborative organism" whose "mission is to make space for collectively imagining an equitable, multispecies future."

By this point I've lost count of how many people have confided to me their feeling that, since having children is a "choice," why should there be "special treatment" for those who opt to procreate (tax credits, special scheduling favors at work, universal daycare, and so on)? In response to such sentiments—which unintentionally echo the right-wing push to defund social services, including public education—opinion writers across the land churn out various entreaties as to why we should care about children, especially the children of others. These arguments vary by the writer's commitments: sometimes children matter because they are a future national citizenry; sometimes they are the bearers of tradition for a disappearing or oppressed people; sometimes they are future taxpayers; sometimes they are future revolutionaries; sometimes they are our future nurses and home caregivers. If these arguments convince some people to care more about other people's children or future lives more generally, great. But they strike me as a bit bizarre, in that it has always seemed to me that children matter simply because they matter—they are our fellow humans, albeit smaller ones with differing levels of need. They are not a separate species; they are already as well as forthcoming. In fact, they were us, they *are* us, even if we tend to forget it (and by forget, I really mean forget, in the Winnicottian sense that good-enough parenting allows the baby to forget the experience of being held, whereas the parent's charge is to keep remembering the baby). Championing the unborn has become understandably dicey business. But there's no reason that antiabortionists should get to rob us of recognizing and valuing the continuum between current and potential life (a continuum sometimes epitomized for me by the astonishing, if overtly biological, fact that a baby born with a uterus already has within it all the eggs it will ever have, which means that the egg cells that might one day become the grandchildren of a gestating mother have already lived inside her).

Caring for the unborn does not mean insisting that all unborn things be born. It means accepting that, by the time you have finished reading this

paragraph, about 250 more babies will have been born into a future that didn't exist when you began it. So before we bliss out on some sublime indifference to that which will postdate us, we might recognize that indifference to their fate is arguably no different from dumping a bunch of toxic waste guaranteed to poison whoever comes into contact with it, then contending that, because you won't know the sickened people personally or won't be alive when they get sick, or because you just aren't that into people anyway, especially small ones that cry on airplanes, you're off the hook. One does not need to be an advocate of fetal personhood, baby showers, the Disneyfication of Times Square, or treating present and future beings as ethically identical to recognize that this logic is morally preposterous.

The climate crisis cannot wait until we have purged people of their allegedly wrongheaded attachment to reproductive futurism. It cannot wait until everyone around the globe has embraced "Make Kin Not Babies!" Doubling down on the conviction—so common in academic and leftist circles—that if we could just agree on the correct framing of the issue (or if we could at least all agree on what frame definitively to jettison), we would be closer to forging the kind of livable collaborations necessary for coexistence and survival, has become a waste of time we don't have. Rather than seek one singular frame to mobilize people on climate issues, we would likely benefit from getting more comfortable with diversity, enacting what Félix Guattari once imagined (as summarized by the translator of *The Three Ecologies*) as "a plurality of disparate groups [coming] together in a kind of unified disunity, a pragmatic solidarity without solidity."

About an ecological dispute in Manggur, Indonesia, that brought parties with vastly different priorities and outlooks together to oppose a logging company, Connolly writes, "The emergent assemblage did not become a unity, let alone a community; it became a moving complex of interests, concerns, and critical perspectives with a few shining points of affinity and commonality. All, for instance, opposed the logging company, but some pursued a wilderness ideal, while others sought to retain the forests as living sites of human-forest-animal-plant intersection. Even the victory did not look the same to all the parties involved."[16] *Even the victory did not look the same to all the parties involved*: this kind of dissonance

does not mean anything went wrong. It means that people are different from each other. Given that close to half the people in the United States have developed an attachment to climate denialism (and/or its twin, a me-first survivalism) so intense that some are willing to take up arms against decarbonizing, we are going to need a lot of help and wisdom in navigating these differences. Many of these folks aren't on the cusp of discovering a queer, multispecies sense of ecojustice. But they may come to feel that the freedom not to lose your home, your health, your livelihood, your food supply, or future possibilities for your children and the children of your children is also worth fighting for. They may also have things to teach us about freedom, care, and constraint that we don't already know, even—or especially—when we already think we do.

WHAT HAS THE FUTURE EVER DONE FOR ME?

When economists contend with global warming, they engage in a process called "future discounting," in which one "weighs future people's benefits against costs borne by people in the present." In contemplating the future, one can ascribe to it a high or low discount rate: as climate researcher David Hodgkinson explains, "If a cost benefit analysis uses a high discount rate, it discounts future benefits to a high degree, giving little weight to the interests of future people." If one uses a low discount rate, then the present generation is called upon "to make urgent sacrifices for the sake of future people." Economists and politicians have basically been future-discounting their asses off, ascribing "a lower weight to human interests the further they are in the future just because of the fact that they exist in the future." As Hodgkinson explains, "The prevailing view at the international level about action on climate change seems to be, 'Why should I care about future generations? What have they ever done for me?'" One scarcely needs to point out the conflict between this prevailing view and that which would insist, as does the Iroquois (Haudenosaunee) Constitution, that we must "look and listen for the welfare of the whole people and have always in view not only the present but also the coming generations, even those whose faces are yet beneath the surface of the ground—the unborn of the future Nation."

Navigating between the extremes of obligation-to-none/obligation-to-all is no easy matter. Even if and when we lean toward the latter, our ambitions are seriously challenged by questions of scale and capacity, not to mention the fact that, when it comes to care, there is no such thing as getting it exactly right. "Being nice to bunny rabbits means not being nice to bunny rabbit parasites." What's more, the attempt to urge "species thinking" upon people without taking into account the difficulties they might face in meeting the needs of their most immediate kin has its own ethical problems (which is why organizations like the Just Transition Fund, a group devoted to communities most directly destabilized by the transition away from coal, emphasize that the "most sustainable solutions are community-driven, developed by those most affected, and built from the ground up").[17]

In the realm of climate negotiation, the problem of variegated obligation actually has an acronym: CBDR-RC, UN lingo for "common but differentiated responsibility and respective capabilities." CBDR-RC negotiations, which aim to address the fact that nations have distinct histories and present challenges when it comes to reducing carbon emissions, justly play a role at any international summit about climate change. Such negotiations are notoriously thorny, and contribute to rendering climate change not just a "wicked problem," defined in 1973 by professors Horst W. J. Rittel and Melvin M. Webber as one that "has innumerable causes, is tough to describe, and doesn't have a right answer," but a "super wicked problem," defined in 2012 by professors Kelly Levin, Benjamin Cashore, Steven Bernstein, and Graeme Auld, as a wicked problem with four added features: "time is running out; those who cause the problem also seek to provide a solution; the central authority needed to address it is weak or non-existent; and, partly as a result, policy responses discount the future irrationally." These four additional features, the researchers say, "combine to create a policy-making 'tragedy.'"

In the face of this difficulty—or, for those already there, this tragedy—some thinkers and writers have started to take a different tack altogether, asking us to question the knee-jerk belief that "survival is always better than non-survival," as Morton has put it. Morton sees this preference for survival at all costs at the core of something he calls "agrilogistics"—a

modality he says developed in Mesopotamia at the end of the Pleistocene/ start of the Holocene, when humans shifted from nomadic hunting-gathering to settled-down agriculture. Over time, agrilogistics scaled up, "eventually requiring steam engines and industry to feed its proliferation." In this version of the story, the steam engine marks not the beginning of a new way of thinking or being, but the moment at which a much older habit or logic found expression in an energy source capable of making a geologically transformative mark.

Because agrilogistics predates industrial capitalism by thousands and thousands of years, Morton—along with some other political and earth scientists—considers industrial capitalism more a symptom than a cause of our predicament. Certainly there is no shortage of villains responsible for our current situation (a definitive cast of characters takes shape after 1965, when the American Association for the Advancement of Science delivered the news to President Lyndon Johnson about the causes and effects of accumulating CO_2 in the atmosphere). But the wider lens used by Morton, Chakrabarty, and others—along with Chakrabarty's provocatively compassionate contention that we "stumbled into" our current predicament—also seems worth bearing in mind, even if it chafes against the habit of blaming capitalism for everything.

If agrilogistics developed as a means for humans to better assure their security and survival *and* has led to the current crisis, then, as Morton argues, "a survival paradox emerges: the attempt to survive at any cost . . . is precisely the dynamic of murder-suicide." In the face of such a paradox, Morton thinks we would do well to shed our attachment to the axiom that "existing is better than any quality of existing" (or, more particularly, that "human existing is always better than any quality of existing"). He wants us to unsettle our unquestioned dedication to the idea that "no matter whether I am hungrier or sicker or more oppressed, underlying these phenomena my brethren and I constantly regenerate, which is to say we refuse to allow for death."

I'm up for thought experiments that allow for the reality of death, and destabilize our knee-jerk conviction that the survival of *Homo sapiens* is that

which matters most. But I scarcely think anyone should get too comfortable with white, first-world intellectuals—me included—musing about what conditions for life merit its continuation, and which forms of suffering (be it hunger, sickness, oppression, or the various deprivations certain peoples have imposed upon others) disqualify a life from perpetuation. At times people choose death rather than continue in gravely oppressive circumstances, or to avoid the near surety of a horrifying fate, or to save the life of another. But if and when someone else makes such a judgment call on behalf of another, or upon a demographic, it's justly called murder, or genocide.

Many branches of radical ecological thinking edge into this territory, insofar as grappling with systemic threats to the biosphere as we know it often demands a kind of zoomed-out perspective on humanity and planet that can prompt deeply unnerving paradigm shifts and proposals. Survival (and, some would say, reproduction) are (arguably) core instincts; philosophers excel at asking us to rethink and recalibrate rote behaviors, helping us to imagine—to feel, to know—that things could be otherwise. We could be otherwise. Our method of inhabiting the planet could be otherwise. Our attitude toward death, including our own individual deaths or that of our species, could be otherwise. Our attitude toward reproductive futurism could be otherwise. Our attitude toward nonhuman forms of life could be otherwise. Our negotiation, distribution, and conceptualization of freedom and obligation could be otherwise. Despite our instinct to preserve "civilization" (cf. Elon Musk's ethos, which he says he derived from Isaac Asimov: "You should try to take the set of actions that are likely to prolong civilization, minimize the probability of a dark age and reduce the length of a dark age if there is one"), it's absolutely worth questioning whether its preservation should be our aim *no matter what*. I agree that the problems before us are not thinkable unless we are willing to experiment with the type of perspective that environmental scholar Laura Watt models when she says: "As climate change shifts things in new and unpredictable ways, I have no doubt that planet Earth will survive, and that various aspects of the biological world will adapt and evolve accordingly. Change will happen, as it always does, and those changes are not necessarily 'good' or 'bad'

in a nonhuman sense; is it better or worse to have a predominance of mammals versus dinosaurs? Neither—these are just different outcomes. What gives climate change its most terrifying charge is the very real possibility that we will not survive it—although again, better or worse to have people around? From our perspective, better, but otherwise it's just another possible outcome on an ever-shifting planet."

The trick is learning how to move between the kind of open-ended thought experiments undertaken by Morton, the big-picture equanimity here evidenced by Watt, and the impassioned, fighting spirit of an activist like Heglar, as when Heglar declares: "Even if I can only save a sliver of what is precious to me, that will be my sliver and I will cherish it. If I can salvage just one blade of grass, I will do it. I will make a world out of it. And I will live in it and for it." Moving between these modes is not just an intellectual exercise. It involves letting ourselves be flooded by ferocious love, and experimenting with how that same love feels with a lessened grip.

UGLY FEELINGS, REVISITED

Talk to anyone about global warming for just a couple of minutes and you're likely to get some variation on "I just can't deal." It's too depressing, too overwhelming, too paralyzing, too sad, too frightening, too unimaginable. I get it. I don't actually think we can or should be able to contemplate in any casual way living through—not to mention causing—a sixth mass extinction that may eventually wipe out life on earth as we know it, including "our children and the children of our children." Given all the intense, daily demands on people's time and hearts, it seems fair enough to ask: When *is* the right time to grapple with climate-related feelings of anxiety, fear, rage, grief, and impotence—feelings that, when experienced in their entirety, threaten to feel bottomless or incapacitating? Especially since, as any student of anxiety knows, catastrophizing about the unknowable future is not a very productive or happy-making activity, and does surprisingly little to strengthen our capacity to cope. And who really cares how we *feel*, anyway, when the real business in front of us should

undoubtedly be action? Why on earth would I continue, at this moment in time, to perseverate on feelings, rather than lobby for the Green New Deal, advocate for reduced consumption of plastic and meat, be of service to those more vulnerable than myself, or just protest madly?

The inverse relationship between the scale of the climate problem and our difficulty in engaging with it emotionally isn't just a cruel irony, or another opportunity to squabble over the proper traffic between the personal and the political. It is one of the structural features of the crisis. So I'm focusing here on feelings, especially ugly ones, not only because I think they're standing in the way of something we like to call "action," but also because, whether we "act" in time to stave off a truly catastrophic rise in temperature or not—and we may very well not—they still matter, insofar as they shape our experience of our lives, determine how we treat others, and decide the ways we are able to "stay with the trouble," sometimes even determining whether we are able to do so at all.

We all struggle with what it means to "know" about global warming, even as we are living it. As Edward Morris and Susannah Sayler of the Canary Project point out, "knowing" is distinct from "believing" as, by their account, true belief would spur action, yet we do not act. (It would help, of course, if we felt surer about what actions to take, or if we had a stronger sense of the collective into which our individual actions poured.) As Morris puts it, "Belief is a function of feeling. We can only believe in climate change—by which I mean *not* the statistically created research object, and not even the hyperobject, but rather the cost in terms of pain that climate change will cause—when we are opened emotionally to it. Pierced." He and Sayler have described this awakening as a type of rupture or trauma. Those who have borne the brunt of climate-related trauma have already been delivered unto this awakening; those who have not face something of a paradox, wherein the continued refusal to be pierced on behalf of others may be precisely what ensures that climate-related trauma will come to them as well.

And yet, once pierced, then what? Who or what is supposed to aid us in navigating this rupture? How can we learn to move in and out of these

bursts of feeling, such that we feel neither subsumed by their intensity nor driven to repression?

Asserting the legitimacy of one's feelings—including one's ugly feelings—can be important, especially when one's being gaslit. And in a real, even literal, sense, we are all being gaslit, insofar as our so-called leaders are definitively *not* leveling with us about the facts of our ecological present or future. As the manifesto of the Dark Mountain Collective—a UK-based group of artists and writers dedicated to "uncivilization"—states: "We hear daily about the impacts of our activities on 'the environment' (like 'nature', this is an expression which distances us from the reality of our situation). Daily we hear, too, of the many 'solutions' to these problems: solutions which usually involve the necessity of urgent political agreement and a judicious application of human technological genius. Things may be changing, runs the narrative, but there is nothing we cannot deal with here, folks. We perhaps need to move faster, more urgently. Certainly we need to accelerate the pace of research and development. We accept that we must become more 'sustainable'. But everything will be fine. There will still be growth, there will still be progress: these things will continue, because they have to continue, so they cannot do anything but continue. There is nothing to see here. Everything will be fine." To which the Collective replies: "We do not believe that everything will be fine."

I don't believe that everything will be fine either. I don't actually know anyone who thinks everything will be fine, or anyone who could say, with a straight face and clear heart, that we are on track to leave behind a healthy, habitable planet that will sustain the miracle of biodiversity along with our children and the children of our children. But despair and depression are not the only possible responses to this fact, however sensical they may be. Despair tends to make a disproportionate claim on our thinking and feeling, as it is "the only thing which can be understood, explained and amply justified" (Stengers). It has, or it appears to have, a truth-value that joy, optimism, and happiness do not.[18] When we are in its grip, optimism and happiness appear foolish: when the true horrors of the past, present, or future are revealed to us—the bitter, cruel, inevitable

realities of life and death—we will rue any childish, illusory feelings of freedom, peace, or goodness we were once naive enough to entertain.

For some time now scholars and activists have tried to mine ugly feelings such as depression, fear, panic, paranoia, rage, jealousy, and shame for their political value.[19] Culp, for instance, laments that "most sober-minded critics find the uglier of our shared feelings unfit for something as noble as liberation," and argues that using negative affects as the basis of shared liberation is a possibility "only visible to those who have given up on the illusion that positive affects draw out the best in people." I agree that one must move through negative affects and not around them. But it seems to me there is a crucial difference between accepting their existence—being curious about them, giving them space, depathologizing them, understanding their cause and potential energy, not treating them as enemies to be purged from our psychic or collective lives—and believing that they signify the ultimate in radicalism or utility, or imbuing them with a kind of truth or use value that exaggerates both their significance and solidity. Habits of mind tend to produce more of the same habits of mind; negative affect is no different. And while positive affects may not always draw out the best in people (whatever that means), the idea that negative affects therefore do belies all of my experience of them (not to mention of those folks who merrily feed their fire).

Scholars Ann Cvetkovich, Moten, and others have noted that a lot of depression and negativity seems to coagulate in places where people are ostensibly "doing what they love," including the art world, activist circles, or the university. As Culp puts it, "Positive affects swirl through both the vortex of Zuccotti Park and the high rises of Goldman Sachs. Negative affects are caught at work at temp jobs but also at feminist conference panels. Like the ambivalence of any other form of power, affect is not a virtue but a diagnostic." Just so, people at Trump rallies seem to feel pretty good, maybe even *really* good, though it's worth considering whether pleasure and disinhibition shot through with scapegoating, nihilism, and odium qualifies, or in what ways it qualifies, as good feeling. Rather than trying to identify particularly miserable realms, it seems to me more fruitful simply to note that there's a lot of misery everywhere, along with an

underdeveloped ability to ask why, when things don't feel good, how we might make them feel better.[20] In which case, it makes sense to ask structural questions about which conditions need to be altered so that a bad thing can feel better, while examining the bad feelings themselves, to see if they are really as immovable or inevitable as we presume them to be. The former is hard because changing conditions and structures is hard; the latter is hard because it involves recognizing that there may be things about our bad feelings we have become habituated to and are loathe to give up, even when we insist that's precisely what we're going for.

This isn't simple perversity. It is hard to defy the strong forces of anxiety and paranoia because they are, as Freud had it, fundamentally forms of defense. ("People become paranoid over things they cannot put up with," Freud wrote, indicating why we can't ever purge paranoia and anxiety from our psychology entirely.) We worry that, if we loosen our grip, it will mean we are not apprehending our situation correctly, that we are denying real threats. We worry that, without sustaining our anxiety, a threat will take us by surprise, and that surprise will be unbearable (hello, near extinction 2030!). We worry that, if we practice a radical acceptance of "things as they are," we will slip into repression, self-indulgence, or inaction (the standard leftist critique of Buddhism and other forms of mindfulness). But paranoia, despair, and anxiety are not known for helping us to "stay with the trouble," or to deepen our fellowship with one another. In fact, they tend to reify an already painful sense of individuation, and to constrict our imagination toward the very worst it can conjure, as if rehearsing our worst fears will lessen our future suffering. Extensive personal experience with this approach has taught me that it does not. Instead, I've come to know it as a completely understandable, extremely effective means of attenuating whatever liberation, expansiveness, or pleasure might be available in the present moment, and depriving oneself of it.

POLITICS AND THERAPY

In 2014, Guy McPherson became a certified grief-recovery specialist, and has since made a career of helping people accept their imminent ex-

tinction. McPherson frames this acceptance as a form of freedom—the only freedom left to us. In a 2019 talk, he quotes concentration camp survivor Viktor Frankl: "Everything can be taken from a man but one thing: the last of the human freedoms—to choose one's attitude in any given set of circumstances, to choose one's own way." McPherson argues that our last act of freedom should be choosing an attitude that enables us to live "fully [and] urgently, with death in mind" as our species exits the stage.

McPherson's trajectory from climate scientist to certified grief-recovery specialist may be more explicit than that of others, but many intellectuals, especially those whose work focuses on climate change, have begun to lean into—if not fully embrace—the role of therapeutic guide. Morton's *Dark Ecology*, for example, leads the reader on a Tibetan-Book-of-the-Dead type of journey through the many layers of difficult feelings that "dark ecology" can bring about: "We usually don't get past the first darkness, and that's if we even care. In this book we are going to try to get to the third darkness, the sweet one, through the second darkness, the uncanny one. Do not be afraid." Berardi has also been quite explicit about this turn, arguing that "politics and therapy will be the same activity in the coming time. People will feel hopeless and depressed and panicking because they are unable to deal with the post-growth economy, and because they will miss the dissolving modern identity. Our cultural task will be attending those people and taking care of their insanity, and showing them the way of an adaptation, of a happy adaptation at hand. Our task will be the creation of social zones of human resistance, intended as zones of therapeutic contagion."

As I made clear earlier, I'm skeptical about turning more and more arenas of life (teaching, activism, art) into caretaking and therapy; as always, I suspect there's more élan to men taking up the cause, insofar as their doing so doesn't reinscribe any expectation of caretaking or healing that still manages to trail women in every sphere. Many men seem quite comfortable in the role of guru, perhaps because it places them in the position of purporting to know: presenting oneself as an authoritative source for diagnosis + treatment can be a performance of mastery as well as,

or in place of, care provision. At the same time, I think it's absolutely right that, when it comes to global warming—in addition to other acute crises that we face, many of which have begun to stack on top of each other—no one can bear the burden alone; the resulting dislocations will undoubtedly scramble our roles and relations (the experience of teaching throughout the COVID-19 pandemic has made this abundantly clear).

Getting past the first darkness of ecological awareness is easier said than done. I'm ashamed to admit it, perhaps because I still don't fully understand it, but the months I spent researching and writing this chapter were accompanied by somatic freak-outs repeatedly diagnosed—to my ferocious irritation—as "anxiety related." It was as if, after reading about mass extinction, environmental racism, and dying oceans all day, my attention and anxiety would unconsciously flip onto a more local object—my body—and fixate on eye twitches, chest pain, itchy skin, overactive bladder, jaw pain, GI distress, dizziness, and more. When I wasn't fixated on my own body, I worried over the health and safety of my son. I had unexplained weeping spells. I felt, like so many feel after deep exposure to the facts, like a wild-eyed Cassandra, unable to believe that anyone—including my own family, or me—could spend any part of any day reheating coffee, watching the US Open on TV, or bitching about email backlogs or annoying coworkers. Watching our so-called leaders not just deny and delay, but spitefully conspire to make things worse, felt like being trapped in a cocoon of ruinous madness, a true upside down, wherein everything from hundreds of thousands of COVID deaths to police violence to mass unemployment to poisoned air and water gets reflected back to us as "terrific" and "beautiful."

If this was staying with the trouble, it sure didn't feel good. In fact, it felt quite lonely. For while many of us think and feel about the climate all the time, no one really wants to talk about it, including, quite often, me. Howling at others to partake in the conversation can end up reinforcing one's alienation ("The Arctic Circle Hit 101°F Saturday, Its Hottest Temperature Ever. The average high temp for June is 68 degrees F. So, the Arctic is running +33 degrees right now. Is anybody listening?" a journalist tweeted today, clearly feeling the desperation).

In retrospect, my fixation on my body was not just pathological displacement. Contending with our collective predicament as a species amplifies the predicament in which we each find ourselves as mortal beings, which can feel overwhelming even on a good day. What we fear is coming for our planet or species is what we already know is coming for us and everyone we love. That's hard.

None of these feelings has gone away, exactly, but I see them now a hair more clearly for what they were, or are: flailing attempts to get through the first darkness unaided by the skills or solidarity that can keep one from collapsing into the whirlpool of individuated suffering. The good news is that those skills, that solidarity, is out there. Sometimes you just have to suffer long enough or hard enough to be compelled to seek it out, or recognize its existence.

RIDING THE BLINDS

Many writers on the climate have argued that artists have a critical role to play in imagining possible futures, be they dystopian or utopian. We can't construct a world unstructured by carbon energy or endless growth, they argue, unless we have imagined it first—or, conversely, we need images of the futures we most want to avoid in order to scare ourselves off course. Novelist Amitav Ghosh makes such an argument in *The Great Derangement*, in which he calls for "a transformed and renewed art and literature" that engages more directly with climate change—a call echoed by everyone from Stengers ("We need to learn telling other tales, neither apocalyptic nor messianic ones . . . Tales that, together with Haraway, I would call SF tales") to the Dark Mountain Collective, which includes British novelist and "recovering environmentalist" Paul Kingsnorth ("We believe that art must look over the edge, face the world that is coming with a steady eye, and rise to the challenge of ecocide with a challenge of its own: an artistic response to the crumbling of the empires of the mind") to Scranton ("We must build . . . cultural arks, to carry forward endangered wisdom. . . . The fate of the humanities, as we confront the end of modern civilization, is the fate of humanity itself").

As much as I understand these calls for us to invent or safeguard stories that might help us reflect and comprehend our circumstances with compassion, imagination, humor, solidarity, and dignity, I also think it valuable to "drop the storyline," as Chödrön has counseled: *all* story lines, including "progressive" ones, which pin their hopes on the arc of history moving toward justice. For at some point in our lives, if we live long enough, we begin to feel in a visceral fashion what we've always known intellectually to be true: our life spans will not allow us to take in the whole story. Indeed, there may be no whole story. Maybe there's no story at all. Our brains may be hardwired to produce story as a means of organizing space and time, but that doesn't mean that story is the only mode available to us in experiencing our lives.

It's hard to drop the story line—not to mention our steadfast conviction of linear time—when you're staring each day at your whitening hair and bearing witness to the stunning dissolve of the polar ice caps. It's hard when your kid is asking you point-blank how we got into this mess, and how—or whether—we're going to get out. "Tell me how it ends," writer Valeria Luiselli's daughter asks her repeatedly throughout Luiselli's book about children seeking asylum at the US-Mexico border. "Sometimes I make up an ending, a happy one," Luiselli writes. "But most of the time I just say: I don't know how it ends yet."

Rather than make recourse to story, often I find myself returning to a certain tableau, one conjured in the opening pages of Harney and Moten's *The Undercommons*. (Tableaux have to do with story, but insofar as they are perched in time, they offer a kind of pause or suspension from it.) The authors explain their book's title by summoning a classic Hollywood scene of the American West, in which—as political scientist Michael Parenti has noted—the colonial settlement is invariably depicted as surrounded by hostile, aggressive forces ("the natives"). This inversion is key to the settler's recasting of his own invasive, murderous colonialism as an act of self-defense. But Moten and Harney are not interested in simply repairing inversions. "The fort really was surrounded," they write, "is besieged by what still surrounds it, the common beyond and beneath—before and before—enclosure." Their task—and ours, if their "we" is in

fact "us" (and I think it can be, if not without some trouble; that is the profound generosity, and, for some, the controversy, of their work)—is "the self-defense of the surround in the face of repeated, targeted dispossessions through the settler's armed incursion." In an interview at the end of *The Undercommons*, Moten and Harney describe this notion of the undercommons, aka *the surround*, as "the first freight that we hopped." After that, Moten says, "we started riding the blinds."

"Riding the blinds": the hobo practice of riding between cars on a moving freight train, so as to evade capture by the train crew or police. The phrase appears often in the blues, that foundational laboratory for allowing any affect to attach to any object, alchemizing pain into sustenance, and creating zones of social resistance and therapeutic contagion. See, for example, Robert Johnson: "Leaving this morn', I have to ride a blind / Babe, I been mistreated, baby, and I don't mind dying."

Riding the blinds means you're out of the authorities' sight. It also means you can't see where you're headed. Maybe you're on a runaway train heading for a concrete wall. Maybe you're heading for a future that is simply impossible to imagine from the present. Maybe life will be better at the next stop; maybe it won't be. "Seen from the future, might the human prove nothing but a pollinator of a machine civilization to come?" ask Robin Mackay and Armen Avanessian in their introduction to *Accelerate: The Accelerationist Reader*. What a thought! I won't live long enough to find out, and neither will you.

One benefit of riding the blinds, or dropping the story line, is that other senses of time can become more palpable, including the feeling of *folded* or *intergenerational* time—what feminist scholars Astrida Neimanis and Rachel Loewen Walker have called "thick time": "a transcorporeal stretching between present, future, and past." "Thick time" is neither repo time nor queer time per se, though I admit to feeling it most often when I look at my son, and behold all the selves and ages he has passed through folded atop one another. (My mother once told me that, when she would go to pick me up from our town's square, she would sometimes get momentarily confused about what kind of body she was looking

for—a toddler body? A teenager body? A preteen body? At the time I thought she was a little nuts, but now I realize she was just touching the kind of thick time I experience all the time these days, when my son is explaining why a hot dog can't freeze in the freezer or how a realm differs from a world in Minecraft, and I'm distracted by noticing that his eyes look exactly as they did when he was an infant, nursing, in all that disordered time spent in the glider. My guess—my hope—is that, as I age, time will thicken further.)

All care—perhaps save hospice, though even that, in its way—has a tacit, if open-ended, relationship to futurity: you feed someone so that she will not grow malnourished; you treat a wound so that it will not become infected; you water seeds in hopes they will grow. It's not that there is no present in care, or that caring in the present is invalidated if and when the desired outcome fails to fruit. It's more that, in caring, time is folded: one is attending to the effects of past actions, attempting to mitigate present suffering, and doing what one can to reduce or obviate future suffering, all at once. Rather than tying ourselves in knots over how much value to assign to the future, or opposing an in-the-moment freedom to a future-concerned obligation, or consigning ourselves to the work of planetary hospice, we might instead recognize that "living fully in the present" always entails making choices about lessening or increasing future suffering. It always entails *temporal abundance*, a phrase lifted from poet-philosopher Denise Riley's beautiful, painful book-length essay *Time Lived, without Its Flow*, in which Riley reckons with the surprise death of her adult son. At her book's end, Riley describes this maternal temporal abundance as an "elaborate, dynamic, silent temporal abundance, even as this is also an abundance in loss." *An abundance, even in loss*: this sounds right to me, even if it pierces.

In an attempt to screw around with our sense of time, perhaps in the hopes of awakening us to the feeling of folded, or thick, or intergenerational, time, Morton often addresses his reader as a time traveler: "There you were, shoveling coal into your steam engine, that great invention patented in 1784 that Marx hails as the driver of industrial capitalism. The very same machine that Paul Crutzen and Eugene Stoermer hail as

the instigator of the *Anthropocene*," he writes. "There you are, turning the ignition of your car. And it creeps up on you. You are a member of a massively distributed thing. This thing is called *species*. . . . My key turning is statistically meaningless. . . . But go up a level and something very strange happens. When I scale up these actions to include billions of key turnings and billions of coal shovelings, harm to Earth is precisely what is happening. I am responsible as a member of this species for the Anthropocene."

So, here we are again, shoveling coal into the tender, or, in my son's case, pantomiming the motion in the ruins. He loves trains and doesn't care about trains anymore, ersatz wind in his toddler hair, real wind on his big-kid face as he flies through the pandemic-emptied lot. Here I am beside him, discovering, for the millionth time, the verity of joy, and how it throbs with impermanence, responsibility, and sorrow. The cord has been cut, most surely. But if I can imagine raising him, and continuing to raise myself, as those who might work on behalf of the surround— the common beneath and beyond—the *already and forthcoming*—if we can love all the misery and freedom of living and, as best we can, not mind dying—then my heart feels less broken, more emboldened. It feels shaped right. Morton says he wants "to awaken us from the dream that the world is about to end, because action on Earth (the real Earth) depends on it." For so long, I didn't know what he meant. I do now.

Afterword

All writing, even that which attempts to address the "now," ends up addressing the "not now," if only because the moment of composition is not commensurate with that of publication or dissemination. This is part of writing's power. It also occasions certain temporal anxieties for the writer. Chief among mine is the fear that I will die before finishing a project; talking with others has led me to believe that this fear is not altogether uncommon. Books long for both complication and resolution, which can make writing feel like running a race while making the route ever more circuitous, the finish line ever more implausible. Another common anxiety involves fantasizing—by which I mostly mean catastrophizing—about the possible futures that might greet one's work in the world. Usually this takes the form of sublunary anxiety about reception, but at other times—such as our own, when a shadow has fallen over the idea of human futurity itself—such anxieties scale up, and reach into more vertiginous territory.

Beginning this book at the start of the Trump era and finishing it during a raging pandemic whose end, as I write, is nowhere in sight has provided ample opportunity to wonder about what kind of world it might fall into (and, due to climate change, what kind of world will come after that). Even if one has little to no investment in one's name or ideas "carrying on," or in the fantasy of one's writing as a consolation for, or bulwark against, the pain of individual or collective mortality, there remains a problem, one Denise Riley discovered when she couldn't write for two

years after the death of her son: "You can't, it seems, take the slightest bit of interest in the activity of writing unless you possess some feeling of futurity. The act of describing would involve some notion of the passage of time. Narrating would imply at least a hint of 'and then' and 'after that.'"

Despite my longstanding Beckett-like resistance to narrative, or my gravitation toward Beckett's notion that each word we write is "an unnecessary stain on silence and nothingness," Riley's observation still strikes a chord. After all, a conviction of "'and then' and 'after that'" is baked into where we are now—an "afterword"—a designation that means to offer the feeling of summation and temporal orientation, but really just means more words after other words, all part of a thought stream that remains unfinished and ongoing.

In his 1844 essay "Experience," Emerson spatialized this dilemma: "We wake and find ourselves on a stair; there are stairs below us, which we seem to have ascended; there are stairs above us, many a one, which go upward and out of sight." Such in-betweenness may be our chronic state, but it has felt to me—as promised—definitively keener at midlife, where I'm currently perched, and where Emerson was perched when he wrote "Experience." (He had also just lost his five-year-old son, Wallie.)

The sense of being trapped on a stair—in time, in midlife, in our bodies, in pain, in history, in grief—able to see the import of our lives and times only through a glass, darkly, is familiar enough. Certainly it has had some strong advocates. But it's not the only interpretation of our situation, or the only tense in which we traffic. As Italian philosopher Rosi Braidotti (among others)[1] has reminded us, there is also the future anterior, a tense notable for its conjuring of a future before the future, a little pocket in time—a fold, or a hatch—from which it makes sense to say, as Braidotti does, "You will have changed," "they will have fought for justice," or "we will have been free." Braidotti calls such assertions "nomadic remembering."

Nomadic remembering. What could it mean? From what place or time or speaker do such assertions derive? What kind of temporal abundance allows us to remember what has not yet been? Does *We will have been free*

move me because it offers a consolation prize, slave-morality style, or because I sense in it an inescapable truth? Does it emanate from a speaker who hopes—who, in fact, knows—that utterances made in the present can shape the past and future? Is it an assurance that arises from who-knows-where (the afterlife?) akin to Moten and Harney's fugitive refrain, "If they ask you, tell them we were flying." Were we? Are we now?

A few years prior to "Experience," Emerson wrote, in "The American Scholar," "This time, like all times, is a very good one, if we but know what to do with it." This inspiring and sometimes galling proposition has provided me with no small measure of provocation and sustenance since I first encountered it over two decades ago, when it was a topic of discussion during my orals exam in graduate school. My exam took place a few weeks after 9/11, a time during which our building, which was across the street from the Empire State Building, was being repeatedly evacuated due to anthrax scares and bomb threats.

It's hard to conjure now how bad that time felt, especially as the bad feelings were soon subsumed by different bad feelings, about the wars on Afghanistan and Iraq (and now that New York City has undergone a fresh wave of collective suffering and death, from COVID-19). But I remember that it felt very bad. *How is this time a very good one?* my committee and I wondered aloud in our gray-carpeted seminar room, each of us eyeing little mounds of chalk dust we worried might be anthrax. *What would it mean to "know what to do with it"?*

After my exam, we debated the safest modes of transit home—some professors said they hadn't been near the subway since so many had been buried alive in the tunnels; others, haunted by the images of people covered in ash and blood being chased down the street by a meteor of debris, insisted the train was safer. I was in the former camp, and thus embarked, postexam, on the long walk home to Brooklyn. "No matter what's going on in the world, you should still mark the occasion by buying yourself something nice, like a fountain pen," one professor counseled, a suggestion that felt as ludicrous as it was kind (I've since dispensed similar advice).

I felt sick to my stomach that day, as I did for months after 9/11. I'd never before felt (and hope never to feel again) what material proximity to thousands of recently murdered people feels like. What it smells like. As I took the long walk home, I turned Emerson's axiom over and over in my head. Its superficial blitheness or coldness reminded me of certain Buddhist teachings, such as the one about "this moment being the perfect teacher," a teaching that can really piss people off (*this cancer? this car accident? this separation from my child? this police shooting? this unjust war? this sixth extinction? this pandemic?*). That we don't get to exempt certain experiences from these propositions is, however, integral to their challenge, as is the fact that something can be a perfect teacher while also ending in our death (one definition, alas, of life itself).

Think we must, we must think. As we think, we might remember that it matters not only with whom and what we choose to think; it also matters what spirit we choose to think with. As the feminist team of economic geographers J. K. Gibson-Graham puts it, "The spirit of our thinking is a matter for ethical decision, as is the choice of techniques and practices of thinking." No doubt this ethical decision is complicated by the fact that, as Gibson-Graham also says, "All thinking is conditioned by feeling." If our feelings shape our thinking, and we don't exactly choose our feelings, how on earth can we choose the spirit of our thought?

There are a thousand ways in which the spirit of my thought feels determined, sometimes overdetermined, by my demographics, my historical moment, my nature, my nurture, the technological means by which I produce and distribute it, the company I keep, and the well-worn grooves of my mind. These proclivities are never entirely within one's control (woe to she who believes otherwise). Yet the fact that a great deal of how we think and feel is spontaneous, habitual, and tied to forces larger than ourselves, be they our traditions, our times, or our temperament, is no reason to presume it fixed. Awakening to the choices we have in such matters is a practice of freedom, and one worth our time.

Thinking aloud with others, as I've tried to do here, is one such practice. It is an ongoing and even dialectical process, in that it involves allow-

ing oneself to be interpenetrated and transformed while retaining the capacity to differentiate and assert. It does not require that we agree. It requires that we not abandon one another. Using discursive language in service of such a goal is tricky, insofar as discursive language monologues, pretends to know. But thinking aloud is distinct from mere argument, bossiness, or persuasion. It involves examining the hold that certain ideas have on us, as individuals, a culture, a subculture, or even a species, and allowing for ventilation, adaptation, and release, so that we don't become unwittingly shackled to them (as can happen with "freedom" itself).[2]

As for the final big night of liberation, I'm still not holding my breath. In fact, my patient labors in the realms of art, sex, drugs, and climate (there could have been more, but limitation begets fruition) have strengthened my respect for the complex, ongoing practices of freedom, care, and constraint, as well as for the challenges of "staying with the trouble." At the same time, as I bring this project to its close, I can literally hear outside the sound of the uprisings that have been filling the streets all summer, their insubordinate conviviality flooding me with hope and gratitude throughout an otherwise heartbreaking and frightening time. The eruption of cacophonous, public assembly in service of freedom and care alike in the midst of such an intensely isolating period (i.e., life under "stay at home" orders, wherein our capacity to touch has been radically constrained) has served as a reminder of the irrepressible power of liberatory spirit, as well as of that spirit's temporal abundance—how it links to past struggles, shape-shifts to meet the present, and has the capacity to transmogrify the future.

As commentators stay busy prognosticating how close we are to falling off one cliff or another, or charting the odds as to whether this moment will serve (or, rather, whether we will make it serve) as a portal to the changes we badly want and need—whether it is, in fact, a good time that we know what to do with—the value of divesting from the horse race of hope and fear has never felt to me so clear.[3] For even if this moment doesn't deliver everything we want—and what moment ever has?—or even if things get radically worse from here, it's not as if the portal then shuts and we're

reconfined to the Matrix, grimly awaiting a deus ex machina to gift us another chance. We will have to keep on—*we will have kept on*—with our love, study, and struggle, the trinity revered by Robin D. G. Kelley, in which each element is inseparable from the others, and each stands ready to buoy us if and when the others falter.

As far as obtaining freedom "in two, three, seconds," and releasing "all the sorrow and regret about the past . . . all the uncertainty and fear about the future," I can't say that's yet happened for me. In fact, one of this book's sleeper surprises was that focusing on freedom brought me into a full-throttle reckoning with anxiety, one of freedom's most formidable adversaries. Perhaps this shouldn't have been a surprise: one of the lessons of interdependence is that you can't get to know anything without getting to know its siblings or surroundings. I would not be the first thinker (or human) to discover the distressing, if potentially fertile, kinship between freedom and anxiety, even if I had to learn it anew for myself.[4] But I can say that, through repeated, often painful excursions, I have learned which habits of mind lead to more panic, more curdled and constricted heart (dread of bad scenes or surprises; the ferocious desire to ward off pain, illness, or death; attempts to control that which dwarfs one's ability to do so), and which ones lead to vastness, empty space, blue sky, whatever you want to call it—the silence and nothingness at the end of writing and everything else. I didn't and still don't know what opening onto that vastness would feel like. Sometimes I feel sure I won't know until I die. But I'm not going for a freedom drive that's primarily a death drive; all that comes soon enough. Until then, I want to be in, all in: all heart, no escape.

Acknowledgments

The following people helped me feel, think, or otherwise write this book: Hilton Als, Matthew Barney, Brian Blanchfield, Ian Bonaparte, Carrie Brownstein, Tisa Bryant, Judith Butler, Andrew Culp, Lenny Dodge-Kahn, Mark Epstein, Bill Forsythe, Miguel Gutierrez, Conner Habib, Claire Haiman, Bill Handley, Laura Harris, Saidiya Hartman, Cathy Park Hong, Miranda July, Wayne Koestenbaum, Dawn Lundy Martin, Mike Mills, Fred Moten, Eileen Myles, Janet Sarbanes, Milagros Saxon, Lee Anne Schmitt, Teri Stein, A. L. Steiner, Simone White, and the brave interlocutors in my Literature of Addiction, Hope & Fear, and Theory & Criticism seminars. Carolee Schneemann infused me with inspiration before her passing, as did David Graeber, whom I never met, but whose work and spirit heartened me throughout. My last intellectual exchange with Christina Crosby was about art, care, and George Eliot; there are no words for how much I will miss her. Long live their uncommon faith in pleasure, conversation, and possibility.

Special gratitude to Eula Biss, Michael Clune, Jack Halberstam, Josh Kun, Anthony McCann, Ed Morris, and Danzy Senna for crucial feedback at critical junctures, and to Ben Lerner, for his inimitable intelligence and friendship every step of the way. Thanks also to the MacArthur Foundation, for the great gifts of money and time; David St. John, for creating the conditions for good work, in all senses of the phrase; Michal Shavit and Jared Bland, for all their input and support; Frances Lazare,

for indispensable editorial assistance in the final hour; and Michael Taeckens, for helping this book find its way in an altered world.

Lastly, huge thanks to Ethan Nosowsky, as well as to Fiona McCrae, Anni Liu, Katie Dublinski, Marisa Atkinson, Caroline Nitz, and all the other good people at Graywolf, for backing this project so thoroughly, making it better, and creating such a hospitable home for thought; PJ Mark, for sixteen years of flawless advice and unflagging support; and Harry Dodge, for all the love, and all the philosophy in the kitchen.

Notes

INTRODUCTION

1. Many have connected rather than opposed love and freedom: see bell hooks's "Love as the Practice of Freedom," in which hooks asserts, "The moment we choose to love we begin to move towards freedom"; Foucault's linkage of "practices of freedom" to "care of the self"; Brazilian philosopher and educator Paulo Freire's focus on "the act of love" as commitment to "the cause of liberation."

2. A. L. Steiner, personal correspondence, August 6, 2016.

3. See Manolo Callahan, "[COVID-19] (Insubordinate) Conviviality in the COVID-19 Conjuncture." Thanks to Fred Moten for bringing this article to my attention.

4. See Ammon Bundy's March 2020 comments about the coronavirus: "[This virus] is being exploited in every way by people in and out of government who want to take what does not belong to them. I pray that enough of [us] will wake up, stand up and put liberty above safety in every case!" See also historian Jelani Cobb's comment on his Twitter feed in April 2020: "The reopen protesters keep saying 'Live Free or Die.' Someone should tell them those two things are not mutually exclusive."

5. This method echoes Eric Foner's, as he describes it in the introduction to *The Story of American Freedom*: "Rather than seeing freedom as a fixed category or predetermined concept, I view it as an 'essentially contested concept,' one that by its very nature is the subject of disagreement. Use of such a concept automatically presupposes an ongoing dialogue with other, competing meanings."

6. See Butler's *The Psychic Life of Power*, 17–18; see also Moten's discussion of this point in *Black and Blur*, 29.

7. See Wendy Brown's *States of Injury* (1995), in which Brown explains how progressive political agendas that demand the state "buttress the rights and increase the entitlements of the socially vulnerable or disadvantaged: people of

color, homosexuals, women, endangered animal species, threatened wetlands, ancient forests, the sick and the homeless" can be shaped more by Nietzschean *ressentiment* (i.e., "the moralizing revenge of the powerless" on the powerful) than by "the dream of democracy—that humans might govern themselves by governing together." See also Angela Davis's *Freedom Is a Constant Struggle*, in which Davis usefully reminds us: "There is this freedom movement and then there is an attempt to narrow the freedom movement so that it fits into a much smaller frame, the frame of civil rights. Not that civil rights is not immensely important, but freedom is more expansive than civil rights."

8. For more on freedom in Trumpism, see Lauren Berlant's essay "Trump, or Political Emotions," published just prior to Trump's election in 2016: "Trump is free. You watch him calculating, yet not seeming to care about the consequences of what he says, and you listen to his supporters enjoying the feel of his freedom. See the brilliant interviews on Samantha Bee's *Full Frontal*, where RNC conventioneers say, over and over: We're for Trump because he's not politically correct, PC has harmed America, and you think, *people feel so unfree*. . . . They want fairness of a sort, but mainly they seek freedom from shame. Civil rights and feminism aren't just about the law after all, they are about manners, and emotions too: those 'interest groups' get right in there and reject *what feels like* people's spontaneous, ingrained responses. People get shamed, or lose their jobs, for example, when they're just having a little fun making fun. Anti-PC means 'I feel unfree.'" For more analysis of freedom as license and its relation to domination, see Wendy Brown's contribution to Brown, Gordon, and Pensky, *Authoritarianism: Three Inquiries in Critical Theory*.

9. A few other examples of this approach, from a variety of spheres:

- On the mainstream, electoral politics front, linguist George Lakoff has written about the need for Democrats to "frame and name" the version of freedom that they stand for, namely, the kind that suggests that without public resources such as "roads, bridges, the interstate highway system, sewers, a water supply, airports and air traffic control, the Federal Reserve, a patent office, public education for your employees, public health, the electric grid, the satellite communications, the internet . . . clean air, clean water, safe food and products, public safety, access to education and health care, housing, employment," we are unable to be truly free. "Republicans talk about freedom all the time," Lakoff says, "but the Democrats are the real party of freedom and need to say it." I'm sure many (leftist) critics of the Democratic Party would disagree with this assessment, and hear in it a watered-down version of the kind of freedom imagined by Marx (or even democratic socialists), but moving on . . .

- In the field of LGBTQ+ studies, Janet Jakobsen and Ann Pellegrini have argued (in *Love the Sin*) that "by moving the ground of debate away from a constricted focus on 'rights' to freedom, we hope to change a movement [the LGBTQ movement] that, as it currently stands, is really only against something (discrimination) into one that is actively and unembarrassedly for something (freedom)."
- Freedom plays a prominent role in anarchist thought: as Mikhail Bakunin wrote: "I am free only when all human beings surrounding me—men and women alike—are equally free. The freedom of others, far from limiting or negating my liberty, is on the contrary its necessary condition and confirmation. I become free in the true sense only by virtue of the liberty of others, so much that the greater the number of free people surrounding me and the greater and deeper and more extensive their liberty, the deeper and larger becomes my liberty." Accepting as foundational that freedom is, at its heart, a social phenomenon, insofar as "one person's freedom necessarily infringes on another's," anarchism treats the juggling act between individual desire and communal good as a positive tension, "a creative and inherent part of human existence," which must be grappled with using methodologies such as direct democracy and consensus decision making in order to create "a free society of free individuals" (see Cindy Milstein, *Anarchism and Its Aspirations*).

10. Sociologist Orlando Patterson famously explores this link in *Slavery and Social Death*, in which—after 1,000+ pages—he arrives at "the unsettling discovery" that "an ideal cherished in the West beyond all others [freedom] emerged as a necessary consequence of the degradation of slavery and the effort to negate it." This leads Patterson to what he calls "a strange and bewildering enigma: are we to esteem slavery for what it has wrought, or must we challenge our conception of freedom and the value we place upon it?" Saidiya Hartman trenchantly takes up this question in *Scenes of Subjection* by offering a meticulous, horrifying account of how white people used the discourse of freedom to reenslave newly freed Blacks in the Reconstruction period and beyond, demonstrating not only how forms of servitude, disenfranchisement, and violent subjugation arrive in the guise of liberation, but also how the "free" liberal subject depends upon the "the denigrated and deprecated, those castigated and saddled by varied corporeal maledictions," the "fleshy substance that enable[s] the universal to achieve its ethereal splendor."

11. See Lordon, *Willing Slaves of Capital*. See also Marx's notion of the "double freedom" of the worker: "For the conversion of his money into capital, therefore, the owner of money must meet in the market with the free labourer, free in the double sense, that as a free man he can dispose of his labour-power as his

own commodity, and that on the other hand he has no other commodity for sale, is short of everything necessary for the realisation of his labour-power."

12. Certainly other peoples and movements have played a role in this conversation—see, for example, Evelyn Nakano Glenn's *Unequal Freedom*, in which Glenn considers the history of Mexicans and Anglos in the Southwest, and Asians and haoles in Hawaii, alongside the history of Blacks and whites in the American South. See also Foner, *Story of American Freedom*, on the conflict between the Native American idea of freedom, which "centered on preserving their cultural and political autonomy and retaining control of ancestral lands" (51) and the white settler/Manifest Destiny notion of such, which entailed annihilating that autonomy. But due to the particular material, juridical, and philosophical centrality of chattel slavery and its afterlife in American history, the Black/white dyad has long structured and dominated the nation's "freedom" discourse.

13. Author and activist adrienne maree brown takes up this point in *Pleasure Activism: The Politics of Feeling Good* (2019). See also the explosion of work on "Black joy," as in Kleaver Cruz's project by that name; and performance artist and writer Gabrielle Civil's 2019 book *Experiments in Joy*.

14. See Berlant, "Trump, or Political Emotions." See also Ann Cvetkovich's *Depression*.

15. In an astonishing letter to Baldwin, published in the *New Yorker* in 1962, Arendt pours colder water still on Baldwin's "gospel of love." "In politics," Arendt writes, "love is a stranger, and when it intrudes upon it nothing is being achieved except hypocrisy. All the characteristics you stress in the Negro people: their beauty, their capacity for joy, their warmth, and their humanity, are well-known characteristics of all oppressed people. They grow out of suffering and they are the proudest possessions of all pariahs. Unfortunately, they have never survived the hour of liberation by even five minutes. Hatred and love belong together, and they are both destructive; you can afford them only in the private and, as a people, only so long as you are not free." (Moten also discusses this letter: see *Black and Blur*, 84–88.)

Arendt is here rejecting the claim of any special knowledge held by oppressed peoples, a claim that, when filtered through a theological register, often takes the form of "redemptive suffering." As British historian Paul Gilroy describes it in *The Black Atlantic*, redemptive suffering takes that which was "initially felt to be a curse" (such as "the curse of homelessness or the curse of enforced exile") and repossesses it. Such repossession, Gilroy points out, is "a familiar element in the theology of Martin Luther King, Jr., which argues not only that black suffering has a meaning but that its meaning could be externalised and amplified so that it could be of benefit to the moral status of the whole world."

Similar claims about Jewish experience proliferated after World War II, and were precisely what Arendt was pushing back against (Arendt thought it dangerous to treat any one group as an undifferentiated moral compass, somehow less susceptible to the banality of evil or the seductions of power).

Claims of special knowledge also course through feminist thought, or at least the strain of it that sees women as more inclined toward relationality, intimacy, and care than toward a hard-hearted mythos of individual freedom. Whereas some feminists argue that women need to practice more individuation and less compulsive caring for others in order to locate and inhabit a more functional autonomy for themselves, others have advocated for a cultural revaluation of the "women's work" of nurturing or caregiving, arguing that it represents a form of knowledge (or, from an economic perspective, unremunerated labor) that coheres society, providing the bonds that make life worth living. Some feminists, it must be said, have rejected as naive and essentialist the suggestion that women have special access to an ethical goodness capable of redeeming a sick world (see, for example, legal scholar Janet Halley's *Split Decisions*, in which Halley excoriates the care-oriented feminism of psychologist Carol Gilligan and legal scholar Robin West).

16. Moten, personal correspondence, October 9, 2016.

17. See Marcus and Schwartz, "Does Choice Mean Freedom and Well-Being?" See also Amartya Sen's *Development as Freedom*.

18. Of course, one can also "feel good" while reenacting, say, white settler occupation, as explored by Anthony McCann in his writing about Ammon Bundy and co's occupation of the Malheur Wildlife Refuge in Oregon. In a 2016 piece titled "Sovereign Feelings," McCann writes (speculatively) about the occupiers: "They must have felt great out there. Even if they didn't really know much about it, even if they were (and they were) basically lost, it's still an awesome place and it must've been great just to be there. Let's leave aside, for the moment, the question of what a place is, or what it is to be lost, or lost in place; let's stick to the feelings, even if place is a feeling, and even if lost is often how one feels, or finds one's way to feeling. It must have felt grand just to be there in that land, in that 'scape, there where they were—in a territory newly liberated, freshly invented, mapped out by the lines of their activity, of their feelings. After all, they weren't just there, they weren't just in it, they were it—and it, their own new thing, was cradled in all this shimmering enormity."

19. "The less sure you are of yourself," Moten has said, "the more possible it is to be in communion" (see "The Black Outdoors," a public conversation with Hartman). Such ideas about the relation between selfhood and communion are common to multiple spiritual traditions, such as Mahayana Buddhism, which considers the individuated self an illusion standing in the way of our

apprehension of oneness; biologists, too, take pains to remind us that, in the biosphere, "there is only one immutable truth: No being is purely individual; nothing comprises only itself. Everything is composed of foreign cells, foreign symbionts, foreign thoughts. This makes each life-form less like an individual warrior and more like a tiny universe, tumbling extravagantly through life like the fireflies orbiting one in the night. Being alive means participating in permanent community and continually reinventing oneself as part of an immeasurable network of relationships" (Weber, *Matter and Desire*, 36).

I. ART SONG

1. See "The New Politics of Care," by Gregg Gonsalves and Amy Kapczynski. See also the *Boston Review*'s summer 2020 edition, titled *The Politics of Care*, with contributions by Robin D. G. Kelley, Gregg Gonsalves and Amy Kapczynski, Walter Johnson, Anne L. Alstott, Melvin Rogers, Amy Hoffman, Sunaura Taylor, Vafa Ghazavi, Adele Lebano, Paul Hockenos, Paul Katz and Leandro Ferreira, Shaun Ossei-Owusu, Colin Gordon, Jason Q. Purnell, Jamala Rogers, Dan Berger, Julie Kohler, Manoj Dias-Abey, Simon Waxman, and Farah Griffin. See also the work of political theorist Deva Woodly, who explains: "Care, here, is not a mere sentiment. Nor does it indicate a posture of deference or coddling. Instead, care is a pragmatic value, requiring the provision of what is necessary for health, welfare, maintenance, and safety with serious attention to doing things correctly in order to avoid unnecessary damage or risk. In this way, the politics of care begins with the conviction that lived-experience matters and the reality of our experiences must be centered in our politics." See also Manolo Callahan and Annie Paradise's "Fierce Care."

For a critique of a "politics of care," see Judith Butler's *The Force of Nonviolence*, in which Butler writes: "As important as it is to revalue vulnerability and give place to care, neither vulnerability nor care can serve as the basis of a politics. . . . If, for instance, by an ethics or politics of care we mean that an ongoing and un-conflicted human disposition can and should give rise to a political framework for feminism, then we have entered into a bifurcated reality in which our aggression is edited out of the picture or projected onto others."

2. See Sharpe's *In the Wake*: "I want to think 'care' as a problem for thought. I want to think care in the wake as a problem for thinking and of and for Black non/being in the world. Put another way, *In the Wake: On Blackness and Being* is a work that insists and performs that thinking needs care ('all thought is Black thought') and that thinking and care need to stay in the wake." Sharpe usefully differentiates this "wake work" from the paternalistic, controlling type of care that emanates from "state-imposed regimes of surveillance": "From the

euphemism of children forcibly removed from their parents into state 'care' to laws like the 'beyond the front door policy' in the Netherlands that forces people, often nonwhite, to open their doors to state monitoring and intrusion, to medical experiments and the forced feeding of hunger strikers, who for example, refuse food to protest *that* they are held *and* the conditions under which they are held. All of this and more is carried out under the rubric of care. Yet I want to find a way to hold onto something like care as a way to feel and to feel for and with, a way to tend to the living and the dying."

3. Obviously this allowance chafes against the "your art and your ethics are one" credo set forth in, say, Larry Neal's "The Black Arts Movement" (1968), in which Neal writes, "The Black Arts Movement believes that your ethics and your aesthetics are one. That the contradictions between ethics and aesthetics in western society is symptomatic of a dying culture."

4. For work on the "crisis of care," see Evelyn Nakano Glenn's *Forced to Care*, Nancy Fraser's "Contradictions of Capital and Care," and Wendy Brown's *Undoing the Demos*. For feminist work on an "ethics of care," see psychologist Carol Gilligan (*In a Different Voice*), philosopher Nel Noddings (*Caring*), political scientist Joan Tronto (*Moral Boundaries*), and philosopher Sara Ruddick (*Maternal Thinking*). Regarding self-care in activist circles, see Audre Lorde's oft-summoned quote (from 1988's *A Burst of Light*), "Caring for myself is not self-indulgence, it is self-preservation, and that is an act of political warfare," and documents such as the *Healing in Action* pamphlet put out by Black Lives Matter: https://blacklivesmatter.com/wp-content/uploads /2017/10/ BLM_HealinginAction-1-1.pdf.

5. Molesworth provides the following examples: "Simone Leigh's therapeutic workshops with women in the movement at the New Museum in New York . . . Karon Davis's elegiac show 'Pain Management' at Wilding Cran Gallery in Los Angeles and Lauren Halsey's spiritual funk fest 'Kingdom Splurge (4)' at Recess in New York; the eloquently reparative albums of Dev Hynes and Solange; and the emergence of the Rebuild Foundation in Chicago and the Underground Museum in Los Angeles (which offer yoga and meditation, respectively, as part of their programs)." In keeping with the Black radical tradition, institutions such as the Underground Museum and the Rebuild Foundation (I'd add LA's Art + Practice to the mix as well) offer services such as job training, childcare, housing support, education, and internships for foster youth, in addition to art programming and exhibition.

6. That Muñoz treated Jack Smith's performances—which he considered "rich antinormative treasure troves of queer possibility"—as foundational even as Muñoz says he was initially "disturbed by what could be described as [their] orientalizing and tropicalizing aspects" demonstrates how disidentification, for

Muñoz, was not predetermined or overdetermined by demographic affiliation; it remained a matter of interpretation, upon which critics could and would differ.

7. The presumption that art is always a cheery force for good, or of inevitable benefit to a community, has been hotly contested by internecine campaigns against neighborhood gentrification, as waged by the Los Angeles groups Defend Boyle Heights and the Boyle Heights Alliance Against Art Washing and Displacement. See also the fierce protests against toxic philanthropy in the art world, as conducted by artist Nan Goldin's PAIN Sackler group, or the activist collective Decolonize This Place; and protests stemming from the #MeToo movement, which have brought salutary attention to various forms of mistreatment that have gone protected under the name of art (for example, unwanted touching during improv theater sessions, or accounts of on-set mistreatment, as in accounts by actresses Maria Schneider [*Last Tango in Paris*] or Uma Thurman [*Kill Bill*], with Thurman alleging treatment that verged upon the murderous).

As for arguments about art as a state of exception, see George Orwell's 1944 essay about Salvador Dalí, "Benefit of Clergy," in which Orwell writes, "It will be seen that what the defenders of Dali are claiming is a kind of *benefit of clergy*. The artist is to be exempt from the moral laws that are binding on ordinary people. Just pronounce the magic word 'Art,' and everything is OK. Rotting corpses with snails crawling over them are OK; kicking little girls in the head is OK; even a film like *L'Age d'Or* is OK. It is also OK that Dali should batten on France for years and then scuttle off like rat as soon as France is in danger. So long as you can paint well enough to pass the test, all shall be forgiven you. One can see how false this is if one extends it to cover ordinary crime. . . . If Shakespeare returned to the earth tomorrow, and if it were found that his favourite recreation was raping little girls in railway carriages, we should not tell him to go ahead with it on the ground that he might write another *King Lear*. . . . One ought to be able to hold in one's head simultaneously the two facts that Dali is a good draughtsman and a disgusting human being. . . . In the same way it should be possible to say, 'This is a good book or a good picture, and it ought to be burned by the public hangman.'" No matter how many times I read this essay, I can't figure out how Orwell—the writer who invented the phrase "the Thought Police"—here cares so little for the distinction between painting grotesque things and "raping little girls in railway carriages"; my only thought is that the stakes of World War II, and Orwell's anger at Dalí for leaving France, overwhelmed his reasoning. (Thanks to Cameron Lange for bringing this essay to my attention.)

8. Of those who signed onto Black's letter, Christina Sharpe is one of the few who has been willing to support an argument for destroying art as art. As Sharpe explained in a 2017 *Hyperallergic* interview about the Schutz contro-

versy, "There can be an ethical call to destroy something. . . . There are a number of ethical responses—that you may or may not agree with—that call for the destruction of certain kinds of representation." I may disagree with Sharpe on the efficacy of such responses, but her stance at least feels more honest than attempting to deprive certain pieces of art of their status as art in order to justify their suppression or destruction.

9. This isn't to say that suppression or ejection is never an appropriate response—certainly I do not allow work that involves the nonconsensual injury of others' bodies, diminishment of others' physical autonomy (as in locking the classroom or theater doors), or incitement of fear of bodily harm (as in brandishing weapons or realistic replicas of weapons). The story of Chris Burden's 2005 resignation from UCLA over a student's use of a gun in a performance piece is relevant here; see Boehm, "Two Artists Quit UCLA over Gun Incident." Some thought Burden's stance was hypocritical, in that Burden himself became famous for his 1971 work *Shoot Piece*, in which he orchestrated being shot in the arm in a gallery setting. But I consider the distinctions Burden made between *Shoot Piece* and the student's stunt, which involved playing Russian roulette in front of the class, then leaving the room and firing a shot (no one was hurt), to be of utmost importance.

10. For the powell quote, see Andrew Marantz, "How Social-Media Trolls Turned U.C. Berkeley into a Free-Speech Circus."

11. An example of the tyranny of contextlessness can be found in a 2019 op-ed by writer Walter Mosley, titled "Why I Quit the Writer's Room," in which Mosley describes how, after using the N-word while telling the story of something a white cop once said to him, a coworker made an anonymous complaint about him to Human Resources; Mosley was then called in and told that he could not say that word at work again, under any circumstance, which led to his quitting.

12. This can be so even with actual hate speech; see, for example, Charles Blow's May 31, 2018, column in the *New York Times* titled "The Moral High Ground," in which Blow writes: "Racist comments don't hurt my feelings. Not at all. However, I find that people assume that they are hurtful, both the persons spewing them and those empathic about the perceived pain." His point—which he bolsters with quotes from Toni Morrison—is that racist comments reflect the moral bankruptcy of the person making them more than anything about their recipient, and that the rhetoric of harm collapses this crucial distinction by presuming that racist comments degrade their recipients rather than their speakers. Obviously this response is particular to Blow, and need not be shared by others. But his point serves as a reminder that there can be a diversity of emotional and ethical responses to noxious speech.

13. See Janet Halley, *Split Decisions*.

14. The circumstances of *Scaffold* differed from that of Schutz's Till painting in a number of important ways: Durant's work was a large sculptural installation visible to the public from a distance, so it became part of people's lives who didn't choose to seek it out; the public land near the work became a gathering point not only for protesters of the piece but also for neo-Nazis and other bigots, whose ideology Durant abhorred; a specific group of people—the Dakota—felt adversely affected by the piece's presence, and asked Durant to address the issue with them directly; the Dakota had a specific, organized means by which they could do so (a committee of elders); both Durant and the Walker agreed that there had been inadequate outreach about the potential effect of the piece on the community before the sculpture was installed; the sculpture had already been installed many times around the world before it came to the Walker, so this wasn't its first or only chance to be seen; Durant's long-standing politicized, conceptual art practice predisposed him to be open to the kind of negotiation that could allow him to incorporate a decision to destroy the work and transfer the intellectual property rights to the tribe as part of his ongoing practice; and so on.

15. In teaching art school, one comes to expect the moment each semester at which a student rages, "Why are we even talking about or making art, when there is so much other more pressing work to do in and for the world?" Often this cry arrives with the nuance: "Why are we talking about or making *this* kind of art [usually abstract or formalist or obscurantist art, or any other art the student doesn't like] when there is so much more pressing work to do in and for the world?" When this happens, I usually say that if one's primary goal in life is to be of direct service to others, one should probably take off the smock and stop trying to make a better oil painting. However, if one wants or needs to go wider and more various, one might take solace in the sentiments expressed in Beth Pickens's self-help book for artists, *Your Art Will Save Your Life*, whose "FAQs for Oppressive Political Climates" contains the following speculative exchange:

> *Should I stop making art and instead go to law school or run for public office?*
> No. Artists have to make art because it's how they process being alive. In my experience, when artists stop making work, they become depressed, anxious, and generally dissatisfied with life. . . . When thinking about making art and all other possibilities, eliminate the word *instead*.
>
> *Is making art trite or self-involved right now?*
> No way! First, see above: you need to make your work because it will help you process the times we are in, which helps you live your life. Second, art helps *other* people . . . live *their* lives. The collective "we" needs art in all forms regardless of political shifts.

Should I devote my practice to overtly political art?
If you *want* to make over[t]ly political art, do it! If you do not, don't! You can contribute actively, publicly, and politically in many ways; your creative practice is just one.

16. As for the age-old antagonisms between artist and audience, artist and critic, artist and patron, artist and epoch, artist and community, artist and institution, see the very short 1937 essay by composer Arthur Schoenberg about his struggle to navigate the waves of demonization and deification that greeted his work over decades; the essay is tellingly titled "How One Becomes Lonely."

17. To take but one example: in 2018, a performance artist was hired to teach for a semester at Pratt Institute of Art. As the semester began, the professor who hired her went to see the artist's show at Joe's Pub in Manhattan, and took issue with a moment in it. The next day, the artist received an email that said she would no longer be permitted to teach her class. As it was relayed to me by the artist, when asked to explain her decision, the professor said that her first priority was to protect her students, and that the artist's show had led her to believe that the artist was someone from whom her students needed protection. No matter that the artist's decades-long career as a boundary-pushing performance artist was well known (presumably, she had been hired on its basis); no matter the message that her firing sent to other artists precariously employed at the Institute; no matter the message sent to students that marshaling institutional power to fire an artist based on a critical reaction to her (off-campus) work is preferable to growing their capacity for engagement, disidentification, or critique: out the contract went, with but an email. (Sadly, when it comes to adjuncts, this is perfectly legal.)

18. This was Zadie's Smith point in her essay "Getting In and Out," in which Smith meditates on Schutz's Till painting alongside Jordan Peele's movie *Get Out*: "When arguments of appropriation are linked to a racial essentialism no more sophisticated than antebellum miscegenation laws, well, then we head quickly into absurdity. Is Hannah Black black enough to write this letter? Are my children too white to engage with black suffering? How black is black enough? Does an 'octoroon' still count?" That such questions were met with a swell of online debate about Smith's own racial status seemed to prove her point. I should note here that Jared Sexton himself disagrees with the notion that Black's letter relies on or reifies such distinctions—in his letter to *Harper's* in response to Smith's essay, he writes: "Hannah Black is no arch-segregationist, much less a Nazi sympathizer. Nor are any of the nearly three dozen black artists and scholars who signed the open letter objecting to Schutz's painting of Emmett Till at the 2017 Whitney Biennial. They are versed in the relevant critical theory. A careful reader of Black's letter will notice that she does not make an essentialist argument. In fact, the only person who, to my knowledge,

has made recourse to the language of biological race ('biracial,' 'quadroon,' 'ace of spades,' 'café au lait') in this exchange is Smith herself, albeit sarcastically."

19. See, for example, a 2018 piece by Wes Enzinna in *Mother Jones* about the movement to deradicalize white supremacists, in which Enzinna documents how such labor often takes place in a painstaking, one-on-one fashion, far from the snow globe of Twitter or the theater of street confrontation. "Confronting white supremacists online and in the streets may feel personally gratifying and politically urgent," Enzinna writes. "Yet . . . deradicalization activists argue that much of what the left thinks it knows about shutting down racist extremists is misplaced. When it comes to changing individuals, denunciation may counteract rather than hasten deradicalization. If that seems like surrender, consider that some researchers who study hate groups think we should view violent extremism not only as a problem of ideology, but also as a problem of addiction. . . . The uncomfortable truth is that the best way to reform racist thugs may be to offer them precisely what they aren't willing to offer others, and precisely what many people in this polarized political moment feel they least deserve: empathy."

20. See Nancy Fraser's "Capitalism's Crisis of Care," in which she explains that "neither nature nor social reproductive capacities are infinite; both of them can be stretched to the breaking point." See also Berardi's work on the exhaustions of cognitive capitalism, in *The Soul at Work* and "Schizo Economy."

21. I'm thinking, for example, of the ICA protesters' demand that museum administrators produce Schutz's *literal body* to stand before them, as if the museum had or should have the power to produce her corpus. ("You related that Dana will not be required to be physically present at her artist talk. To justify this you claimed that the artist does not have to talk, and quoting you, Eva [Respini, chief curator at the ICA], the artist's 'broader artistic concerns go beyond this painting.' This line of defense does not accede the power structure that compels such accountability.") In such conflicts, it helps to be clear about whether one's goal is political theater or ethical exchange. If the goal is political theater, then a stunt such as the hoax apology for the Till painting, sent out to national publications under Schutz's name (from her hacked email address), was effective (even if the hacking and impersonation presented their own ethical problems). But if the goal was to move toward ethical exchange, such a stunt offered but a parody. Ethical exchange asks us to contend with the fact that others do not usually speak the exact words we want to hear. They speak their own words. Often, they aren't even close to what we want to hear, for all kinds of historical and personal reasons. (Sometimes, they choose not to speak at all.) All of this can be terrifically frustrating—enraging, even—yet it cannot be wished away, any more than we can wish each other away.

And here I disagree profoundly with Sarah Schulman when she encourages her readers in *Conflict Is Not Abuse* not to take no for an answer, and to defy other people's stated boundaries if and when they assert that they no longer wish to be contacted or continue a conversation, especially if such a request is made online. ("Sometimes angry, supremacist, or traumatized people send emails commanding 'Do not contact me.' I want to state here, for the record, that no one is obligated to obey a unidirectional order that has not been discussed. . . . When adults give orders while hiding behind technology, they are behaving illegitimately.") As many 12-step programs have helped people to understand, one person's breakneck insistence on fulfilling a "duty to repair"—much less demanding that another fulfill it—is unlikely to go very far if and when it violates the stated boundaries of another, or seems otherwise likely to cause harm. So sure, you don't have to "obey" someone when they tell you that they don't want to have anything to do with you, but know that you're pushing more toward being blocked or a restraining order than toward productive conversation.

22. In a September 2020 essay titled "Reflections on *Scaffold* after Three Years," Sam Durant revisited his initial statements about agency and power, and said the following:

> Contrary to some of my previous statements where I claimed to have had significant agency, I now see this as a misunderstanding of the dynamics among the stakeholders during the mediation. I want to be clear, now, not to give the impression that I was an actor with significant agency, or that I was somehow in control and wielding substantive decision-making power throughout the mediation process. Quite the opposite, I held relatively less power as the Dakota elders negotiated with Walker management, Minnesota state and Minneapolis city representatives over the fate of *Scaffold*. This is not to diminish my status as a member of the dominant population (i.e. white male benefiting from the status quo conditions of white supremacy) but to distinguish the specificities of my position as an artist and outsider within a group of others who wielded relatively more agency *in that particular circumstance*. I also want to be clear that the Dakota elders wielded their power masterfully, they were anything but victims. This can be understood clearly in that both the Dakota and the State of Minnesota got what they wanted, the removal of the sculpture and an end to the protests respectively. My agency mainly resided in the ability to agree to the removal of the work and to transfer copyright of *Scaffold* to the Dakota Oyate. This is not insignificant. And it does not constitute a suppression of my free speech as some have proposed, I freely agreed to the conditions above.

23. Such principles might include: those most directly affected by the harm should be those most involved in its resolution; the affected parties should

hear out each other's stories if and whenever possible; victims and perpetrators alike are in need of compassion and care; the end goal of the process is re-integration of the offender into the community rather than banishment (see the Centre for Justice and Reconciliation, http://restorativejustice.org/#sthash .eoh1btIH.dpbs). Applying such principles to the realm of art faces problems right off the bat, in that restorative justice depends upon a shared agreement that a harm has been done (usually, a legible crime); when it comes to art, there is not usually any such consensus. Also, restorative justice depends upon participation in an agreed-upon structure to facilitate interaction and resolution; pop-up panels at museums run by defensive curators and administrators and attended by angry protesters rarely fit this bill (another reason why Durant's private meeting with the Dakota elders was so singular). As Durant described this meeting later in an interview: "There was a group from the Walker, the Dakota elders and me. It was a ceremonial circle. From their perspective, it was a spiritual session and not a political one—which allowed for a certain kind of dialogue, maybe a more open and honest one. It was very emotional."

24. All the Brown quotes in this paragraph come from a March 2017 talk titled "Populism, Authoritarianism, and Making Fascism Fun Again" Brown gave at the UCSD International Institute.

25. One can hear such an approach in Natasha Lennard's description of the aesthetic and libidinal pleasure she derives from watching a video of neo-Nazi Richard Spencer getting punched in the face: "The transcendental experience of watching Roger Federer play tennis, David Foster Wallace wrote, was one of 'kinetic beauty.' Federer's balletic precision and mastering of time, on the very edge of what seems possible for a body to achieve, was a form of bodily genius. What Foster Wallace saw in a Federer Moment, I see in a video of neo-Nazi Richard Spencer getting punched in the face. . . . Anyone enjoying the Nazi-bashing clip (and many are) should know that they're watching anti-fascist bloc tactics par excellence—pure kinetic beauty." Such accounts serve as powerful reminders that any human animal, no matter their political affiliations, can become libidinally and aesthetically energized by violence, and alchemize that excitation into a virtue.

26. See Ahmed's *The Promise of Happiness*.

27. See Icebox Project Space, https://iceboxprojectspace.com/killjoys-kastle-2019. See also Mitchell and McKinney, eds., *Inside Killjoy's Kastle*.

28. Again, this has to do with power dynamics, in that I can't think of too many contemporary artists who waste their time ganging up on the vulnerable; only stand-up comedy comes to mind as foraying into this territory with any regularity. For great short primers on the issue of humor, subject position, and power dynamics, see Gerard Koskovich's essay on AIDS humor titled *Conventions of*

Power/Strategies of Defiance: Queer Notes on AIDS Humor; see also Paul Beatty's introduction to the 2006 anthology *Hokum: An Anthology of African-American Humor*. Also, although art can engage processes of arousal and discharge, it's important to note that not all such states are created equal: as neuropsychologist Allan Schore (among others) has researched, the kind of arousal associated with, say, rallies at which crowds are roused into anger at scapegoated enemies may reify processes of disassociation and fragmentation rather than provide discharge.

29. The distinction John Berger makes between the two "faces of art" in his famous essay "The White Bird" is relevant here: "Several years ago, when considering the historical face of art, I wrote that I judged a work of art by whether or not it helped men in the modern world claim their social rights. I hold to that. Art's other, transcendental face raises the question of man's ontological right. . . . The transcendental face of art is always a form of prayer."

30. Foucault's writing on the care of the self makes use of the Delphic imperative "Know thyself" and characterizes care as the process by which individuals "effect by their own means, or with the help of others, a certain number of operations on their own bodies and souls, thoughts, conduct, and way of being, so as to transform themselves in order to attain a certain state of happiness, purity, wisdom, perfection, or immortality." In such a model, aesthetic care would serve as one of the technologies at the heart of Foucault's ethics.

31. Another such binary might be that which pits freedom against discipline, constraint, or form, in art or otherwise. This notion, prevalent throughout the 1960s, spawned a worthy corrective in feminist Jo Freeman's 1972–3 essay, "The Tyranny of Structurelessness," in which Freeman explains how any group of people coming together will form a structure of some sort; the real question is to what extent that structure is formalized and made transparent. Understanding the inevitability of structure or form is crucial in art as well as activism, as early modernist experiments with *vers libre* and *parole in libertà* made clear (as did much of the conceptual, procedural, and performance art of the 1960s and '70s). Form is not opposed to formlessness, or the informal—they grow from each other, depend on each other. As Trungpa writes, "You cannot have form if you do not have formlessness, if you do not acknowledge or perceive formlessness." See also Fred Moten's interview at the end of *The Undercommons*: "Form is not the eradication of the informal. Form is what emerges from the informal. . . . The informal is not the absence of form. It's the thing that gives form. The informal is not formlessness." Releasing ourselves from dualistic thinking on this account saves us from arguments that presume, for example, that if one believes tyranny to be an unjust and undesirable form of government, one's art should therefore be purged of all tyrannical elements (aka the "the imitative fallacy").

32. See Kelly Shindler's "Spotlight Essay: Nicole Eisenman, *Tea Party*, 2012," in which Shindler writes: "Several art historians have begun to articulate the notion of a 'queer formalism' in the work of [Nicole] Eisenman, Amy Sillman, Harmony Hammond, Scott Burton, and others"; Shindler then traces the concept in Julia Bryan-Wilson's "Draw a Picture, Then Make It Bleed," "Queer Formalisms: Jennifer Doyle and David Getsy in Conversation," and William J. Simmons, "Notes on Queer Formalism." See also the Hammer Museum's 2015 show *A History of Refusal: Black Artists and Conceptualism*, Ligon's curated 2017 show *Blue Black* at the Pulitzer Arts Foundation, and Adrienne Edwards's curated 2016 show *Blackness in Abstraction* at Pace Gallery.

33. See Bradford: "I'm fascinated by the fact that the Civil Rights movement took off concurrently with the development of abstraction in America. Jackson Pollock had been in *Life* just a few years before Emmett Till's murder in Mississippi. So my work bounces between social issues and the history of abstract art. I'm not a spokesperson for social issues, but I do have an interest. I try to keep one foot in art history and the other foot at the bus stop." This concurrence in the pages of *Life* magazine has an even more concentrated corollary in a piece of art news from 2015, when an X-ray of Kazimir Malevich's 1915 painting *Black Square*—widely considered the first abstract painting in modernist history, and an icon of formalist art—revealed a racist joke scrawled on a corner of the canvas by Malevich, reading "Combat de Nègres dans une cave pendant la nuit" (Negroes fighting in a cellar at night), a reference to a joke by Alphonse Allais, a famous French humorist of the period. If one needed any direct evidence that the partition between abstraction/formalism and the messy "content"—of bodies, of identities—has always been a fantasy, the X-ray has spoken.

34. My thinking here has been influenced by Lisa Guenther's article "'Like a Maternal Body'"; I am quoting Guenther's paraphrase of Levinas.

35. To be fair, the interviewer was zeroing in, if unintentionally, on the very problem that Nancy Fraser, Wendy Brown, and Elizabeth Warren (in *The Two-Income Trap*) have long been pointing out: If all the parents are working or otherwise appearing in the public sphere, who the hell is picking up the kids? In a country committed to deficient social services, a privatized familialism, and a gendered division of labor that no longer functions in an (at least) two-income economy, most families are forced to reckon with such questions every day, solving them in ingenious and often inadequate ways. Money is obviously key: as Fraser describes it, we basically "now have a dual organization of care work in which those who can afford domestic help simply pay for it, while those who cannot scramble to take care of their families, often by doing the paid care work for the first group, and often at very, very low wages

with virtually no protections." COVID-19 laid bare and eviscerated even this precarious, unjust organization of care: see Deb Perelman's "In the Covid-19 Economy, You Can Have a Kid or a Job. You Can't Have Both."

36. The Schutz controversy's evocation of questions about maternity and inter-racial empathy was particularly painful and instructive: in painting Till—and in titling her painting *Open Casket*—Schutz put herself in an analogous po-sition to Mamie Till-Mobley, Emmett's mother, who famously insisted that her son's casket be left open so "the world [could] see what they did to [her] baby." Such positioning took an even more disquieting turn when, after the controversy erupted, Schutz provided a statement for the amended wall text at the Whitney that read in part: "I do not know what it is like to be Black in America. But I do know what it is like to be a mother." The elision of what it's like to be a *Black mother* underscores the difficulty, if not to say the im-possibility, of relying on maternity as a shared category of experience. Sexton elaborates on this point when he writes: "[Schutz] forgets that her interracial maternal empathy for Till-Mobley does not mitigate the fact that she is a white woman depicting a black boy killed, infamously, on the initiative of a white woman. Her empathy is entangled in that initiative."

37. See philosopher Martin Hägglund's 2019 book *This Life: Secular Faith and Spiritual Freedom*, in which Hägglund argues (after Marx) that the foundation for a more just democratic socialist society lies in ascertaining the difference be-tween "the realm of freedom" and "the realm of necessity," and augmenting the former while reducing the demands of the latter. That contemporary phi-losophers such as Berardi or Hägglund would make recourse to this division, and classify "art" as belonging to the realm of freedom, isn't surprising. That Hägglund would merrily place childcare in "the realm of freedom" is. (His ar-gument is that childcare, while occasionally onerous, counts as "an end in itself" and is therefore "a commitment" rather than a "necessity." To which mothers around the world, from those who have been conscripted into domestic labor to those without adequate access to reproductive rights to those simply laboring under the "there *is* no no" edict of ordinary devotion, say: *Huh?* It doesn't come as much of a surprise, then, that in its 443 pages, Hägglund's book cites almost no female thinkers, and has no index entry for "maternity" or "motherhood"—though it does have a hefty one for "Fatherhood [parenthood].") Even as his vision depends upon the binary of necessity and freedom, Hägglund does ac-knowledge that "eliminating socially necessary labor is not even an intelligible goal for a free life, since the question of where to draw the distinction between necessity and freedom must itself remain a living question for anyone who leads a free life." My point is that this question benefits from being considered along-side the racial and sexual histories that shape it at its root.

38. How to classify aesthetic labor has long been a subject of debate, with artists themselves of differing minds on the subject. Some, like the contemporary group W.A.G.E. (Working Artists and the Greater Economy), fully embrace the notion of artists as "a work force" or "cultural workers," and demand compensation for the service of "making the world more interesting," as W.A.G.E. puts it (a view that echoes that of the Art Workers' Coalition of the Vietnam era, or the New Deal's Federal Art Project, or even the endlessly beleaguered National Endowment for the Arts). Others fiercely resist the assimilation of aesthetic labor into capitalist discourse, preferring to treat it as something that stands apart from, or disrupts, the logic of the market (this is easier to do, of course, when no one's paying you for your work).

Despite an art market ghoulishly inflated at its uppermost levels—a farcical scene littered with international art fairs and billionaire collectors that has led many to decry art as a counterrevolutionary activity for the 1 percent—the fact remains that most art that gets made doesn't sell, and even when it does, rarely does it do so at prices that correspond in any fair-wage sense to the time and labor put into its making. In the public imagination, however, the reverse narrative often holds: that art notoriously alchemizes everyday objects—a urinal, splattered house paint, a banana duct-taped to a wall—into outrageous, galling fortunes. This can happen. But just as often (if not far more often), art functions more like poetry, which devalues the material it touches. As poet Charles Bernstein put it, "A piece of paper with nothing on it has a definite economic value. If you print a poem on it, this value is lost." For more on the subject, see Lewis Hyde's enduring study *The Gift*, in which Hyde sidesteps the above overvalued/undervalued binary to consider art as occupying a dual role, circulating in both a nonalienated, noncommodified gift economy, and in an alienated, commodified market economy, with art's status as a "gift"—in the sense of a gift given to the artist by unknowable forces, and a gift given by the artist to the world—being what makes art art. See also Eula Biss's revisitation of the issue in *Having and Being Had*.

2. THE BALLAD OF SEXUAL OPTIMISM

1. Despite the "sex positive" reputation of many queers, this attitude has firm precedent in queer-theory land: Lauren Berlant and Lee Edelman have been wondering for years "what it would mean to think about or even desire the experience of sex without optimism." See their coauthored book, *Sex, or The Unbearable*.

2. Donegan's and Wypijewski's focus is on straight folks, but arguments against mainstream gay culture and "pinkwashing" make a similar critique: "[Gay pride] is basically commercial advertising everywhere," the *Guardian* quotes

one gay man as saying in a 2016 article titled "Too Straight, White and Gay Corporate: Why Some Queer People Are Skipping SF Pride." "It just seems like what I'd call Gay Inc. We're just one more thing for people to purchase." For an extension of this argument into global politics, see Jasbir Puar's *Terrorist Assemblages: Homonationalism in Queer Times* (2007), which links gay assimilation and consumerism with whiteness, Western imperialism, and the war on terror, creating "a fusing of homosexuality to U.S. pro-war, pro-imperialist agendas" that Puar calls "homonationalism."

3. Goldberg utilizes this Flynn quote in her article "The Problem with Idolizing Sexual Liberation."

4. See Sara Ahmed's "Why Complain?," a blog entry on her *Feminist Killjoys* blog, in which Ahmed describes the virtues of complaint as follows: "A complaint can be how you live with yourself because a complaint is an attempt to address what is wrong, not to cope with something; not to let it happen; not to let it keep happening. You make a complaint as a way of doing something. And so: a complaint can be a way of *not doing nothing.* Many who make complaints don't do so because they feel they will necessarily get justice or some other resolution of a problem, although of course different people enter the process with different expectations about what they can achieve. A beginning can be a refusal: *you refuse to cope with a situation that is unjust.*" I agree with all of this. My aim here is to draw a distinction between acknowledging the occasional necessity of complaint and valorizing it as a habit of mind.

5. See the "sexual realism" described by legal and sexual justice scholar Joseph Fischel, which maintains that "choices are always constrained by circumstance but are choices nonetheless." This emphasis obviously differs from the Andrea Dworkin–Catherine MacKinnon POV, which focuses on how, due to the patriarchy's grip on women's psyches, certain of their decisions cannot really be considered decisions at all. See Fischel's discussion of such in *Sex and Harm in the Age of Consent.*

6. Gayle Rubin's "Thinking Sex: Notes for a Radical Theory of Sexual Politics" was published in 1984; as the decade wore on, AIDS would pose challenges to its theory of benign sexual variation, with hard-core sexual liberationists (as in the founding members of Sex Panic!, Allan Bérubé, Christopher Murray, Douglas Crimp, Kendall Thomas, Michael Warner, Gregg Gonsalves, and Dennis Davidson) sparring with figures such as Larry Kramer, Andrew Sullivan, Michelangelo Signorile, and Gabriel Rotello, the latter arguing that "sexual variation" in the forms of promiscuity and unsafe sex could not be considered benign if they contributed to the spread of a fatal disease.

7. Katherine Angel has also made this point: see her February 14, 2020, piece "Sex and Self-Knowledge: Beyond Consent": "In urging women to be confident and clear about their sexual desires, the consent discourse risks denying

the fact that women are often punished for precisely the sexually confident and assertive positions they are being asked to cultivate. What's more, the exhortations to confidence and positivity—the insistence on defiant affirmation—have an underbelly: they render lack of confidence, insecurity, or not-knowing as ugly, abject, and shameful. They brook little vulnerability or ambivalence. And they make inadmissible the experience of not knowing what one wants in the first place."

8. See sociologist Lisa Diamond's *Sexual Fluidity: Understanding Women's Love and Desire*, in which Diamond tracks nearly one hundred women who at some point testified to experiencing "same-sex attraction," and finds an astonishing amount of changeability in their desires and identifications over the course of a decade, with many moving away from fixed notions of sexual orientation and toward a context-dependent understanding of desire.

9. This letter aimed to contrast the alleged puritanism of #MeToo feminism with a commitment to "sexual freedom," which, for the authors of the letter, includes something they call men's "freedom to bother" (*la liberté de déranger*).

10. The varying iterations of—and reactions to—the SlutWalk movement around the globe, from Latin America to India to Singapore to Israel to Canada to South Korea to Australia, offer a quick, fascinating primer to culturally distinct perspectives on slut shaming, victim blaming, and the appearance of women in the public sphere. See Teekah, et al., eds., *This Is What a Feminist Slut Looks Like*.

11. In an essay celebrating the reprint of Myles's *Chelsea Girls*, Michelle Tea testifies to the same: "I became obsessed with Eileen Myles via a worn-out copy of *Not Me*, a bright green book of poems that streamed in skinny columns. These were poems that I read so often and with such mania that a line would often ring through my head like a song. Any life can look back on itself and wonder how it all would have shaken out if, perhaps, you *had* gone to college, or if your parents hadn't gotten divorced, or if you'd moved to women's land in Arizona rather than urban California. I wonder what my life would look like if I *hadn't* read Eileen Myles. I can't imagine who I would be or what exactly I would be doing." Meanwhile, Myles has forged ahead, as in 2006's "Tapestry," a piece originally rejected by *Vice* magazine in which Myles catalogs the vicissitudes of the many vulvas they have known: "Clits were all different. Hers was larger. All rubbery, more like porn. I had seen a pussy like hers before but not so close. It was like a lip going vertical. I mean, if you had your head right there. It was kind of a lippy trail, actually this is not her clit, it's her labia I'm describing, what I used to describe as a little girl my gum. Outer gum. Hers was a very uncomplicated female and large, a red road to a small swollen button. . . . One woman was told by a lover that she had a fat cooch. It was true—

her outer lips were pillowy and fat. Full. Her inner lips were regulation healthy and her clit—it was a small red little spud. It was however guardian of one of the most avid pussies I've ever known. . . . A small woman who had a lacy-looking pussy that she hated. There was like this frottage over her clit. Instead of a hood it had a large mantilla."

12. See the project "No One is Disposable: Everyday Practices of Prison Abolition" by Dean Spade and Tourmaline. In part 3 of this video series ("What About the Dangerous People"), Tourmaline draws upon the work of prison abolitionist Ruth Wilson Gilmore to explain the importance of the idea that "no one is innocent. There's not a violent person and a non-violent person. We're always doing—all of us together—are doing things that are hurting other people. Part of being in relation with people means that one person at some point is going to enact harm on another person. . . . There's not a dichotomy of innocent people and guilty people. The logic of the state, of the prison system, demands that idea . . . so that all sorts of structures and all sorts of processes—like policing, prisons, imprisonment, deportation—can be justified."

13. Vicki Schultz, on behalf of a group of law professors in "Open Statement on Sexual Harassment from Employment Discrimination Law Scholars" (published in the *Stanford Law Review*'s #MeToo Symposium in 2018), writes, "Research shows that companies sometimes use alleged harassment as a pretext for firing employees for less salutary reasons, such as sexual orientation, race, or age. Such an overzealous approach to sexual expression invites cynicism and backlash against initiatives to combat harassment. It fails to promote equality for women, while leaving LGBTQ people, men of color, and others who are stereotyped as overly sexual vulnerable to disproportionate punishment and job loss."

14. See Sarah Schulman's *Conflict Is Not Abuse*, in which Schulman differentiates between "power struggle" and "power over."

15. "Those who made a way out of no way" is a rephrasing of Emily Hobson's description of gay and lesbian leftists in *Lavender and Red* (8). As for these other ways, I'm thinking of *affidamento*, an Italian feminist term for women "entrusting" themselves to another to get things that they want, for making political, social, or creative space for one another. *Affidamento* differs from homosocial versions of "networking" in that women's working together has not historically led to an accrual of power in the standard, hierarchical sense of the word (indeed, one could argue it has led to the opposite). But in the sense of the word that interests me most—the drive, determination, and imaginative force required to make new things happen, to rearrange current distributions of the sensible—it's the main game in town.

16. It's also worth remembering that, as Dean Spade has made clear, much of what we want and need regarding sexual freedom exceeds legal definitions: see Spade's *Normal Life*.

17. See Andy Newman's front page story in the *New York Times* about sexual misconduct in the Shambhala community, "'The King' of Shambhala Buddhism Is Undone by Abuse Report."

3. DRUG FUGUE

1. In *Soul on Ice*, Eldridge Cleaver recounts raping both Black and white women, but speaks about the matter in broad terms, without walking the reader through particular scenes. Cleaver's sense of having nothing left to lose likely derived from his already having served time for rape; Pepper too was in and out of prison for much of his life.

2. See Johnson's discussion of self-resistance and "resistance to theory" in the work of Paul de Man in "Deconstruction, Feminism, and Pedagogy." Johnson's broader question—which is no less urgent now than it was in 1987, with repercussions that extend way beyond gender—is whether, given that "the self-resistance and uncertainty *of women* has been part of what has insured their lack of authority and their invisibility," the task of feminism must involve the "overcoming of self-resistance," or whether feminism is better off forsaking such a goal, even if that entails a loosened claim on authority and visibility.

3. See Balibar's "Subject and Subjectivation." Balibar goes on: "If freedom means freedom *of the subject*, is it because there is, in 'subjectivity,' an originary source of spontaneity and autonomy, something irreducible to objective constraints and determinations? Or is it not rather because 'freedom' can only be the result and counterpart of liberation, emancipation, *becoming* free: a trajectory inscribed *in* the very texture of the individual, with all its contradictions, which starts with subjection and always maintains an inner or outer relation with it?"

4. Making the gender dynamics of *Pull My Daisy* even more complex is its casting of famed painter Alice Neel as "the Bishop's mother," a staid, black-clad matron whose persona contrasts starkly with Neel's real-life bohemian iconoclasm. More complex still: Neel's own behind-the-scenes negotiation of the roles of artist and mother, which are detailed, sometimes painfully, in a 2007 documentary about her made by her grandson, *Alice Neel*.

5. Had he considered it, Derrida might have found the maternal pushed his famous question "What do we hold against the drug addict?" into moral and juridical overdrive, as the glut of prosecutions of pregnant women for drug-

related offenses, from the crack wars through the opioid crisis, has made painfully clear. In the late 1980s, hundreds of criminal drug prosecutions were brought against mothers or pregnant women, including "assault with a deadly weapon" (the weapon being crack, the victim being the fetus) and drug trafficking, for the delivery of drugs to an infant through the umbilical cord during the sixty to ninety seconds between delivery and clamping. Needless to say, these prosecutions were unevenly distributed by race: a 1989 study of public and private clinics revealed that although pregnant Black women and pregnant white women regularly tested about equally for drug use, with white women in fact testing slightly higher—15.4 percent for whites and 14.1 percent for Blacks—Black women were nearly ten times more likely to be reported and exposed to prosecution (see Loren Siegel, "The Pregnancy Police Fight the War on Drugs"). In the age of opioids, the conjoined war on pregnant women and drugs continues: in Alabama, a state with particularly punitive laws for mothers, 479 new and expecting mothers have been prosecuted since 2006 for "chemical endangerment of a child," including Casey Shehi, who was jailed for taking half a Valium while pregnant. The penalties for such charges are "exceptionally stiff: one to 10 years in prison if her baby suffers no ill effects, 10 to 20 years if her baby shows signs of exposure or harm and 10 to 99 years if her baby dies" (see Martin, "Take a Valium, Lose Your Kid, Go to Jail").

6. This would be Hortense Spillers's point, in "Mama's Baby, Papa's Maybe: An American Grammar Book," about the pulverized kinship structures wrought by slavery—a pulverization that, as Spillers has it, annihilated both patriarchal and matriarchal positions for African Americans, leaving gender difference itself unmoored from normative meaning. In Spillers's analysis, the white maternal position is occupied by "a *patriarchilized* female gender, which, from one point of view, is the *only* female gender there is," whereas the Black maternal position has "no symbolic integrity," as slavery and its aftermath have thrown "the customary lexis of sexuality, including 'reproduction,' 'motherhood,' 'pleasure,' and 'desire'" into "unrelieved crisis."

7. See Johann Hari's "The Hunting of Billie Holiday."

8. See, for example, Andrea Long Chu's back-to-back pieces in 2018 ridiculing Ronell, her former teacher, and celebrating Valerie Solanas, who shot people.

9. For writing about drug and alcohol that explicitly tethers collective and personal struggle, see work by Malcolm X, Iceberg Slim, D. Watkins, George Cain, Ray Shell, Piri Thomas, Sherman Alexie, and more. In the realm of the fictive/allegorical, Toni Morrison and Octavia Butler have repeatedly plumbed the subject of drugs in their work (see, for example, Butler's *Parable of the Sower*, which features a drug called Pyro, which gives those who take it sexual pleasure from arson, and a drug called Parateco, which gives its users the power

of hyperempathy; for Morrison, see *Sula*, in which the character Eva contends with her love for her drug-addicted son Plum, whom she eventually burns to death rather than bear witness to his slow death from addiction). As far as auto-biography goes, I can think of many book-length classics by women of color that take bearing witness to the addictions of (mostly male) others as a central focus (see Jamaica Kincaid's *My Brother*, Jesmyn Ward's *Men We Reaped*, Joy Harjo's *Crazy Brave*, Natalie Diaz's *When My Brother Was an Aztec*), but fewer first-person accounts of addiction or recovery (though eclectic anthologies such as Palmer and Horowitz, eds., *Sisters of the Extreme: Women Writing on the Drug Experience*, offer avenues to complicate such generalizations). See also recent work by writers such as Tao Lin and Ottessa Moshfegh that contributes to a new canon of drug writing in which prescription pharmaceuticals (such as Klonopin, Percocet, Ambien, Adderall, Tylenol 3, Oxycodone, Xanax, and Ritalin) play a starring role; see also recent work by Michael Pollan, Ayelet Waldman, and Chris Rush for more recent reflections on psychedelics.

10. Thanks to Tisa Bryant for her insights and conversation on this point.

11. Decades after Nixon's 1971 declaration of the War on Drugs, his former chief of domestic policy, John Ehrlichman, told author Dan Baum that the war had always been about persecuting Nixon's enemies: "The Nixon campaign in 1968, and the Nixon White House after that, had two enemies: the antiwar left and black people. . . . We knew we couldn't make it illegal to be either against the war or black, but by getting the public to associate the hippies with marijuana and blacks with heroin, and then criminalizing both heavily, we could disrupt those communities. We could arrest their leaders, raid their homes, break up their meetings, and vilify them night after night on the evening news. Did we know we were lying about the drugs? Of course we did." But the racialized war was on long before 1971. In "The Hunting of Billie Holiday," Johann Hari documents how, as far back as 1914, the specter of "Negro cocaine 'fiends'"—"superhuman hulks who could take bullets to the heart without flinching"—was used to muster support for the passage of the Harrison Narcotics Tax Act, which mandated the regulation and taxation of products containing opiates and coca in the United States. Congressional testimony and media coverage leading up to the passage of the act depended heavily on this specter: in a classic fusion of racist fears, one pharmacist testified to Congress that "most of the attacks upon the white women of the South are the direct result of a cocaine-crazed Negro brain"; a medical expert's testimony that the "cocaine [n-gger] sure is hard to kill" provided the "official reason that some police in the South increased the caliber of their guns," from .32 to .38.

12. As for the law's disparate treatment of drug use by white and nonwhite women, see Hari's account of how Harry Anslinger, the federal agent hell-bent

on destroying Billie Holiday's career and liberty, responded to being told that "there were also white women, just as famous as Billie, who had drug problems": "He called Judy Garland, another heroin addict, in to see him. They had a friendly chat, in which he advised her to take longer vacations between pictures, and he wrote to her studio, assuring them she didn't have a drug problem at all."

13. Following in the tradition of Du Bois, Baldwin, Thandeka, Noel Ignatiev, and others, writers such as Eula Biss (in her essay "White Debt") have attempted to articulate the "wages of whiteness," as Du Bois had it; in his 2019 book *Dying of Whiteness: How the Politics of Racial Resentment Are Killing America's Heartland*, physician Jonathan M. Metzl attempts to quantify the literal, mortal costs of whiteness, charting how racist right-wing ideology decreases white life expectancy, a trend in which opioid abuse, lack of access to affordable health care, and gun ownership all play a part. Both Biss and Metzl run up against the same difficulty, however, which is that trading years of one's life, or the moral goodness of that life, for a measure of power and superiority over Black and brown others, still strikes many as a worthwhile bargain: see also Toni Morrison's trenchant analysis of this deal in "Making America White Again," her take on Trump's 2016 election.

14. Think of the ayahuasca craze, which has sent scores of people—many of them white, but by no means all—to the Amazon (including comedian Chelsea Handler, who filmed herself taking the drug with a Peruvian shaman for her series on Netflix). In a piece on this craze for *Bitch* magazine, Bani Amor describes the drug as "the latest trendy tonic for White People Problems," and wonders "how whiteness can heal itself from the violence in which it was forged, and if it's possible to keep that violence from spreading wherever white people go." It's a good question, though ultimately quite complex, insofar as people of all kinds seek entheogenic, healing, or transformative experiences via cultures to which they have no self-evident, uncontested ancestral claim (or, even when they think they have one, or have one by proxy, the locals tend to set them straight). For an amusing portrait of such contamination and entanglement filtered through the lens of gender, I recommend the website of the Women and Entheogenic Conference, which offers a fascinating assemblage of Indigenous, Black, white, and other speakers specializing in Reiki, yoga, mushroom farming, Egyptology, you name it. As the organizers enthuse: "Whether it's the mystical herb Iboga of the African bush, or Ayahuasca, the brew from Amazon of South America, or the magic of Psilocybin Mushrooms from pretty much anywhere, the Women & Entheogens Conference has you covered! Dealing with topics like LSD, MDMA, cannabis and the most powerful hallucinogen known, DMT, The 2017 Women & Entheogens Conference is sure to be heavy hitting like only Women & Entheogens can."

15. An express desire for addiction itself, as an all-consuming activity or identity that might give structure and identity to an otherwise wanting life (as in Barbara Quinn's "Wow, man! I was a junkie. Jay-you-en-kay-eye-ee junkie. Junkie was something special, something big and important and heroic. Real wild") is not as uncommon as one might think. This is not to say that addiction doesn't sneak up on people who don't expect it, or who are hoping against hope to avoid it; few to none desire it once in its grip. But many drug memoirs do express a hope, especially at the start of using, that addiction might offer at least a partial solution to the problem of being. As Marlowe writes in *How to Stop Time*, "Nonusers wonder why junkies with serious habits don't see the absurdity of arranging their whole day around their need for heroin, but they've got it the wrong way around. One reason people become junkies is to find some compelling way of arranging their lives on an hour-to-hour basis. . . . Addiction creates a god so that time will stop—why all gods are created." Unsurprisingly, Marlowe's memoir drew criticism for its controversial convictions that addiction is a choice, that withdrawal symptoms are not as big a deal as people make them out to be, and so on.

16. See Barbara Johnson's "Muteness Envy," in which Johnson discusses the history of feminized, silent love objects in lyric poetry, especially John Keats's "Grecian Urn," which Keats addresses as a "still unravished bride of quietness!" The essay, which culminates in a discussion of Jane Campion's film *The Piano*, ends on this evergreen point: "If feminism is so hotly resisted, it is perhaps less because it substitutes women's speech for women's silence than because, in doing so, it interferes with the official structures of self-pity that keep patriarchal power in place, and, in the process, tells the truth behind the beauty of muteness envy."

17. Though Barad coined the phrase "agential realism," she prefers not to speak of matter as "having agency" per se; her research has instead led her to believe that "agency is not held, it is not a property of persons or things; rather, agency is an enactment, a matter of possibilities for reconfiguring entanglements." See also Moten's point at the opening of *In the Break*, when Moten takes up Marx's notion of the commodity that does not speak by reminding us that there have existed commodities that speak, namely, slaves. In terms that evoke Preciado's writing about T, Moten writes, "While subjectivity is defined by the subject's possession of itself and its objects, it is troubled by a dispossessive force objects exert such that the subject seems to be possessed—infused, deformed—by the object it possesses."

18. See "The Addictive Image" in Clune's scholarly work *Writing Against Time*.

19. See Clune's "How Computer Games Helped Me Recover from My Heroin Addiction."

20. Butler's larger point in *Precarious Life: The Powers of Mourning and Violence* is that an inability to accept the pain and disorientation stemming from grief, intersubjectivity, and desire can lead us into destructive, reckless political actions, a phenomenon she examines vis-à-vis the United States' rush to war in the wake of 9/11.

4. RIDING THE BLINDS

1. The term *Anthropocene* was coined in the 1980s by ecologist Eugene F. Stoermer and popularized by atmospheric chemist Paul Crutzen. It is now widely used to designate the period after the Holocene, the epoch that began about twelve thousand years ago, at the end of the last Ice Age. Though most scientists agree that we have entered the Anthropocene, they are still debating exactly how and where to mark its inception (they call the geological mark they are looking for the "golden spike"—a railroad term, even if the eventual decision ends up pre- or postdating the railroads). Some argue that the spike goes back as far as eight thousand years, with the first farming; some argue for 1610, with the European conquest of the Americas and subsequent deforestation and global spread of disease; some for the Industrial Revolution (the Intergovernmental Panel on Climate Change uses 1750 as a baseline for charting greenhouse gas emissions, which roughly corresponds to Morton's comments about the steam engine); some for the mid-twentieth century, with the first deployment of the atomic bomb and the depositing of nuclear isotopes into the earth's strata. For a critique of "golden spike" logic and theory, see "Golden Spikes and Dubious Origins" in Kathryn Yusoff's *A Billion Black Anthropocenes or None*.

2. See the 2014 and 2016 "Living Planet" reports by scientists at the World Wildlife Foundation and the Zoological Society of London.

3. See Union of Concerned Scientists: https://blog.ucsusa.org/peter-frumhoff/global-warming-fact-co2-emissions-since-1988-764.

4. See NASA's Global Climate Change page: https://climate.nasa.gov/faq/16/is-it-too-late-to-prevent-climate-change/.

5. See the National Climate Association, https://nca2018.globalchange.gov/: "Future climate change is expected to further disrupt many areas of life, exacerbating existing challenges to prosperity posed by aging and deteriorating infrastructure, stressed ecosystems, and economic inequality. Impacts within and across regions will not be distributed equally. People who are already vulnerable, including lower-income and other marginalized communities, have lower capacity to prepare for and cope with extreme weather and climate-related

events and are expected to experience greater impacts." Each day brings more granular analyses underscoring the same fact, such as Christopher Flavele's June 18, 2020, *New York Times* article "Climate Change Tied to Pregnancy Risks, Affecting Black Mothers Most."

6. See Amy Westervelt's 2019 article "The Case for Climate Rage" (*Popula*, August 19, 2019), in which Westervelt forcefully rejects the (often white, male) habit of using the first-person plural or generalizing about "humanity" when laying the blame for the climate crisis: "People in power have never willingly dismantled the systems that benefit them. Thus David Wallace-Wells earned an eye-popping advance for *The Uninhabitable Earth*, a book in which he makes some solid and necessary points, and then concludes, in the absence of credible evidence, that 'we,' who are responsible for climate change, will solve it with geoengineering; Nathaniel Rich was given a whole issue of the *New York Times Magazine* in which to wax poetic about 'our' failure to stop climate change, a story optioned almost instantly for a book and a film; Jonathan Safran Foer will soon join them with his own version of the 'we are all to blame' narrative, *We Are the Weather* [since published in 2019], in which he argues first, incorrectly, that human diets are the primary cause of climate change, and then that 'we' need to tackle it by making the necessary lifestyle changes. . . . But when women like my colleagues point the finger, it is not at one company or even one industry. The oil, coal, and automotive industries all play a role, the utilities, too, the PR flacks and lobbyists who carry out their vision, the politicians who cave. It's a lot of people, but it's not *all* people, it's not 'humanity.'"

Multiple data points—such as a 2017 Carbon Majors report that details how more than 70 percent of the world's greenhouse gas emissions released since 1988 have been produced by only one hundred companies—underscore Westervelt's conviction that it's not "humanity." Stepping back further still, certainly not all humans have lived as recklessly and destructively as have white Europeans and Americans for the past six hundred years or so; noting the difference matters, not just for assigning accountability but also for figuring out how to move forward. At the same time, given the depth of our own entanglement with fossil fuels and daily participation in their consumption, I don't think a strict "us/them" mindset is the most fruitful approach; Kate Marvel's acknowledgment of complicity and responsibility, as when she writes, "In the end, I am responsible for the gases that are changing the climate and, in raising my son in comfort and convenience, am passing on that responsibility and guilt to him," also seems important to bear in mind. See also Amitav Ghosh's case for Asia's centrality in the climate crisis in *The Great Derangement*.

7. In "The Case for Climate Rage," Westervelt offers the following list, which I see no reason to try to best:

- Psychologist Renée Lertzman first wrote about climate grief, and how to process it into action, more than a decade ago
- Mary Annaïse Heglar writes beautifully about the intersection between racism and climate change
- Katharine Wilkinson is a vocal advocate for amplifying the voices of women of color on climate
- Marine biologist Ayana E. Johnson writes on ocean conservation, a critical and weirdly overlooked component of tackling climate change
- Bina Venkataraman's forthcoming book *The Optimist's Telescope: Thinking Ahead in a Reckless Age* focuses on long-range thinking for a better future
- NASA scientist Kate Marvel writes regularly about the interface between science and human values
- Tamara Toles O'Laughlin is transforming the climate activist group 350.org into a diverse and equitable force for justice
- Rhiana Gunn-Wright is writing the real policy that will help create a Green New Deal
- Oceanographer Sarah Myhre fought for, and won, the freedom to bring feeling and conviction into communicating the science of climate change.

See also Somini Sengupta's June 5, 2020, resource list in the *New York Times* about overlaps between racism and the climate crisis.

8. See, for example, Jonathan Lear's *Radical Hope: Ethics in the Face of Cultural Devastation*, in which Lear meditates on the story of the Crow Nation to explore how other cultures might courageously face the possibility of their collapse. Lear focuses on the philosophical implications of a statement made by Plenty Coups, the last traditional Crow chief, shortly before his death: "When the buffalo went away the hearts of my people fell to the ground, and they could not lift them up again. After this nothing happened." Of particular interest to Lear are these last four words, as they indicate the difficulty the Crow had in attributing meaning—or even temporality—to events that transpired after the destruction of the matrix that gave Crow life significance. See also David Treuer's *The Heartbeat of Wounded Knee*, which recasts the story of Native America from 1890 to the present as "one of unprecedented resourcefulness and reinvention" rather than one of disappearance and decimation.

9. See McKibben, *The Quarantine Tapes* podcast, https://quarantine-tapes .simplecast.com/episodes/the-quarantine-tapes-036-bill-mckibben-cmRf5Wlk.

10. See McKibben's 2018 *New Yorker* piece, "How Extreme Weather Is Shrinking the Planet."

11. McKibben, "Extreme Weather."

12. See also Matthew T. Huber's *Lifeblood: Oil, Freedom, and the Forces of Capital*.

13. See Métis scholar Zoe Todd's account of going to a talk by Bruno Latour, and feeling disheartened by people's "celebrating and worshipping a european thinker for 'discovering' what many an Indigenous thinker around the world could have told you for millennia" ("An Indigenous Feminist's Take on Ontology").

14. See, for example, Rebekah Sheldon's *The Child to Come*; Jasbir Puar's *Terrorist Assemblages*, in which Puar describes queer engagement with the "capitalist reproductive economy" as "simulations" of heteronormativity; or Heidi Nast's writing about the faulty "queer alibi" white queers with kids allegedly use to protect themselves from charges of participating in "queer patriarchies, queer racisms."

15. See the remarks made by Emma González, one of the most outspoken of the Parkland, Florida, #NeverAgain survivor/activists, in the face of ugly attacks on her and her peers by right-wing media and the NRA: "When did *children* become such a dirty word? . . . We have always been told that if we see something wrong, we need to speak up; but now that we are, all we're getting is disrespect from the people who made the rules in the first place. Adults like us when we have strong test scores, but they hate us when we have strong opinions."

16. Connolly is here summarizing a story Anna Lowenhaupt Tsing tells in *The Mushroom at the End of the World*, a dense, compassionate examination of the matsutake, a valuable mushroom that thrives in human-disturbed forests, which Tsing considers an example of the kind of resurgent, contaminated forms of life from which we might learn how to live in the ruins of our dreams (or someone else's).

17. These are the words of Heidi Binko of the Just Transition Fund, as quoted in Eliza Griswold, "People in Coal Country Worry about the Climate, Too."

18. Paranoia and despair are not identical, but Sedgwick's discussion of paranoia in "Paranoid Reading and Reparative Reading" bears relevance here, as when she discusses the axiom "Just because you're paranoid doesn't mean they're *not* out to get you": "The truth-value of the original axiom, assuming it to *be* true, doesn't actually make a paranoid imperative self-evident. Learning that 'just because you're paranoid doesn't mean you don't have enemies,' somebody might deduce that being paranoid is not an effective way to get rid of enemies. Rather than concluding 'so you can never be paranoid enough,' this person might instead be moved to reflect, 'but then, just because you have enemies doesn't mean you have to be paranoid.'" See also Michael Snediker's *Queer Optimism*, in which Snediker writes (in discussing a Sedgwick passage about joy in Proust), "I'm riveted by the idea that

joy could be a guarantor of truth—differently put, that joy could be persuasive." I am, too.

19. To take just a few examples: see Audre Lorde's "The Uses of Anger," Ann Cvetkovich's *Depression*, and Rebecca Traister's *Good and Mad*. Also, in *Ugly Feelings*, Ngai differentiates "relatively unambiguous emotions" (such as anger and fear) from "unprestigious" negative feelings (such as envy, irritation, and paranoia), and terms only the latter "ugly feelings." For my purposes here, I'm ignoring this distinction and treating all negative feelings under the rubric of "ugly."

20. See Moten, *The Undercommons* (117): "How come we can't be together and think together in a way that feels good, the way it should feel good? For most of our colleagues and students, however much you want to blur that distinction, that question is the hardest question to get people to consider. Everybody is pissed off all the time and feels bad, but very seldom do you enter into a conversation where people are going, 'why is it that this doesn't feel good to us?' There are lots of people who are angry and who don't feel good, but it seems hard for people to ask, collectively, 'why doesn't this feel good?' I love poetry, but why doesn't reading, thinking, and writing about poetry in this context feel good? To my mind, that's the question that we started trying to ask."

AFTERWORD

1. See the psychoanalytical notion of the future perfect, as in "If I believe this story, then I will have been other than I was, or thought I was" (Lapanche and Pontalis, *The Language of Psychoanalysis*); see also Derrida's preference for the future perfect in his later texts; see also Simone White's *Dear Angel of Death*, in which White gathers thinking by Édouard Glissant, Fred Moten, Amiri Baraka, Nathaniel Mackey, Jared Sexton, Gilles Deleuze, and others to discuss future anteriority, the tense of "wouldly," "hauntological time," and the fold (or folded time), in relation to blackness.

2. See Moten's *Stolen Life*, in which he talks about the possibility of becoming "chained to the struggle for freedom"; Moten is here paraphrasing Chicano lawyer, activist, and novelist Oscar Zeta Acosta, who wrote, in his 1973 novel *The Revolt of the Cockroach People*, "Somebody still has to answer for all the smothered lives of all the fighters who have been forced to carry on, chained to a war for Freedom just like a slave is chained to his master."

3. The language regarding COVID-19 as a portal can be found in Arundhati Roy's April 3, 2020, piece in the *Financial Times*, "The Pandemic Is a Portal": "Historically, pandemics have forced humans to break with the past and imagine their world anew. This one is no different. It is a portal, a gateway between

one world and the next." Robin Kelley picks up on this language in a June 24, 2020, interview with *The Intercept*, agreeing with Roy that the pandemic "is a portal. And as a portal, it is just an opening. And as an opening, nothing's guaranteed, but it's an opening because it exposed the structure of racial and gendered capitalism and the violence meted out to people who are most vulnerable. . . . The question is, what are we going to do in this portal? Do we have the political will to basically recognize the fact that all these conditions are inseparable, that all these conditions—you cannot simply reform your way out of this. . . . Whether that happens or not remains to be seen. But I don't think many portals open up."

4. See Kierkegaard's *The Concept of Anxiety*, in which Kierkegaard discusses anxiety as the "dizziness of freedom"; see also Heidegger's notion of anxiety as an experience of freedom, as summarized by Simon Critchley in "Being and Time, Part 5: Anxiety." The link between anxiety and freedom that I've struggled with doesn't really resemble a "dizziness of freedom," per se, or what Milan Kundera termed "the unbearable lightness of being." It's more that, insofar as indeterminacy—which is a form of freedom, i.e., the freedom of not knowing what's going to happen next—allows for "what if?" thinking, and insofar as "what if?" thinking leads some of us into chronic catastrophizing, I'm very much in the game.

Works Cited

Acosta, Oscar Zeta. *The Revolt of the Cockroach People*. New York, NY: Vintage, 1989.

Ahmed, Sara. "Feminist Killjoys (and Other Willful Subjects)." *Scholar and Feminist Online* 8, no. 3 (Summer 2010).

———. *The Promise of Happiness*. Durham, NC: Duke University Press.

———. "Why Complain?" *Feminist Killjoys* (blog), July 22, 2019. https://feministkilljoys.com/2019/07/22/why-complain.

Alexander, Anna, and Mark S. Roberts, eds. *High Culture: Reflections on Addiction and Modernity*. Albany, NY: State University of New York Press, 2003.

Allison, Dorothy. Foreword to *My Dangerous Desires: A Queer Girl Dreaming Her Way Home*, by Amber Hollibaugh. Durham, NC: Duke University Press, 2000.

Allman Brothers. "Ramblin' Man." Track 9 on *Brothers and Sisters*, Capricorn Records, 1973.

American Civil Liberties Union. "What Is Censorship?" https://www.aclu.org/other/what-Censorship.

Amor, Bani. "The Heart of Whiteness." *Bitch* 79 (Summer 2019).

Angel, Katherine. Interview with Conner Habib. *Against Everyone* (podcast), March 3, 2020. https://podcasts.apple.com/us/podcast/against-everyone-with-conner-habib/id1298708750.

———. "Sex and Self-Knowledge: Beyond Consent." Verso blog, February 14, 2020. https://www.versobooks.com/blogs/4573-sex-and-self-knowledge-beyond-consent.

Arendt, Hannah. Letter to James Baldwin. "The Meaning of Love in Politics," November 21, 1962. http://www.hannaharendt.net/index.php/han/article/view/95/156.

———. "What Is Freedom?" In *The Portable Hannah Arendt*, edited by Peter Baehr. New York, NY: Penguin, 2000.

Azimi, Negar. "The Charming, Disgusting Paintings of Tala Madani." *New Yorker*, April 28, 2017.

Bakunin, Mikhail. *The Political Philosophy of Bakunin.* Edited by G. P. Maximoff. Glencoe, IL: The Free Press, 1953.

Baldwin, James. "The Black Boy Looks at the White Boy" (1961) and *The Devil Finds Work* (1976). In *Collected Essays*, edited by Toni Morrison. New York, NY: Library of America, 1998.

———. *The Fire Next Time.* 1st Vintage International edition. New York, NY: Vintage International, 1993.

Balibar, Étienne. "Subjection and Subjectivation." In *Supposing the Subject*, edited by Joan Copjec. New York, NY: Verso, 1994.

Barad, Karen. "Matter Feels, Converses, Suffers, Desires, Yearns and Remembers: Interview with Karen Barad." In *New Materialism: Interviews & Cartographies*, edited by Rick Dolphijn and Iris van der Tuin. https://quod.lib.umich.edu/o/ohp/11515701.0001.001/1:4.3/--new-materialism-interviews-cartographies?rgn=div2;view=fulltext.

Beatty, Paul, ed. *Hokum: An Anthology of African-American Humor.* New York, NY: Bloomsbury, 2006.

Bennett, Jane. *Vibrant Matter: A Political Ecology of Things.* Durham, NC: Duke University Press, 2010.

Berardi, Franco, "Bifo." "How to Heal a Depression?" (2015). https://www.scribd.com/document/74998394/Bifo-How-to-Heal-a-Depression.

———. "Schizo Economy." Translated by Michael Goddard. *SubStance* 36, no. 1, issue 112: Italian Post-Workerist Thought (2007).

———. *The Soul at Work: From Alienation to Autonomy.* Translated by Francesca Cadel and Giuseppina Mecchia. Los Angeles, CA: Semiotext(e), 2009.

Bergen Assembly. "Actually, the Dead Are Not Dead." Exhibition announcement, e-flux (online journal), September 5–November 10, 2019. https://www.e-flux.com/announcements/267069/actually-the-dead-are-not-dead.

Berger, John. "The White Bird." In *The Sense of Sight.* New York, NY: Vintage, 1993.

Berlant, Lauren. *The Queen of America Goes to Washington City: Essays on Sex and Citizenship.* Durham, NC: Duke University Press, 1997.

———. "Trump, or Political Emotions." *New Inquiry*, August 5, 2016.

———, and Lee Edelman. *Sex, or the Unbearable.* Durham, NC: Duke University Press, 2014.

Bernstein, Charles. *My Way: Speeches and Poems.* Chicago, IL: University of Chicago Press, 2010.

Bersani, Leo. "Is the Rectum a Grave?" *October* 43, AIDS: Cultural Analysis/Cultural Activism (Winter 1987): 197–222.

Biss, Eula. *Having and Being Had.* New York, NY: Riverhead Books, 2020.

———. "White Debt." *New York Times*, December 2, 2015. https://www.nytimes.com/2015/12/06/magazine/white-debt.html.

Black Lives Matter. *Healing in Action*. Self-published pamphlet. https://black livesmatter.com/wp-content/uploads/2017/10/BLM_HealinginAction -1-1.pdf.

Black, Hannah. "Open Letter to the Curators and Staff of the Whitney Biennial." Originally posted to Facebook, reprinted in *ARTNews*, March 21, 2017.

Blanchfield, Brian. "On Frottage." In *Proxies: Essays Near Knowing*. Brooklyn, NY: Nightboat Books, 2016.

Blow, Charles. "The Moral High Ground." *New York Times*, May 31, 2018.

Boal, Augusto. "The Cop in the Head: Three Hypotheses." *TDR* 34, no. 3 (Autumn 1990): 35–42.

Boehm, Mike. "2 Artists Quit UCLA over Gun Incident." *Los Angeles Times*, January 22, 2005. https://www.latimes.com/archives/la-xpm-2005-jan-22 -me-profs22-story.html.

Boon, Marcus. *The Road of Excess: A History of Writers on Drugs*. Cambridge, MA: Harvard University Press, 2002.

Bradford, Mark. "Artist Mark Bradford on Creating Works of Social Abstraction." Interview with Paul Laster. *Time Out*, November 11, 2015.

———. Quoted in "What Else Can Art Do? The Many Layers of Mark Bradford's Work," profile by Calvin Tomkins. *New Yorker*, June 22, 2015.

Braidotti, Rosi. *Nomadic Theory: The Portable Rosi Braidotti*. New York, NY: Columbia University Press, 2011.

Braverman, Kate. Interview. *Bookslut.com* (blog), February 2006. http://www .bookslut.com/features/2006_02_007804.php.

Breton, André. *Manifestoes of Surrealism*. Translated by Richard Seaver and Helen R. Lane. Ann Arbor, MI: University of Michigan Press, 1969.

Brooks, David. "After the Women's March." *New York Times*, January 24, 2017.

brown, adrienne maree. *Pleasure Activism: The Politics of Feeling Good*. Chico, CA: AK Press, 2019.

Brown, Wendy. "Populism, Authoritarianism, and Making Fascism Fun Again." Lecture at the UCSD International Institute, March 2017. https://www .youtube.com/watch?v=CUAJ2-Z4PqI&t=3770s.

———. *States of Injury: Power and Freedom in Late Modernity*. Princeton, NJ: Princeton University Press, 1995.

———. *Undoing the Demos: Neoliberalism's Stealth Revolution*. New York, NY: Zone Books, 2017.

———, Peter Eli Gordon, and Max Pensky. *Authoritarianism: Three Inquiries in Critical Theory*. Chicago, IL: University of Chicago Press, 2018.

Brownstein, Carrie. *Hunger Makes Me a Modern Girl: A Memoir*. New York, NY: Riverhead Books, 2015.

Bryan-Wilson, Julia. "Draw a Picture, Then Make It Bleed." In *Dear Nemesis: Nicole Eisenman 1993–2013*. St. Louis, MO: Contemporary Art Museum St. Louis; Cologne, Ger.: König, 2014.

Buddha. "We Can Do it." Excerpted in Sharon Salzberg, *The Kindness Handbook: A Practical Companion*, 35. Boulder, CO: Sounds True Publishing, 2008.

Bundy, Ammon. "Are we starting to see it yet?" Facebook, March 25, 2020.

Burke, Tarana (@TaranaBurke). "I've said repeatedly that the #metooMVMT is for all of us." Twitter thread, August 20, 2018, 4:08 AM (PST). https://twitter.com/TaranaBurke/status/1031498904158855170?s=20.

Burroughs, William S. *Naked Lunch*. Paris, Fr.: Olympia Press, 1959.

———, and Sylvère Lotringer. *Burroughs Live: The Collected Interviews of William S. Burroughs, 1960–1997*. Semiotext(e) Double Agents Series. Cambridge, MA: MIT Press, 2001.

Butler, Judith. "The Body You Want." Interview with Liz Kotz. *Artforum* 31 (November 1992): 82–89.

———. *The Force of Nonviolence: An Ethico-Political Bind*. New York, NY: Verso, 2020.

———. *Precarious Life: The Powers of Mourning and Violence*. New York, NY: Verso, 2004.

———. *The Psychic Life of Power: Theories in Subjection*. Palo Alto, CA: Stanford University Press, 1997.

Butler, Octavia E. *Parable of the Sower*. New York, NY: Grand Central Publishing, 2019.

Cain, George. *Blueschild Baby*. New York, NY: Ecco, 2019.

Califia, Patrick. "Notes and Letters." *Feminist Studies* 9, no. 3 (Autumn 1983): 589–615.

California Institute of the Arts (CalArts). "Exhibitions/Presentations Policy." https://policies.calarts.edu/all-policies/exhibitionspresentationspolicy.

Callahan, Manolo. "[COVID-19] (Insubordinate) Conviviality in the COVID-19 Conjuncture." *Convivial Thinking* (blog), April 24, 2020. https://www.convivialthinking.org/index.php/2020/04/24/insubordinateconviviality.

———, and Annie Paradise. "Fierce Care: Politics of Care in the Zapatista Conjuncture." *Transversal*, 2017. https://transversal.at/blog/Fierce-Care.

Camillus, John C. "Strategy as a Wicked Problem." *Harvard Business Review*, May 2008. https://hbr.org/2008/05/strategy-as-a-wicked-problem.

Caney, Simon. "Climate Change and the Future: Discounting for Time, Wealth, and Risk." *Journal of Social Philosophy* 40, no. 2 (June 2009): 163–86.

Carbon Disclosure Project. *Carbon Majors Report 2017*. https://www.cdp.net/en/articles/media/new-report-shows-just-100-companies-are-source-of-over-70-of-emissions.

Carnevale, Fulvia, and John Kelsey. "Art of the Possible: An Interview with Jacques Rancière." *Artforum* (March 2007): 256–69.

C. E. "Undoing Sex: Against Sexual Optimism." *LIES: A Journal of Materialist Feminism* 1, no. 1 (2012): 15–34.

Ceballos, Gerardo, Paul R. Ehrlich, and Rodolfo Dirzo. "Biological Annihilation via the Ongoing Sixth Mass Extinction Signaled by Vertebrate Population Losses and Declines." *Proceedings of the National Academy of Sciences* 114, no. 30 (July 25, 2017).

Césaire, Aimé. Quoted in David Marriott, "Response to Race and the Poetic Avant-Garde." *Boston Review*, March 10, 2015.

Chakrabarty, Dipesh. "The Climate of History: Four Theses." *Critical Inquiry* 35, no. 2 (2009): 197–222.

Chan, Jamie, and Leah Pires. "Kai Althoff." *4Columns*, November 30, 2018.

Chan, Paul. "Paul Chan by Nell McClister." *BOMB*, July 1, 2005. https://bomb magazine.org/articles/paul-chan.

Chödrön, Pema. Letter to the Shambhala Community, September 22, 2018. https:// shambhala.report/r/pema-chodron-letter-to-the-shambhala-community.

———. "No Right, No Wrong: An Interview with Pema Chödrön." *Tricycle*, Fall 1993.

———. *When Things Fall Apart*. Boston, MA: Shambhala, 2004.

Chu, Andrea Long. "I Worked with Avital Ronell. I Believe Her Accuser." *Chronicle of Higher Education* (August 30, 2018).

———. "On Liking Women." *n+1* 30 (Winter 2018).

———. "Would #MeToo Jump the Shark?" *n+1* 31 (Spring 2018).

Civil, Gabrielle. *Experiments in Joy*. Fairfax, VA: Civil Coping Mechanisms, 2019.

Cleaver, Eldridge. *Soul on Ice*. New York, NY: Dell, 1999.

Clune, Michael W. "Author Michael W. Clune on the Secret Life of Heroin." *Phoenix House*, September 16, 2013. https://www.phoenixhouse.org/news -and-views/our-perspectives/author-michael-w-clune-on-the-secret-life-of -heroin.

———. *Gamelife: A Memoir*. New York, NY: Farrar, Straus and Giroux, 2015.

———. "How Computer Games Helped Me Recover from My Heroin Addiction." *View*, September 14, 2015.

———. *White Out: The Secret Life of Heroin*. Center City, MN: Hazelden, 2013.

———. *Writing Against Time*. Palo Alto, CA: Stanford University Press, 2013.

Coates, Ta-Nehisi. "Kanye West in the Age of Donald Trump." *Atlantic*, May 7, 2018.

Cobb, Jelani (@jelani9). "The reopen protesters keep saying 'Live Free or Die.'" Twitter, April 26, 2020. https://twitter.com/jelani9/status/125442801277 6431618.

"A Community Response to ICA, Boston Re: Upcoming Dana Schutz Exhibition." July 25, 2017. https:// news.artnet.com/app/news-upload/2017/07 /Follow-Up-Letter-to-ICA.pdf.

Connolly, William E. *Facing the Planetary: Entangled Humanism and the Politics of Swarming*. Durham, NC: Duke University Press, 2017.

Crimp, Douglas. *Melancholia and Moralism: Essays on AIDS and Queer Politics*. Cambridge, MA: MIT Press, 2004.

Critchley, Simon. "*Being and Time*, part 5: Anxiety." *Guardian*, July 6, 2009. https://www.theguardian.com/commentisfree/belief/2009/jul/06/heidegger-philosophy-being.

———. *Infinitely Demanding: Ethics of Commitment, Politics of Resistance*. New York, NY: Verso, 2008.

Culp, Andrew. "Chapter 4: Affect." *Anarchistwithoutcontent* (blog), August 12, 2013. https://anarchistwithoutcontent.wordpress.com/2013/08/12/chapter-4-affect.

———. *Dark Deleuze*. Minneapolis, MN: University of Minnesota Press, 2016.

———. "Everybody Talks About the Weather, but Nobody Does Anything About It: Interiority, Affect, and Negation in the Metropolis." *Anarchist without Content* (blog). https://anarchistwithoutcontent.wordpress.com/works.

Cvetkovich, Ann. *Depression: A Public Feeling*. Durham, NC: Duke University Press, 2012.

Dark Mountain Project. *Walking on Lava: Selected Works for Uncivilised Times*. Chelsea, VT: Dark Mountain Project, 2017.

Davies, Dave. "Climate Change Is 'Greatest Challenge Humans Have Ever Faced,' Author Says." Interview with Bill McKibben. *Fresh Air*, NPR, April 16, 2019.

Davis, Angela Y. *Freedom Is a Constant Struggle: Ferguson, Palestine, and the Foundations of a Movement*. Chicago, IL: Haymarket Books, 2016.

Davis, Noela. "Subjected Subjects? On Judith Butler's Paradox of Interpellation." *Hypatia* 27, no. 4 (Fall 2012): 881–97.

"Dear Oprah Winfrey: 142 Writers Ask You to Reconsider *American Dirt*." *Literary Hub*, January 29, 2020. https://lithub.com/dear-oprah-winfrey-82-writers-ask-you-to-reconsider-american-dirt.

De Boever, Arne. "Democratic Exceptionalisms (on Sam Durant's *Scaffold*)." In *Against Aesthetic Exceptionalism*. Minneapolis, MN: University of Minnesota Press, 2019.

Deleuze, Gilles, and Félix Guattari. *Anti-Oedipus: Capitalism and Schizophrenia*. Translated by Robert Hurley, Mark Seem, and Helen R. Lane. New York, NY: Viking Press, 1977.

———, and Claire Parnet. *Dialogues* (1977). Translated by Hugh Tomlinson and Barbara Habberjam. London: Althone Press, 1987.

Deneuve, Catherine, et al. "Nous défendons une Liberté d'importuner, indispensable à la liberté sexuelle." *Le Monde*, January 13, 2018.

Derrida, Jacques. "The Rhetoric of Drugs." In *High Culture: Reflections on Addiction and Modernity*, edited by Anna Alexander and Mark S. Roberts. Albany, NY: State University of New York Press, 2003.

Despentes, Virginie. *King Kong Theory*. Translated by Stéphanie Benson. New York, NY: Feminist Press, 2010.

Diamond, Jonny. "Elon Musk Learns All the Wrong Lessons from Isaac Asimov's Foundation Trilogy." *Literary Hub*, February 24, 2020. https://lithub.com/elon-musk-learns-all-the-wrong-lessons-from-isaac-asimovs-foundation-trilogy.

Diamond, Lisa. *Sexual Fluidity: Understanding Women's Love and Desire*. Cambridge, MA: Harvard University Press, 2009.

Diaz, Natalie. *When My Brother Was an Aztec*. Port Townsend, WA: Copper Canyon Press, 2012.

Dillard, Annie. *For the Time Being*. New York, NY: Knopf Doubleday, 2010.

Dolphijn, Rick, and Iris van der Tuin, eds. *New Materialism: Interviews & Cartographies*. Ann Arbor, MI: Open Humanities Press, 2012.

Donohue, William (Bill). "Ant-Covered Jesus Video Removed from National Portrait Gallery." Live Q&As, WashingtonPost.com, December 1, 2010.

———. Quoted in Ian Schwartz. "Megyn Kelly vs. Catholic League's Bill Donohue." *RealClearPolitics*, January 9, 2015.

Donegan, Moira. "Sex During Wartime: The Return of Andrea Dworkin's Radical Vision." *Bookforum* 25, no. 5 (February 2019).

Doyle, Jennifer, and David Getsy. *Campus Sex, Campus Security*. South Pasadena, CA: Semiotext(e), 2015.

———. "Queer Formalisms: Jennifer Doyle and David Getsy in Conversation." *Art Journal* 72 (Winter 2013): 58–71.

D'Souza, Aruna. "Who Speaks Freely? Art, Race, and Protest." *Paris Review* (blog), May 22, 2018. https://www.theparisreview.org/blog/2018/05/22/who-speaks-freely-art-race-and-protest.

Durant, Sam. "Q&A with Carolina A. Miranda." *Los Angeles Times*, June 17, 2017.

———. "Reflections on *Scaffold* after Three Years." https://samdurant.net/files/downloads/SamDurant-ReflectionsOnScaffold-2020.pdf.

Dustan, Guillaume. *In My Room* (*Dans ma chambre*). Translated by Brad Rumph. London: Serpent's Tail, 1998.

Edelman, Lee. *No Future: Queer Theory and the Death Drive*. Durham, NC: Duke University Press, 2004.

Elrichman, John. Quoted in "Legalize It All," by Dan Baum. *Harper's*, April 2016.

Emerson, Ralph Waldo. "The American Scholar" (1837). In *The Collected Works of Ralph Waldo Emerson*, edited by Robert Ernest Spiller, Alfred R. Ferguson, Joseph Slater, and Jean Ferguson Carr. Cambridge, MA: Belknap Press of Harvard University Press, 1971.

———. "Circles" (1841). In *The Collected Works of Ralph Waldo Emerson*.

———. "Experience" (1844). In *The Collected Works of Ralph Waldo Emerson*.

Emre, Merve. "All Reproduction Is Assisted." *Boston Review.* Special Issue "Once and Future Feminist," Summer 2018.

English, Darby. *How to See a Work of Art in Total Darkness.* Cambridge, MA: MIT Press, 2007.

————. *1971: A Year in the Life of Color.* Chicago, IL: University of Chicago Press, 2016.

Enzinna, Wes. "Inside the Radical, Uncomfortable Movement to Reform White Supremacists." *Mother Jones,* July 2018.

Estrada, Alvaro. *María Sabina: Her Life and Chants.* Santa Barbara, CA: Ross Erickson, 1981.

Ettorre, Elizabeth. *Women and Substance Use.* New Brunswick, NJ: Rutgers University Press, 1992.

Fahs, Breanne. "'Freedom to' and 'Freedom from': A New Vision for Sex-Positive Politics." *Sexualities* 17, no. 3 (2014): 267–90.

Fairbanks, Ashleigh. "Genocide and Mini-Golf in the Walker Sculpture Garden." *City Pages* (Minneapolis), April 27, 2017.

Ferreira da Silva, Denise. "On Difference without Separability." In *Incerteza viva/Living Uncertainty.* São Paulo, Brazil: 32a São Paulo Art, 2016. Biennial exhibition catalog.

Fischel, Joseph J. *Screw Consent: A Better Politics of Sexual Justice.* Oakland, CA: University of California Press, 2019.

————. *Sex and Harm in the Age of Consent.* Minneapolis, MN: University of Minnesota Press, 2016.

Flavelle, Christopher. "Climate Change Tied to Pregnancy Risks, Affecting Black Mothers Most." *New York Times,* June 18, 2020. https://www.nytimes.com /2020/06/18/climate/climate-change-pregnancy-study.html.

Flavelle, Genevieve. "Inside KillJoy's Kastle, a Lesbian Feminist Haunted House." *InVisible Culture* 27 (November 2017).

Folden, Kathleen. Quoted in "Montana Woman Takes Crowbar to Disputed Artwork in Loveland," by Monte Whaley. *Denver Post,* October 6, 2010. https://www.denverpost.com/2010/10/06/mont-woman-takes-crowbar -to-disputed-artwork-in-loveland.

Foner, Eric. *The Story of American Freedom.* New York, NY: W. W. Norton, 1998.

Foucault, Michel. *Essential Works of Michel Foucault, 1954–1984.* Vol. 1, *Ethics: Subjectivity and Truth,* edited by Paul Rabinow. Translated by Robert Hurley and others. New York, NY: New Press, 1997.

Frank, Robert, and Alfred Leslie, directors. *Pull My Daisy* (1959).

Frank, Barney. *Frank: A Life in Politics from the Great Society to Same-Sex Marriage.* New York, NY: Farrar, Straus and Giroux, 2015.

Frankl, Viktor E. *Man's Search for Meaning* (1946). New York, NY: Pocket Books, 1984.

Franks, Mary Anne. Review of *Split Decisions: How and Why to Take a Break from Feminism*, by Janet Halley. *Harvard Journal of Law & Gender* 30 (2007): 257– 67.

Fraser, Nancy. "Contradictions of Capital and Care." *New Left Review* 100 (July/August 2016). https://newleftreview.org/issues/II100/articles/nancy -fraser-contradictions-of-capital-and-care.

———, and Sarah Leonard. "Capitalism's Crisis of Care." *Dissent*, Fall 2016.

Freeman, Jo. "The Tyranny of Structurelessness." *Berkeley Journal of Sociology* 17 (1972–73): 51–165.

Freire, Paulo. *Pedagogy of the Oppressed*. Translated by Myra Ramos. New York, NY: Continuum, 2000.

Freud, Sigmund, and J. Moussaieff Masson. *The Complete Letters of Sigmund Freud to Wilhelm Fliess, 1877–1904*. Cambridge, MA: Belknap Press of Harvard University Press, 1985.

Frumhoff, Peter. "Global Warming Fact: More Than Half of All Industrial CO_2 Pollution Has Been Emitted since 1988." *Union of Concerned Scientists* (blog), December 15, 2014. https://blog.ucsusa.org/peter-frumhoff/global -warming-fact-co2-emissions-since-1988-764.

Gessen, Masha. "When Does a Watershed Become a Sex Panic?" *New Yorker*, November 14, 2017.

———. "Why Are Some Journalists Afraid of 'Moral Clarity'?" *New Yorker*, June 24, 2020.

Gibson-Graham, J. K. *A Postcapitalist Politics*. Minneapolis, MN: University of Minnesota Press, 2006.

Gilligan, Carol. *In a Different Voice: Psychological Theory and Women's Development*. Cambridge, MA: Harvard University Press, 1982.

Gilroy, Paul. *The Black Atlantic: Modernity and Double Consciousness*. Cambridge, MA: Harvard University Press, 1993.

Glenn, Evelyn Nakano. *Forced to Care: Coercion and Caregiving in America*. Cambridge, MA: Harvard University Press, 2012.

———. *Unequal Freedom: How Race and Gender Shaped American Citizenship and Labor*. Cambridge, MA: Harvard University Press, 2004.

Gold, Tanya. "The Fall of Milo Yiannopoulos." *Spectator*, April 10, 2018. https:// www.spectator.co.uk/article/the-fall-of-milo-yiannopoulos.

Goldberg, Michelle. "Post-Roe America Won't Be Like Pre-Roe America. It Will Be Worse." *New York Times*, May 16, 2019.

———. "The Problem with Idolizing Sexual Liberation." *Nation*, September 14, 2015.

Gonsalves, Gregg, and Amy Kapczynski. "The New Politics of Care." *Boston Review*, April 27, 2020.

González, Emma. "Parkland Student Emma González Opens Up about Her Fight for Gun Control." *Harper's Bazaar*, February 26, 2018. https://www.harpersbazaar.com/culture/politics/a18715714/protesting-nra-gun-control-true-story.

Gordon, Avery F. *The Hawthorn Archive: Letters from the Utopian Margins.* New York, NY: Fordham University Press, 2017.

"Grace" (pseudonym). Quoted in "I Went on a Date with Aziz Ansari. It Turned into the Worst Night of My Life," by Katie Way. Babe.net, January 14, 2018. https://babe.net/2018/01/13/aziz-ansari-28355.

Graeber, David. *Possibilities: Essays on Hierarchy, Rebellion, and Desire.* Oakland, CA: AK Press, 2007.

Griswold, Eliza. "People in Coal Country Worry about the Climate, Too." *New York Times*, July 13, 2019. https://www.nytimes.com/2019/07/13/opinion/sunday/jobs-climate-green-new-deal.html.

Guattari, Félix. "Socially Significant Drugs." In *High Culture: Reflections on Addiction and Modernity*, edited by Anna Alexander and Mark S. Roberts. Albany, NY: State University of New York Press, 2003.

———. *The Three Ecologies.* Translated by Ian Pindar and Paul Sutton. New York, NY: Continuum, 2005.

Guenther, Lisa. "'Like a Maternal Body': Emmanuel Levinas and the Motherhood of Moses." *Hypatia* 21, no. 1 (2006): 119–36.

Gutierrez, Miguel. Quoted in "A Choreographer Gives in to His Ambition of Recklessness," by Gina Kourlas. *New York Times*, January 4, 2019. https://www.nytimes.com/2019/01/04/arts/dance/miguel-gutierrez-this-bridge-chocolate-factory.html.

Habib, Conner (@ConnerHabib). "Sex holds meaning for people." Twitter, September 17, 2019, 12:33 AM (PST). https://twitter.com/ConnerHabib/status/1173862566558392325.

Hägglund, Martin. *This Life: Secular Faith and Spiritual Freedom.* New York, NY: Pantheon Books, 2019.

Halberstam, Jack. *In a Queer Time and Place: Transgender Bodies, Subcultural Lives.* New York, NY: New York University Press, 2005.

Halley, Janet E. *Split Decisions: How and Why to Take a Break from Feminism.* Princeton, NJ: Princeton University Press, 2006.

Hamer, Fannie Lou. "Nobody's Free until Everybody's Free." Speech delivered at the founding of the National Women's Political Caucus, Washington, DC, July 10, 1971. In *The Speeches of Fannie Lou Hamer: To Tell It Like It Is*, edited by Maegan Parker Brooks and Davis W. Houck. Jackson, MS: University of Mississippi Press, 2013.

Hanh, Thich Nhat. "The Degree of Freedom." Plum Village Dharma Talk, June 25, 2012.

Haraway, Donna J. *Staying with the Trouble: Making Kin in the Chthulucene.* Durham, NC: Duke University Press, 2016.

Hari, Johann. "Everything You Think You Know about Addiction Is Wrong." TED talk, June 2015. https://www.ted.com/talks/johann_hari_everything _you_think_you_know_about_addiction_is_wrong.

———. "The Hunting of Billie Holiday." *Politico,* January 17, 2015. https://www .politico.com/magazine/story/2015/01/drug-war-the-hunting-of-billie -holiday-114298.

Harney, Stefano, and Fred Moten. *The Undercommons: Fugitive Planning & Black Study.* Wivenhoe, UK: Minor Compositions, 2013.

Hartman, Saidiya V. "The Belly of the World: A Note on Black Women's Labors." *Souls* 18, no. 1 (2016): 166–73.

———. "Interview: Saidiya Hartman on Insurgent Histories and the Abolitionist Imaginary." *Artforum,* July 14, 2020. https://www.artforum.com /interviews/saidiya-hartman-83579.

———. *Scenes of Subjection: Terror, Slavery, and Self-Making in Nineteenth-Century America.* New York, NY: Oxford University Press, 1997.

———. *Wayward Lives, Beautiful Experiments: Intimate Histories of Riotous Black Girls, Troublesome Women, and Queer Radicals.* New York, NY: W. W. Norton, 2019.

Heglar, Mary Annaïse. "Home Is Always Worth It." *Medium,* September 12, 2019. https://medium.com/@maryheglar/home-is-always-worth-it-d2821634dcd9.

———. (@MaryHeglar). "What if doomerism and relentless hope are 2 sides of the same emotionally immature, over-privileged coin?" Twitter, September 12, 2019, 7:12 AM (PST), https://twitter.com/maryheglar/ status/1172151110733312002.

Hobson, Emily K. *Lavender and Red: Liberation and Solidarity in the Gay and Lesbian Left.* Oakland, CA: University of California Press, 2016.

Hodgkinson, David. "Thomas Piketty, Climate Change and Discounting Our Future." *Conversation,* August 11, 2014. https://theconversation.com/thomas -piketty-climate-change-and-discounting-our-future-30157.

Hodson, Chelsea. "Pity the Animal." In *Tonight I'm Someone Else: Essays.* New York, NY: Henry Holt, 2018.

Hollibaugh, Amber. *My Dangerous Desires: A Queer Girl Dreaming Her Way Home.* Durham, NC: Duke University Press, 2000.

Hollingsworth, Trey. Quote from interview with Tony Katz. WIBC 93, Indianapolis Public Radio, April 14, 2020.

hooks, bell. "Love as the Practice of Freedom." In *Outlaw Culture: Resisting Representations.* New York, NY: Routledge, 1994.

Howard, Gerald. "Descent of a Woman: Iris Owens's Darkly Comic Tour de Force Returns." *Bookforum,* December/January 2011.

Huber, Matthew T. *Lifeblood: Oil, Freedom, and the Forces of Capital*. Minneapolis, MN: University of Minnesota Press, 2013.

Hughes, Langston. "The Negro Artist and the Racial Mountain" (1926). In *The Collected Works of Langston Hughes*, edited by Arnold Rampersad and David Roessel. Columbia, MO: University of Missouri Press, 2001.

Hyde, Lewis. *The Gift: How the Creative Spirit Transforms the World*. New York, NY: Vintage, 2019.

Institute of Queer Ecology. "About." 2017. https://queerecology.org/about.

Irigaray, Luce. *This Sex Which Is Not One*. Translated by Catherine Porter with Carolyn Burke. Ithaca, NY: Cornell University Press, 1985.

Iroquois (Haudenosaunee) Constitution, reconstructed from oral history. Modern History Sourcebook, Fordham University online, http://source books.fordham.edu/mod/iroquois.asp.

Jakobsen, Janet R., and Ann Pellegrini. *Love the Sin: Sexual Regulation and the Limits of Religious Tolerance*. New York, NY: New York University Press, 2003.

Johnson, Barbara. *The Barbara Johnson Reader*. Edited by Melissa González, Bill Johnson González, Lili Porten, and Keja L. Valens. Durham, NC: Duke University Press, 2014.

———. "Deconstruction, Feminism, and Pedagogy" and "The Fate of Deconstruction." In *A World of Difference*. Baltimore, MD: Johns Hopkins University Press, 1987.

———. "Gender and Poetry." In *The Feminist Difference: Literature, Psychoanalysis, Race, and Gender*. Cambridge, MA: Harvard University Press, 2000.

Johnson, Mykel. "Butchy Femme." In *The Persistent Desire: A Femme-Butch Reader*, edited by Joan Nestle. Boston, MA: Alyson Publications, 1992.

Johnson, Robert. "Walkin' Blues." Track 4 on *King of the Delta Blues Singers*. Columbia Records, 1961.

Juliana v. United States. First Amended Complaint for Declaration and Injunctive Relief. Case No.: 6:15-cv-01517-TC. September 10, 2015.

Jung, Carl. Letter to Bill Wilson. January 30, 1961. http://friendsofbillandbob .org/1961-bill-wilson-writes-to-carl-jung.php.

Kaba, Mariame. "Abolishing Prisons with Mariame Kaba." Interview with Chris Hayes on *Why Is This Happening?* (podcast), April 10, 2019. https://podcasts .apple.com/us/podcast/revisited-abolishing-prisons-with-mariame-kaba /id1382983397?i=1000478147531.

Kavan, Anna. *Julia and the Bazooka*. Chester Springs, PA: Peter Owen, 1970.

Keene, John. "On Vanessa Place, *Gone with the Wind*, and the Limit Point of Certain Conceptual Aesthetics." *J'S THEATER* (blog), May 18, 2015. http:// jstheater.blogspot.com/2015/05/on-vanessa-place-gone-with-wind-and .html.

Kelley, Robin D. G. *Freedom Dreams: The Black Radical Imagination*. Boston, MA: Beacon Press, 2008.

————. "The Rebellion against Racial Capitalism." Interview in *Intercept*, June 24, 2020. https://theintercept.com/2020/06/24/the-rebellion-against -racial-capitalism.

————. "Robin Kelley on Love, Study, and Struggle." *Quarantine Tapes*, podcast hosted by Paul Holdengraber, August 5, 2020.

Kennedy, Randy. "White Artist's Painting of Emmett Till at Whitney Biennial Draws Protests." *New York Times*, March 21, 2017. https://www.nytimes .com/2017/03/21/arts/design/painting-of-emmett-till-at-whitney-biennial -draws-protests.html.

Kerouac, Jack. *On the Road*. New York, NY: Viking Books, 1957.

Kierkegaard, Søren. *The Concept of Anxiety: A Simple Psychologically Oriented Deliberation in View of the Dogmatic Problem of Hereditary Sin*, 1st ed. Translated by Alastair Hannay. New York, NY: Liveright, 2015.

Kincaid, Jamaica. *My Brother*. New York, NY: Farrar, Straus and Giroux, 1997.

King, Martin L. "I Have a Dream." Speech presented at the March on Washington for Jobs and Freedom, Washington, DC, August 28, 1963.

Kingsnorth, Paul, and Dougald Hine. *Uncivilisation: The Dark Mountain Manifesto*. Self-published pamphlet, 2009.

Kipnis, Laura. *Unwanted Advances: Sexual Paranoia Comes to Campus*. New York, NY: HarperCollins, 2017.

Klein, Naomi. "Capitalism vs. the Climate." *Nation*, November 9, 2011.

Koch, Stephen. "Stephen Koch on Iris Owens." Interview with Emily Gould. *Emily Books* (blog), October 11, 2013. https://emilybooks.com/2013/10/18 /stephen-koch-on-iris-owens.

Koestenbaum, Wayne. *Cleavage: Essays on Sex, Stars, and Aesthetics*. New York, NY: Ballantine Books, 2000.

————. Interview with Colin Dekeersgieter. *Washington Square Review* 39 (Spring 2017).

Kopelson, Karen. "Radical Indulgence: Excess, Addiction, and Female Desire." *Postmodern Culture* 17, no. 1 (2006).

Koskovich, Gerard. *Conventions of Power/Strategies of Defiance: Queer Notes on AIDS Humor*. San Francisco, CA: Kiki Gallery Publications, 1983.

Lakoff, George. "In Politics, Progressives Need to Frame Their Values." Interview with Mark Karlin. *Truthout*, November 23, 2014. https://truthout.org /articles/george-lakoff-progressives-cannot-succeed-without-expressing -respect-values.

Laplanche, Jean. *The Language of Psychoanalysis* (online). Translated by Donald Nicholson-Smith. London, UK: Routledge, 2018.

Latour, Bruno. *Down to Earth: Politics in the New Climatic Regime*. Medford, MA: Polity Press, 2018.

Lear, Jonathan. *Radical Hope: Ethics in the Face of Cultural Devastation*. Cambridge, MA: Harvard University Press, 2006.

LeCain, Timothy J. "Heralding a New Humanism: The Radical Implications of Chakrabarty's 'Four Theses.'" In "Whose Anthropocene? Revisiting Dipesh Chakrabarty's 'Four Theses,'" edited by Robert Emmett and Thomas Lekan. *RCC Perspectives: Transformations in Environment and Society*, no. 2 (2016): 15–20.

Lee, A., and Bruce Shlain. *Acid Dreams: The Complete Social History of LSD; The CIA, the Sixties, and Beyond*. New York, NY: Grove Press, 1985.

Lennard, Natasha. "Neo-Nazi Richard Spencer Got Punched." *Nation*, January 22, 2017.

———. "Policing Desire." In *Being Numerous: Essays on Non-Fascist Life*. Brooklyn, NY: Verso, 2019.

Levin, Kelly, Benjamin Cashore, Steven Bernstein, and Graeme Auld. "Overcoming the Tragedy of Super Wicked Problems: Constraining Our Future Selves to Ameliorate Global Climate Change." *Policy Sciences* 45, no. 2 (2012): 123–52.

Levin, Sam. "Too Straight, White and Corporate: Why Some Queer People Are Skipping SF Pride." *Guardian*, June 25, 2016. https://www.theguardian.com /us-news/2016/jun/25/san-francisco-gay-pride-corporate-orlando-shooting.

Levinas, Emmanuel. *Otherwise Than Being, or, Beyond Essence*. Translated by Alphonso Lingis. Pittsburgh, PA: Duquesne University Press, 1998.

Levy, Ariel. "Catherine Opie, All-American Subversive." *New Yorker*, March 13, 2017.

Lewinsky, Monica. "Emerging from the 'House of Gaslight' in the Age of #MeToo." *Vanity Fair*, March 2018. https://www.vanityfair.com/news/2018/02/monica -lewinsky-in-the-age-of-metoo.

Lewis-Kraus, Gideon. Review of Michael Clune's *White Out*. "In Heroin's White Thrall." *New Yorker*, May 28, 2013. https://www.newyorker.com/books/page -turner/in-heroins-white-thrall.

Ligon, Glenn. *Blue Black*. St. Louis, MO: Pulitzer Foundation, 2017. Published in conjunction with an exhibition of the same title.

Lin, Tao. *Taipei*. New York, NY: Vintage Contemporaries, 2013.

———. *Trip: Psychedelics, Alienation, and Change*. New York, NY: Vintage, 2018.

Living Planet Report 2014: Species and Spaces, People and Places. Living Planet Report, World Wildlife Foundation and the Zoological Society of London, 2014. http://awsassets.panda.org/downloads/lpr_living_planet _report_2014.pdf.

Living Planet Report 2016: Risk and Resilience in a New Era. Living Planet Report, World Wildlife Foundation and the Zoological Society of London, 2016. http://awsassets.panda.org/downloads/lpr_living_planet_report_2016.pdf.

Logue, Deirdre, and Allyson Mitchell. "Killjoy's Kastle: A Lesbian Feminist Haunted House." *Icebox Project Space*, October 16, 2019. https://icebox projectspace.com/killjoys-kastle-2019.

Lorde, Audre. *A Burst of Light: And Other Essays* (1988). Mineola, NY: Ixia Press, 2017.

———. "The Uses of Anger: Woman Responding to Racism." Keynote presentation at the National Women's Studies Association Conference, Storrs, CT, June 1981.

Lordon, Frédéric. *Willing Slaves of Capital: Spinoza and Marx on Desire.* Translated by Gabriel Ash. London, UK: Verso, 2014.

Lucas, Sarah. "Sarah Lucas on Her Art, the Venice Biennale, and Learning to Be Less Abject." Interview by Ian Wallace for *Artspace*, April 26, 2014. https://www.artspace.com/magazine/interviews_features/qa/sarah_lucas _interview-52228.

Luiselli, Valeria. *Tell Me How It Ends: An Essay in Forty Questions.* Minneapolis, MN: Coffee House Press, 2017.

Lydon, Christopher. "Michael Clune on Heroin Addiction and Memories of the First Time." Interview with Michael Clune. *Literary Hub*, August 4, 2017. https://lithub.com/michael-clune-on-heroin-addiction-and-memories -of-the-first-time.

Mackay, Robin, and Armen Avanessian, eds. *#Accelerate: The Accelerationist Reader.* Falmouth, UK: Urbanomic Media, 2017.

Mailer, Norman. "The White Negro." *Dissent*, Fall 1957.

Mallory, Tamika. Speech at Black Lives Matter protest in response to the murder of George Floyd. Minneapolis, MN, May 29, 2020.

Marantz, Andrew. "How Social-Media Trolls Turned U.C. Berkeley into a Free-Speech Circus." *New Yorker*, June 25, 2018.

Marinetti, F. T. *The Manifesto of Futurism* (1909). In *Manifesto: A Century of Isms.* Edited by Mary Ann Caws. Lincoln, NE: University of Nebraska Press, 2001.

Markus, Hazel Rose, and Barry Schwartz. "Does Choice Mean Freedom and Well-Being?" *Journal of Consumer Research* 37, no. 2 (2010): 344–55.

Marlowe, Ann. *How to Stop Time: Heroin from A to Z.* New York, NY: Anchor Books, 2000.

Marriott, David. *On Black Men.* New York, NY: Columbia University Press, 2000.

Martin, Nina. "Take a Valium, Lose Your Kid, Go to Jail." *ProPublica*, September 23, 2015. https://www.propublica.org/article/when-the-womb-is-a-crime -scene.

Martin, Dawn Lundy. "Because I Distrust this Mode: Talking to Dawn Lundy Martin." Interview with Andy Fitch. *BLARB* (Los Angeles Review of Books blog), April 26, 2019. https://blog.lareviewofbooks.org/interviews /distrust-mode-talking-dawn-lundy-martin.

Marvel, Kate. "We Should Have Never Called It Earth." *On Being* (blog). On Being Project, August 1, 2017. https://onbeing.org/blog/kate-marvel-we -should-never-have-called-it-earth.

Marx, Karl. *Capital: A Critique of Political Economy.* Vol. 1, *The Process of Production of Capital.* Edited by Frederick Engels. Translated by Samuel Moore and Edward Aveling. New York, NY: Random House, 1936.

Massumi, Brian. "Navigating Movements." Interview with Mary Zournazi in *Hope: New Philosophies for Change.* Annandale, Aus.: Pluto Press, 2002.

Matsuda, Mari, ed. *Words That Wound: Critical Race Theory, Assaultive Speech, and the First Amendment.* Boulder, CO: Westview Press, 1993.

McCann, Anthony. "Malheur, Part I: Sovereign Feelings." *Los Angeles Review of Books,* September 7, 2016. https://lareviewofbooks.org/article/malheur-part-i.

———. *Shadowlands: Fear and Freedom at the Oregon Standoff; A Western Tale of America in Crisis.* New York, NY: Bloomsbury, 2019.

McKibben, Bill. "How Extreme Weather Is Shrinking the Planet." *New Yorker,* November 16, 2018.

McPherson, Guy. Testimony at the New York City Council Committee on Environmental Protection on June 24, 2019. https://guymcpherson.com/2019/06 /yesterdays-testimony.

Merleau-Ponty, Maurice. "Cézanne's Doubt" (1945). In *Sense and Non-Sense.* Translated by Hubert L. Dreyfus and Patricia Allen Dreyfus. Evanston, IL: Northwestern University Press, 1964.

Metzl, Jonathan. *Dying of Whiteness: How the Politics of Racial Resentment Is Killing America's Heartland.* New York, NY: Basic Books, 2019.

Michaux, Henri. *Miserable Miracle: Mescaline* (1977). Translated by Louise Varese and Anna Koshovakis. New York, NY: New York Review Books, 2002.

Miller, Ellen. *Like Being Killed.* New York, NY: Plume, 1999.

———. "Like Being Killed: Interview with Ellen Miller," by Marion Winik, *Austin Chronicle,* September 11, 1998.

Millet, Catherine. *The Sexual Life of Catherine M.* Translated by Adriana Hunter. New York, NY: Grove Press, 2003.

Milstein, Cindy. *Anarchism and Its Aspirations.* Edinburgh, UK: AK Press, 2010.

Mitchell, Allyson, and Cait McKinney. *Inside Killjoy's Kastle: Dykey Ghosts, Feminist Monsters, and Other Lesbian Hauntings.* Vancouver, BC: University of British Columbia Press, 2019.

Mitchell, Timothy. *Carbon Democracy: Political Power in the Age of Oil.* New York, NY: Verso, 2011.

MoCA. "Feminaissance: Colloquium Schedule." April 27–29, 2007.

Mo Fei. "Beijing Poets: An Interview with Mo Fei and Zang Li by Leonard Schwartz and Zhang Er." *Poetry Project Newsletter* 169, April/May 1998.

Molesworth, Helen. "The Year in Shock." *Artforum*, December 2016. https://www.questia.com/magazine/1G1-473922779/the-year-in-shock.

Moraga, Cherríe. Interview with Amber Hollinbaugh. In Hollibaugh, *My Dangerous Desires*.

Morrison, Toni. "Making America White Again." *New Yorker*, November 14, 2016. https://www.newyorker.com/magazine/2016/11/21/making-america-white-again.

———. *Playing in the Dark: Whiteness and the Literary Imagination*. Cambridge, MA: Harvard University Press, 1992.

———. *Sula*. New York, NY: Vintage International, 2004.

Morton, Timothy. *Dark Ecology: For a Logic of Future Coexistence*. New York, NY: Columbia University Press, 2016.

———. *Humankind: Solidarity with Nonhuman People*. London, UK: Verso, 2017.

———. *Hyperobjects: Philosophy and Ecology after the End of the World*. Minneapolis, MN: University of Minnesota Press, 2013.

———. "What Is Agrilogistics?" *Ecology without Nature* (blog), October 11, 2015. http://ecologywithoutnature.blogspot.com/2015/10/what-is-agrilogistics.html.

Mosley, Walter. "Why I Quit the Writers' Room." *New York Times*, September 6, 2019. https://www.nytimes.com/2019/09/06/opinion/sunday/walter-mosley.html.

Moten, Fred. *Black and Blur*. Durham, NC: Duke University Press, 2017.

———. "The Black Outdoors: Fred Moten and Saidiya Hartman at Duke University." Duke University, Durham, NC, October 5, 2016. https://www.youtube.com/watch?v=t_tUZ6dybrc.

———. *In the Break: The Aesthetics of the Black Radical Tradition*. Minneapolis, MN: University of Minnesota Press, 2003.

———. *Stolen Life*. Durham, NC: Duke University Press, 2018.

———, and Stefano Harney. *The Undercommons: Fugitive Planning and Black Study*. Wivenhoe, UK: Minor Compositions, 2013.

Muñoz, José Esteban. *Disidentifications: Queers of Color and the Performance of Politics*. Minneapolis, MN: University of Minnesota Press, 1999.

———. "Thinking beyond Antirelationality and Antiutopianism in Queer Critique." In "The Antisocial Thesis in Queer Theory." Roundtable discussion in *PMLA* 121, no. 3 (May 2006): 819–28.

Myles, Eileen. *Afterglow: A Dog Memoir*. New York, NY: Grove Press, 2017.

———. *Chelsea Girls*. Santa Rosa, CA: Black Sparrow Press, 1994.

———. *Not Me*. New York, NY: Semiotext(e), 1991.

———. "Tapestry." *Vice*, November 30, 2006. https://www.vice.com/en_us/article/4w4yzb/tape-v13n12.

————. *We, the Poets*. In Reading series no. 38. Brooklyn, NY: Belladonna Press, 2003.

————, and Jill Soloway. "The Thanksgiving Paris Manifesto." *Femaletrouble* (blog), November 2015. https://femaletroublearchive.tumblr.com/post /154679508535/the-thanksgiving-paris-manifesto.

Nast, Heidi J. "Queer Patriarchies, Queer Racisms, International." *Antipode* 34, no. 5 (November 2002): 874–909.

National Academy of Sciences. "Biological Annihilation via the Ongoing Sixth Mass Extinction Signaled by Vertebrate Population Losses and Declines." Authors Gerardo Ceballos, Paul R. Ehrlich, and Rodolfo Dirzo. *Proceedings of the National Academy of Sciences* 114, no. 30 (July 25, 2017).

National Coalition Against Censorship. "NCAC Criticizes Walker Art Center's Decision to Destroy Sam Durant's Installation." NCAC blog, September 7, 2017. https://ncac.org/news/blog/ncac-criticizes-walker-art-centers -decision-to-destroy-sam-durants-installation.

————. "Symbols Into Soldiers: Art, Censorship and Religion." NCAC website, https://ncac.org/resource/symbols-into-soldiers-art-censorship-and-religion.

Neal, Larry. "The Black Arts Movement." *Drama Review*, Summer 1968.

Neimanis, Astrida. *The Philosopher's Eye* (blog). Response to comment about "Weathering." August 25, 2014. https://philosophycompass.wordpress.com /2014/08/21/hypatia-symposium-weathering-climate-change-and-the-thick -time-of-transcorporeality-by-astrida-neimanis-rachel-loewen-walker.

————, and Rachel Loewen Walker. "Weathering: Climate Change and the 'Thick Time' of Transcorporeality." *Hypatia* 29, no. 3 (2014): 558–75.

Nelson, Eric S. "Against Liberty: Adorno, Levinas, and the Pathologies of Freedom." *Theoria: A Journal of Social and Political Theory* 60, no. 131 (June 2012): 64–83.

Nestle, Joan. "The Femme Question." In Nestle, ed., *The Persistent Desire: A Femme-Butch Reader*. Boston, MA: Alyson Publications, 1992.

Newman, Andy. "'The King' of Shambhala Buddhism Is Undone by Abuse Report." *New York Times*, July 11, 2018.

Newman, Saul. "Anarchism and the Politics of Ressentiment," *Theory and Event* 4, no. 3, 2000.

Ngai, Sianne. *Ugly Feelings*. Cambridge, MA: Harvard University Press, 2005.

Nitzke, Solvejg, and Nicolas Pethes, eds. *Imagining Earth: Concepts of Wholeness in Cultural Constructions of Our Home Planet*. Bielefeld, Ger.: Transcript, 2017.

Noddings, Nel. *Caring: A Feminine Approach to Ethics and Moral Education*. Berkeley, CA: University of California Press, 1984.

Notley, Alice. *Disobedience*. New York, NY: Penguin, 2001.

————. "Poetics of Disobedience." Paper delivered at King's College London, Centre for American Studies, February 28, 1998.

Nussbaum, Martha. *Love's Knowledge: Essays on Philosophy and Literature*. Oxford, UK: Oxford University Press, 1993.

O'Hara, Frank. "Meditations in an Emergency" (1957). In *The Collected Poems of Frank O'Hara*, edited by Donald Allen. Berkeley, CA: University of California Press, 1995.

Oppen, George. "Leviathan" (1965). In *New Collected Poems*. New York, NY: New Directions Books, 2008.

Orenstein, Peggy. "'Girls & Sex' and the Importance of Talking to Young Women about Pleasure." Interview by Terry Gross. *Fresh Air*, NPR, March 29, 2016.

Orwell, George. "Benefit of Clergy: Some Notes on Salvador Dali" (1944). Reprinted in *George Orwell: As I Please, 1943–1946*, edited by Sonia Orwell. Boston, MA: Godine, 2000.

———. *1984*. London, UK: Secker and Warburg, 1949.

Owens, Iris. *After Claude* (1973). New York, NY: New York Review Books, 2010.

Palmer, Cynthia, and Michael Horowitz, eds. *Sisters of the Extreme: Women Writing on the Drug Experience*. Rochester, VT: Park Street Press, 2000.

Patterson, Orlando. *Slavery and Social Death: A Comparative Study*. Cambridge, MA: Harvard University Press, 1982.

Penny, Laurie (@PennyRed). "I'm so sick." Twitter, April 25, 2018, 2:07 AM (PST). https://twitter.com/pennyred/status/989068464928251904.

Pepper, Art, and Laurie Pepper. *Straight Life: The Story of Art Pepper*. New York, NY: Da Capo Press, 1994.

Perelman, Deb. "In the Covid-19 Economy, You Can Have a Kid or a Job. You Can't Have Both." *New York Times*, July 2, 2020.

Piver, Susan. "On Shambhala." *Open Heart Project* (blog), June 30, 2018. https://openheartproject.com/on-shambhala.

Phillips, Adam. "Politics in the Consulting Room: Adam Phillips in Conversation with Devorah Baum." *Granta* 146 (February 14, 2019).

Pickens, Beth. *Your Art Will Save Your Life*. New York, NY: Feminist Press, 2018.

Pinegrove Band. "A message from evan." Facebook, November 17, 2017. https://www.facebook.com/Pinegroveband/posts/10155748505559774.

Prager, Emily. Introduction to *After Claude*, by Iris Owens. New York, NY: New York Review Books, 2010.

Preciado, Paul B. "A letter from a trans man to the old sexual regime." Translated by Simon Pleasance. *Texte zur Kunst*, January 22, 2018. https://www.textezurkunst.de/articles/letter-trans-man-old-sexual-regime-paul-b-preciado.

———. *Testo Junkie: Sex, Drugs, and Biopolitics in the Pharmacopornographic Era*. Translated by Bruce Benderson. New York, NY: Feminist Press, 2013.

Puar, Jasbir K. *Terrorist Assemblages: Homonationalism in Queer Times*. Durham, NC: Duke University Press, 2017.

Rancière, Jacques. "Art of the Possible: An Interview with Jacques Rancière." With Fulvia Carnevale and John Kelsey. *Artforum* (March 2007): 256–69.

———. *The Emancipated Spectator*. London, UK: Verso, 2011.

Rankine, Claudia, and Beth Loffreda. Introduction to *The Racial Imaginary: Writers on Race in the Life of the Mind*. Edited by Claudia Rankine, Beth Loffreda, and Max King Cap. Albany, NY: Fence Books, 2015.

Republican National Committee. "RNC Message Celebrating Christmas." December 25, 2016. https://gop.com/rnc-message-celebrating-christmas-2016.

Riley, Denise. *Time Lived, Without Its Flow*. London, UK: Picador, 2019.

Rimbaud, Arthur. *Complete Works*. Translated by Paul Schmidt. New York, NY: Harper Perennial, 2000.

Rivera, Sylvia. Talk at Latino Gay Men of New York (LGMNY). Lesbian and Gay Community Services Center, New York, NY, June 2001.

Ronell, Avital. *Crack Wars: Literature, Addiction, Mania*. Lincoln, NE: University of Nebraska Press, 1992.

Rose, Jacqueline. *Mothers: An Essay on Love and Cruelty*. New York, NY: Farrar, Straus and Giroux, 2018.

Roy, Arundhati. "The Pandemic Is a Portal." *Financial Times*, April 3, 2020. https://www.ft.com/content/10d8f5e8-74eb-11ea-95fe-fcd274e920ca.

Rubin, Gayle. A conversation with Jewelle Gomez and Amber Hollibaugh, San Francisco, CA, Spring 1996. Reprinted in Hollibaugh, *My Dangerous Desires*.

———. "Thinking Sex: Notes for a Radical Theory of the Politics of Sexuality." In *Deviations: A Gayle Rubin Reader*. Durham, NC: Duke University Press, 2011.

Ruddick, Sara. *Maternal Thinking: Toward a Politics of Peace*. Boston, MA: Beacon Press, 1989.

Sabina, María. *Selections*. Edited by Jerome Rothenberg. Text and commentaries by Alvaro Estrada and others. Berkeley, CA: University of California Press, 2003.

Savage, Dan (@fakedansavage). "What are you into?" Twitter, February 4, 2015, 6:42 AM (PST). https://twitter.com/fakedansavage/status/562984560255057921.

Schneemann, Carolee. Interview with Kate Haug. *Wide Angle* 20, no. 1 (1998): 20–49.

Schoenberg, Arthur. "How One Becomes Lonely" (1937). In *Style and Idea: Selected Writings of Arthur Schoenberg*. Translated by Leon Black. Berkeley, CA: University of California Press, 1984.

Schore, Allan. *Affect Dysregulation and Disorders of the Self.* New York, NY: W. W. Norton, 2003.

Schulman, Sarah. *Conflict Is Not Abuse: Overstating Harm, Community Responsibility, and the Duty of Repair.* Vancouver, BC: Arsenal Pulp Press, 2016.

Schultz, Vicki. "Open Statement on Sexual Harassment from Employment Discrimination Law Scholars." *Stanford Law Review*, #MeToo Symposium, 2018. Written for law professors Rachel Arnow-Richman, Ian Ayres, Susan Bisom-Rapp, Tristin Green, Rebecca Lee, Ann McGinley, Angela Onwuachi-Willig, Nicole Porter, Vicki Schultz, and Brian Soucek.

Schwartz, Ian. "Megyn Kelly vs. Catholic League's Bill Donohue." *RealClearPolitics*, January 9, 2015. https://www.realclearpolitics.com/video /2015/01/09/megyn_kelly_catholic_leagues_bill_donohue_charlie_hebdo _self-censorship_friend_freedom.html.

Scranton, Roy. *Learning to Die in the Anthropocene: Reflections on the End of a Civilization.* San Francisco, CA: City Lights Publishers, 2015.

————. *We're Doomed. Now What? Essays on War and Climate Change.* New York, NY: Soho Press, 2018.

Sedgwick, Eve Kosofsky. "Epidemics of the Will." In *Tendencies.* Durham, NC: Duke University Press, 1993.

————. *Fat Art, Thin Art.* Durham, NC: Duke University Press, 1994.

————. "Paranoid Reading and Reparative Reading." In *Touching Feeling: Affect, Pedagogy, Performativity.* Durham, NC: Duke University Press, 2002.

Sen, Amartya. *Development as Freedom.* New York, NY: Alfred A. Knopf, 1999.

Sengupta, Somini. "Read Up on the Links between Racism and the Environment." *New York Times*, June 5, 2020. https://www.nytimes.com/interactive /2020/06/05/climate/racism-climate-change-reading-list.html.

Serisier, Tanya. "'Is Consent Sexy?'" *E*vibes—for an Emancipatory Practice* (blog), May 27, 2015. https://evibes.org/2015/05/27/is-consent-sexy.

Sexton, Jared. "Black Like Me," letter to the editor. *Harper's*, September 2017.

————. "The Rage: Some Closing Comments on 'Open Casket.'" *Contemp+orary*, May 21, 2017. https://contemptorary.org/the-rage-sexton.

Sharpe, Christina. *In the Wake: On Blackness and Being.* Durham, NC: Duke University Press, 2016.

————. "'What Does It Mean to Be Black and Look at This?' A Scholar Reflects on the Dana Schutz Controversy." Interview by Siddhartha Mitter. *Hyperallergic*, March 24, 2017. https://hyperallergic.com/368012/what-does -it-mean-to-be-black-and-look-at-this-a-scholar-reflects-on-the-dana-schutz -controversy.

Sheldon, Rebekah. *The Child to Come: Life after the Human Catastrophe.* Minneapolis, MN: University of Minnesota Press, 2016.

Shell, Ray. *Iced.* New York, NY: Random House, 1993.

Shriver, Lionel. "Fiction and Identity Politics." Keynote speech given at the Brisbane Writers Festival, September 8, 2016. Text reprinted in *Guardian*, September 13, 2016. https://www.theguardian.com/commentisfree/2016/sep/13/lionel-shrivers-full-speech-i-hope-the-concept-of-cultural-appropriation-is-a-passing-fad.

Shuster, David (@DavidShuster). "The Arctic Circle Hit 101°F Saturday." June 22, 2020. http://twitter.com/DavidShuster/status/1275245034858840065.

Siegel, Loren. "The Pregnancy Police Fight the War on Drugs." In *Crack in America: Demon Drugs and Social Justice*. Edited by Craig Reinarman and Harry Gene Levine. Berkeley, CA: University of California Press, 1997.

Sillman, Amy. "FEMINISM!" *Texte zur Kunst* 2, no. 84 (December 2011): 78–81.

———. "Shit Happens: Notes on Awkwardness." *Frieze*, November 10, 2015. https://www.frieze.com/article/shit-happens.

Simmons, William J. "Notes on Queer Formalism." *Big Red and Shiny*, December 16, 2013. http://bigredandshiny.org/2929/notes-on-queer-formalism.

Simone, Nina. "Feeling Good." Track 7 on *I Put a Spell on You*. Phillips Records, 1965.

Smith, Zadie. "Getting In and Out: Who Owns Black Pain?" *Harper's*, July 2017.

Snediker, Michael. *Queer Optimism: Lyric Personhood and Other Felicitous Persuasions*. Minneapolis, MN: University of Minnesota Press, 2009.

Sontag, Susan. *Against Interpretation, and Other Essays*. New York, NY: Farrar, Straus and Giroux, 1966.

———. *Regarding the Pain of Others*. New York, NY: Picador, 2003.

Spade, Dean. *Normal Life: Administrative Violence, Critical Trans Politics, and the Limits of Law*. Durham, NC: Duke University Press, 2011.

———, with Tourmaline. "No One is Disposable: Everyday Practices of Prison Abolition." A series of video conversations filmed for the Barnard Center for Research on Women. http://bcrw.barnard.edu/event/no-one-is-disposable-everyday-practices-of-prison-abolition.

Spahr, Juliana. *Everybody's Autonomy: Connective Reading and Collective Identity*. Tuscaloosa, AL: University of Alabama Press, 2001.

Spillers, Hortense. "Mama's Baby, Papa's Maybe: An American Grammar Book." *Diacritics* 17, no. 2 (1987): 65–81.

Sprinkle, Annie. "My Brushes and Crushes with the Law." AnnieSprinkle.org(asm), 1995. http://anniesprinkle.org/my-brushes-and-crushes-with-the-law.

Steiner, A. L., Zackary Drucker, and Van Barnes. Description of *You Will Never Be a Woman. You Must Live the Rest of Your Days Entirely as a Man and You Will Only Grow More Masculine with Every Passing Year. There Is No Way Out*, 2008. https://www.hellomynameissteiner.com/You-will-never-ever-be-a-woman-You-will-live-the-rest-of-your-days.

Stengers, Isabelle. "Gaia, the Urgency to Think (and Feel)." Talk delivered at The Thousand Names of Gaia: From the Anthropocene to the Age of the Earth (*Os Mil nomes de Gaia: Do Antropoceno a idade da terra*), Rio de Janeiro, Brazil, March 24, 2015.

Sundell, Margaret. "Invitation: An Aesthetics of Care." *4Columns*, 2017.

Sunrise Movement. "Who We Are." https://www.sunrisemovement.org/about.

Susann, Jacqueline. *Valley of the Dolls*. New York, NY: Bernard Geis Associates, 1966.

Szasz, T. S. *Ceremonial Chemistry: The Ritual Persecution of Drugs, Addicts, and Pushers*. Revised Edition. Holmes Beach, FL: Learning Publications, 1985.

———. *Our Right to Drugs: The Case for a Free Market*. Syracuse, NY: Syracuse University Press, 1996.

Tea, Michelle. *Black Wave*. New York, NY: Feminist Press, 2016.

———. "How Not to Be a Queer Douchebag." In *Against Memoir: Complaints, Confessions, and Criticisms*. New York, NY: Feminist Press, 2018.

———. "Sex and the Sacred Text: Michelle Tea on the Republication of Eileen Myles's 'Chelsea Girls.'" *Los Angeles Review of Books*, October 4, 2015. https://lareviewofbooks.org/article/sex-and-the-sacred-text-michelle-tea-on-the-republication-of-eileen-myless-chelsea-girls.

Teekah, Alyssa, with Erika Jane Scholz, May Friedman, and Andrea O'Reilly, eds. *This Is What a Feminist Slut Looks Like: Perspectives on the Slutwalk Movement*. Bradford, ON: Demeter Press, 2015.

Thomas, Piri. *Down These Mean Streets*. New York, NY: Vintage, 1997.

Todd, Zoe. "An Indigenous Feminist's Take on the Ontological Turn: 'Ontology' Is Just Another Word for Colonialism (Urbane Adventurer: Amiskwací)." *Uma (in)certa antropologia*, October 26, 2014. https://umaincertaantropologia.org/2014/10/26/an-indigenous-feminists-take-on-the-ontological-turn-ontology-is-just-anotherword-for-colonialism-urbane-adventurer-amiskwaci.

Tourmaline, with Dean Spade. "No One is Disposable: Everyday Practices of Prison Abolition." A series of video conversations filmed for the Barnard Center for Research on Women. http://bcrw.barnard.edu/event/no-one-is-disposable-everyday-practices-of-prison-abolition.

Traister, Rebecca. *Good and Mad: The Revolutionary Power of Women's Anger*. New York, NY: Simon & Schuster, 2018.

Treuer, David. *The Heartbeat of Wounded Knee: Native America from 1890 to the Present*. New York, NY: Riverhead Books, 2019.

Tronto, Joan C. *Moral Boundaries: A Political Argument for an Ethic of Care*. New York, NY: Routledge, 1993.

Trungpa, Chögyam. "Journey without Goal." In *The Collected Works of Chögyam Trungpa*. Boston, MA: Shambhala, 2003.

————. *The Myth of Freedom and the Way of Meditation*. Boston, MA: Shambhala, 2002.

————. *Training the Mind & Cultivating Living Kindness*. Boston, MA: Shambhala, 1993.

Tsing, Anna Lowenhaupt. *The Mushroom at the End of the World: On the Possibility of Life in Capitalist Ruins*. Princeton, NJ: Princeton University Press, 2015.

US Global Change Research Program (USGCRP). *Fourth National Climate Assessment*. Globalchange.gov, 2017, 1–470. https://nca2018.globalchange.gov.

Van Dyke, Jason Lee, quoted in "Republicans Are Adopting the Proud Boys," by Kelly Weill. *Daily Beast*, October 16, 2018. https://www.thedailybeast.com/republicans-are-adopting-the-proud-boys.

Verwoert, Jan. "Exhaustion and Exuberance: Ways to Defy the Pressure to Perform." In *What's Love (or Care, Intimacy, Warmth, Affection) Got to Do with It?* Berlin, Ger.: Sternburg Press, 2017.

Viso, Olga. Statement on Sam Durant's *Scaffold* on behalf of the Walker Art Center. May 27, 2017. https://walkerart.org/magazine/a-statement-from-olga-viso-executive-director-of-the-walker-art-center-05-27-17.

Warren, Elizabeth, and Amelia Warren Tyagi. *The Two-Income Trap: Why Middle-Class Mothers and Fathers Are Going Broke*. New York, NY: Basic Books, 2004.

W.A.G.E. (Working Artists and the Greater Economy). "WOMANIFESTO," 2008. https://wageforwork.com/about/womanifesto.

Wallace-Wells, David. *The Uninhabitable Earth*. New York, NY: Tim Duggan Books, 2019.

Wang, Jackie. "Against Innocence: Race, Gender, and the Politics of Safety." *LIES: A Journal of Materialist Feminism* 1, no. 1 (2012).

Ward, Jane. "Bad Girls: On Being the Accused." *Bully Bloggers* (blog), December 21, 2017. https://bullybloggers.wordpress.com/2017/12/21/bad-girls-on-being-the-accused.

Ward, Jesmyn. *Men We Reaped: A Memoir*. New York, NY: Bloomsbury, 2013.

Watt, Laura A. "Politics of Anthropocene Consumption: Dipesh Chakrabarty and Three College Courses." *RCC Perspectives*, no. 2 (2016): 73–80.

Weiner, Joshua. "There Are No Rats: Some Figuring on Race." In *The Racial Imaginary: Writers on Race in the Life of the Mind*, 123–39. Albany, NY: Fence Books, 2015.

Weber, Andreas. *Matter and Desire: An Erotic Ecology*. White River Junction, VT: Chelsea Green Publishing, 2017.

Westervelt, Amy. "The Case for Climate Rage." *Popula*, August 19, 2019. https://popula.com/2019/08/19/the-case-for-climate-rage.

"What Is Censorship?" American Civil Liberties Union. https://www.aclu.org
/other/what-censorship.

White, Simone. *Dear Angel of Death*. Brooklyn, NY: Ugly Duckling Presse, 2018.

Wittgenstein, Ludwig. *Philosophical Investigations*. 2nd ed. Translated by G. E. M.
Anscombe. Oxford, UK: Blackwell, 1958.

Women and Entheogens Conference, Detroit Psychedelics Community website,
2017. http://kilindi.wix.com/entheogenicconf.

Woodly, Deva. "The Politics of Care with Deva Woodly." New School Public
Programs and Events, June 18, 2020. https://event.newschool.edu/woodly
currentmoment.

Wojnarowicz, David. *Close To the Knives: A Memoir of Disintegration*. New York,
NY: Vintage, 1991.

Wypijewski, JoAnn. "What We Don't Talk about When We Talk about #MeToo."
Nation, February 22, 2018.

Yiannopoulos, Milo. Quoted in "The Fall of Milo Yiannopoulos," by Tanya Gold,
Spectator, April 10, 2018. https://www.spectator.co.uk/article/the-fall-of-milo
-yiannopoulos.

Yusoff, Kathryn. *A Billion Black Anthropocenes or None*. Minneapolis, MN: University of Minnesota Press, 2018.

Zournazi, Mary, ed. *Hope: New Philosophies for Change*. Annandale, Aus.: Pluto
Press, 2002.

Index of Names

Acosta, Oscar Zeta, 253n2
Ahmed, Sara, 61, 78, 236n26, 241n4
Ahwesh, Peggy, 128
Akerman, Chantal, 137
Alexie, Sherman, 245–46n9
Allais, Alphonse, 238n33
Allison, Dorothy, 91, 108
Als, Hilton, 152
Althoff, Kai, 27
Althusser, Louis, 157
Amor, Bani, 247n14
Angel, Katherine, 77, 241–42n7
Anger, Kenneth, 30
Ansari, Aziz, 84, 85, 116
Anslinger, Harry, 246–47n12
Arendt, Hannah, 3, 12–13, 14, 77, 226–27n15
Argento, Asia, 108
Armey, Richard Keith (Dick), 7
Artaud, Antonin, 132, 149, 150, 152, 154, 166
Asimov, Isaac, 199
Atkinson, Ti-Grace, 161
Augustine, Saint, 13
Auld, Graeme, 197
Avanessian, Armen, 209

Baeyer, Adolf von, 139
Bakunin, Mikhail, 224–25n9

Baldwin, James, 8, 14, 150, 152, 226–27n15, 247n13
Balibar, Étienne, 135, 244n3
Bambara, Toni Cade, 8
Barad, Karen, 163, 190, 248n17
Baraka, Amiri, 253n1
Barnes, Djuna, 30
Barnes, Van, 40
Basquiat, Jean-Michel, 31
Baudelaire, Charles, 132, 134, 135
Baum, Dan, 246n11
Beatty, Paul, 47, 236–37n28
Beck, Robert. See Iceberg Slim (Robert Beck)
Beckett, Samuel, 21, 214
Bee, Samantha, 224n8
Benderson, Bruce, 91
Benjamin, Walter, 132, 135
Bennett, Jane, 163
Berardi, Franco "Bifo," 22, 71, 97, 205, 234n20, 239n37
Berger, John, 237n29
Berlant, Lauren, 95, 177, 192–93, 224n8, 226n14, 240n1
Bernstein, Charles, 240n38
Bernstein, Steven, 197
Berryman, John, 132
Bersani, Leo, 76, 95, 161
Bérubé, Allan, 241n6

Beyoncé (Beyoncé Giselle Knowles-Carter), 74
Binko, Heidi, 252n17
Biss, Eula, 240n38, 247n13
Black, Hannah, 34, 51, 57, 63, 64, 230–31n8, 233–34n18
Blake, Nayland, 91
Blanchfield, Brian, 89
Blow, Charles, 231n12
Boal, Augusto, 45
Boon, Marcus, 127, 135, 170
Bordowitz, Gregg, 91
Bornstein, Kate, 160
Bowles, Paul, 148
Bradford, Mark, 65, 238n33
Braidotti, Rosi, 214
Braverman, Kate, 133
brown, adrienne maree, 226n13
Brown, Wendy, 5, 6, 8, 12, 13, 60–61, 115–16, 223–24n7, 224n8, 227n4, 236n24, 238–39n35
Brownstein, Carrie, 112
Bryant, Carolyn, 104
Buddha, 17
Bukowski, Charles, 48–49, 132
Bundy, Ammon, 223n4, 227n18
Burden, Chris, 231n9
Burke, Tarana, 108
Burroughs, William S., 130, 132, 133, 148, 156, 170
Burton, Scott, 238n32
Burton, Virginia Lee, 171
Butler, Judith, 5, 27, 155, 166, 169, 223n6, 228n1, 249n20
Butler, Octavia E., 245–46n9

C. E., 73–74, 83, 87, 98, 125
Cain, George, 245–46n9
Calhoun, John C., 10
Califia, Patrick, 82, 91
Callahan, Manolo, 4, 223n3, 228n1
Campion, Jane, 248n16

Carroll, Jim, 132
Cashore, Benjamin, 197
Castaneda, Carlos, 132
Césaire, Aimé, 65, 66
Cézanne, Paul, 44
Chagoya, Enrique, 41
Chakrabarty, Dipesh, 185, 198
Chan, Jamie, 27
Chan, Paul, 20
Chödrön, Pema, 121–23, 124–25, 166, 167, 208
Chu, Andrea Long, 56, 193, 245n8
Civil, Gabrielle, 226n13
Cleaver, Eldridge, 59, 244n1
Clinton, Bill, 118–21, 128
Clune, Michael W., 129, 130, 163–65, 167, 169, 248n18, 248n19
Coates, Ta-Nehisi, 10–11, 112
Cobb, Jelani, 223n4
Coleridge, Samuel Taylor, 132
Connolly, William E., 178–79, 195, 252n16
Cooper, Dennis, 47
Cornell, Joseph, 30
Corso, Gregory, 136
Crawford, Joan, 152
Crimp, Douglas, 91–92, 241n6
Critchley, Simon, 67, 254n4
Crowley, Aleister, 132
Crutzen, Paul, 210–11, 249n1
Cruz, Kleaver, 226n13
Cullen, Countee, 55
Culp, Andrew, 174, 203
Cvetkovich, Ann, 203, 226n14

Dalí, Salvador, 230n7
Davidson, Dennis, 241n6
Davis, Angela Y., 5, 160, 223–24n7
Davis, Bette, 152
Davis, Karon, 229n5
Davis, Vaginal, 31, 47, 88
De Boever, Arne, 35

Delany, Samuel R., 91
Deleuze, Gilles, 76, 131, 253n1
De Man, Paul, 134, 244n2
Deneuve, Catherine, 99
De Quincey, Thomas, 132, 148
Derrida, Jacques, 135, 136, 149, 151, 153, 170, 244–45n5, 253n1
Despentes, Virginie (VD), 83, 91, 155, 160–62
Diamond, Lisa, 242n8
Diaz, Natalie, 245–46n9
Dillard, Annie, 173–74
Donegan, Moira, 74, 90, 240–41n2
Donohue, William (Bill), 33, 57–58
Doyle, Jennifer, 49–50, 84, 86, 92, 238n32
Drucker, Zackary, 40
D'Souza, Aruna, 34
Du Bois, W. E. B., 247n13
Durant, Sam, 32, 33–34, 35, 41, 57, 58, 232n14, 235n22, 235–36n23
Duras, Marguerite, 135
Durham, Jimmie, 47
Dustan, Guillaume (GD), 155, 158–60, 161, 162
Dworkin, Andrea, 74, 241n5
Dylan, Bob, 152

Edelman, Lee, 95, 161, 191, 192, 193, 240n1
Edwards, Adrienne, 65, 238n32
Ehrlichman, John, 246n11
Eisenman, Nicole, 238n32
Emerson, Ralph Waldo, 169–70, 214, 215, 216
Eminem (Marshall Bruce Mathers III), 152
English, Darby, 44, 66
Enzinna, Wes, 234n19
Eriksson, Annika, 67
Ettore, Elizabeth, 136

Fahs, Breanne, 80–81, 86
Fanon, Frantz, 43
Faust, Marguerite, 135
Federer, Roger, 236n25
Feinberg, Leslie, 91
Ferreira da Silva, Denise, 12
Finley, Karen, 88
Firbank, Ronald, 30
Fischel, Joseph J., 106, 109, 241n5
Fisher, Mark, 188
Fitzgerald, F. Scott, 132
Flaubert, Gustave, 131–32
Floyd, George, 191
Flynn, Gillian, 83–84, 241n3
Foer, Jonathan Safran, 250n6
Folden, Kathleen, 41
Foner, Eric, 10, 223n5, 226n12
Foucault, Michel, 6, 16, 25, 31, 77, 78–79, 91, 114–15, 155, 223n1, 237n30
Frank, Barney, 13–14
Frank, Robert, 136
Frankl, Viktor E., 205
Franks, Mary Anne, 95
Fraser, Nancy, 229n4, 234n20, 238–39n35
Freeman, Jo, 237n31
Freire, Paulo, 223n1
Freud, Sigmund, 132, 135, 204
Fung, Richard, 31

Gaines, Charles, 47
Garland, Judy, 246–47n12
Gessen, Masha, 59, 103
Ghosh, Amitav, 207, 250n6
Gibson-Graham, J. K., 111, 216
Gilligan, Carol, 93, 226–27n15, 229n4
Gilmore, Ruth Wilson, 243n12
Gilroy, Paul, 226–27n15
Ginsberg, Allen, 132, 136
Glenn, Evelyn Nakano, 226n12

Glissant, Édouard, 68, 253n1
Goldberg, Michelle, 83, 125, 241n3
Goldin, Nan, 230n7
Goldman, Emma, 59
Gomez, Marga, 31
Gonsalves, Gregg, 20, 228n1, 241n6
González, Emma, 252n15
Gordon, Avery F., 8
Göring, Hermann, 139
"Grace" (pseudonym), 84, 85, 116
Graeber, David, 15, 17, 145
Griswold, Eliza, 252n17
Guattari, Félix, 76, 195
Guerra, Salvador, 153
Guibert, Hervé, 91
Gunn-Wright, Rhiana, 250–51n7
Gurdjieff, George, 124
Gutierrez, Miguel, 66

Habib, Conner, 86
Hägglund, Martin, 239n37
Halberstam, Jack, 191
Halley, Janet E., 94–95, 120,
 226–27n15, 232n13
Halsey, Lauren, 229n5
Hamer, Fannie Lou, 11
Hammond, Harmony, 238n32
Handler, Chelsea, 247n14
Haneke, Michael, 27
Hanh, Thich Nhat, 17
Haraway, Donna J., 179–80, 186,
 192, 207
Hari, Johann, 165, 245n7, 246n11,
 246–47n12
Harjo, Joy, 245–46n9
Harney, Stefano, 12, 208–9, 215
Hartman, Saidiya V., 71, 137, 145,
 189, 225n10, 227–28n19
Hegel, Georg Wilhelm Friedrich, 64
Heglar, Mary Annaïse, 180, 200,
 250–51n7

Heidegger, Martin, 132, 135, 254n4
Hemphill, Essex, 91
Hendrix, Jimi, 151
Hickok, Wild Bill (James Butler
 Hickok), 133
Hitler, Adolf, 21
Hobson, Emily K., 243n15
Hodgkinson, David, 196
Hodson, Chelsea, 94, 97
Holiday, Billie, 145, 156, 162, 245n7,
 246n11, 246–47n12
Hollibaugh, Amber, 89–90, 91, 97,
 108–9
Hollingsworth, Trey, 182
hooks, bell, 223n1
Horowitz, Michael, 245–46n9
Hughes, Holly, 30, 55, 59
Hughes, Langston, 32, 55, 59
Huxley, Aldous, 132
Hyde, Lewis, 240n38
Hynde, Chrissie, 112
Hynes, Dev, 229n5

Iceberg Slim (Robert Beck), 137,
 245–46n9
Ignatiev, Noel, 247n13
Irigaray, Luce, 43

Jackson, Michael, 11
Jagger, Mick, 152
Jakobsen, Janet R., 113, 224–25n9
James, Henry, 21
Johnson, Ayana E., 249–51n7
Johnson, Barbara, 133–34, 244n2,
 248n16
Johnson, Denis, 132
Johnson, Lyndon, 198
Johnson, Mykel, 96
Johnson, Robert, 209
Jung, Carl, 169
Jünger, Ernst, 135

Kaba, Mariame, 105
Kant, Immanuel, 132
Kapczynski, Amy, 20, 228n1
Kavan, Anna, 138, 147
Keats, John, 248n16
Keene, John, 48
Kelley, Mike, 64
Kelley, Robin D. G., 5, 218, 228n1,
 253–54n3
Kerouac, Jack, 129, 132, 148,
 149–50, 154
Kesey, Ken, 132
Kester, Grant, 24
Kierkegaard, Søren, 254n4
Kincaid, Jamaica, 245–46n9
King, Martin Luther, Jr., 6,
 226–27n15
Kingsnorth, Paul, 207
Kipnis, Laura, 87–88, 95, 101
Klein, Melanie, 29–30
Klein, Naomi, 181–83
Knausgaard, Karl Ove, 134
Koch, Stephen, 143, 146
Koestenbaum, Wayne, 4–5, 64
Koestler, Arthur, 129
Kopelson, Karen, 144
Kramer, Larry, 241n6
Kundera, Milan, 254n4

Labrum, Machig, 124
Lakoff, George, 224–25n9
La Pasionaria (Isidora Dolores
 Ibárruri Gómez), 160
Latour, Bruno, 188–89, 252n13
Lear, Jonathan, 251n8
LeCain, Timothy J., 189
Leigh, Simone, 229n5
Lennard, Natasha, 81–82, 84,
 236n25
Lennon, John, 152
Lertzman, Renée, 250–51n7

Leslie, Alfred, 136
Levi, Primo, 139
Levin, Kelly, 197
Levinas, Emmanuel, 25–26, 67, 131
Levy, Ariel, 38
Lewinsky, Monica, 118–21
Ligon, Glenn, 65, 238n32
Lin, Tao, 245–46n9
Loffreda, Beth, 42, 43, 55
Logue, Deirdre, 62
Lorde, Audre, 229n4, 253n19
Lordon, Frédéric, 7, 225n11
Love, Courtney, 145
Lowry, Malcolm, 132
Lucas, Sarah, 16
Ludlam, Charles, 30
Luiselli, Valeria, 208

Mackay, Robin, 209
Mackey, Nathaniel, 253n1
MacKinnon, Catherine, 241n5
Madani, Tala, 45, 46, 70
Mailer, Norman, 148, 150, 151, 154
Malcolm X (Malcolm Little), 137,
 245–46n9
Malevich, Kazimir, 238n33
Mallory, Tamika, 191
Marinetti, Filippo Tommaso, 25
Marlowe, Ann, 147–48, 156, 248n15
Marriott, David, 43
Martin, Agnes, 47
Martin, Dawn Lundy, 62
Marvel, Kate, 187, 250n6, 250–51n7
Marx, Karl, 4, 71, 78, 126, 210,
 224–25n9, 225–26n11, 239n37,
 248n17
Massumi, Brian, 155–56, 184
Matsuda, Mari, 38
McCann, Anthony, 163, 227n18
McKibben, Bill, 175, 181, 183,
 251n9, 251n10

McPherson, Guy, 179, 204–5
Merleau-Ponty, Maurice, 44
Metzl, Jonathan M., 247n13
Michaux, Henri, 132–33, 134–35
Milstein, Cindy, 224–25n9
Mill, John Stuart, 39
Miller, Ellen, 138–41, 144
Millet, Catherine, 99–100, 101
Mitchell, Allyson, 62, 236n27
Mitchell, Timothy, 185–86
Mo Fei, 44
Molesworth, Helen, 26, 229n5
Moraga, Cherríe, 97
Morris, Edward, 201
Morrison, Jim, 149
Morrison, Toni, 147, 231n12,
 245–46n9, 247n13
Morton, Timothy, 163, 172, 190,
 197–98, 200, 205, 210–11,
 249n1
Moshfegh, Ottessa, 245–46n9
Mosley, Walter, 231n11
Moten, Fred, 5, 15, 62, 68, 189,
 203, 208–9, 215, 223n3, 223n6,
 225–26n15, 227n16, 227–28n19,
 237n31, 248n17, 253n1, 253n2,
 253n20
Mueller, Cookie, 88
Muñoz, José Esteban, 26, 29–31,
 191, 229–31n6
Murray, Christopher, 241n6
Musk, Elon, 199
Mussolini, Benito, 25
Myhre, Sarah, 250–51n7
Myles, Eileen, 23, 50, 91, 100–101,
 134, 242–43n11

Nabokov, Vladimir, 47
Nast, Heidi J., 252n14
Neal, Larry, 229n3
Neel, Alice, 244n4
Neimanis, Astrida, 114, 209

Nestle, Joan, 91, 94, 96, 108
Newman, Andy, 244n17
Newman, Saul, 111
Newton, Huey, 5
Ngai, Sianne, 253n19
Nietzsche, Friedrich Wilhelm, 13,
 15, 132, 135, 156, 223–24n7
Nixon, Richard, 246n11
Noddings, Nel, 229n4
Notley, Alice, 46
Nussbaum, Martha, 21

Oakley, Annie, 133
O'Hara, Frank, 187
O'Laughlin, Tamara Toles,
 250–51n7
Opie, Catherine, 38
Oppen, George, 5
Orenstein, Peggy, 83
Orlovsky, Peter, 136
Orwell, George, 230n7
Owens, Iris, 141–44, 145, 146

Palmer, Cynthia, 245–46n9
Paradise, Annie, 228n1
Parenti, Michael, 208
Patterson, Orlando, 224n10
Paul, Saint (the apostle), 13
Peele, Jordan, 233–34n18
Pellegrini, Ann, 113, 224–25n9
Penny, Laurie, 51–52
Pepper, Art, 130–31, 148, 163, 244n1
Phillips, Adam, 45, 50, 51, 54
Pickens, Beth, 232–33n15
Piper, Adrian, 47
Pires, Leah, 27
Plato, 162
Plenty Coups (Crow chief), 251n8
Plotinus, 13
Pollock, Jackson, 151, 238n33
Pope.L, William, 47
powell, john a., 39, 231n10

Prager, Emily, 142, 145
Preciado, Paul B., 74, 154–55, 158–62, 163, 165–66, 248n17
Proust, Marcel, 252–53n18
Pryor, Richard, 47, 152
Puar, Jasbir K., 240–41n2, 252n14

Quinn, Barbara, 133, 248n15

Rancière, Jacques, 21, 24
Rankine, Claudia, 42, 43, 55
Reich, Wilhelm, 76, 155
Respini, Eva, 234–35n21
Rich, Nathaniel, 250n6
Richards, Keith, 152
Riggs, Marlon, 88, 91
Riley, Denise, 210, 213–14
Rimbaud, Arthur, 132, 148–49, 150, 151, 152, 154
Rittel, Horst W. J., 197
Rivera, Sylvia, 77, 91
Rivers, Larry, 136
Romney, Mitt, 136
Ronell, Avital, 108, 128, 129, 130, 131–32, 135, 144, 146, 147, 245n8
Rose, Jacqueline, 69
Rotello, Gabriel, 241n6
Roy, Arundhati, 253–54n3
Rubin, Gayle, 78, 84, 91, 98, 108, 241n6
Ruddick, Sara, 229n4

Sabina, María, 152–54, 162, 165
Sade, Marquis de, 47, 59, 98
Sartre, Jean-Paul, 132
Savage, Dan, 116
Sayler, Susannah, 201
Schneemann, Carolee, 126
Schneider, Maria, 230n7
Schoenberg, Arthur, 232n16
Schore, Allan, 236–37n28

Schulman, Sarah, 29, 234–35n21, 243n14
Schultz, Vicki, 243n13
Schutz, Dana, 33, 34, 35, 41, 57, 230–31n8, 232n14, 233–34n18, 234–35n21, 239n36
Scranton, Roy, 177, 178, 207
Sedgwick, Eve Kosofsky, 26, 28, 29–31, 33, 48, 59, 78, 155, 156, 191–92, 252–53n18
Serisier, Tanya, 115
Sexton, Jared, 51, 233–34n18, 239n36, 253n1
Seyrig, Delphine, 137
Shakespeare, William, 230n7
Sharpe, Christina, 20, 228–29n2, 230–31n8
Shehi, Casey, 244–45n5
Sheldon, Rebekah, 193, 252n14
Shell, Ray, 245–46n9
Shindler, Kelly, 238n32
Shriver, Lionel, 55–56
Signorile, Michelangelo, 241n6
Sillman, Amy, 22, 65–66, 71–72, 159, 238n32
Simone, Nina, 15
Smith, Jack, 30, 31, 47, 229–30n6
Smith, Patti, 151
Smith, Zadie, 41, 47, 233–34n18
Snediker, Michael, 252–53n18
Solanas, Valerie, 48–49, 59, 160, 245n8
Solange (Solange Piaget Knowles), 229n5
Soloway, Jill, 50
Sontag, Susan, 23, 24, 63, 64
Spade, Dean, 244n12, 244n16
Spahr, Juliana, 21
Spencer, Richard, 236n25
Spillers, Hortense, 245n6
Sprinkle, Annie, 36, 91, 160
Stein, Gertrude, 5
Steiner, A. L., 40, 223n2

Stengers, Isabelle, 176, 202, 207
Stoermer, Eugene F., 210–11, 249n1
Sullivan, Andrew, 241n6
Susann, Jacqueline, 147
Szasz, Thomas S., 156–57, 167

Tea, Michelle, 88, 91, 99, 148, 242–43n11
Teeman, Diane, 163
Teresa de Ávila, Saint, 135
Thandeka (Sue Booker), 247n13
Thomas, Kendall, 241n6
Thomas, Piri, 245–46n9
Thompson, Hunter S., 132
Thoreau, Henry David, 59
Thunberg, Greta, 192
Thurman, Uma, 230n7
Till, Emmett, 33, 34, 35, 104, 232n14, 233–34n18, 234–35n21, 238n33, 239n36
Till-Mobley, Mamie, 239n36
Todd, Zoe, 252n13
Tomkins, Silvan, 28, 29
Tourmaline, 243n12
Traister, Rebecca, 253n19
Treuer, David, 251n8
Trocchi, Alexander, 132
Tronto, Joan, 229n4
Trump, Donald J., 7–8, 14, 63, 203, 213, 224n8, 226n14, 247n13
Trungpa, Chögyam, 52, 121–22, 124, 167, 173, 237n31
Tsang, Wu, 47
Tsing, Anna Lowenhaupt, 252n16
Tubman, Harriet, 10
Turner, Nat, 10

Venkataraman, Bina, 250–51n7
Verwoert, Jan, 53, 67

Walker, Kara, 47, 62
Walker, Rachel Loewen, 209
Wallace, David Foster, 236n25
Wallace-Wells, David, 180, 250n6
Wang, Jackie, 112
Ward, Jane, 103–4, 106
Ward, Jesmyn, 245–46n9
Warhol, Andy, 31
Warner, Michael, 241n6
Warren, Elizabeth, 238–39n35
Wasson, R. Gordon, 152, 153
Waters, John, 30
Watkins, D., 137, 245–46n9
Watt, James, 172, 178
Watt, Laura A., 199–200
Weber, Andreas, 227–28n19
Webber, Melvin M., 197
Weiner, Joshua, 43
Welsh, Irvine, 132
West, Kanye, 10
West, Robin, 226–27n15
Westervelt, Amy, 250n6, 250–51n7
White, Simone, 253n1
Wilde, Oscar, 64
Wilkinson, Katharine, 250–51n7
Willis, Ellen, 74
Wilson, Bill, 169
Winfrey, Oprah, 51, 74
Winnicott, Donald Woods, 194
Wittgenstein, Ludwig, 4, 42
Wittig, Monique, 160
Wojnarowicz, David, 33, 88, 91, 100
Woodly, Deva, 228n1
Woolf, Virginia, 160
Wypijewski, JoAnn, 75, 240–41n2

Yiannopoulos, Milo, 24
Yusoff, Kathryn, 181, 249n1

MAGGIE NELSON is the author of several books of poetry and prose, including the *New York Times* best seller and National Book Critics Circle Award winner *The Argonauts* (2015), *The Art of Cruelty: A Reckoning* (2011; a *New York Times* Notable Book of the Year), *Bluets* (2009; named by *Bookforum* as one of the top ten best books of the past twenty years), *The Red Parts* (2007; reissued 2016), and *Women, the New York School, and Other True Abstractions* (2007). Her poetry titles include *Something Bright, Then Holes* (2007) and *Jane: A Murder* (2005; finalist for the PEN/ Martha Albrand Award for the Art of the Memoir). She has been the recipient of a MacArthur "Genius" Fellowship, a Guggenheim Fellowship, an NEA Fellowship, an Innovative Literature Fellowship from Creative Capital, and an Arts Writers Grant from the Andy Warhol Foundation. She is currently a professor of English at University of Southern California and lives in Los Angeles.

The text of *On Freedom* is set in Adobe Garamond Pro.
Book design by Rachel Holscher.
Composition by Bookmobile Design and Digital Publisher Services, Minneapolis, Minnesota.
Manufactured by McNaughton & Gunn on acid-free, 100 percent postconsumer wastepaper.